Miami

Trends and Traditions

Photographs by Roberto Schezen
Text by Beth Dunlop

EVERGREEN

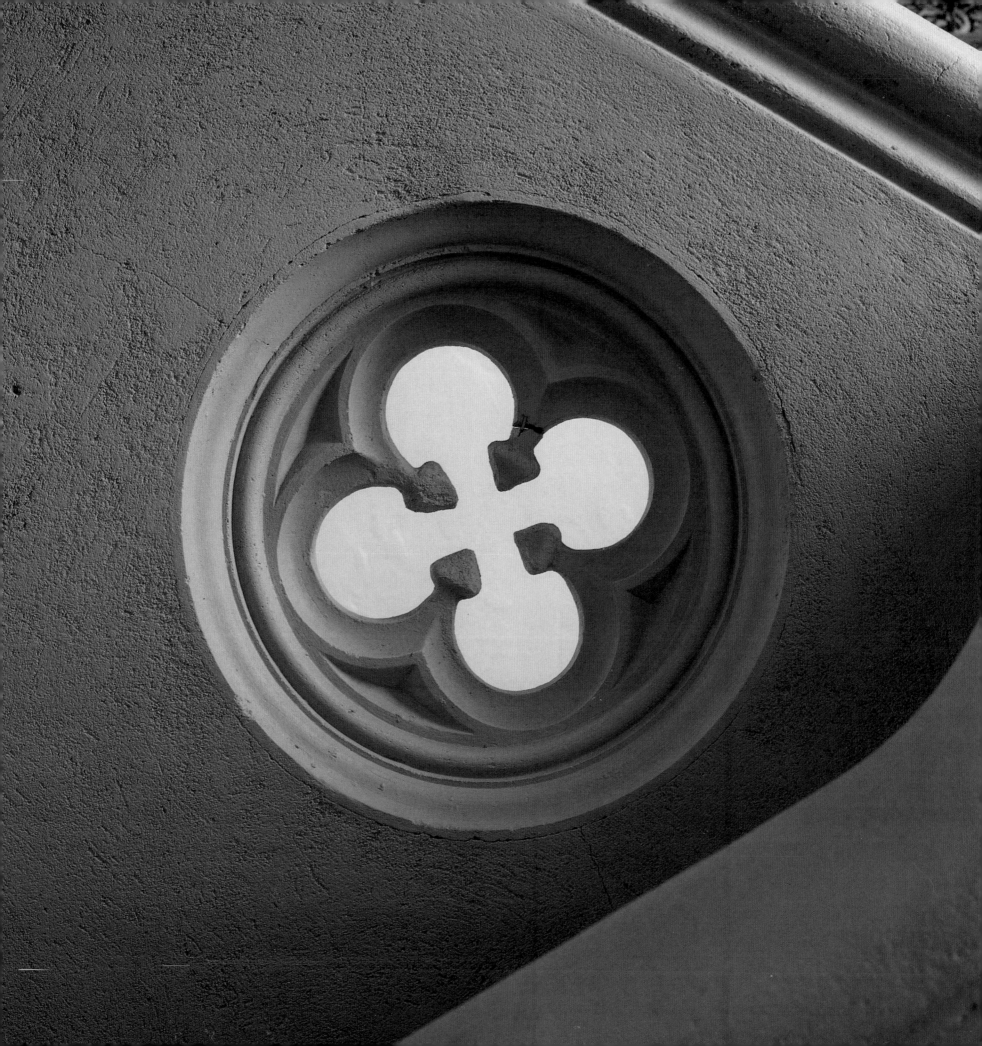

CONTENTS
INHALT
SOMMAIRE

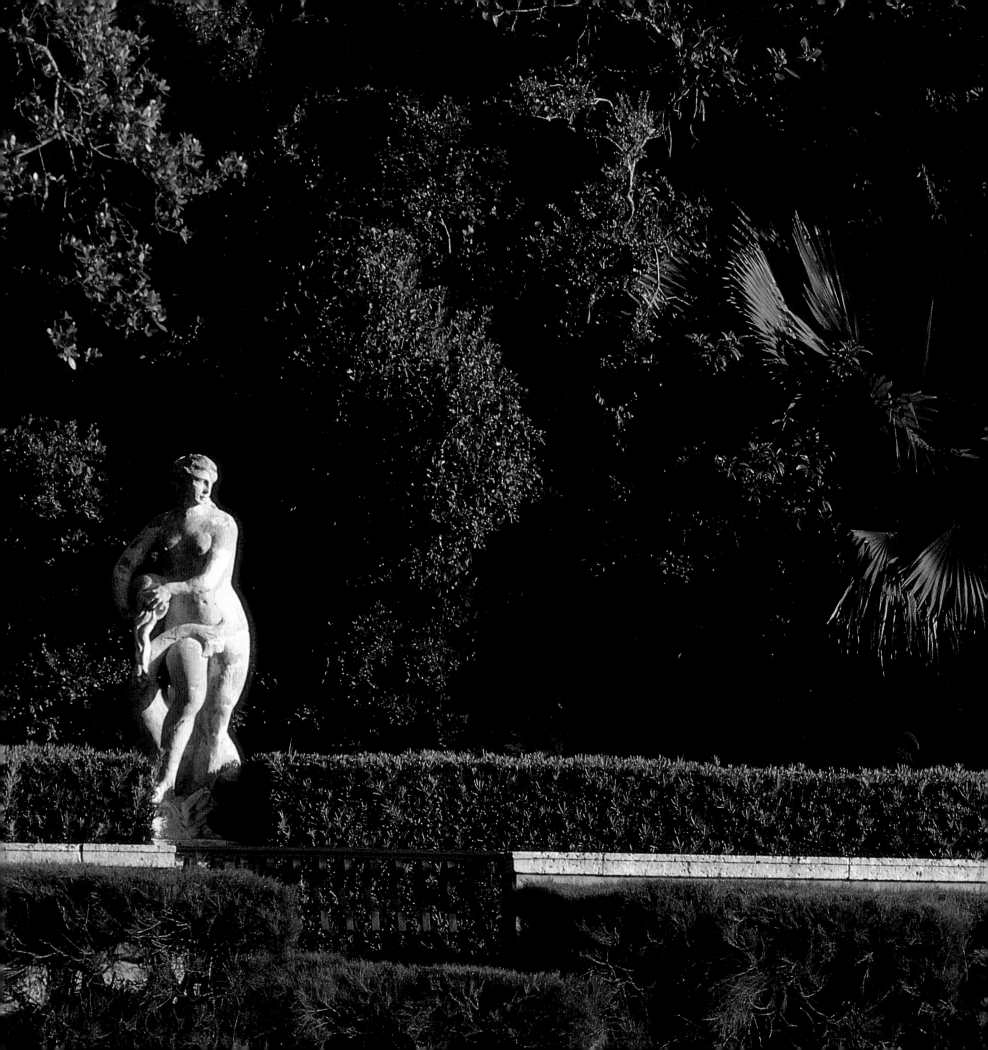

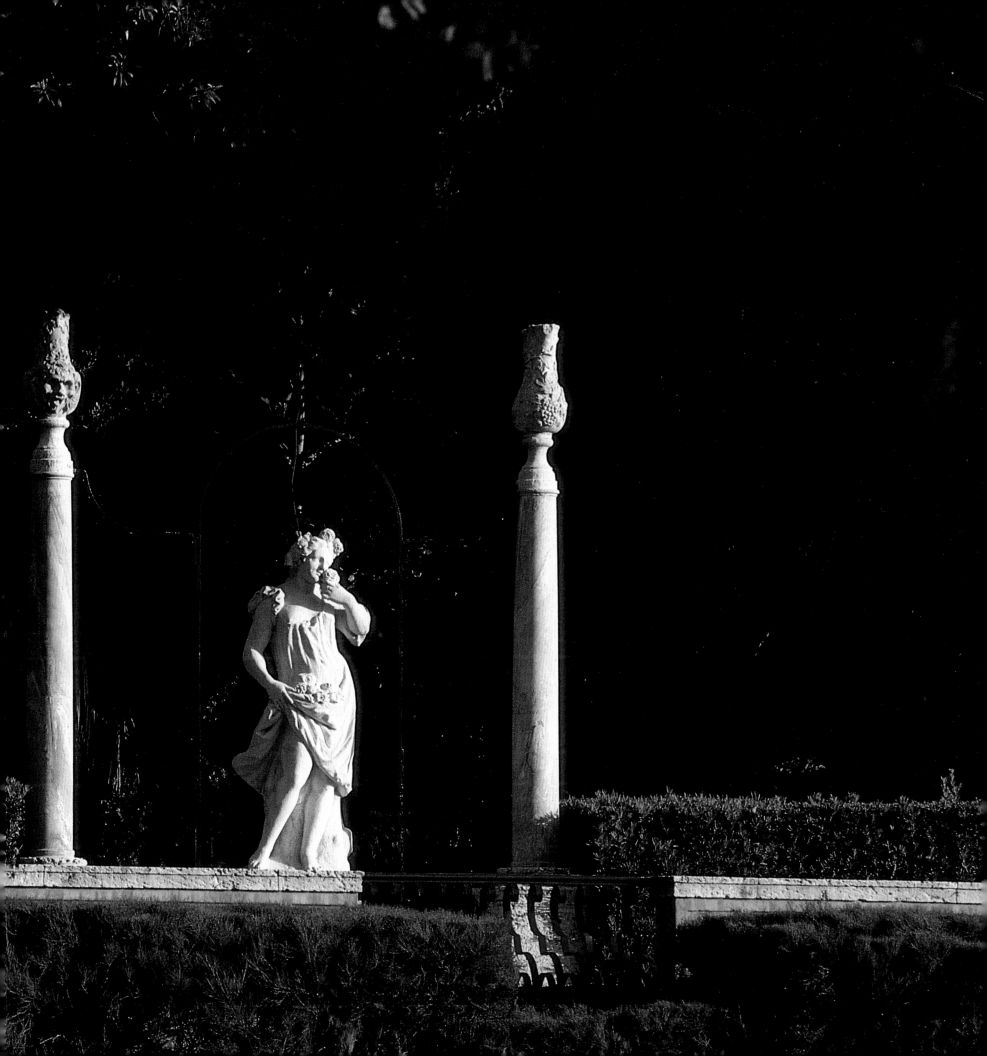

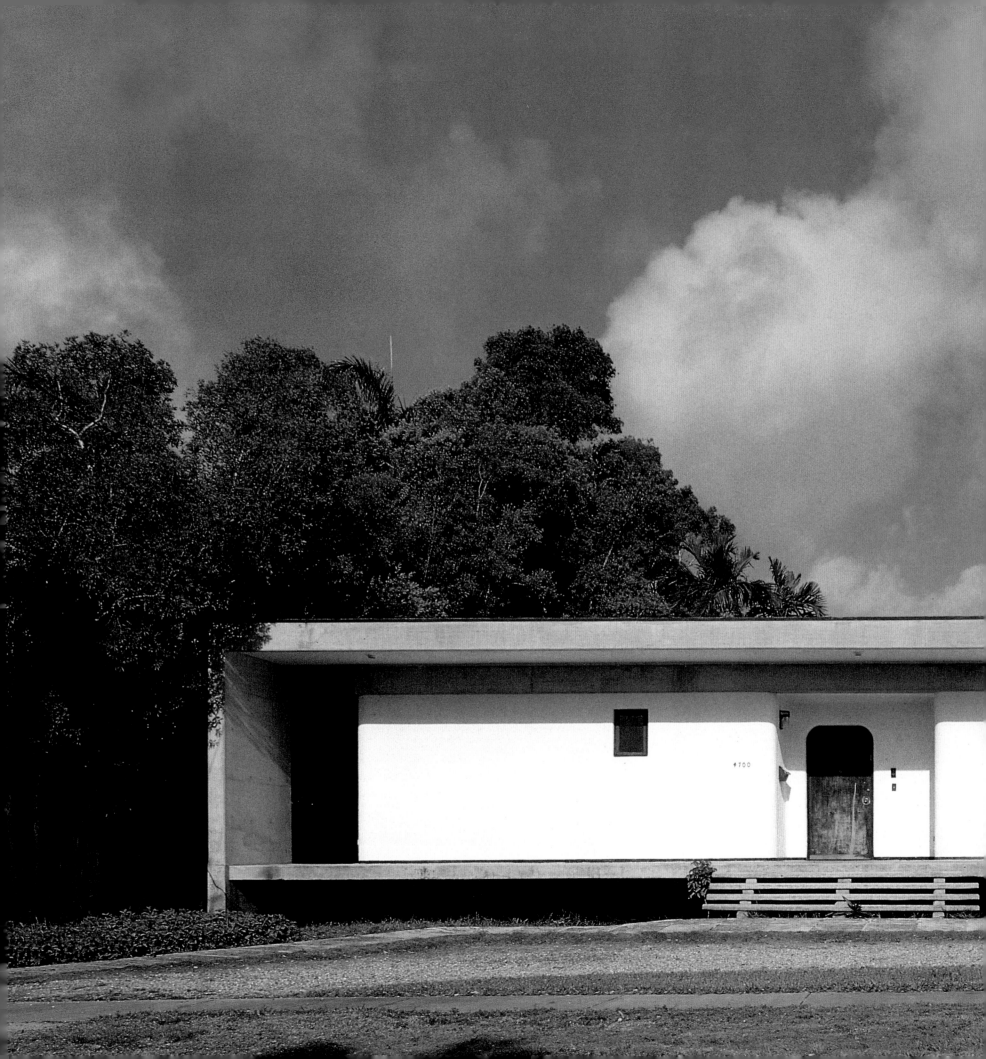

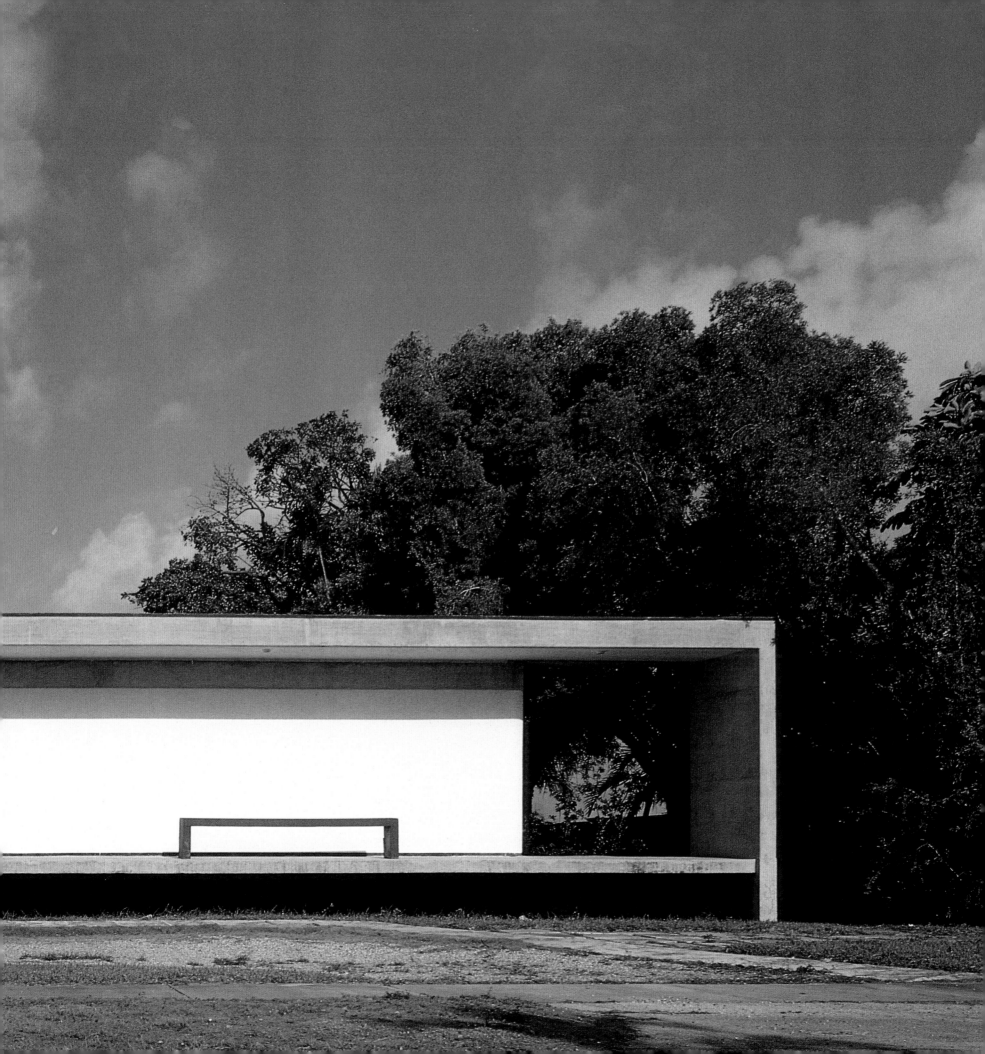

New edition published throughout the world
(except on the North American continent) in 1997 by
Benedikt Taschen Verlag GmbH
Hohenzollernring 53, D-50672 Köln
Germany

First published in 1996 by
The Monacelli Press, Inc.
10 East 92nd St, New York, New York 10128

German Translation by Heinrich Koop, Hürth
French Translation by Jacques Bosser, Paris

Printed in Italy
ISBN 3-8228-7875-8

Miami is a city of unexpected pleasures, of hidden beauty, of strong links between old and new. To find the real Miami, a city that is cherished and cultivated much as a garden is, it is necessary to slow down, step inside, and once in, look back out again.

For all its flamboyance, Miami is a city of private spaces, a city at its best on a intimate scale. Yet to say that Miami is a city of houses is not nearly enough, for it is the sensitive balance between buildings and landscape that shapes the private dmain here and transforms its architecture.

There is something unalterably domestic about the tropics – the way the houses nestle in amid the vegetation, the architecture articulated by palm fronds and banana leaves. More than in other places, the landscape informs the architecture – in the relationship of houses to streets, to the water's edge, to gardens, to trees. These delicate interactions are at work in Miami's best architecture, from the oldest extant houses to the city' newest and boldest works.

Miami today is a modern metropolis, a city of many cultures and many architectural attitudes. Admittedly, it is a city where too much is done too fast and without much thought to the ultimate implications. That was not necessarily the case earlier in the city's history, nor is it true without exception now.

For Miami's first settlers, the place seemed at once to be an impenetrable jungle and a glorious paradise. Some saw the landscape only as a place to be controlled, a potential backdrop for architecture with ever-greater possibilities; others came to revel in the original landscape, to live in – and occasionally improve upon – Eden.

The best illustration of this dichotomy is Vizcaya, a Venetian palazzo presiding over Italian gardens at the edge of Biscayne Bay. Vizcaya stands apart from the rest of Miami, both in terms of the achievements of its architects and landscape designers and in its profound influence on what was to follow.

At first glance, this grand house and its gardens – built between 1914 and 1917, when Miami was still sparsely settled – might seem an anomaly. But it is not; Vizcaya offers the first essential lesson in Miami architecture. Conceived as a house in the jungle, the buildings and gardens occupied just 10 of the 180 acres owned by James Deering, a cofounder of International Harvester; the rest was left nearly intact, with

Miami ist eine Stadt voll angenehmer Überraschungen, versteckter Schönheit und enger Beziehungen zwischen Alt und Neu. Um das wahre Miami zu entdecken – eine Stadt, die wie ein Garten gepflegt und kultiviert wird –, muß der Besucher innehalten, den Garten betreten und aus dem Inneren wieder nach draußen schauen.

Die Tropen wirken hier unwiderruflich gezähmt – die Häuser scheinen sich gemütlich zwischen der Vegetation zu verstecken, und Palmwedel und Bananenblätter bilden wichtige Bestandteile der Architektur. Stärker als an anderen Orten durchdringt die Landschaft die Architektur. Diese empfindliche Wechselwirkung ist in Miamis besten architektonischen Werken deutlich zu spüren – von den ältesten erhaltenen Häusern bis hin zu den neuesten und kühnsten Bauwerken der City.

Das heutige Miami ist eine moderne Metropole, eine Stadt vieler Kulturen und vielfältiger architektonischer Standpunkte. Und zugegebenermaßen handelt es sich um eine Stadt, in der zu vieles zu schnell und ohne einen Gedanken an die Folgen gebaut wurde. Dies war in der Geschichte Miamis jedoch nicht immer der Fall und ist auch heute nicht allgemeingültig.

Den ersten Siedlern Miamis schien der Ort ein undurchdringlicher Dschungel und ein wunderbares Paradies zugleich. Manche betrachteten die Landschaft nur als ein zu beherrschendes Areal, als potentiellen Hintergrund für eine Architektur mit ungekannten Möglichkeiten; andere kamen, um die ursprüngliche Landschaft zu genießen und in diesem Garten Eden zu leben.

Das beste Beispiel für diese Dichotomie bietet Vizcaya, ein venezianischer Palazzo, der unmittelbar an der Biscayne Bay über seinen italienischen Gärten thront. Vizcaya hebt sich in zweierlei Hinsicht vom Rest der Stadt ab – zum einen aufgrund der Leistung seiner Baumeister und Landschaftsarchitekten und zum anderen aufgrund seines weitreichenden Einflusses auf spätere Bauwerke.

Auf den ersten Blick mögen dieser imposante Bau und seine Gärten – die zwischen 1914 und 1917 entstanden, als Miami noch relativ dünn besiedelt war – wie ein Fremdkörper erscheinen. Aber dieser Eindruck täuscht: In Wirklichkeit verkörpert Vizcaya das erste grundlegende Prinzip der Architektur Miamis. Es wurde als Haus im Dschungel entworfen, wobei die Gebäude und Gärten nur 4 der 72 Hektar einnah-

Miami est une ville de plaisirs inattendus, de splendeurs cachées et de liens puissants entre un monde ancien et la modernité. Pour comprendre cette ville si aimée de ses habitants, entretenue à la manière d'un jardin, il faut ralentir le pas, entrer dans les maisons, et, une fois à l'intérieur, regarder vers l'extérieur.

Les Tropiques semblent à jamais apprivoisés dans la manière dont les maisons se nichent au cœur de la végétation, et se développent en fonction des palmiers et des bananiers. Plus qu'ailleurs, le paysage «informe» l'architecture. Ces interactions délicates se retrouvent dans les plus brillantes créations architecturales, des maisons les plus anciennes et les plus traditionnelles aux plus récentes et plus audacieuses.

Miami est aujourd'hui une métropole moderne, ville de multiples cultures et positions architecturales. Si l'on peut penser que trop a été édifié trop vite, sans beaucoup de respect pour les conséquences, ce n'était pas le cas jadis, et l'on trouve encore d'heureuses exceptions aujourd'hui.

Pour les premiers colons qui s'y installèrent, l'endroit devait sembler à la fois une jungle impénétrable et un merveilleux paradis. Certains ne virent dans ce paysage qu'un territoire à contrôler, une toile de fond potentielle pour une architecture aux possibilités infinies, d'autres souhaitèrent jouer avec le paysage vierge, afin de vivre au cœur d'un éden, quitte à le rendre plus confortable, bien sûr.

La meilleure illustration de cette dichotomie est Vizcaya, ce palais vénitien qui règne sur des jardins italiens au fond de Biscayne Bay. Vizcaya joue un rôle particulier à Miami, aussi bien en termes de réussite architecturale et de travail du paysage que pour sa profonde influence sur ce qui allait suivre.

Au premier abord, cette superbe demeure et ses jardins, créés entre 1914 et 1917, lorsque Miami était encore à peine peuplée, pourrait sembler anormale. Mais elle ne l'est pas. Vizcaya offrait à Miami sa première grande leçon d'architecture. Conçue comme une maison dans la jungle, le bâtiment et ses jardins occupaient 4 hectares seulement sur les 72 de la propriété de James Deering, cofondateur d'International Harvester. Le reste fut laissé pratiquement intact, si ce n'est quelques allées et petites «folies» implantées dans la mangrove et la forêt tropicale. Katherine Chapman Harwood, qui a passé près de vingt ans à étudier les plans de la résidence et

just a few paths and small follies cut into the mangrove and hardwood hammock. Katherine Chapman Harwood, who spent twenty years researching the house's design and decoration, contends that the idea was to use the dense tropical landscape in a theatrical way, as if it were a stage set.

Others who came to South Florida in the years surrounding World War I treated the terrain with the same sense of respect and awe. The artist Frederic Bartlett set his own Bonnet House (1921) in such a fashion that its very discovery might have seemed an adventure, so lush was the landscape and so mysterious were the vistas and paths leading to it. Richard Kiehnel, the architect for El Jardin (1918), the winter home of Pittsburgh steel manufacturer John Bindley, and La Brisa (1926–28), designed for another Pittsburgh industrialist, John B. Semple, gave his houses Classical settings but left much of the adjacent landscape untamed, as if it were a tropical version of the sacred wood.

The utopian dreamer turned developer George Merrick saw Coral Gables, which he founded in the mid-1920s, as both a city in a garden and as "America's Riviera." Joanna Lombard, an architect and garden historian, calls Merrick's city "a vast and wonder-filled garden," where the community is tucked into the landscape. His designers included the landscape architect Frank Button, who laid out the city, and his artist-uncle Denman Fink, whose sketches imbued Coral Gables' architecture and plan with a lyrical, almost phantasmic quality.

By the end of the 1920s, the landscape, both wild and tamed, was being drawn into the architecture in the form of ornament. It is not unusual to find carved stone or cast concrete featuring palm fronds or banana trees in lieu of the more expected acanthus; many of Miami's splendid Art Deco buildings feature natural motifs, flora and fauna alike. One example, the doorway of Robert Law Weed's General Electric Model House (1935), is a decorative ode to the landscape.

In some places the interplay of architectural color, texture, and form with landscape and light might imply a poetic abstraction, but not in Miami. Miami's architecture is, in general, more representational, more figurative, and less abstract than in many American cities. But even in abstraction, as in Carlos Zapata's daringly engineered Golden Beach House, there is an inex-

men, die James Deering, der Mitbegründer von International Harvester, erworben hatte; der Rest des Geländes blieb weitgehend unberührt, wobei nur einige Pfade und kleine Pavillons in das Mangroven- und Laubwalddickicht gesetzt wurden. Katherine Chapman Harwood, die sich zwanzig Jahre mit dem Entwurf und der Innenausstattung des Hauses beschäftigte, behauptet, die Grundidee habe darin bestanden, die dichtbewachsene tropische Landschaft als eine Art Bühnenbild zu benutzen.

Andere, die in den Jahren des Ersten Weltkriegs nach Südflorida kamen, behandelten das Terrain ebenfalls mit einer Mischung aus Respekt und Ehrfurcht. Der Künstler Frederic Bartlett plante sein eigenes Bonnet House (1921) in einer Weise, die den Zugang zum Haus zu einer kleinen Entdeckungsreise werden ließ – so üppig war die Vegetation und so geheimnisvoll wirkten die Ausblicke und die dorthin führenden Wege. Richard Kiehnel, Architekt von El Jardin (1918), der Winterresidenz des Pittsburgher Stahlbarons John Bindley, und von La Brisa (1926–28), das er für einen weiteren Industriellen aus Pittsburgh, John B. Semple, entwarf, gab seinen Häusern eine klassische Anmutung, ließ aber einen Großteil der umgebenden Landschaft unberührt, so als handelte es sich um eine Tropenversion des heiligen Hains.

George Merrick – ein utopischer Träumer, der sich zum Bauunternehmer entwickelte – betrachtete das von ihm Mitte der 20er Jahre gegründete Coral Gables gleichzeitig als Stadt in einem Garten und als »amerikanische Riviera«. Joanna Lombard, Architektin und Gartenhistorikerin, bezeichnet Merricks Stadt als »einen riesigen Garten voller Wunder«, bei dem die Bebauung in der Landschaft versteckt ist. Zu Merricks Mitarbeitern gehörten der Landschaftsarchitekt Frank Button, der den Grundriß der Stadt anlegte, und sein Künstler-Onkel Denman Fink, dessen Zeichnungen Coral Gables' Architektur und Bebauungsplan lyrische, nahezu phantastische Eigenschaften verlieh.

Gegen Ende der 20er Jahre bezog man die wilde und gezähmte Natur gleichermaßen in ornamentaler Form in die Architektur ein. Steinmetz- oder Gußbetonelemente, die an Stelle der üblichen Akanthusblätter Palmwedel oder Bananenbäume aufweisen, waren nicht unüblich, und viele der großartigen Art-Deco-Bauten Miamis sind mit Naturmotiven aus Flora und Fauna verziert. Ein Beispiel dafür, der Eingang zu Robert

sa décoration, pense que l'idée de départ était de se servir de la densité du paysage tropical comme d'un décor de théâtre.

D'autres, qui vinrent s'installer en Floride du Sud dans les années autour de la Première Guerre mondiale, traitèrent le terrain avec le même respect. L'artiste Frederic Bartlett implanta sa propre maison, Bonnet House (1921), de telle manière qu'y accéder relevait de l'expédition, tant elle était perdue au milieu d'une végétation impénétrable et d'un entrelacs de chemins mystérieux. Richard Kiehnel, l'architecte de El Jardin (1918), résidence d'hiver du maître de forges de Pittsburgh John Bindley, et de La Brisa (1926–28), conçue pour un autre industriel de Pittsburgh, John B. Semple, donna à ses maisons une implantation classique mais en sauvegarda pour l'essentiel l'environnement naturel, conservé tel un bois sacré tropical.

Rêveur utopique devenu promoteur immobilier, George Merrick imagina de faire de Coral Gables, qu'il fonda au milieu des années 20, une ville dans un jardin et une «Riviera américaine». Joanna Lombard, architecte et historienne des jardins, la décrit comme «un vaste jardin empli de merveilles», où la vie se cache dans le paysage. Parmi ses concepteurs figurent l'architecte paysagiste Frank Button, auteur du plan de la ville, et son oncle, l'artiste Denman Fink, dont les dessins conférèrent à l'architecture et au plan de Coral Gables une qualité lyrique, presque fantasmatique.

À la fin des années 20, le paysage, qu'il soit sauvage ou dompté, s'intègre à l'architecture sous forme d'ornements. Il est fréquent de trouver des pierres sculptées ou des blocs de béton moulé imitant des palmes ou des feuilles de bananiers à la place des classiques acanthes. De nombreux remarquables immeubles Art Déco de Miami font appel à des motifs inspirés de la flore et de la faune locales. L'encadrement de la porte de la maison modèle General Electric de Robert Law Weed (1935) est une ode au paysage environnant.

Si dans certains endroits, le jeu entre la couleur, les textures, les formes architecturales, le paysage et la lumière peuvent impliquer une certaine abstraction, ce n'est pas le cas à Miami. L'architecture y est, en général, plus axée sur la représentation, plus figurative que celle de nombreuses cités américaines. Mais même dans l'abstraction, comme dans le cas de l'audacieuse Golden Beach House de Carlos Zapata,

tricable link to landscape. Zapata designed the house to look out on a pool that seems to flow directly into the ocean, connecting land and sea, house and place. It is a primal link, more related to the discovery of virgin land (which this was not) than to the layers of history that could have been peeled away.

Other architects working in Miami today tend to embrace history, striving – often within the constraints of a quarter- or half-acre – to impart at least the idea of the house in the garden, or the garden city. But now that the metropolis sprawls so endlessly and so inelegantly across miles of former scrub and swampland, it may seem impossible to believe that Miami was ever conceived as a city of gardens.

Architecture as Narrative
The second essential element of Miami's architecture is the idea of the architect as storyteller. From early on, Miami's architects and builders embraced the opportunity to tell a tale of one sort or another, imbuing single buildings or whole cities with a theme.

Thus came such towns as Opa-locka, built with an *Arabian Nights* motif, Hialeah, intended as a Mission-style city, and Miami Springs, done in the Pueblo style. Coral Gables was primarily built in the newly invented Mediterranean Revival style, but it included little villages that were French, Italian, Chinese, and Dutch South African – one might call these subplots, themes within a theme. None of these – nor any other in Florida – was pure or authoritative; the architecture's sources and inspiration ranged from authenic Renaissance buildings to illustrations in travel books and movie backdrops. But what the architecture lacks in accuracy and seriousness it makes up in spirit: it was all made in service of a story.

The authors of the WPA's 1939 guide to Florida referred to Miami architecture almost querulously, writing that the links between Florida and early European culture "has brought into startling conjunction, and sometimes conflict, many schools of architecture, and perhaps a few innovations without academic ancestry." Architect and architectural historian Jorge Hernandez likes to term this erratic impulse in a more succinct fashion as "the dangling quotation." Indeed, almost all that meets the eye in Miami (except perhaps the palm-thatch chickees of the Seminole and Miccosukee Indians) was

Law Weeds General Electric Model House (1935), wirkt wie eine dekorative Ode an die Landschaft.

Andernorts würde das Zusammenspiel von architektonischer Farbe, Struktur und Form mit Landschaft und Licht eine poetische Abstraktion beinhalten – nicht aber in Miami. Die Architektur Miamis wirkt im Ganzen gegenständlicher, figurativer und weniger abstrakt als in vielen anderen amerikanischen Städten. Und selbst in der Abstraktion – wie etwa bei Carlos Zapatas kühn konstruiertem Golden Beach House – findet man eine unauflösliche Verbindung zur Landschaft. Zapata entwarf das Haus mit Blick auf einen Swimmingpool, der direkt in den Ozean zu fließen scheint, und verband so Land und Meer, Haus und Umgebung. Es handelt sich um eine ursprüngliche Verbindung, die mehr mit der Entdeckung unberührten Landes zu tun hat (was hier nicht der Fall ist) als mit historischen Prämissen, die man hätte abtragen können.

Dagegen neigen andere, in Miami tätige Architekten dazu, die Vergangenheit bereitwillig anzunehmen. In ihren Entwürfen streben sie danach – oft innerhalb der räumlichen Begrenzung weniger Quadratmeter –, zumindest das Konzept eines Hauses im Garten oder der Gartenstadt zu vermitteln. Dabei erscheint es gerade heute – angesichts einer Metropole, die sich wahllos und endlos über Meilen ehemaligen Busch- und Sumpflandes ausbreitet – fast unmöglich, sich vorzustellen, daß Miami jemals als eine Stadt der Gärten geplant war.

Architektur als Erzählung
Das zweite grundlegende Prinzip der Architektur Miamis ist die Idee des Architekten als Geschichtenerzählers. Bereits bei den ersten Gebäuden nahmen die Architekten und Baumeister der Stadt die Möglichkeit wahr, in ihren Arbeiten eine Geschichte erzählen zu können und konzipierten einzelne Gebäude oder ganze Stadtviertel rund um ein Thema.

Auf diese Weise entstanden Städte wie Opa-locka, nach Motiven aus Tausendundeiner Nacht, Hialeah, geplant als Stadt im Mission Style und Miami Springs, das im Pueblo Style entworfen wurde. Coral Gables entstand überwiegend im neuentwickelten Mediterranean Revival Style, aber es umfaßte kleinere Dörfer französischen, italienischen, chinesischen und niederländisch-südafrikanischen Ursprungs – die man als Nebenhandlung bezeichnen könnte,

s'observe un lien étonnamment étroit avec le paysage. Zapata a conçu cette maison de manière à ce qu'elle donne sur une piscine qui semble se déverser directement dans l'océan, unissant du même coup la terre et la mer, la maison et le site. Il met en scène un lien primal, plus lié à la découverte d'une terre vierge (ce qui n'était pas le cas) qu'à des aspects historiques éventuels.

D'autres architectes, qui travaillent actuellement à Miami aujourd'hui, ont tendance à s'intéresser à l'histoire – souvent dans les contraintes étroites d'un terrain de quelques centaines de mètres carrés – pour communiquer l'idée d'une maison dans un jardin, ou de cité-jardin. Mais aujourd'hui, alors que la métropole s'étale à l'infini et sans la moindre élégance sur des kilomètres de marais ou de garrigue, il semble impossible de croire que Miami ait été conçue comme une cité de jardins.

L'architecture en tant que narration
Second élément essentiel à la compréhension de l'architecture de Miami : l'architecte raconte une histoire. Dès le début, face à un site vierge, les architectes et les constructeurs de la ville saisissent l'opportunité de tenir une sorte de discours historique, sous forme de thème plaqué sur des constructions ou des cités entières.

C'est ainsi qu'apparaissent des villes comme Opa-Locka, construite dans un esprit Mille et Une nuits, Hialeah, en style Mission, et Miami Springs, en style Pueblo. Coral Gables est dès le départ pensée dans le nouveau style néo-méditerranéen, mais n'en comprend pas moins de petits villages dans le «goût» français, italien, chinois ou hollandais d'Afrique du Sud. On pourrait parler d'intrigue secondaire, de thèmes dans le thème. Aucun d'entre eux – ni aucun dans toute la Floride – n'est pur ou vraiment affirmé : les sources de l'architecture et de l'inspiration vont de la Renaissance authentique à des illustrations entrevues dans des guides touristiques ou des décors de cinéma. Mais ce dont cette architecture manque en précision et sérieux, elle le retrouve dans l'esprit : tout est mis au service d'une «histoire».

Les auteurs du guide de Floride WPA (Works Progress Administration) de 1939 parlent de l'architecture de Miami sur un ton assez critique, écrivant que les liens entre la Floride et la culture européenne ancienne «ont mis en rapport de manière surprenante, et parfois conflic-

drawn from other places, both real and imagined. Architecture in Florida has always involved equal parts of invention and appropriation.

To understand these aspects of Miami, one must briefly step back to 1884, when the steel tycoon Henry Flagler brought his railroad to St. Augustine. He found a city he expected to be Spanish but wasn't. It was, in fact, a relatively drab, workman-like town that had been one of the least desirable Spanish Colonial outposts. Flagler needed to make St. Augustine a glamorous destination in order to attract people to his railroad line, so he hired the then up-and-coming New York architectural firm of Carrere and Hastings to design hotels that would make St. Augustine look "Spanish."

The Ponce de Leon and Alcazr Hotels in St. Augustine offered an improbably romantic take on European architecture that governed much of what was to follow on both coasts. The Ponce de Leon borrowed freely from both Spanish and Italian architecture, with a gateway taken fairly literally from the Certosa at Pavia. The "Spanish" style was to germinate for a couple decades, reemerging as the hybrid Mediterranean style just after World War I. In 1917 – as Vizcaya was being completed and a year before Addison Mizner moved to Palm Beach – the German-born architect Richard Kiehnel began work on El Jardin and then La Brisa in a hybrid "Spanish" style that depended on picturesque proportions and near-Baroque detailing. This set him apart from his contemporaries, who were still working with architecture that was more typically Western and Southwestern, in the Mission and Spanish Colonial styles.

Although most historians now regard Kiehnel and his partner, John Elliot, as the first of Florida's Mediterranean Revival architects, his career ist poorly documented. There is little archival material to explain his motivations or to trace the development of his career in Miami and across Florida. One surviving document points out that he gave his buildings a feeling of age by adding artificial veining to stone and by using four coats of paint applied with varying intensity to give his houses a patina; another praises his "knowledge, sympathy and understanding."

Kiehnel's place in history has long been eclipsed by the daunting – and unquestionably brilliant – career of Addison Mizner, the architect who perfected Mediterranean Revival, a pastiche

als Themen innerhalb eines Themas. In ganz Florida war keines dieser Themen stilrein; die Quellen und Inspirationen der Architekten reichten von Originalgebäuden der Renaissance bis hin zu Illustrationen in Reiseführern und Filmszenarien. Aber was dieser Architektur an Genauigkeit und Ernsthaftigkeit fehlte, machte sie durch ihre Einstellung wieder wett – alles wurde der Erzählung untergeordnet.

Die Autoren des 1939 im Auftrag der WPA (Works Progress Administration) erstellten Florida-Führers äußerten sich beinahe widerwillig über die Architektur Miamis und schrieben, daß die Verbindungen zwischen Florida und den frühen europäischen Kulturen »viele Architekturschulen auf verblüffende Weise miteinander verbunden und manchmal miteinander in Konflikt gebracht hat. Dabei entstanden auch einige wenige Innovationen ohne traditionelle Vorlagen«. Der Architekt und Architekturhistoriker Jorge Hernandez bezeichnet diese ziellose Triebkraft etwas prägnanter als »das beziehungslose Zitat«. Tatsächlich stammen fast alle Baustile, die man in Miami bewundern kann (vielleicht bis auf die Palmenhütten der Seminole- und Miccosukee-Indianer), aus anderen Orten und Gegenden – ob real oder fiktiv. Die Architektur Floridas bestand schon immer zu gleichen Teilen aus Innovation und Adaption.

Um diesen Aspekt der Stadt Miami zu verstehen, muß man kurz in das Jahr 1884 zurückgehen, als der Stahlbaron Henry Flagler seine Eisenbahnlinie nach St. Augustine baute und eine Stadt vorfand, die seiner Ansicht nach spanisch sein sollte, dies aber nicht war. In Wirklichkeit handelte es sich um eine relativ langweilige Arbeiterstadt, die zu den uninteressantesten Außenposten der spanischen Kolonien gehört hatte. Flagler mußte aus St. Augustine ein großartiges Reiseziel machen, um Kunden für seine Eisenbahn zu gewinnen; also erteilte er dem aufstrebenden New Yorker Architekturbüro Carrere and Hastings den Auftrag, in St. Augustine Hotels zu entwerfen, die »spanisch« wirken sollten.

Das Ponce de Leon und das Alcazar-Hotel in St. Augustine entstanden als unwirklich romantische Reaktion auf die europäische Architektur und waren für vieles maßgeblich, was danach an beiden Küsten erbaut werden sollte. Das Ponce de Leon griff freizügig sowohl auf spanische wie auch auf italienische Architektur zurück, wobei der Portalbau fast gänzlich von der

tuelle, de nombreuses écoles architecturales, et peut-être quelques innovations sans antécédents académiques connus». L'architecte et historien de l'architecture Jorge Hernandez parle plus succinctement d'une pulsion désordonnée qu'il qualifie joliment de «citations ballantes». En fait, presque tout ce qui arrête le regard à Miami (excepté peut-être les *chickees* couvertes de palmes des indiens Séminoles et Miccosukkee) vient d'un ailleurs parfois réel, parfois imaginaire. L'architecture en Floride s'est toujours appuyée à part égales sur l'invention et l'appropriation.

Pour comprendre ces aspects de Miami, il est utile de se reporter brièvement à l'année 1884, au moment où le roi de l'acier, Henry Flagler, ouvre une voie ferrée jusqu'à St. Augustine. Il découvre alors une petite ville qu'il imaginait espagnole, mais ne l'était pas. C'était, en réalité, une cité ouvrière assez terne, l'un des moins séduisants de tous les avant-postes espagnols. Mais Flagler avait besoin d'en faire une destination séduisante pour rentabiliser sa ligne de chemin de fer, aussi loue-t-il les services d'une agence d'architecture new-yorkaise alors à la mode, Carrere et Hastings, pour créer des hôtels qui donneront un caractère plus hispanique à St. Augustine.

Les hôtels Ponce de Leon et Alcazar offraient une vision assez improbable de l'architecture européenne, annonçant plus ou moins ce qui allait être édifié sur les deux côtes de l'Etat. Le Ponce de Leon empruntait librement aux architectures de l'Espagne et de l'Italie, avec une entrée littéralement copiée sur celle de la Chartreuse de Pavie. Le style «espagnol» va germer lentement pendant quelques décennies, réémergeant en un style hybride méditerranéen juste après la Première Guerre mondiale. En 1917 – Vizcaya vient d'être achevée et, un an plus tôt, Addison Mizner s'est installé à Palm Beach – l'architecte d'origine allemande Richard Kiehnel commence à travailler sur les plans de El Jardin et de La Brisa dans un style «espagnol» mélangé, de proportions pittoresques et chargé de détails quasi néo-baroques. Ces réalisations le distinguent de ses contemporains qui, eux, travaillaient toujours dans des versions plus «Western» et «South Western» des styles Mission et colonial espagnol.

Bien que la plupart des historiens considèrent aujourd'hui Kiehnel et son associé, John Elliot, comme les premiers architectes néo-médi-

of the Spanish, Moorish, Italian, Venetian, Gothic, and Renaissance, and literally invented the winter playground that is Palm Beach. Mizner assembled those sources in huge and dramatic houses to create a style that was, as one former ambassador put it upon visiting Mizner's Cielito Lindo, "more Spanish than anything I saw in Spain," even though it wasn't really Spanish at all.

Kiehnel and Mizner were the first of many Florida inheritors of the tradition that Carrere and Hastings had begun in St. Augustine. They worked almost simultaneously, though in different communities. Throughout the 1920s and 1930s, young architects and draftsmen went back and forth between Mizner's Palm Beach and Kiehnel's Miami. Maurice Fatio, the Swiss-born architect whose imprint on Palm Beach was almost as strong as Mizner's, designed numerous houses in Miami as well, uncluding the Maytag/Robinson Residence on Sunset Island and, more notably, the Vanderbilt Estate on Fisher Island, now converted into a private clubhouse.

Venice is a continuing reference in Miami and throughout Florida: Vizcaya, the Venetian Pool in Coral Gables, and even the very recent Ca' Ziff, which makes its reference even in the use of the Venetian term "Ca'," for the *case* that face Venice's Grand Canal. The Mediterranean Revival style makes copious use of Venetian imagery: in Miami Beach, Venetian-inspired houses perch precariously along the narrow Collins Canal; Fort Lauderdale was criss-crossed with canals to make it "America's Venice," in counterpoint to "America's Riviera" in Coral Gables; and across the state, the planner John Nolen laid out a town called Venice, another homage to the abrupt and dramatic way land and water meet in Florida.

Likewise, odes to Moorish architecture occur and recur in various incarnations. Just after Flagler finished the Ponce de Leon and Alcazar Hotels in St. Augustine, his railroad rival Henry Plant built the Tampa Bay Hotels as a Moorish fantasy, all minarets and spires. Addison Mizner and his contemporaries, including Walter de Garmo in Miami, incorporated Moorish aspects into their houses. The ultimate effort in this vein was Mar-a-lago, designed for E. F. Hutton by the Viennese-born architect and set designer Joseph Urban.

It is not making too much of the subject to dwell on the notion of architecture as fiction –

Certosa di Pavia übernommen wurde. Dieser »spanische« Stil keimte im Laufe der nächsten Jahrzehnte und erblühte kurz nach Ende des Ersten Weltkriegs als Stilmischung unter dem Namen Mediterranean Style. Im Jahre 1917 – dem Jahr der Fertigstellung des Vizcaya und ein Jahr, bevor Addison Mizner nach Palm Beach zog – begann der in Deutschland geborene Architekt Richard Kiehnel mit den Arbeiten am El Jardin und dem La Brisa und bediente sich dabei eines »spanischen« Stilgemisches, das stark auf pittoresken Proportionen und fast barocker Gestaltung basierte. Dadurch unterschied er sich von seinen Zeitgenossen, die immer noch in den für den Westen und Südwesten der USA typischen Mission und Spanish Colonial Styles arbeiteten.

Obwohl die meisten Historiker Kiehnel und seinen Partner John Elliot als die ersten Architekten des Mediterranean Revival Style in Florida betrachten, ist Kiehnels Karriere nur ungenügend dokumentiert. Es gibt kaum Archivmaterial, anhand dessen sich seine Beweggründe erläutern oder die Entwicklung seiner Laufbahn in Miami und Florida nachvollziehen ließe. Eines der wenigen erhaltenen Dokumente besagt, daß Kiehnel seinen Bauten ein historisches Äußeres verlieh, indem er Mauern mit künstlicher Maserung versah oder vier Farbschichten von unterschiedlicher Intensität auf die Wände auftragen ließ, um den Eindruck von Patina zu erzeugen; ein anderes Dokument lobt Kiehnels »Wissen, Einfühlungsvermögen und Verständnis«.

Kiehnels Platz in der Architekturgeschichte wird seit langem überschattet von der imponierenden und fraglos brillanten Karriere von Addison Mizner, dem Architekten, der das Mediterranean Revival – ein Pastiche aus Gotik und Renaissance sowie spanischer, maurischer, italienischer und venezianischer Architektur – perfektionierte und im wahrsten Sinne des Wortes das Winterparadies Palm Beach erfand. Mizner kombinierte diese Inspirationsquellen zu riesigen, aufsehenerregenden Bauten und schuf damit einen Stil, der, nach den Worten eines ehemaligen Botschafters über Mizners Cielito Lindo, »spanischer war als alles, was ich je in Spanien gesehen habe« – auch wenn er mit Spanien überhaupt nichts zu tun hatte.

Kiehnel und Mizner zählten zu den ersten Erben einer Tradition in Florida, die Carrere und Hastings in St. Augustine begonnen hatten. Sie arbeiteten beinahe zeitgleich, wenn auch in ver-

terranéens de Floride, sa carrière reste mal connue. Peu d'archives permettent d'expliquer ses motivations, ou de retracer le développement de sa carrière à Miami et en Floride. Un des rares documents parvenus jusqu'à nous montre qu'il vieillissait ses réalisations en veinant artificiellement la pierre, et en appliquant quatre couches de peinture d'intensités différentes pour créer un effet de patine. Un autre document loue sa «compétence, son caractère sympathique, son esprit compréhensif».

La place de Kiehnel dans l'histoire a longtemps été éclipsée par la carrière audacieuse et brillante d'Addison Mizner, l'architecte qui perfectionne le style néo-méditerranéen, ce pastiche de styles espagnol, mauresque, italien, vénitien, gothique et Renaissance, et invente Palm Beach, la future célèbre villégiature d'hiver. Mizner fait appel à de multiples sources pour créer des maisons énormes et spectaculaires dans un style dont un ambassadeur fit remarquer en visitant sons Cielito Lindo que cette maison était «plus espagnole que tout ce que j'ai pu voir en Espagne», même si rien n'était authentique.

Kiehnel et Mizner sont les premiers des innombrables héritiers de la tradition initiée par Carrere et Hastings à St. Augustine. Ils travaillent presque au même moment, bien que dans différents lieux. Au cours des années 20 et 30, beaucoup de jeunes architectes et dessinateurs vont et viennent entre le Palm Beach de Mizner et le Miami de Kiehnel. Maurice Fatio, l'architecte d'origine suisse dont l'empreinte sur Palm Beach est presque aussi forte que celle de Mizner, conçoit également de nombreuses maisons pour Miami, dont la Maytag/Robinson Residence sur Sunset Island et, plus célèbre encore, le domaine Vanderbilt, sur Fisher Island, aujourd'hui reconverti en club privé.

Venise est une référence récurrente à Miami et dans toute la Floride, comme dans Vizcaya, la piscine vénitienne de Coral Gables, et même la très récente Ca' Ziff qui s'y réfère jusque dans l'utilisation du terme vénitien de «Ca» pour casa. Le style néo-méditerranéen emprunte généreusement à l'imagerie vénitienne : à Miami Beach, des maisons d'inspiration vénitienne s'élèvent le long de l'étroit canal Collins; Fort Lauderdale est parcouru de canaux qui en font la «Venise de l'Amérique», contrepoint à la «Riviera de l'Amérique» que serait Coral Gables; de l'autre côté de l'Etat, l'urbaniste John Nolen dessine une ville appelée Venice, autre hom-

Miami has always been part myth and part reality. Purists may argue against any form of pastiche, but the Mediterranean style is at once picturesque and highly compositional. "A list of the decorative and functional details from just one of his buildings reads like a glut of architectural jargon; it belies the dignity, complex symmetry, and delicate elegance of their assembly," the preservation expert and architectural historian Margot Ammidown has written of de Garmo's work.

Indeed, many a more conventional judge of architecture might find much to fault – from excessive sentimentality to comparatively slapdash construction – but from the start, Miami seemed destined to be different from any other place. It was also, somehow, destined to become a burgeoning city, not just a tropical outpost.

Three Traditions

Three separate traditions inform Miami's architecture. The first, the pioneer tradition, is that of the handmade house. The pioneer craftsman house, though drawn from more northerly sources, makes practical sense in the tropics, with its broad overhanging roofs.

Miami's earliest American settlers – the handful who arrived in the nineteenth century – drew on the building traditions of a wide range of other untamed places, among them the Adirondacks and Polynesia. In general, though, they built houses that were elegantly proportioned and ecologically sound, square houses with pitched roofs and broad overhangs.

Described in one account as being of "high social class, often intellectuals, with an independent spirit," this first wave of residents included botanists, writers, and artists drawn to the tropics by the climate and the exotic landscape. Little is left of their period. A single Flagler railroad worker's house, much altered, was turned into a restaurant. Sections of the verandah of Flagler's Royal Palm Hotel were moved to a restaurant on SW Eighth Street when the hotel was demolished in 1930. But the other evidence of the era – the down-town boarding houses, the big hotels – have been gone for generations. In fact, with just a few exceptions, all traces of the nineteenth century have vanished.

In the early part of this century and well into the 1920s, Miami houses were largely wrought by those who constructed them, working with widely available patterns or simple

schiedenen Städten. Während der 20er und 30er Jahre pendelten junge Architekten und Handwerker zwischen Mizners Palm Beach und Kiehnels Miami hin und her. Maurice Fatio, ein aus der Schweiz gebürtiger Architekt, dessen Einfluß auf Palm Beach beinahe an Mizner heranreichte, entwarf auch in Miami zahlreiche Häuser wie etwa die Maytag/Robinson Residence auf Sunset Island und das besser bekannte Vanderbilt Estate auf Fisher Island, das heute als privates Clubhaus benutzt wird.

Venedig dient in Miami und in ganz Florida als nie versiegende Inspirationsquelle: Beispiele sind das Vizcaya, der venezianische Teich in Coral Gables und sogar das vor kurzem fertiggestellte Ca' Ziff, das überdies durch die Benutzung des venezianischen Ausdrucks »Ca« (für die Case, die einen Ausblick auf den Canale Grande bieten) einen Bezug herstellt. Der Mediterranean Revival Style macht ausgiebig Gebrauch von der venezianischen Bildsprache: In Miami Beach thronen venezianisch inspirierte Häuser gefährlich nahe am schmalen Collins Canal; Fort Lauderdale wurde mit Kanälen durchzogen, um es zum »Venedig Amerikas« zu machen – im Gegensatz zur »amerikanischen Riviera« in Coral Gables; und auf der anderen Seite des Staates entwarf der Stadtplaner John Nolen eine Stadt namens Venice, eine weitere Hommage an die abrupte und dramatische Art und Weise, in der Wasser und Land in Florida aufeinandertreffen.

In ähnlicher Weise kehren auch die Referenzen an die maurische Architektur in immer neuen Inkarnationen zurück. Kurz nachdem Flagler das Ponce de Leon und das Alcazar in St. Augustine fertiggestellt hatte, ließ sein Konkurrent, der Eisenbahnbesitzer Henry Plant, das Tampa Bay Hotel als maurische Phantasie erbauen, die nur aus Minaretten und Turmspitzen zu bestehen schien. Addison Mizner und seine Zeitgenossen, darunter Walter de Garmo in Miami, integrierten maurische Elemente in ihre Entwürfe. Der Höhepunkt dieser Entwicklung war Mar-a-lago, das der in Wien geborene Architekt und Bühnenbildner Joseph Urban für E.F. Hutton erbaute.

Es ist an dieser Stelle durchaus lohnend, das Thema »Architektur als Fiktion« noch etwas genauer zu betrachten – denn Miami hat immer zu gleichen Teilen aus Mythos und Realität bestanden. Auch wenn sich die Puristen gegen jede Form von Pastiche verwehren, ist der Mediterra-

mage à la façon spectaculaire et parfois brutale dont la terre et les eaux se mêlent en Floride.

Dans le même esprit, les hommages à l'architecture mauresque se multiplient sous diverses formes. Juste après que Flagler a achevé les hôtels Ponce de Leon et Alcazar à St. Augustine, son rival en chemins de fer, Henry Plant, élève le Tampa Bay Hotel, une fantaisie mauresque toute en minarets et flèches. Addison Mizner et ses contemporains, y compris Walter de Garmo à Miami, n'hésitent pas à incorporer des détails mauresques dans leurs maisons. L'effort le plus marquant dans cette direction est Mar-a-Lago, conçue pour E. F. Hutton par l'architecte et décorateur de théâtre d'origine viennoise Joseph Urban.

On peut à juste titre s'arrêter sur le concept d'architecture en tant que fiction – Miami a toujours été en partie un mythe et en partie une réalité. Les puristes peuvent discuter de sa nature de pastiche, mais le style méditerranéen est à la fois une recherche du pittoresque et un art de composition. «Une liste des détails décoratifs et fonctionnels d'une seule de ses réalisations se lit comme un dictionnaire de jargon architectural, mais dans le désordre; elle masque cependant la dignité, la symétrie complexe et l'élégance de leur assemblage», dit de l'œuvre de Garmo cette spécialiste en patrimoine architectural qu'est l'historienne de l'architecture Margot Ammidown.

Il est de fait que des observateurs critiques peuvent repérer de nombreuses erreurs – d'une sentimentalité excessive à une construction relativement bâclée – mais dès le départ, Miami semblait vouée à la différence. Elle était aussi, d'une certaine façon, destinée à devenir une ville tentaculaire, et non simplement un avant-poste sous les Tropiques.

Trois traditions

Trois traditions indépendantes nourrissent l'architecture de Miami. La première, celle des pionniers, a trait aux maisons construites de manière artisanale. Ce type de maison au toit largement débordant, bien qu'issu de régions plus septentrionales, est tout à fait adapté aux Tropiques.

Les premiers colons américains de Miami – une poignée d'hommes dont l'arrivée remonte au XIXe siècle – s'inspirent des traditions de construction de diverses régions plus ou moins sauvages, comme les Adirondacks et la Polynésie. Ils édifient en général des maisons carrées,

know-how. Some of South Florida's finest works come from the hands of little-known architects, or even, in some cases, the hands of the owners themselves, a craftsman tradition that began with Ralph Munroe's Barnacle (1891), designed partly as an Adirondack "cabin" and partly as a South Seas hut. The artist Frederic Bartlett built Bonnet House himself, drawing on the design of Southern coastal houses he'd seen in his travels and ultimately embellishing it with found objects – from seashells he embedded into walls to Baroque wood columns that had already traveled from Spain to Cuba.

The second Miami tradition is, of course, the Mediterranean Revival, a style that dominated through the 1920s and well into the 1930s. It dealt with climate and landscape somewhat differently, relying on courtyards and well-spaced windows to offer ventilation, and on tile and stucco to keep temperatures cool. The style offered an urban architecture where the whole added up to more than the sum of its parts, and it gave definition and character to a quickly developing boomtime city, where whole towns seemed to appear almost overnight.

By the 1930s, a third movement in architecture had taken hold, the modern – which at the time meant Moderne, what we now call Art Deco. Stripped down and streamlined, Miami Beach's Art Deco buildings offered a new kind of urbanism, a seaside resort city with buildings that often seemed like so many ships at berth, with front porches that functioned as if they were decks. Most of Miami Beach's Art Deco buildings were constructed at the height of the Depression, and as such, they are an ode to optimism, their spires reaching skyward, their architectural attitude uncompromisingly buoyant.

In houses, Moderne meant innovation and progress. The houses of the mid-to-late 1930s and 1940s (though many were still being designed in Mediterranean and other formalistic styles) tended toward the sleek, a number of them highly nautical and others – like Weed's General Electric Model House – at once elegant and industrial.

As time went on, these three traditions began to converge. In the 1950s, a group of young architects began practicing a particularly tropical brand of Modernism, one that drew specifically from the pioneer buildings and embraced the unadorned Miesian esthetic. It was a small,

nean Style zugleich pittoresk und aus vielen Elementen zusammengesetzt. »Eine Aufzählung aller dekorativen und funktionalen Details von nur einem seiner Gebäude liest sich wie ein Lexikon der Architektur; es täuscht über die Würde, komplexe Symmetrie und zarte Eleganz ihrer Zusammenstellung hinweg«, schreibt die Konservatorin und Architekturhistorikerin Margot Ammidown über de Garmos Arbeiten.

Und in der Tat könnte ein etwas konventionellerer Architekturkritiker viele Mängel finden – von exzessiver Sentimentalität bis hin zu vergleichsweise schlampiger Bauweise. Aber Miami schien von Anfang an dazu ausersehen, sich von allen anderen Orten zu unterscheiden – und sich nicht nur zu einem tropischen Außenposten, sondern zu einer blühenden Stadt zu entwickeln.

Drei Traditionen
Die Architektur Miamis wird von drei voneinander unabhängigen Traditionen geprägt. Die erste, die Pionier-Tradition, ist die des handgefertigten Hauses. Obwohl das typische amerikanische Pionierhaus eher in den nördlicheren Regionen der USA zu Hause ist, eignet es sich aufgrund seines breiten, überhängenden Daches sehr gut für die Tropen.

Die ersten amerikanischen Siedler Miamis – die wenigen, die im 19. Jahrhundert hier eintrafen – griffen auf die Bautraditionen einer Vielzahl anderer, wenig erschlossener Gegenden zurück, wie etwa der Adirondacks oder Polynesien. Im allgemeinen bauten sie jedoch ihrer Umwelt angepaßte Häuser mit eleganten Proportionen, quadratische Häuser mit Pultdächern und breiten Überhängen.

Zu dieser ersten Welle von Siedlern, die in einem Dokument als »aus hohen Gesellschaftsschichten stammend, häufig intellektuell und von unabhängigem Geist« beschrieben wurden, gehörten Botaniker, Schriftsteller und Künstler, die das Klima und die exotische Landschaft in die Tropen lockten. Viel ist aus dieser Periode nicht bewahrt geblieben – ein einziges Eisenbahnarbeiterhaus Flaglers, das nach vielen Umbauten in ein Restaurant verwandelt wurde. Und nachdem Flaglers Royal Palm Hotel 1930 abgerissen wurde, nahm man einige Teile der Veranda und verbaute sie in einem Restaurant auf der SW Eighth Street. Alle anderen Zeugnisse dieser Zeit – die Pensionen in der Innenstadt und die großen Hotels – sind seit Generationen verschwunden. Tatsächlich kann man sagen,

de proportions élégantes, écologiquement bien pensées, avec des toits à deux pentes et de grands avant-toits.

Décrite dans un document comme composée «d'individus de classe sociale élevée, souvent des intellectuels, à l'esprit indépendant», la première vague de ces résidents comprend des botanistes, des écrivains et des artistes attirés par les Tropiques, le climat et l'exotisme du paysage. Il ne reste pas grand chose de cette période. Une maison d'ouvrier des chemins de fer de Flagler, très modifiée, a été transformée en restaurant. Des parties de la véranda du Royal Palm Hotel de Flagler ont été remontées dans un restaurant de SW 8th Street lorsque l'hôtel a été démoli en 1930. Mais les autres souvenirs de cette période – les pensions du centre, les grands hôtels – ont disparu depuis des générations. En fait, à quelques rares exceptions près, toute trace du XIXe siècle semble avoir disparu. Au début de ce siècle, et jusque tard dans les années 20, les maisons de Miami sont pour l'essentiel dessinées par ceux qui les construisent et qui font appel à un savoir-faire largement répandu. Certaines des plus belles réalisations du sud de la Floride sont dues à des architectes peu connus, et même, dans certains cas, aux propriétaires eux-mêmes, tradition artisanale qui remonte à la maison Barnacle de Ralph Munroe (1891), inspirée en partie d'une «cabane» de l'Adirondack et des huttes des mers du Sud. L'artiste Frederic Bartlett construit lui-même Bonnet House, d'après des croquis de maisons côtières du sud des Etats-Unis aperçues lors de ses voyages. Il l'embellit d'objets trouvés, de coquillages incrustés dans les murs et de colonnes baroques en bois, venues d'Espagne via Cuba.

La seconde tradition de Miami est celle d'un style néo-méditerranéen qui va dominer toutes les années 20 et une bonne partie des années 30. Il s'adapte au climat de manière un peu différente, au moyen de cours, d'ouvertures de ventilation, de carrelages et de stuc pour conserver la fraîcheur. Ce style autorise une architecture de caractère urbain, l'ensemble apportant un peu plus que la somme de ses parties, et donnant une personnalité et un caractère à des villes en plein développement, où des quartiers entiers semblaient surgir en une nuit.

Pendant les années 30, un troisième mouvement architectural prend le dessus. Il s'agit de cette forme de modernisme que nous appelons aujourd'hui le style Art Déco. Epurés, les im-

masterful group that included Rufus Nims, Robert Bradford Browne, George Reed, and Peter Jefferson, with others following later. These architects fashioned houses of wood, or tried out experimental structural systems to make their houses sit gently in the native landscape. One of their contemporaries, Alfred Browning Parker, did much the same while bringing a touch of Frank Lloyd Wright to the tropics. (Wright himself designed Florida Southern College in Lakeland and a never-built house in Fort Lauderdale, but he inspired Parker and several others to explore his more organic approach and to use such materials as copper and chipped colored glass.)

In the late 1970s Elizabeth Plater-Zyberk and Andres Duany began to explore the idea that the fabric of Miami could be woven together, if not as whole cloth, then at least as a tapestry. They began to explore ways to merge the three traditions, drawing on the best of each. Others followed, notably Luis, Jorge, and Mari Tere Trelles, whose Tigertail House is an attempt to embody the constructive traditions of its neighborhood, Coconut Grove – the garden walls of Vizcaya, the block and stucco bungalows – and to evoke a memory of the Spanish Caribbean.

Still others began to approach architecture as the area's earliest architects might have, going back to the original Spanish and Italian sources and starting anew. This is particularly true in the case of Jorge Hernandez and in the single finished work of Maria de la Guardia and Teofilo Victoria, Ca' Ziff. Although largely Italian, Ca' Ziff conveys the feeling of a colonial Caribbean house.

These young architects form a new generation for a new and ever-changing city, and in their evolution they are capturing the essence of the past and translating it into an architecture that is not only of its own time but of yesterday and tomorrow as well.

Roberto Schezen's Photographs
This is not a book about public monuments. It is a book about private dreams and the potential of architecture to transcend the mundane. In the photographs that follow, Roberto Schezen shows the interior life of Miami, a particular Miami where the city's architectural legacy has been cherished or celebrated. The houses and interiors here cover almost precisely eighty years, with examples from every decade but the

daß bis auf wenige Ausnahmen alle Spuren des 19. Jahrhunderts getilgt wurden.

Zu Beginn dieses Jahrhunderts und bis in die 20er Jahre hinein wurden die Häuser in Miami größtenteils von denselben Menschen dekoriert, die sie auch erbauten – wobei man meist auf beliebte Muster und einfache Techniken zurückgriff. Einige der schönsten Bauwerke Südfloridas stammen aus dem Œuvre kaum bekannter Architekten oder in manchen Fällen sogar von den Eigentümern selbst – eine handwerkliche Tradition, an deren Anfang Ralph Munroes Barnacle (1891) steht, das zum Teil als Adirondack-»Blockhaus« und teilweise als Südseehütte entworfen ist. Auch der Künstler Frederic Bartlett baute sein Bonnet House selbst; er griff dabei auf die Entwürfe von Häusern an der amerikanischen Südküste zurück, die er auf seinen Reisen sah, und dekorierte sein Haus mit Fundstücken – von Muscheln, die er in die Mauern einbettete, bis hin zu barocken Holzsäulen, die bereits die Reise von Spanien nach Kuba hinter sich hatten.

Die zweite Bautradition Miamis ist natürlich die des Mediterranean Revival Style – eines Stils, der die Stadt in den 20er Jahren und bis in die 30er Jahre beherrschte. Dieser Baustil fand andere Lösungen für den Umgang mit Klima und Landschaft: Innenhöfe und großzügige Fenster boten ausreichend Ventilation, und Fliesen und Putz sorgten für ein kühles Hausinneres. So entstand eine urbane Architektur, bei der das Ganze mehr war als die Summe seiner Einzelteile, die einer aufstrebenden Stadt, in der ganze Viertel über Nacht aus dem Boden zu wachsen schienen, Definition und Charakter verlieh.

In den 30er Jahren begann eine dritte, modernere Strömung in der Architektur Fuß zu fassen – ein Stil, der damals als »modern« und heute als Art Deco bezeichnet wird. Die klaren, stromlinienförmigen Art-Deco-Bauten von Miami Beach vertraten eine neue Form des Urbanismus: Hier nahm ein Seebad mit Gebäuden Gestalt an, die an vor Anker liegende Schiffe erinnerten und deren Vorbauten die Funktion eines Schiffsdecks übernahmen. Viele der Art-Deco-Bauten in Miami Beach entstanden auf dem Höhepunkt der Depression und wirkten wie eine Hymne an den Optimismus mit ihren zum Himmel emporragenden Türmen und ihrer kompromißlos heiter wirkenden Architektur.

In bezug auf den Wohnhausbau war die Moderne gleichbedeutend mit Innovation und

meubles Art Déco de Miami Beach illustrent un nouvel urbanisme, celui d'une ville de bord de mer composée de grandes constructions, tels des paquebots ancrés à quai, auxquels on accédait par des entrées-passerelles. La plupart de ces immeubles sont édifiés en pleine dépression économique. Ils chantent à leur manière, avec leurs flèches pointant vers le ciel et leur allégresse architecturale, un hymne à l'optimisme. Côté aménagements intérieurs, cette modernité entraîne aussi de multiples progrès techniques.

Les maisons du milieu des années 30 jusqu'aux années 40 (même si beaucoup sont encore conçues en style méditerranéen ou autre) tendent à l'allégement, et un certain nombre d'entre elles s'inspirent de la construction navale, tandis que d'autres, comme la Model House de General Electric (architecte : Weed) sont à la fois élégantes et d'esprit industriel.

Avec le temps, ces traditions convergent. Dans les années 50, un groupe de jeunes architectes lance une forme de modernisme tropical, ouvertement inspiré des réalisations des pionniers et de l'esthétique de Mies van der Rohe. Ce petit mouvement compte parmi ses membres Rufus Nims, Robert Bradford Browne, George Reed et Peter Jefferson, rejoints par quelques autres un peu plus tard. Ils aiment les maisons en bois ou recherchent de nouvelles solutions structurelles pour mieux adapter l'habitat au paysage naturel. Un de leurs contemporains, Alfred Browning Parker, fait la même chose en important en quelque sorte le style de Frank Lloyd Wright sous les Tropiques (Wright lui-même avait dessiné le Florida Southern College à Lakeland et une maison – jamais construite – à Fort Lauderdale, mais il donna à Parker et à d'autres l'envie de s'intéresser à une approche plus organique et à utiliser des matériaux comme le cuivre et le verre de couleur).

A la fin des années 70, Elizabeth Plater-Zyberk et Andres Duany commencent à travailler sur l'unification du tissu urbain de Miami. Leur objectif n'est pas tant d'en faire une couverture, qu'une tapisserie. Ils étudient la fusion des trois traditions, empruntant à chacune ce qu'elle offre de meilleur. D'autres suivent, en particulier Luis, Jorge et Mari Tere Trelles, dont la Tigertail House est une tentative d'unir les traditions de Coconut Grove – les murs du jardin de Vizcaya, la construction en parpaings et les bungalows en stuc – aux souvenirs des Caraïbes espagnoles.

D'autres également tentent une approche

1940s, and each of Miami's architectural traditions – the vernacular of the pioneer craftsman, the Mediterranean, and the Modern.

Schezen's photographs do not provide a comprehensive description of Miami or its architectural history. Rather, they are like poetry, offering similes and metaphors that add up to a visual whole. Some devoted historians will notice gaps, and indeed there are some. Not every important architect who has worked in Miami has work depicted here; in some cases this is because the work is largely public and highly accessible, while in others owners seek privacy, barricading their architectural prizes behind gates and electronic surveillance systems.

Yet most of these gaps occur because so much of Miami's historic architecture has been treated with cavalier disdain. Time, and the occupants of Miami's extraordinary houses, have taken their toll. Windows have been replaced without attention to appropriate proportion or dimension. Tile floors – perfect to the climate and typically manufactured in the tropics – are covered over with marble, parquet, or carpeting more suitable to other places and other climates. Walls have been ripped down, rooms realigned. Many other houses have been allowed to languish, and the list of great works that have been demolished over the years reads like a roll-call of war dead.

For these reasons, houses by such architects as August Geiger, Phineas Paist, Denman Fink, Russell Pancoast, and Carlos Schoeppl, each of whom has a share of significant buildings to his credit, do not appear in this intimate depiction of Mediterranean Revival and Art Deco houses.

It is our great luck, for example, that the miraculous El Jardin fell into the caring hands of Carrolton School. Likewise, an even earlier wood-frame house called the Pagoda – dating back to 1902 – belongs to Ransom Everglades School and is thus ensured survival well into the next century.

The saga of the saving of Vizcaya is a much longer tale to tell. After James Deering died in 1925, Vizcaya was briefly operated as a museum, then closed for lack of funds. In 1945, Deering's heirs sold most of the grounds – 130 of the 180 acres – to the Catholic archdiocese, which in turn built a hospital and a high school on the grounds. In 1952, Dade County acquired the rest of the estate. That might have been the story's

Fortschritt. Und obwohl viele Häuser immer noch im Mediterranean Style oder anderen formalistischen Stilen gebaut wurden, wirkten die Entwürfe, die ab der Mitte der 30er bis in die 40er Jahre entstanden, schnittig, teilweise sehr maritim oder – wie Weeds General Electric Model House – elegant und industriell zugleich.

Im Laufe der Zeit näherten sich diese drei Traditionen einander an. In den 50er Jahre entwickelte eine Gruppe junger Architekten eine spezifisch tropische Spielart der Moderne, die von den Bauten des Pionier-Stils ausging und zu einer schmucklosen Ästhetik à la Mies van der Rohe tendierte. Zu dieser kleinen Gruppe von Baumeistern gehörten ursprünglich Rufus Nims, Robert Bradford Browne, George Reed und Peter Jefferson; später stießen noch weitere hinzu. Diese Architekten bevorzugten Holzbauten und experimentierten mit neuartigen Bausystemen, um ihre Häuser möglichst natürlich in die umgebende Landschaft einzupassen. Einer ihrer Zeitgenossen, Alfred Browning Parker, ging von einem ähnlichen Konzept aus, brachte aber noch einen Hauch Frank Lloyd Wright in die Tropen (Wright selbst entwarf das Florida Southern College in Lakeland sowie ein nicht realisiertes Haus in Fort Lauderdale; er inspirierte Parker und einige andere dazu, sich mit seinem organischen Ansatz auseinanderzusetzen und Materialien wie Kupfer und geschliffenes Buntglas zu verwenden).

Ende der 70er Jahre kamen Elizabeth Plater-Zyberk und Andres Duany auf den Gedanken, die unterschiedlichen Webarten Miamis miteinander zu vereinen – wenn nicht zu einem dichten Tuch, dann zumindest zu einer Tapisserie. Sie beschäftigten sich mit der Möglichkeit, das Beste der drei Traditionen miteinander zu verschmelzen. Andere folgten diesem Konzept, darunter Luis, Jorge und Mari Tere Trelles, deren Tigertail House einen Versuch darstellt, die Bautraditionen von Coconut Grove – die Gartenmauern von Vizcaya, die gemauerten und verputzten Bungalows – zu vereinen und Erinnerungen an die spanische Karibik zu wecken.

Andere Architekten begannen sich ihren Entwürfen so zu nähern, wie es die ersten hier ansässigen Baumeister getan haben müssen – sie gingen zurück zu den ursprünglichen spanischen und italienischen Wurzeln und begannen noch einmal von vorn. Dies gilt vor allem für Jorge Hernandez und die einzige bisher realisierte Arbeit von Maria de la Guardia und Teofilo

de l'architecture semblable à celle des premiers architectes, en se référant aux sources espagnoles et italiennes authentiques et en repartant de zéro. C'est particulièrement vrai dans le cas de Jorge Hernandez et dans la seule réalisation achevée de Maria de la Guardia et Teofilo Victoria, Ca' Ziff. Bien que d'inspiration largement italienne, la Ca' Ziff donne le sentiment d'une maison coloniale des Caraïbes.

Ces jeunes architectes constituent une nouvelle génération au service de cette ville nouvelle, sans cesse changeante. Dans leur évolution, ils captent l'essence du passé pour la traduire en une architecture qui n'est pas seulement de son temps mais aussi d'hier et de demain.

Les photographies de Roberto Schezen

Cet ouvrage n'est pas consacré aux monuments publics. Il s'agit d'un livre sur des rêves personnels et privés, et sur le pouvoir de l'architecture à transcender le quotidien. Dans les photographies qui suivent, Roberto Schezen montre la vie intérieure de Miami, un Miami particulier qui chérit et célèbre son héritage architectural. Les maisons et les intérieurs représentés ici s'étalent sur près de quatre-vingts ans, avec des exemples illustrant chaque décennie sauf les années 40, et chaque tradition architecturale locale, qu'elle soit vernaculaire (celle des artisans pionniers), néo- méditerranéenne ou moderne.

Les photographies de Schezen ne nous fournissent pas une description exhaustive de Miami ou de son histoire architecturale. Elles se lisent plutôt comme des poèmes qui nous offriraient des images et des métaphores contribuant à la richesse visuelle de la composition d'ensemble. Certains historiens observateurs noteront des lacunes, et il y en a certes quelques-unes. Plusieurs réalisations d'architectes importants ne sont pas représentées. Dans quelques cas, leur travail est déjà amplement connu et facilement accessible, tandis que dans d'autres les propriétaires veulent protéger leur vie privée, et dissimulent leurs trésors d'architecture derrière des portes et des systèmes électroniques de surveillance.

Néanmoins, la plupart de ces lacunes tiennent à ce qu'une bonne part de l'architecture historique de la ville a été traitée avec un dédain cavalier. Le temps, et les occupants des maisons de Miami, ont laissé des traces. Les fenêtres ont été remplacées sans respect aucun pour les pro-

end, and Vizcaya might have been a public park with a house in it and little more, had it not been for a small band of Miamians who took it upon themselves to restore the house to its full and accurate glory. Much later, in the mid-1980s, Vizcaya suffered what most historians and preservationists regard as a serious blow to its architectural integrity. A steel "space-frame" roof was installed over the courtyard, ostensibly to allow for full air-conditioning and to protect the furniture. (More cynical observers felt it was to make Vizcaya more appealing for party rentals.)

In some cases, the preservationist tide is now turning, as happened at the Kiehnel & Elliot house called La Brisa, a building with a history as rich and colorful as Miami itself. Over several decades the house was altered, added to, and allowed to deteriorate until the mid-1990s, when new owners chose to take it back to its origins with the help of their architect, José Gelabert-Navia. Such patrons of authenticity are ever rarer in a city like Miami, where the perpetual movement of the population encourages little respect for a heritage not held in common and little understanding of the importance of architectural authenticity.

Nor is there a full understanding of appropriate ways to build new structures in the tropics. In 1939, the WPA guide to Florida decried the unnecessary addition of ten-story buildings to towns that before only had structures of one or two stories. These new buildings foreshadowed what was to come a half-century later, as giant house-monsters and condominiums were erected in neighborhoods of gentle scale, with little regard for the pace, cadence, or the nature of the place. This has been true in almost every Miami neighborhood, with the exception of a few still undervalued by the real estate market. The lust for grandiosity has taken its toll on Coconut Grove, Coral Gables, and Miami Beach, both at the residential scale and the commercial.

It is interesting, by contrast, to look at the most venturesome and least historicist of all the works included here – the Golden Beach House by Carlos Zapata and John West. Unlike the clumsy residential design that plagues much of Miami today, the house respects the scale and proportions of earlier domestic design while exploring the edges of engineering know-how, as walls tilt and roofs seem to float unconnected to the body of the house.

Victoria, Ca' Ziff: Obwohl größtenteils italienischen Ursprungs, vermittelt dieses Bauwerk den Eindruck eines Kolonialhauses im karibischen Stil.

Diese Architekten stehen an der Spitze einer neuen Generation in dieser jungen, sich ständig verändernden Stadt, und in ihrer Entwicklung erfassen sie die Grundprinzipien der Vergangenheit und übersetzen sie in eine Architektur, die nicht nur in der Gegenwart, sondern ebenso in der Vergangenheit und der Zukunft lebt.

Roberto Schezens Fotografien
Dies ist kein Buch über öffentliche Bauten. Es ist ein Buch über persönliche Träume und über die Möglichkeiten der Architektur, sich über das Alltägliche hinauszuheben. In den folgenden Fotografien zeigt uns Robert Schezen das Innenleben Miamis, eines besonderen Miami, in dem das architektonische Erbe der Stadt geschätzt und bewahrt wird. Die hier vorgestellten Häuser und Inneneinrichtungen umfassen eine Zeitspanne von nahezu achtzig Jahren und bieten mit Ausnahme der 40er Jahre Beispiele aus jedem Jahrzehnt und aus jeder der Architekturtraditionen der Stadt – dem Pionier-Stil, dem Mediterranean Revival und der Moderne.

Schezens Fotografien bieten keine umfassende Beschreibung der Stadt Miami oder ihrer architektonischen Entwicklung. Sie wirken eher wie ein Gedicht und bieten dem Betrachter Gleichnisse und Metaphern, die sich zu einem visuellen Ganzen verbinden. Einige eifrige Architekturhistoriker werden chronologische Lücken bemerken – und zwar völlig zu Recht: Nicht alle bedeutenden Architekten, die in Miami gearbeitet haben, sind hier aufgeführt. Dies geschah in manchen Fällen, weil ihre Projekte allgemein bekannt und der Öffentlichkeit leicht zugänglich sind, und in anderen Fällen, weil die Besitzer dieser Bauten ungestört bleiben wollen und ihre architektonischen Schmuckstücke hinter Toren und elektronischen Sicherheitssystemen verbarrikadieren.

Aber die meisten dieser Lücken entstanden, weil ein Großteil der historischen Architektur Miamis mit unbekümmerter Geringschätzung behandelt wurde. Die Zeit und die Bewohner vieler außergewöhnlicher Häuser Miamis haben ihre Spuren hinterlassen. Fenster wurden ersetzt, ohne auf passende Proportionen oder Abmessungen zu achten. Kachelböden

portions ou les dimensions. Les carrelages typiques des Tropiques et parfaits pour le climat sont recouverts de marbre, de parquet ou de moquette mieux adaptés à d'autres lieux ou d'autres climats. Les murs ont été grattés, les pièces réalignées. De nombreuses maisons ont été plus ou moins délaissées, et la liste des chefs-d'œuvre démolis au cour des années se lit comme l'inscription d'un monument aux morts.

Pour ces raisons, les maisons d'architectes comme Auguste Geiger, Phineas Paist, Denman Fink, Russell Pancoast et Carlos Schoeppl, qui ont chacun d'importantes réalisations à leur crédit, ne figurent pas dans ce portrait intime des demeures néo-méditerranéennes et Art Déco.

Nous avons eu beaucoup de chance, par exemple, avec le miraculeux El Jardin, sauvé grâce à l'engagement de la Carrolton School. De même, une maison à ossature de bois plus ancienne encore appelée La Pagoda (1902) appartient à la Ransom Everglades School. Elle est certaine, maintenant, de survivre au moins quelques décennies.

La saga des efforts de sauvetage de Vizcaya est une histoire beaucoup plus longue. Après la mort de James Deering en 1925, Vizcaya fut brièvement transformée en musée, puis fermée faute de financements. En 1945, les héritiers de Deering vendirent la plus grande partie du terrain – 52 des 72 hectares – au diocèse catholique, qui y construisit un hôpital et un collège. En 1952, le comté de Dade fit l'acquisition du reste du domaine. L'histoire aurait pu s'arrêter là, et Vizcaya serait devenue un jardin public avec une maison au milieu, n'eut-ce été l'intervention d'un petit groupe de Miamiens qui prirent sur eux de redonner à la demeure sa gloire ancienne. Beaucoup plus tard, dans les années 80, Vizcaya souffrit de ce que la plupart des historiens et des protecteurs du patrimoine regardent comme un coup sévère porté à son intégrité architecturale. Un toit en acier à structure tridimensionnelle fut posé au-dessus de la cour intérieure, officiellement pour permettre l'installation de l'air conditionné et protéger le mobilier (des observateurs cyniques firent remarquer que cela facilitait surtout la location de la maison pour des réceptions).

Dans certains cas, les protecteurs du patrimoine remportent des victoires, comme dans le cas de La Brisa, de Kiehnel & Elliot, une demeure dont l'histoire est aussi riche et haute en couleurs que celle de Miami. En plusieurs décen-

Preservationists might quarrel with Philippe Starck's adaptation of the Delano Hotel, where little was left of its original appearance. But the Delano speaks to another aspect of Miami and Miami Beach. What has passed for glamour in the last few decades has too often been excessive, glitzy, ersatz. Starck's Delano takes on all that self-aggrandizement and self-indulgence and turns it into a spoof.

This is not to say that there isn't a place for some excessive glitz. Miami has always had an indulgent impulse, best typified in the work of Morris Lapidus at the Fontainebleau, the Eden Roc, and the Americana (now the Sheraton Bal Harbour), where he created, literally, the image of Miami Beach in the 1950s and 1960s. Lapidus took Miami's ever-present theatrical impulse and turned it inside out. His hotels offered landscapes for the mind, a pure stage set for vacationers. Numerous redecorations over the years have cannibalized his inventive interiors beyond the point of recognition. There is now only one place to glimpse Lapidus's aesthetic, his own apartment.

In some ways, Lapidus's heir is the firm Arquitectonica, led by Laurinda Spear, which began working in Miami in the late 1970s. Arquitectonica made an indelible impact on the city's identity with its three boldly patterned and brightly colored apartment towers along Brickell Avenue – the Atlantis, the Babylon, and The Palace. The Lapidus connection is more psychological than actual; if Lapidus's hotels were stage sets for the vacation idylls of a newly leisured middle class, Arquitectonica's audacious early high-rises offered a backdrop and a visual definition for a city moving at high speed. In the 1980s Miami's newly cosmopolitan car culture devoured its leisure in work and long suburban commutes, socializing not by dallying in parks or gardens or public plazas or even in hotel lobbies but by endless mobile telephone conversations.

For Arquitectonica, the Brickell Avenue apartment buildings remain signature structures, even well into their second decade. At a private scale, the firm's most notable building is what has long been known as the "Pink House," done for Laurinda Spear's parents, Harold and Sue Spear, on Biscayne Bay in Miami Shores. It is the earliest, and in many ways the clearest expression of tropical Modernism. Like most of the best of Miami's architecture, it combines many of the elements of the villa in the garden –

– die sich perfekt für dieses Klima eignen und außerdem vor Ort hergestellt werden – wurden mit Marmor, Parkett oder Teppichen bedeckt, die eher an andere Orte und in andere Klimazonen passen würden. Wände wurden niedergerissen und Räume neu ausgerichtet. Viele andere Häuser erfuhren nicht die verdiente Pflege, und die Liste bedeutender Bauwerke, die im Laufe der Jahre abgerissen wurden, liest sich wie eine Namensverlesung von Kriegsopfern.

Aus diesen Gründen erscheinen in dieser Darstellung von Häusern im Mediterranean Revival- und Art-Deco-Stil keine Entwürfe von Architekten wie August Geiger, Phineas Paist, Denman Fink, Russell Pancoast oder Carlos Schoeppl, die jeder für sich ein Œuvre bedeutender Bauten geschaffen haben.

Es ist ein großes Glück, daß beispielsweise das wunderbare El Jardin in die sorgsamen Hände der Carrolton School fiel. Gleiches gilt für ein noch älteres – 1902 erbautes – Holzrahmenhaus namens The Pagoda, das sich im Besitz der Ransom Everglades School befindet, so daß für seine Erhaltung bis ins nächste Jahrtausend gesorgt ist.

Für die Geschichte der Rettung von Vizcaya muß man wesentlich weiter ausholen. Nachdem James Deering 1925 starb, wurde Vizcaya kurzzeitig als ein Museum betrieben, das aber aus Mangel an Geldmitteln seine Tore schließen mußte. 1945 verkauften Deerings Erben einen Großteil des Grundstücks – 52 der 72 Hektar – an die katholische Erzdiözese, die ihrerseits ein Krankenhaus und eine Highschool auf dem Gelände errichtete. Im Jahre 1952 erwarb das Dade County den Rest des Grundstücks. Hier hätte die Geschichte enden und Vizcaya ein öffentlicher Park mit einem Haus und wenig anderen Sehenswürdigkeiten werden können, wenn nicht eine kleine Gruppe von Miamians den Versuch unternommen hätte, das Haus in seiner ganzen ursprünglichen Pracht zu restaurieren. Jahrzehnte später, nämlich Mitte der 8oer Jahre, erlebte Vizcaya etwas, was die meisten Historiker und Konservatoren als einen ernsthaften Angriff auf seine architektonische Integrität betrachten: Der Innenhof wurde mit einem stählernen Rahmentragwerk überdacht, angeblich um eine Klimaanlage zum Schutz des Mobiliars betreiben zu können. (Zynischere Beobachter waren der Ansicht, daß Vizcaya sich so als noch attraktiverer Ort für Partys vermarkten ließ.)

In anderen Fällen wendete sich für die Kon-

nies, cette maison a été transformée, agrandie et laissée à l'abandon jusqu'au milieu des années 90, lorsque ses nouveaux propriétaires décidèrent de la restaurer telle qu'elle était à l'origine, avec l'aide de leur architecte, José Gelabert-Navia. De tels mécènes sont de plus en plus rares dans cette ville, où le mouvement perpétuel de la population n'encourage ni le respect d'un héritage qui n'est pas partagé, ni la compréhension de l'importance de l'authenticité architecturale.

De même les procédés de construction adaptés aux Tropiques ne sont pas toujours bien assimilés. En 1939, le guide WPA de Floride critiquait la construction inutile de blocs de dix étages dans des villes habituées à un ou deux niveaux seulement. Ces nouveaux immeubles annonçaient ce qui allait survenir cinquante ans plus tard, quand d'énormes ensembles en copropriété s'élevèrent au voisinage de maisons à échelle humaine, sans guère de considération pour le rythme ou la nature du lieu. Ceci s'est produit dans presque tout Miami, à l'exception de quelques quartiers peu cotés sur le marché de l'immobilier. Le goût du «grandiose» s'est imposé à Coconut Grove, Coral Gables et Miami Beach, aussi bien dans l'habitat que dans les équipements commerciaux.

Par contraste, il est intéressant de regarder la plus aventureuse et la moins éclectique de toutes les œuvres présentées dans ces pages, la Golden Beach House de Carlos Zapata et John West. A la différence du style résidentiel maladroit qui est la plaie de la plus grande partie du Miami d'aujourd'hui, cette maison respecte l'échelle et les proportions des réalisations antérieures, tout en explorant les limites du savoirfaire de l'ingénieur au moyen de murs inclinés et de toits qui paraissent flotter sans la moindre connexion avec les murs.

Les préservationnistes peuvent protester contre la rénovation du Delano Hotel que Philippe Starck vient de réaliser, en ne laissant presque rien de son apparence originale. Mais le Delano nous parle d'un autre aspect de Miami et de Miami Beach. Ce qui passait pour du glamour au cours des décennies révolues a trop souvent sombré dans l'excès, le faux-brillant et l'ersatz. Le Delano de Starck s'approprie cette prétention et cette complaisance et les transforme en parodie.

Ceci ne veut pas dire qu'il ne reste pas de place pour un peu d'excès. Miami a toujours eu un faible pour les folies personnelles, dont les

albeit a highly structured garden – with the pictorial and theatrical in order to tell a story.

It is almost inconceivable that a mere century ago so little of Miami existed, and for a quarter of a century more it was little more than what the great writer and environmentalist Marjorie Stoneman Douglas described as a railroad town of 3,500 people, which, she wrote, became "the most maddening, stimulating, life-encouraging city in the world."

In Miami today, it is easy to comprehend the maddening and stimulating aspects of the city. They are there for the taking, both at once. It is only in the finer details, in the more intimate Miami, that its "life-encouraging" quality emerges as clearly.

servatoren das Blatt zum Positiven. Ein Beispiel dafür ist das von Kiehnel & Elliot entworfene La Brisa – ein Gebäude, dessen Geschichte so vielfältig und interessant ist wie Miami selbst. Im Laufe von Jahrzehnten wurde das Haus mit Umbauten und Anbauten versehen und verfiel schließlich bis zur Mitte der 90er Jahre, als seine neuen Besitzer sich entschlossen, es mit Hilfe ihres Architekten, José Gelabert-Navia, wieder in seinen Originalzustand zu versetzen. Derartige Mäzene sind selten geworden in einer Stadt wie Miami, wo die Bevölkerung aufgrund der starken Fluktuation nur wenig Respekt für ein Erbe zeigt, was nicht allen gemein ist und kaum Verständnis für die Bedeutung architektonischer Authentizität aufbringt.

Ebensowenig findet man hier ein tieferes Verständnis für die Art und Weise, in der Neubauten in den Tropen konzipiert werden sollten. 1939 beklagte der WPA-Führer für Florida den unnötigen Bau von zehnstöckigen Häusern in Städten, in denen bis dahin nur Häuser von ein oder zwei Stockwerken gestanden hatten. Diese Neubauten waren ein Vorbote dessen, was ein halbes Jahrhundert später geschehen sollte, als in Vierteln von bisher bescheidenen Ausmaßen gigantische Hausmonster und Eigentumswohnanlagen errichtet wurden – ohne dabei dem Tempo, dem Rhythmus oder dem Charakter des Ortes Rechnung zu tragen. Dies gilt für fast alle Stadtteile Miamis, mit Ausnahme einiger weniger, bisher vom Immobilienmarkt unterschätzter Viertel. Der Wunsch nach Großartigkeit – sowohl bei den Wohn- wie bei den Geschäftsgebäuden – hat in Coconut Grove, Coral Gables und Miami Beach seine Spuren hinterlassen.

Einen interessanten Kontrast dazu bietet das gewagteste und am wenigsten eklektizistische aller hier gezeigten Bauwerke – das Golden Beach House von Carlos Zapata und John West. Im Gegensatz zu den plumpen Wohnhausentwürfen, die einen Großteil des heutigen Miami verschandeln, respektiert dieses Haus den Maßstab und die Proportionen früherer Wohnbauten, während es gleichzeitig die Grenzen des Bauingenieurwissens auslotet – mit schrägen Wänden und Dächern, die völlig losgelöst über dem Baukörper des Hauses zu schweben scheinen.

Denkmalschützer und Konservatoren werden ihre Schwierigkeiten mit Philippe Starcks Umbau des Delano Hotels haben, von dessen ursprünglichem Erscheinungsbild nur wenig übriggeblieben ist. Aber das Delano spricht ei-

meilleurs exemples sont les interventions de Morris Lapidus sur le Fontainebleau, l'Eden Roc et l'Americana au cours des années 60. Lapidus a capté le goût de cette ville pour le théâtral et retourné l'intérieur vers l'extérieur. Ses hôtels sont des paysages mentaux, une pure mise en scène pour vacanciers. De nombreuses transformations au cours des années on cannibalisé ses intérieurs si inventifs au point qu'ils en sont devenus méconnaissables. Le seul lieu où règne encore son esthétique est son propre appartement.

A sa façon, l'héritier de Lapidus est l'agence Arquitectonica, dirigée par Laurinda Spear, qui a commencé à travailler à Miami à la fin des années 70. Arquitectonica a exercé un impact indélébile sur l'identité de la ville avec ses trois audacieuses tours d'appartements aux couleurs vives, sur Brickell Avenue – l'Atlantis, le Babylon et le Palace. Le lien avec Lapidus est plus psychologique que réel. Si les hôtels de Lapidus étaient des décors pour les idylles vacancières d'une nouvelle classe moyenne attirée par les loisirs, les tours d'Arquitectonica offrent un décor de fond et une définition visuelle à une ville qui se déplace à grande vitesse. Dans les années 80, la nouvelle culture automobile et cosmopolite s'est développée, et se déplace de longs trajets sont aujourd'hui nécessaires pour se rendre à son travail. Les échanges sociaux ne se font plus seulement les parcs, les jardins, les places ou même les halls d'hôtels, mais plutôt par d'interminables conversations au téléphone mobile.

Les immeubles de Brickell Avenue restent la signature d'Arquitectonica, même dix ans plus tard. A une échelle privée, la réalisation longtemps la plus remarquable de l'agence demeure la Pink House, édifiée pour les parents de Laurinda Spear, Harold et Sue Spear, sur Biscayne Bay à Miami Shores. C'est la plus ancienne et peut-être la plus claire expression d'un modernisme tropical. Comme beaucoup des meilleurs exemples de l'architecture de Miami, elle réunit les éléments d'une villa dans un jardin – très structuré – avec un sens du pittoresque et du théâtral qui sait nous parler.

Il est presque inconcevable de penser qu'il y a un siècle seulement, très peu du Miami actuel existait. Pendant vingt-cinq ans encore, la cité ne fut guère plus que ce que Marjorie Stoneman Douglas, grand écrivain et défenseur de l'environnement, a décrit comme une ville de gare de 3 500 habitants qui allait devenir «la ville

nen anderen Aspekt von Miami und Miami Beach an: Was in den letzten Jahrzehnten als Glamour bezeichnet wurde, hat sich allzu oft als exzessiv, grell und künstlich erwiesen. Starcks Delano macht sich diese Selbsterhöhung und Maßlosigkeit zu eigen und verwandelt sie in eine Parodie.

Damit soll nicht gesagt werden, daß es hier keinen Platz für ein wenig exzessive Künstlichkeit gibt. Miami besaß schon seit jeher ein Faible für Maßlosigkeit, das am besten in den Arbeiten von Morris Lapidus am Fontainebleau, dem Eden Roc und dem Americana (dem heutigen Sheraton Bal Harbour) zum Ausdruck kommt, mit denen er im wahrsten Sinne des Wortes das Bild von Miami Beach in den 50er und 60er Jahren schuf. Lapidus nahm Miamis allgegenwärtigen Hang zum Theatralischen und stellte ihn auf den Kopf. Seine Hotels boten Landschaften für den Geist, reine Bühnenbilder für Touristen. Allerdings wurden seine phantasievollen Innendekorationen im Laufe der Jahre durch zahllose Umgestaltungen bis an die Grenze der Unkenntlichkeit entstellt. Heute gibt es nur noch eine Möglichkeit, einen unverfälschten Blick auf Lapidus' Ästhetik zu werfen – in seinem eigenen Appartement.

In gewisser Hinsicht hat die von Laurinda Spear geleitete Firma Arquitectonica, die gegen Ende der 70er Jahre in Miami ihre ersten Bauten realisierte, Lapidus' Erbe angetreten. Arquitectonica prägte die Identität der Stadt auf unvergleichliche Weise mit ihren drei kühn gemusterten und leuchtend bunten Appartementtürmen an der Brickell Avenue – Atlantis, Babylon und The Palace. Die Verbindung zu Lapidus ist eher psychologischer als faktischer Art; während seine Hotels Bühnenbilder für die Urlaubsidylle einer neuen begüterten Mittelklasse darstellten, boten Arquitectonicas kühne erste Hochhäuser den passenden Hintergrund und die visuelle Definition einer Stadt, die sich mit Höchstgeschwindigkeit fortbewegte. In den 80er Jahren verbrauchte Miamis neue kosmopolitische Autokultur ihre Freizeit durch Arbeit und lange Pendlerfahrten in die Vororte; das gesellschaftliche Miteinander bestand nicht aus Treffen in Parks, an öffentlichen Plätzen oder in Hotellobbies, sondern aus endlosen Gesprächen über das Mobiltelefon.

Auch nach über einem Jahrzehnt stellen die Appartementhäuser in der Brickell Avenue für Arquitectonica typische Bauwerke dar. Auf dem privaten Sektor ist das bedeutendste Gebäude der Firma der als »Pink House« bekannte Entwurf für das Haus von Harold und Sue Spear, Laurinda Spears Eltern, das in Miami Shores an der Biscayne Bay liegt. Es handelt sich um eines der ersten und in vieler Hinsicht unverfälschtesten Beispiele einer tropischen Moderne. Wie viele der besten Beispiele der Architektur Miamis verbindet es die Elemente der Villa im Garten – wenn auch eines stark strukturierten Gartens – mit dem Pittoresken und Theatralischen, und erzählt damit eine Geschichte.

Es erscheint beinahe unbegreiflich, daß diese Stadt – die vor knapp einem Jahrhundert kaum existierte und selbst ein knappes Vierteljahrhundert kaum mehr als ein Eisenbahnknotenpunkt mit 3.500 Einwohnern war – sich nach den Worten der großartigen Schriftstellerin und Umweltschützerin Marjorie Stoneman Douglas zur »in den Wahnsinn treibenden, stimulierendsten und lebensbejahendsten Stadt der Welt« entwickeln konnte.

Es ist einfach, im heutigen Miami die in den Wahnsinn treibenden und stimulierenden Aspekte der Stadt zu erfassen – denn sie befinden sich beide, zum Greifen nahe, vor unseren Augen. Aber die lebensbejahenden Eigenschaften lassen sich nur in den subtileren Details und intimen Ansichten von Miami entdecken.

du monde la plus folle, la plus stimulante, la plus capable de dynamiser la vie».

Aujourd'hui, il est facile d'appréhender les aspects fous et stimulants de Miami. Ils s'offrent à nous dans le même regard. C'est seulement dans une approche plus fine, dans un Miami plus intime que sa qualité d'exhortation à la vitalité s'impose.

BONNET HOUSE

Frederic Bartlett, 1921

Bonnet House sits amid sea grape, ficus, and mahogany trees on thirty-five untouched acres a few minutes from the commercial bustle of Fort Lauderdale. Built by the artist Frederic Clay Bartlett, Bonnet House was fashioned after a tropical plantation house, with a two-story verandah and rooms wrapping aground a vast courtyard.In 1931, Bartlett married Evelyn Fortune, also an artist, and together the two amateurs began to transform a fairly plain, if elegant, house into an expression of their idiosyncratic enthusiasms and their ever-growing collections of art, furniture, porcelain, shells, temple animals from the Far East, and carousel animals. The grounds were carefully tended but never made formal; the estate takes its name from the bonnet water lilies in the naturalistic ponds surrounding the house.

At the time it was built, in 1920 and 1921, the population of Fort Lauderdale was so sparse and the location so remote that supplies had to be shipped in by barge; the concrete blocks that were the primary structural material were cast on site. As the city began to envelop Bartlett's enclave, it became clear that something had to be done to ensure its survival. In 1983, Evelyn Bartlett deeded her house to the Florida Trust for Historic Preservation, and over the next twelve years oversaw its care and restoration, stipulating once that it "not [be] manicured – I don't ever want it ever to look like a Palm Beach place. I want it to look as it did in the old days. I don't want it to change."

Bonnet House liegt inmitten eines 14 Hektar großen, unberührten Geländes mit Feigen- und Mahagonibäumen, in unmittelbarer Nachbarschaft zum geschäftigen Treiben Fort Lauderdales. Das von dem Künstler Frederic Clay Bartlett entworfene Haus mit seiner zweigeschossigen Veranda und den um einen großen Innenhof gruppierten Räumen wurde einem tropischen Herrensitz nachempfunden. 1931 heiratete Bartlett die Künstlerin Evelyn Fortune, und gemeinsam begannen die beiden Amateure mit der Umwandlung eines relativ schlichten und doch eleganten Hauses in ein Bauwerk, das ihre eigenen Vorlieben zum Ausdruck bringen und ihre ständig wachsende Sammlung an Kunstobjekten beherbergen sollte. Das umliegende Gelände wurde sorgfältig gepflegt, aber nie in einen konventionellen Park umgewandelt, wobei die Seerosen (bonnet water lily) in den Naturteichen rund um das Haus dem Anwesen seinen Namen verliehen.

Während der Bauzeit (1920–21) war das Gelände so weit abgelegen, daß sämtliche Materialien mit Schleppkähnen antransportiert werden mußten, wobei die Betonblocksteine vor Ort gegossen wurden. Als die Stadt sich immer weiter in Richtung von Bartletts Enklave ausdehnte, wurde klar, daß etwas zur Erhaltung des Anwesens getan werden mußte: 1983 schenkte Evelyn Bartlett ihr Haus dem Florida Trust for Historic Preservation. In den darauffolgenden Jahren betreute sie die Restaurierungsarbeiten. Sie machte zur Bedingung, daß das Gebäude »so aussehen soll wie früher; ich möchte es nicht verändern«.

Bonnet House est nichée dans les vignes de mer, les ficus et les acajous sur 14 hectares de terrain vierge à quelques minutes de l'animation de Fort Lauderdale. Construite par l'artiste Frederic Clay Bartlett, elle s'inspire d'une maison de planteur des Tropiques, dans sa véranda sur deux niveaux et ses pièces entourant une vaste cour. En 1931, Bartlett épouse Evelyn Fortune, artiste elle aussi, et les deux architectes amateurs commencent à faire d'une maison assez banale, bien qu'élégante, l'expression vivante de leur passion et de leur collection toujours plus vaste d'art, de mobilier, de porcelaines, de coquillages, d'animaux de temples d'Extrême-Orient et de manège. Le terrain est soigneusement entretenu, mais sans être formellement organisé. Le domaine tire son nom des nénuphars «bonnet» des étangs naturels qui entourent la maison.

Au moment de la construction (1920–1921), Fort Lauderdale était si peu peuplé et le site si isolé que l'approvisionnements se faisait par barge. Les parpaings qui forment le matériau de base furent coulés sur place. La ville en se développant encercla peu à peu le domaine des Bartlett, et il devint nécessaire de prendre des mesures pour assurer sa pérennité. En 1983, Evelyn Bartlett fit don de la propriété au Florida Trust for Historic Preservation, et au cours de ces douze dernières années, a supervisé son entretien et sa restauration. Elle déclara un jour : «la maison ne doit pas être trop soignée – je ne veux absolument pas qu'elle ressemble à une de ces maisons de Palm Beach. Je veux qu'elle soit comme elle était jadis. Je veux que rien ne soit changé.»

RIGHT: Naturalistic gardens of Bonnet House.
OVERLEAF: The Bonnet House, based on the design of Louisiana plantation houses, was constructed of materials either barged in or fabricated on site.

RECHTS: Die naturalistischen Gärten von Bonnet House.
FOLGENDE DOPPELSEITE: Bonnet House, dessen Entwurf an die alten Herrensitze Louisianas erinnerte, entstand aus Materialien, die entweder per Schleppkahn zum Baugelände gebracht oder vor Ort angefertigt wurden.

A DROITE: Les jardins naturels de Bonnet House.
DOUBLE PAGE SUIVANTE: Bonnet House, construite d'après les plans d'une maison de planteur de Louisiane, fut édifiée avec des matériaux transportés par bateau ou fabriqués sur place.

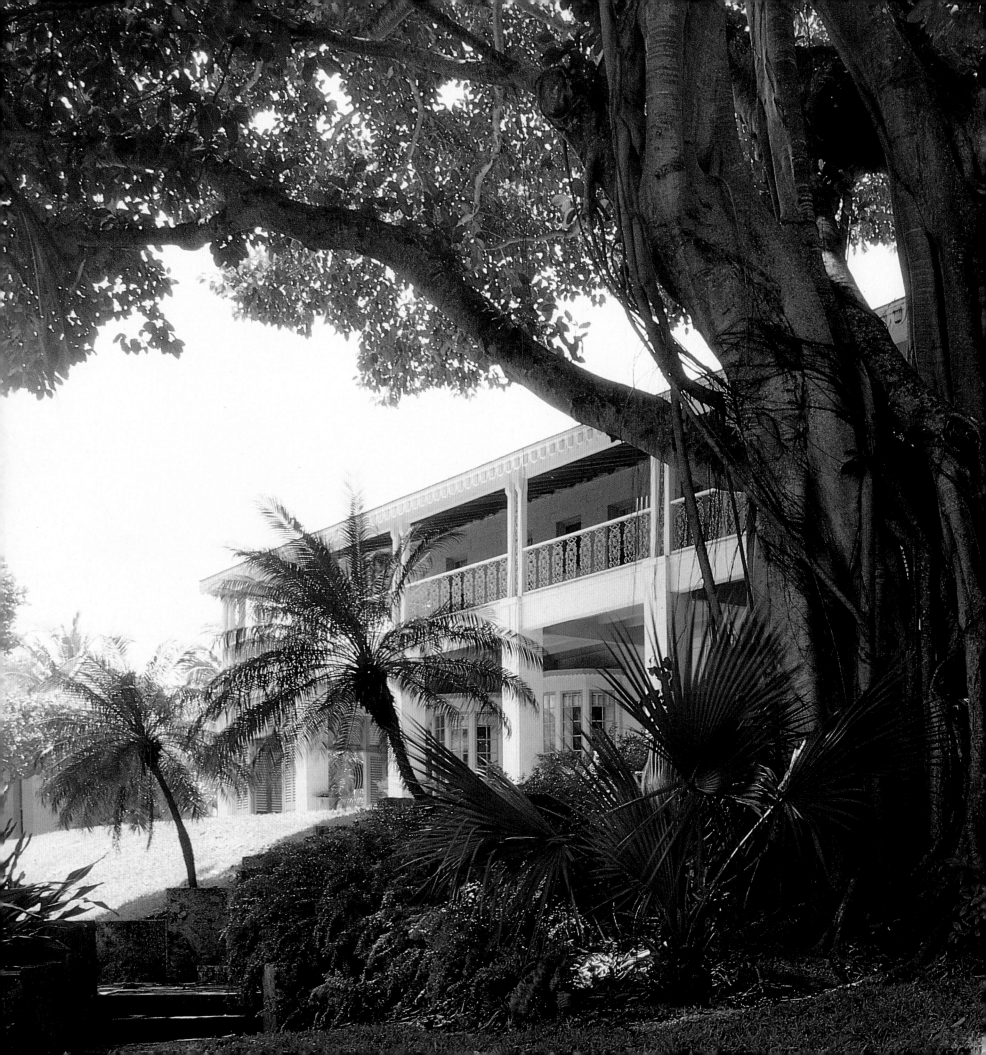

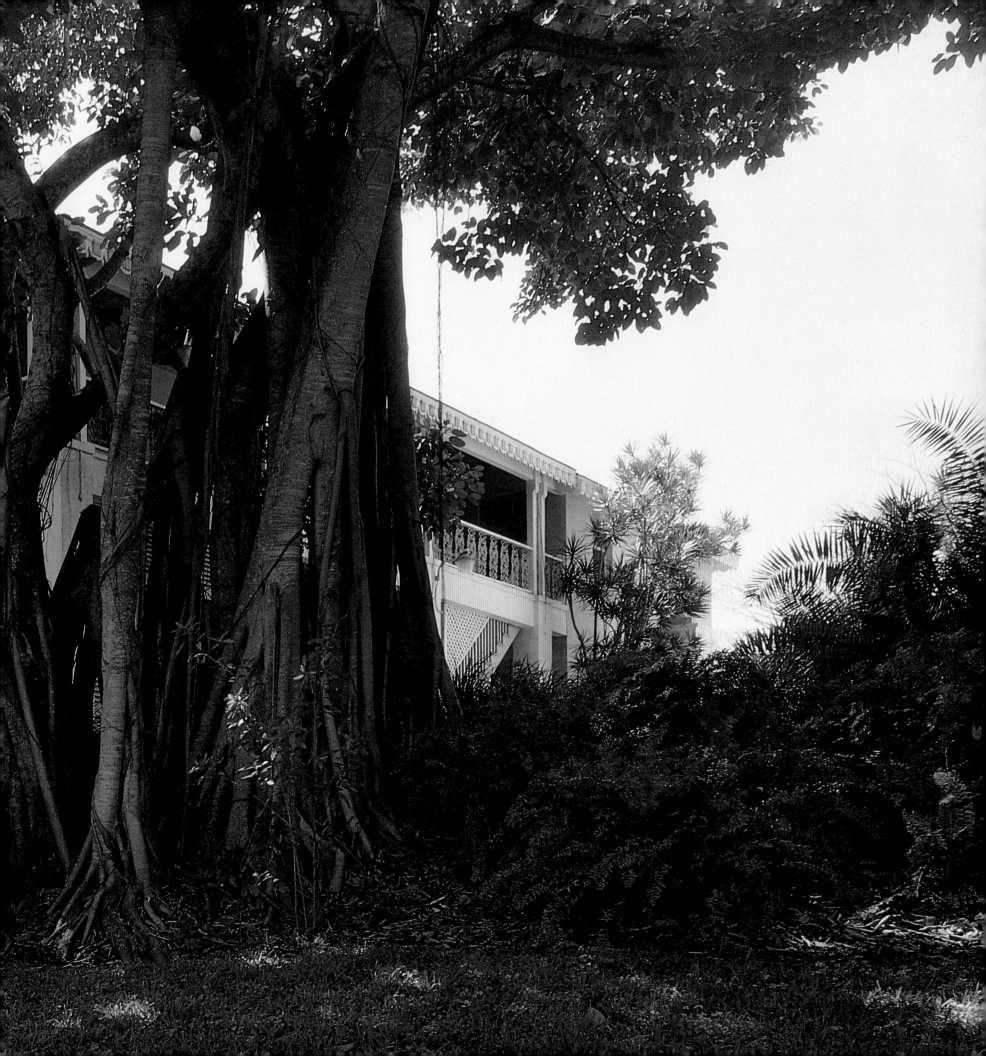

LEFT AND ABOVE: The dense vegetation of the Bonnet House's gardens.

LINKS UND OBEN: Die üppige Vegetation der Gärten von Bonnet House.

A GAUCHE ET CI-DESSUS: La végétation dense des jardins de Bonnet House.

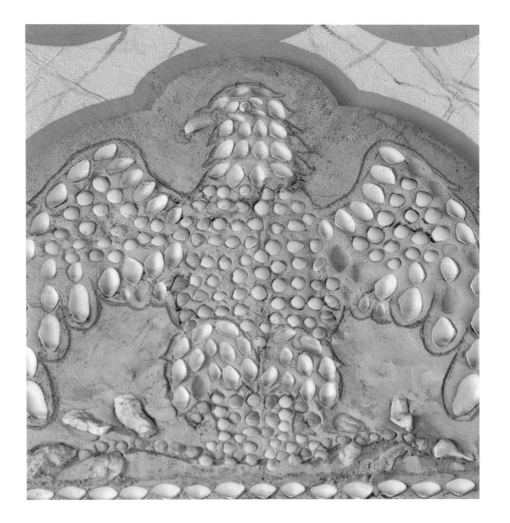

ABOVE: A handmade design in the "shell room."
RIGHT: Detail of the Bonnet House's exterior.

OBEN: Ein handgefertigtes Ornament im »Shell Room«.
RECHTS: Detail der Außenfassade von Bonnet House.

CI-DESSUS: Motif réalisé à la main dans la «salle aux coquillages».
A DROITE: Détail de la façade de Bonnet House.

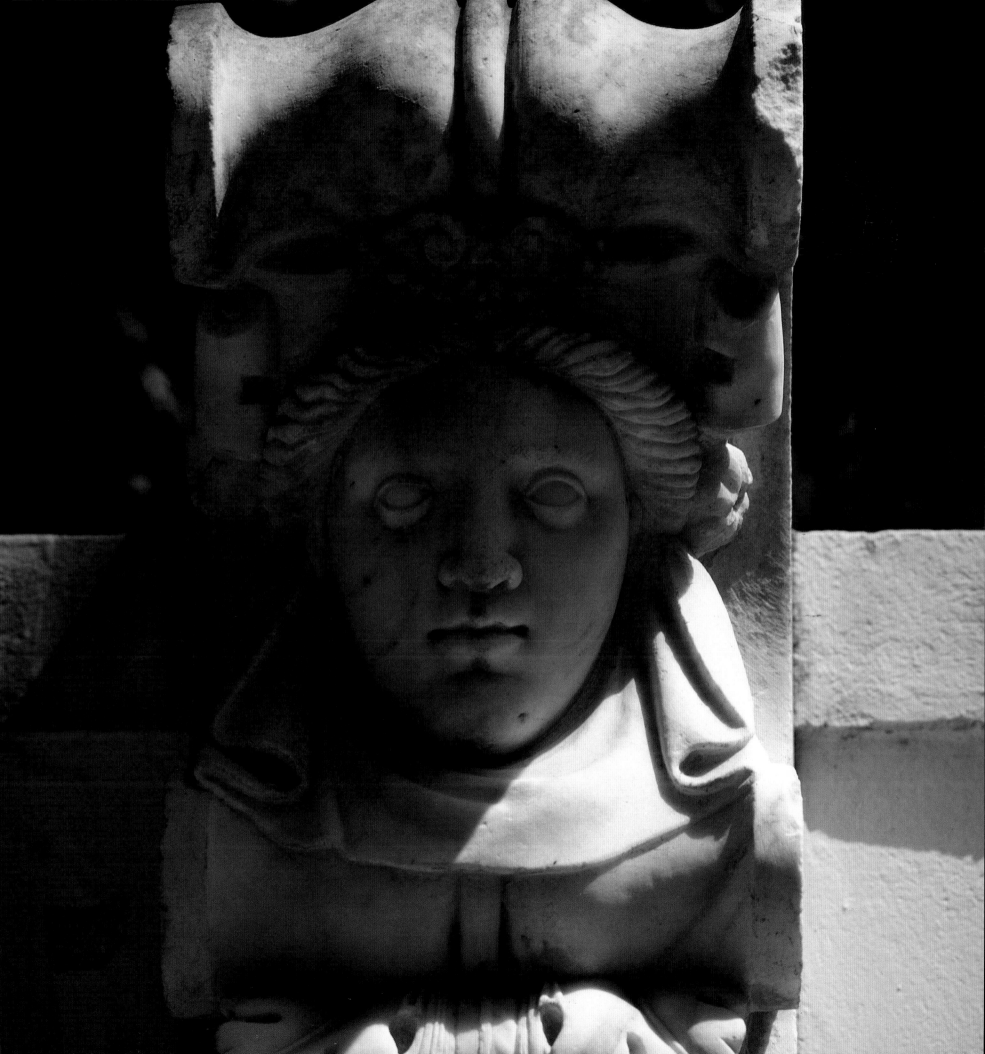

LA BRISA

Richard Kiehnel, Kiehnel & Elliot, 1926–28; renovations José Gelabert-Navia, 1995

Few houses in Miami have as colorful or storied a past as La Brisa. The site's earliest archeological traces are of Indian battles – two early settlers were probably killed there during the Third Seminole War in 1856. It is not known who built the simple wooden house that now functions as a guest cottage, but in 1886 this bayfront estate became home to Kirk Munroe, a writer of popular boy's adventure stories, and his wife, Mary Barr Munroe. In the 1920s, the Munroes sold the land to John B. Semple, a Pittsburgh lawyer who commissioned the architect Richard Kiehnel, whose firm had offices in Pittsburgh and Miami, to design a larger, more lavish house in the Mediterranean Revival style. Later, the house was bought by Henry Field, an anthropologist and grand-nephew of the department store mogul Marshall Field, and his wife, Julia, a lion tamer and zoo curator.

Kiehnel's design is, in the words of the architect José Gelabert-Navia, who is responsible for recent renovations, "a gem, a jewel." The facade facing the long sloping lawn that leads to Biscayne Bay is a complex assemblage of loggias and arcaded porches, with two wings flanking a central tower. The design is complex enough to evoke the idea of a city street, or perhaps a villa that had been added to generation after generation, over the course of centuries.

Nur wenige Häuser in Miami besitzen solch eine abwechslungsreiche und sagenumwobene Geschichte wie La Brisa. Die frühesten archäologischen Funde auf dem Gelände gehen in die Zeit der Indianerkriege zurück – wahrscheinlich wurden hier 1856 während des Dritten Seminolenkriegs zwei Siedler umgebracht. Der Erbauer des schlichten Holzhauses, das heute als Gästehaus dient, ist nicht bekannt, aber 1886 übernahmen Kirk Munroe – Autor zahlreicher Abenteuergeschichten für Jugendliche – und seine Frau Mary Barr Munroe das Grundstück an der Biscayne Bay. In den 20er Jahren verkauften sie das Gelände an John B. Semple, einen Anwalt aus Pittsburgh. Semple wiederum beauftragte den Architekten Richard Kiehnel, der Büros in Pittsburgh und Miami unterhielt, mit dem Bau eines größeren, prächtigeren Gebäudes im Mediterranean Revival Style. Später erwarben Henry Field (Anthropologe und Großneffe des Warenhausmoguls Marshall Field) und seine Frau Julia (eine Löwenbändigerin und Zoodirektorin) das Anwesen.

Kiehnels Entwurf ist laut Aussage des Architekten José Gelabert-Navia, der für die in jüngster Zeit ausgeführten Renovierungsarbeiten verantwortlich zeichnete, »ein Edelstein, ein Juwel«. Die Fassade auf der Rasenseite, die langsam zur Biscayne Bay hin abfällt, besteht aus einer komplexen Collage von Loggias und Arkadengängen, wobei zwei Flügel einen zentralen Turm flankieren. Der Entwurf ist so komplex, daß er das Bild einer ganzen Straßenzeile heraufbeschwört oder an eine Villa erinnert, die im Laufe der Jahrhunderte von Generation zu Generation erweitert und vergrößert wurde.

Peu de maisons à Miami peuvent se targuer d'un passé aussi coloré que La Brisa. Le site est celui de quelques batailles contre les Indiens, et deux colons y ont probablement été tués pendant la troisième guerre contre les Séminoles en 1856. On ne sait qui a élevé la petite construction de bois toute simple qui sert aujourd'hui de maison d'amis, mais, en 1886, ce domaine en bordure de la baie devint la propriété de Kirk Munroe – auteur de romans populaires pour adolescents – et de son épouse, Mary Barr Munroe. Dans les années 20, ils vendirent le terrain à John B. Semple, un avocat de Pittsburgh qui demanda à l'architecte Richard Kiehnel, dont l'agence possédait des bureaux à Pittsburgh et Miami, de lui dessiner une demeure plus grande et plus luxueuse en style néo-méditerranéen. Plus tard, la maison fut acquise par Henry Field, anthropologue et petit-neveu du roi des grands magasins, Marshall Field, et son épouse Julia, dompteuse de lions et conservatrice de zoo.

Les plans de Kiehnel sont, selon les termes de l'architecte José Gelabert-Navia, chargé des rénovations récentes : «une gemme, un joyau». La façade qui domine la grande pelouse en pente sur Biscayne Bay est un assemblage complexe de loggias et de porches à arcades, autour d'une «tour» centrale flanquée de deux ailes. La conception est suffisamment complexe pour évoquer l'idée d'une rue dans une ville, ou peut-être d'une villa qui aurait été agrandie de génération en génération.

RIGHT: Cast-stone column capital.
OVERLEAF: View of La Brisa from Biscayne Bay.

RECHTS: Säulenkapitell aus Kunststein.
FOLGENDE DOPPELSEITE: Blick auf La Brisa von der Biscayne Bay aus.

A DROITE: Chapiteau en pierre moulée.
DOUBLE PAGE SUIVANTE: Vue de La Brisa de Biscayne Bay.

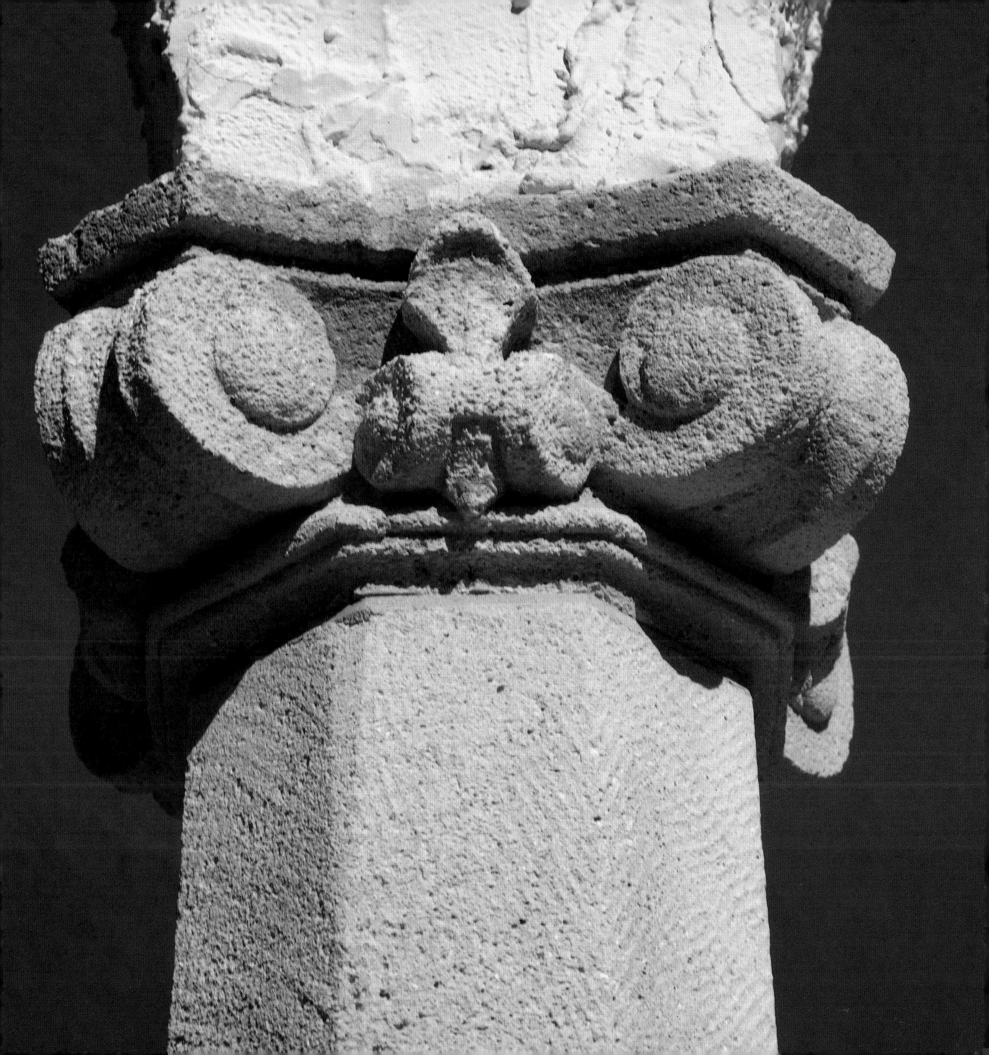

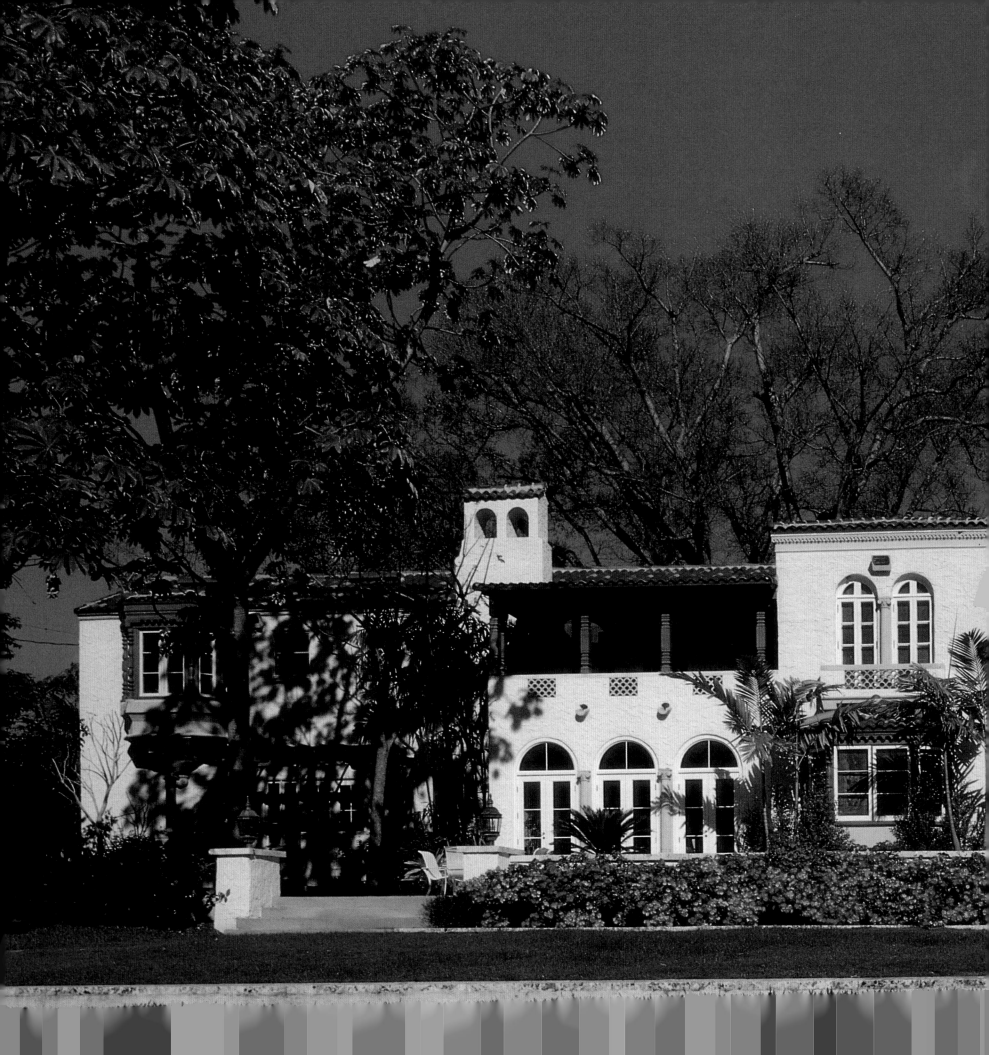

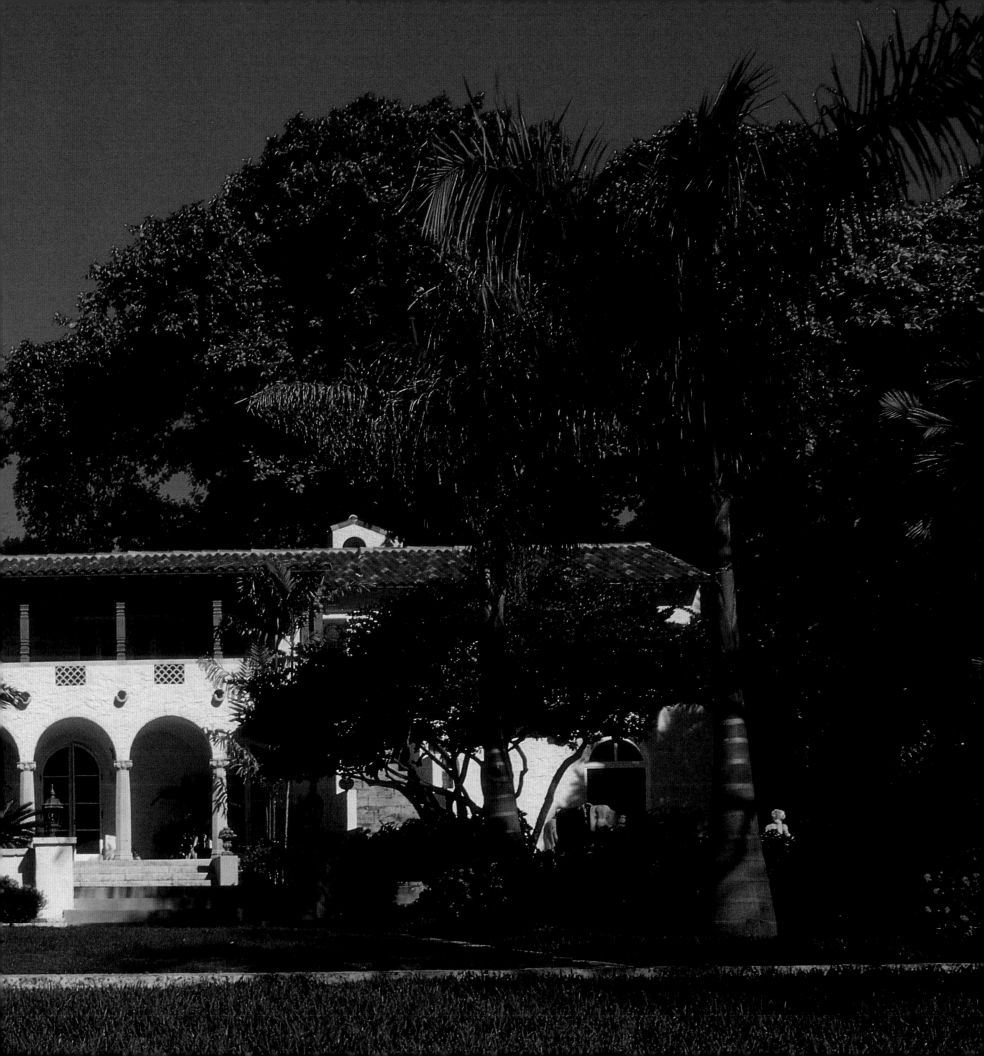

A. H. SWETLAND RESIDENCE, CAMP BISCAYNE AT COCONUT GROVE

George Fink, 1928

A historic house on a historic site, the A. H. Swetland House was conceived as part of a 1920s subdivision, but most of the land around it was not developed until much later. (Even today, it is sparsely settled by Miami standards.) A. H. Swetland arrived in Miami in the early 1920s, bought a tract of bayfront land in Coconut Grove, and built a house there. The house has remained in the family ever since, an unusual achievement in Miami.

Like many Miami houses of the 1920s, the Swetland Residence is neither grand nor pretentious, relying instead on the elegance of its massing and its composition. It is united with its setting, a true house-in-a-garden, sitting high on a lawn that slopes down to Biscayne Bay.

George Fink, the house's architect, is less well known than some of his contemporaries, like Walter de Garmo, Phineas Paist, and Richard Kiehnel, yet he played a pivotal role in the development of the Mediterranean Revival style. Fink was a cousin of George Merrick, the utopian dreamer who developed Coral Gables, and a relative of Denman Fink, the artist whose storybook imaginings were transformed into such treasured landmarks as the Venetian Pool. Fink went to Europe with Merrick to develop ideas for the design of Coral Gables, and in turn sent others to Spain to look around as they designed houses and civic buildings for the city.

Die A.H. Swetland Residence – ein historisches Gebäude auf historischem Gelände – entstand in den 20er Jahren im Rahmen eines Besiedelungsprojektes; allerdings wurde der größte Teil des Geländes erst sehr viel später erschlossen. Zu Beginn der 20er Jahre erwarb A.H. Swetland ein Grundstück an der Biscayne Bay in Coconut Grove und errichtete hier ein Haus, das sich seit dieser Zeit im Familienbesitz befindet – eine Rarität in Miami.

Wie viele der während der 20er Jahre in Miami entstandenen Häuser ist auch die Swetland Residence weder großartig noch pompös; ihre Wirkung beruht vielmehr auf der Eleganz ihrer Proportionen und ihrer Komposition. Ganz in seine Umgebung eingepaßt ist es ein wahres Haus-im-Garten und liegt hoch oben auf einem abschüssigen Rasengelände, das sich bis zur Biscayne Bay erstreckt.

George Fink, der Architekt der Swetland Residence, ist zwar weniger bekannt als manche seiner Zeitgenossen, spielte aber dennoch eine entscheidende Rolle bei der Entwicklung des Mediterranean Revival Style. Fink war mit George Merrick verwandt, dem utopischen Träumer, der Coral Gables entworfen hatte, und mit Denman Fink, dem berühmten Künstler, dessen märchenhafte Vorstellungen in solch kostbaren Sehenswürdigkeiten wie dem Venetian Pool umgesetzt wurden. Zusammen mit Merrick ging Fink nach Europa, um weitere Ideen und Anregungen für den Entwurf von Coral Gables zu sammeln, und entsandte wiederum andere Architekten nach Spanien, die sich dort für den Bau von Privathäusern und öffentlichen Gebäuden inspirieren lassen sollten.

Maison historique sur un site historique, cette résidence a été conçue dans le cadre d'un lotissement, mais la plupart des constructions avoisinantes sont beaucoup plus tardives. Aujourd'hui encore, le cadre semble relativement épargné par rapport aux critères de Miami. A. H. Swetland arrive en Floride au début des années 20, achète un terrain en bord de mer à Coconut Grove, et y fait édifier une résidence. La maison est restée dans la famille depuis cette date, fait assez rare en Floride.

Comme beaucoup de maisons de Miami des années 20, celle-ci n'est ni grandiose ni prétentieuse, mais recherche plutôt l'élégance dans ses masses et sa composition. Elle appartient à son environnement, authentique maison-dans-un-jardin, dominant une pelouse qui descend jusqu'à Biscayne Bay.

George Fink, son architecte, est moins connu que certains de ses contemporains tels Walter de Garmo, Phineas Paist ou Richard Kiehnel, bien qu'il ait joué un rôle fondamental dans le développement du style néo-méditerranéen. Fink était cousin de George Merrick, l'utopiste à l'origine de Coral Gables, et parent de Denman Fink, un artiste dont l'imagination romanesque a donné naissance à des monuments aussi précieux que la Venetian Pool. Fink se rendit en Europe avec Merrick pour préciser ses idées sur Coral Gables, puis, à son tour, incita d'autres architectes chargés de chantiers de maisons et d'immeubles municipaux à parcourir l'Espagne pour se documenter.

RIGHT: Detail of shells embedded in facade of A. H. Swetland House.
OVERLEAF: The A. H. Swetland House tucked amid the trees.

RECHTS: Auf der Detailaufnahme der Fassade des A. H. Swetland House sind die eingebetten Muscheln zu erkennen.
FOLGENDE DOPPELSEITE: Das von Bäumen umgebene A. H. Swetland House.

A DROITE: Détail de coquillages incrustés dans la façade d'A. H. Swetland House.
DOUBLE PAGE SUIVANTE: La résidence A. H. Swetland, nichée parmi les arbres.

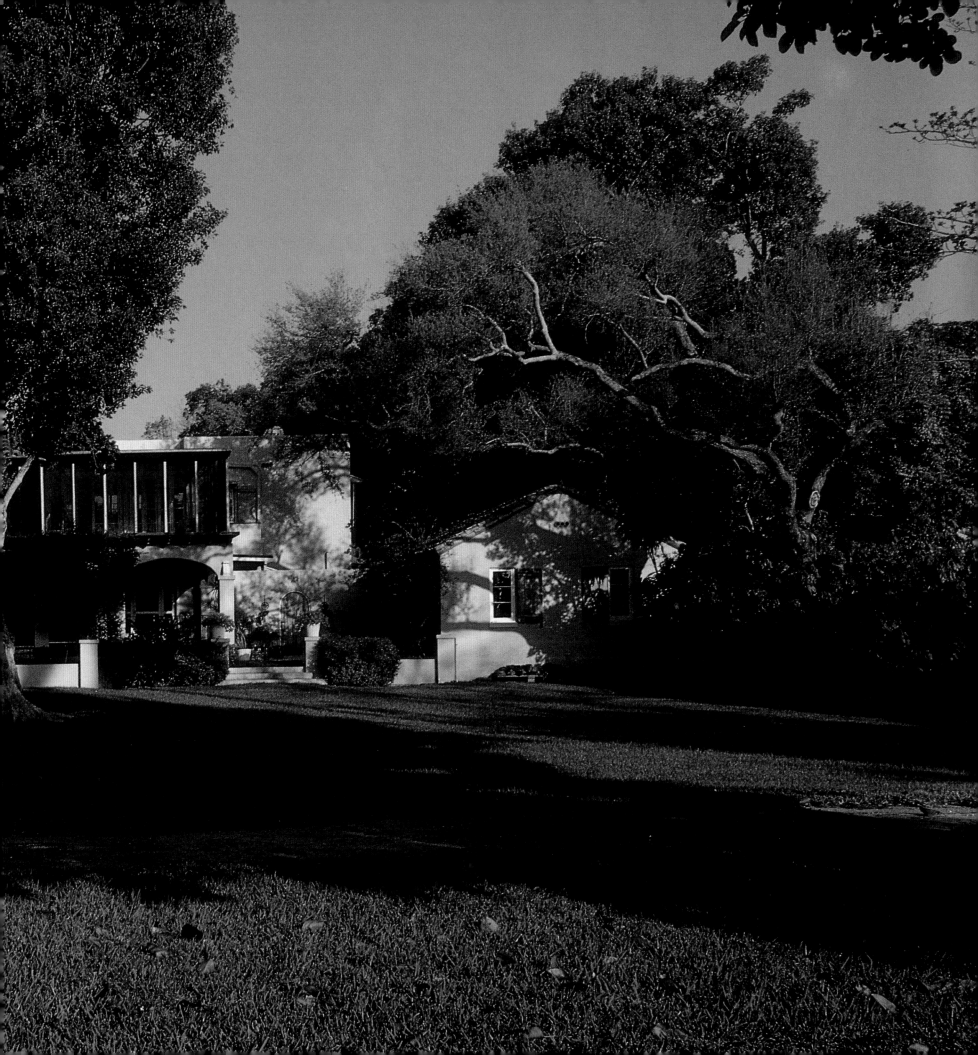

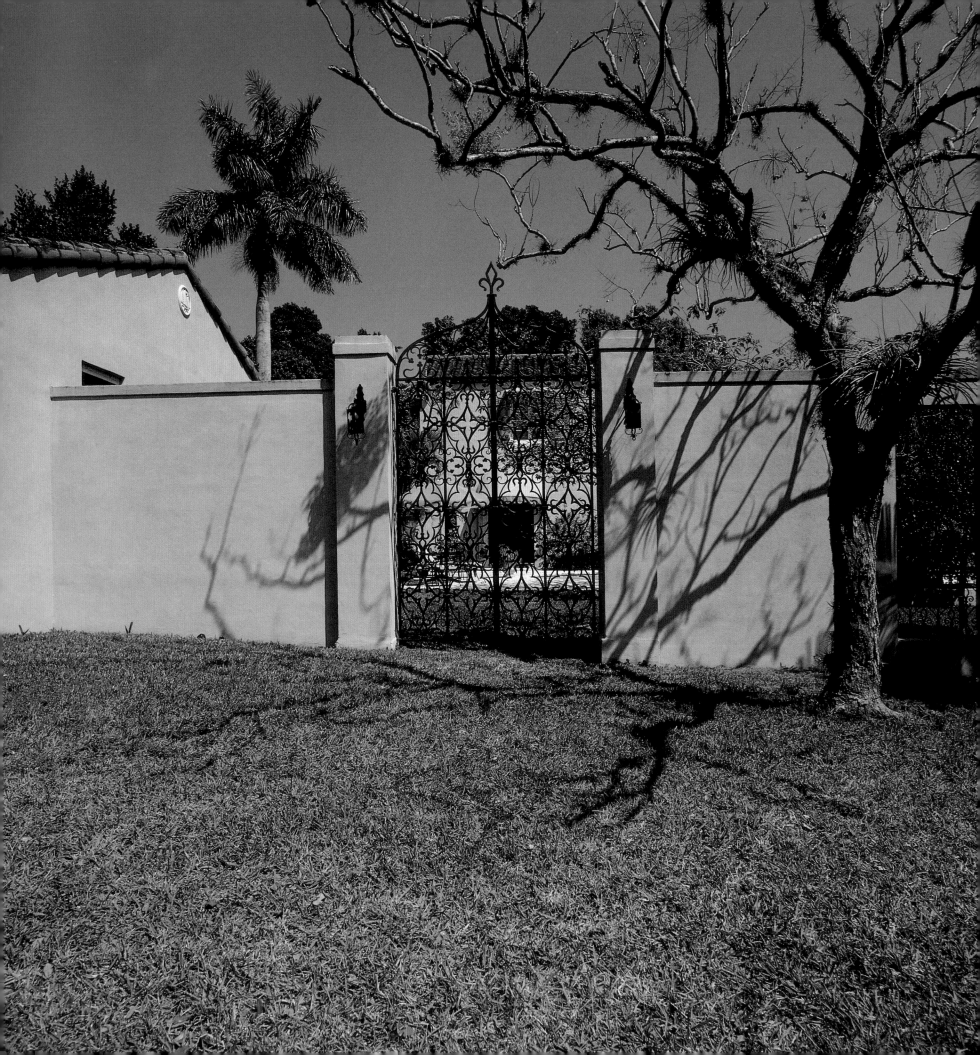

LEFT: Courtyard entrance to the house.
ABOVE: The ceiling retains its original polychrome paint.

LINKS: Eingang zum Innenhof.
OBEN: Die Decke besitzt immer noch ihr polychromes Originaldekor.

A GAUCHE: Entrée côté cour.
CI-DESSUS: Le plafond a conservé son décor peint polychrome d'origine.

EL JARDIN

Richard Kiehnel, Kiehnel & Elliot, 1918

When John Bindley, president of Pittsburgh Steel, decided to build a winter home in Miami, he selected a young Pittsburgh architect, Richard Kiehnel, a partner in the firm of Kiehnel & Elliot. The landmark house Kiehnel designed for Bindley, El Jardin, is considered the first real Mediterranean Revival building in South Florida, the first to use a picturesque montage of architectural elements drawn from a range of sources – Spanish, Moorish, Tuscan, Venetian. It was begun just after Vizcaya was finished, and it took many of the ideas of Vizcaya – the mingling of architectural allusions, the aura of age – a step further.

El Jardin is elegantly proportioned and beautifully detailed. Its ornamentation includes elaborate carvings on column capitals and a highly ornamented frieze. Kiehnel developed a method of applying several coats of paint, some imperfectly, to give El Jardin the patina of age. He also used coral rock and oolitic limestone – both of them made to look aged – in fountains and walls. Like many other waterfront houses of that era, uncluding Vizcaya, its most important facade faces the bay.

Als sich John Bindley, Direktor von Pittsburgh Steel, zum Bau eines Wintersitzes in Miami entschloß, fiel seine Wahl auf einen jungen Architekten aus Pittsburgh, Richard Kiehnel, Mitinhaber des Architekturbüros Kiehnel & Elliot. Das berühmte Gebäude El Jardin, das Kiehnel für Bindley entwarf, gilt als Südfloridas erstes Bauwerk im Mediterranean Revival Style, da es eine pittoreske Collage architektonischer Elemente unterschiedlicher Herkunft – spanischen, maurischen, toskanischen und venezianischen Ursprungs – darstellt. Mit den Bauarbeiten wurde kurz nach der Fertigstellung von Vizcaya begonnen, und viele der dort verwirklichten Ideen – etwa die Mischung architektonischer Bezüge oder die Aura eines alten Bauwerks – konnten beim Bau von El Jardin weiterentwickelt werden.

El Jardin zeichnet sich durch elegante Proportionen und wunderschöne Details aus; seine Ornamentik umfaßt kunstvolle Steinmetzarbeiten an Säulenkapitellen und einen reich verzierten Fries. Kiehnel entwickelte eine besondere Technik zum Auftragen mehrerer, teilweise unvollkommen ausgeführter Farbschichten, um dem Haus eine besondere Patina, die Aura eines alten Bauwerks zu verleihen. Darüber hinaus setzte er bei der Gestaltung von Brunnen und Wänden Korallenstein und Kalkoolith ein, beide ebenfalls künstlich verwittert. Wie bei vielen anderen am Wasser gelegenen Häusern dieser Zeit (einschließlich Vizcaya) blickt auch El Jardins Hauptfassade auf die Biscayne Bay.

Lorsque John Bindley, président de Pittsburgh Steel, décida de se faire construire une résidence d'hiver à Miami, il choisit un jeune architecte de Pittsburgh, Richard Kiehnel, associé de l'agence Kiehnel & Elliot. La maison monumentale que Kiehnel lui dessina, El Jardin, est considérée comme la première réalisation totalement néo-méditerranéenne de Floride du Sud, et la première à faire appel à un montage pittoresque d'éléments architecturaux issus de multiples sources espagnoles, mauresques, toscanes et vénitiennes. Les travaux commencèrent juste après l'achèvement de ceux de Vizcaya. El Jardin allait reprendre de nombreuses idées mises au point pour Vizcaya – comme le mélange de citations architecturales ou l'évocation du temps qui passe – mais en les amplifiant.

El Jardin est de proportions élégantes et sa réalisation superbe jusque dans les moindres détails. Son ornementation comprend des chapiteaux sculptés élaborés et une frise très fouillée. Kienel mit au point une méthode de peinture à plusieurs couches, dont certaines étaient appliquées maladroitement, pour donner à El Jardin la patine du temps. Il se servit également de pierre de corail et de calcaire oolithique – qui tous deux donnaient l'impression d'être anciens – pour les fontaines et les murs. Comme beaucoup d'autres résidences du bord de mer, y compris Vizcaya, la façade la plus majestueuse regarde vers la baie.

RIGHT: Detail of El Jardin's facade.
OVERLEAF: The "city side" of El Jardin.

RECHTS: Fassadendetail des El Jardin.
FOLGENDE DOPPELSEITE: Die »Stadtseite« von El Jardin.

A DROITE: Détail de la façade d'El Jardin.
DOUBLE PAGE SUIVANTE: El Jardin, côté ville.

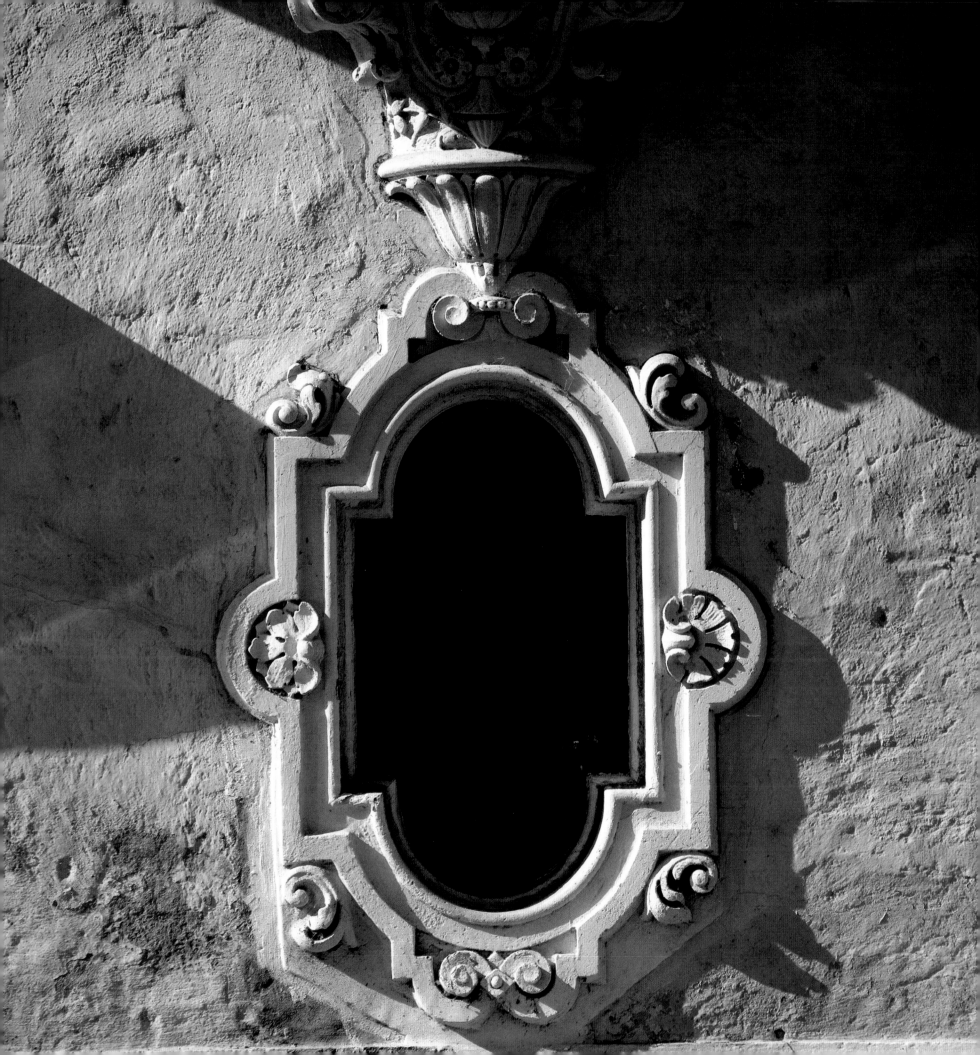

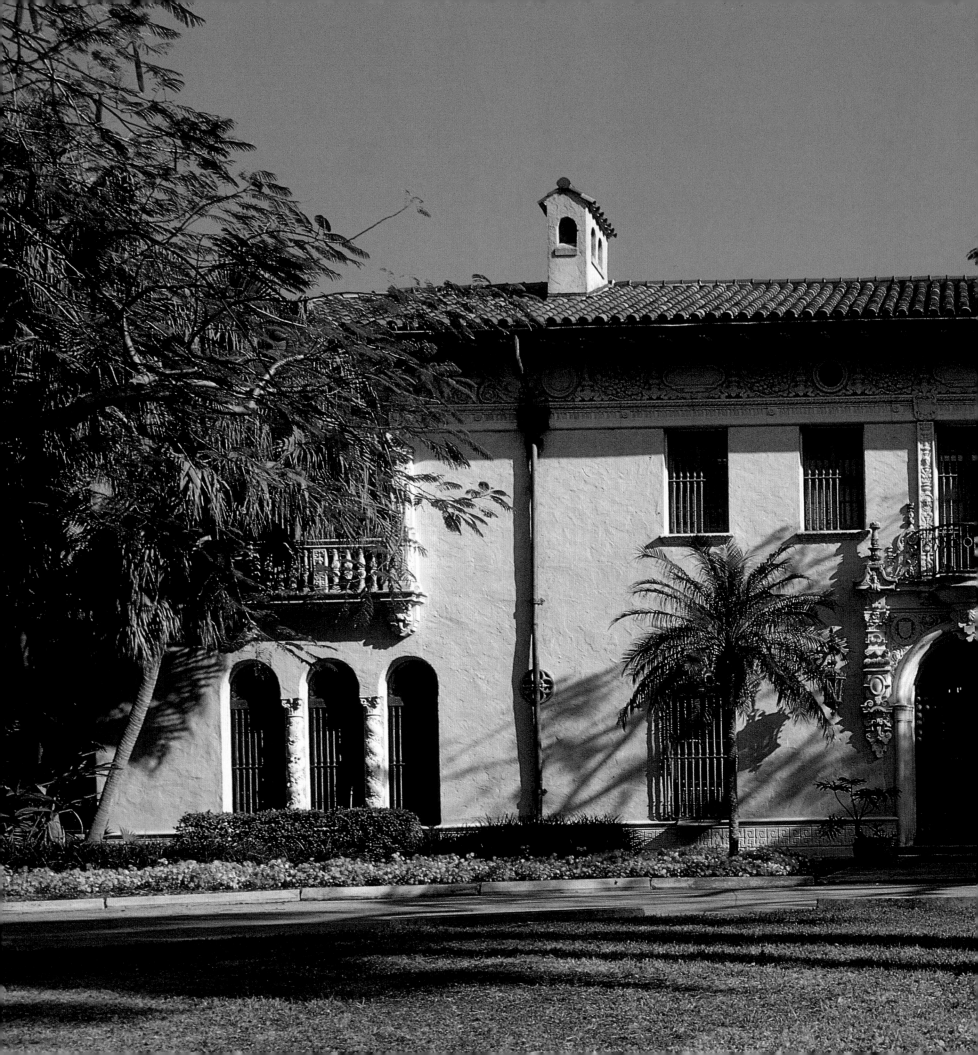

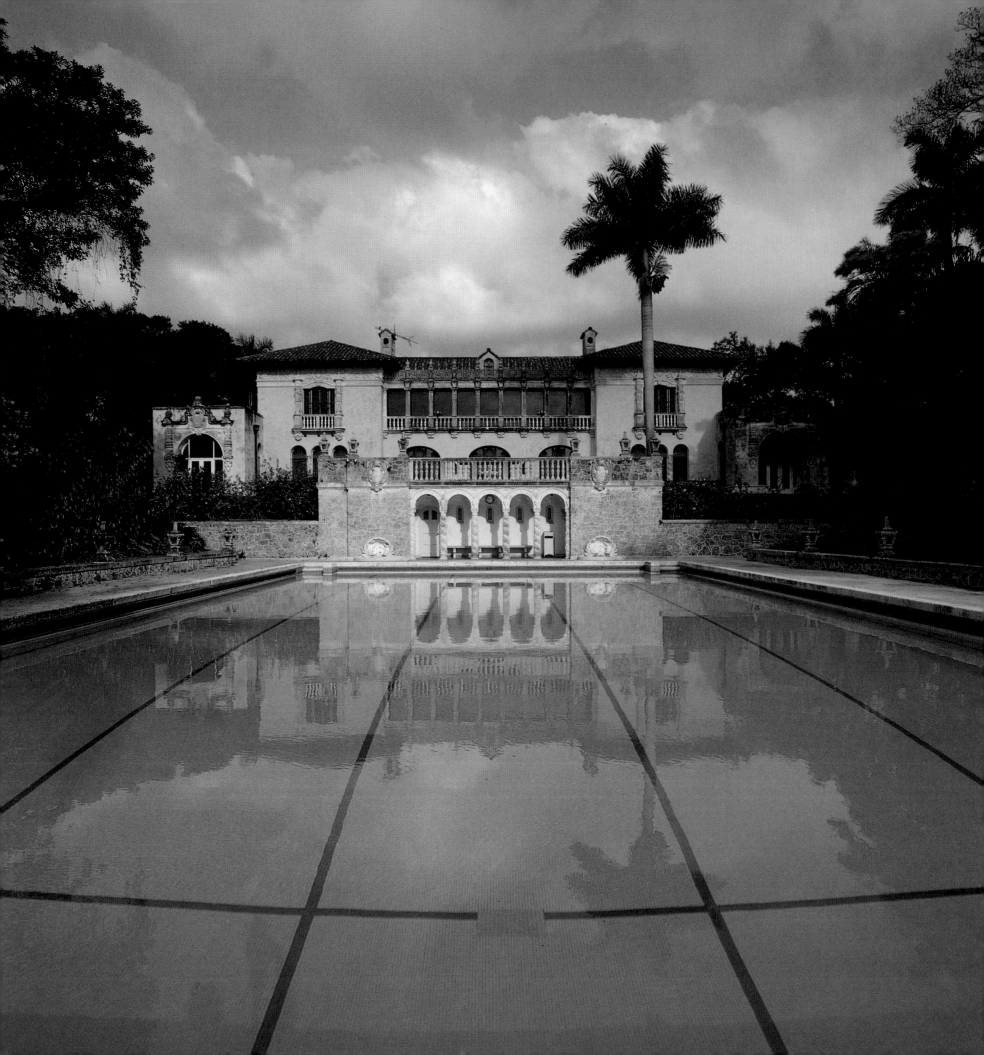

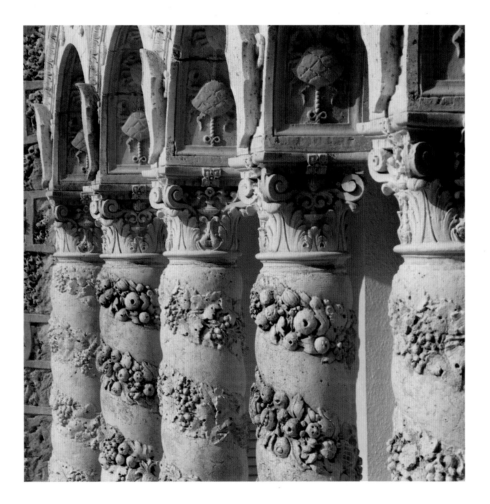

LEFT: View of El Jardin from Biscayne Bay.
ABOVE: Intricately detailed columns in the arcade.

LINKS: Blick auf El Jardin von der Biscayne Bay aus.
OBEN: Die kunstvoll verzierten Säulen des Bogengangs.

A GAUCHE: El Jardin, vu de la baie.
CI-DESSUS: Le travail de sculpture des colonnes de l'arcade.

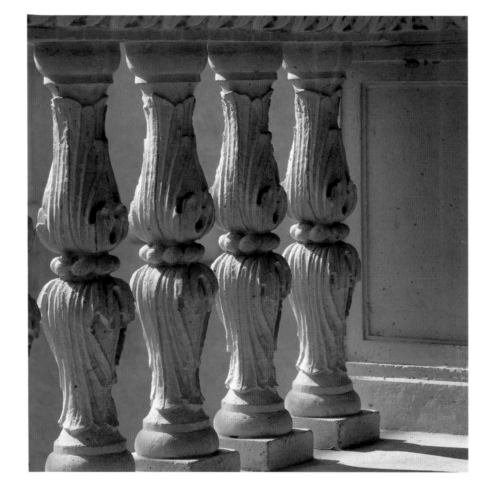

LEFT: Detail of an exterior balustrade.
ABOVE: Carved-stone relief of a mythological animal.

OBEN: Detailaufnahme einer äußeren Balustrade.
RECHTS: Das Steinrelief zeigt ein mythologisches Tier.

CI-DESSUS: Détail d'une balustrade extérieure.
A DROITE: Bas-relief de grotesque, en pierre sculptée.

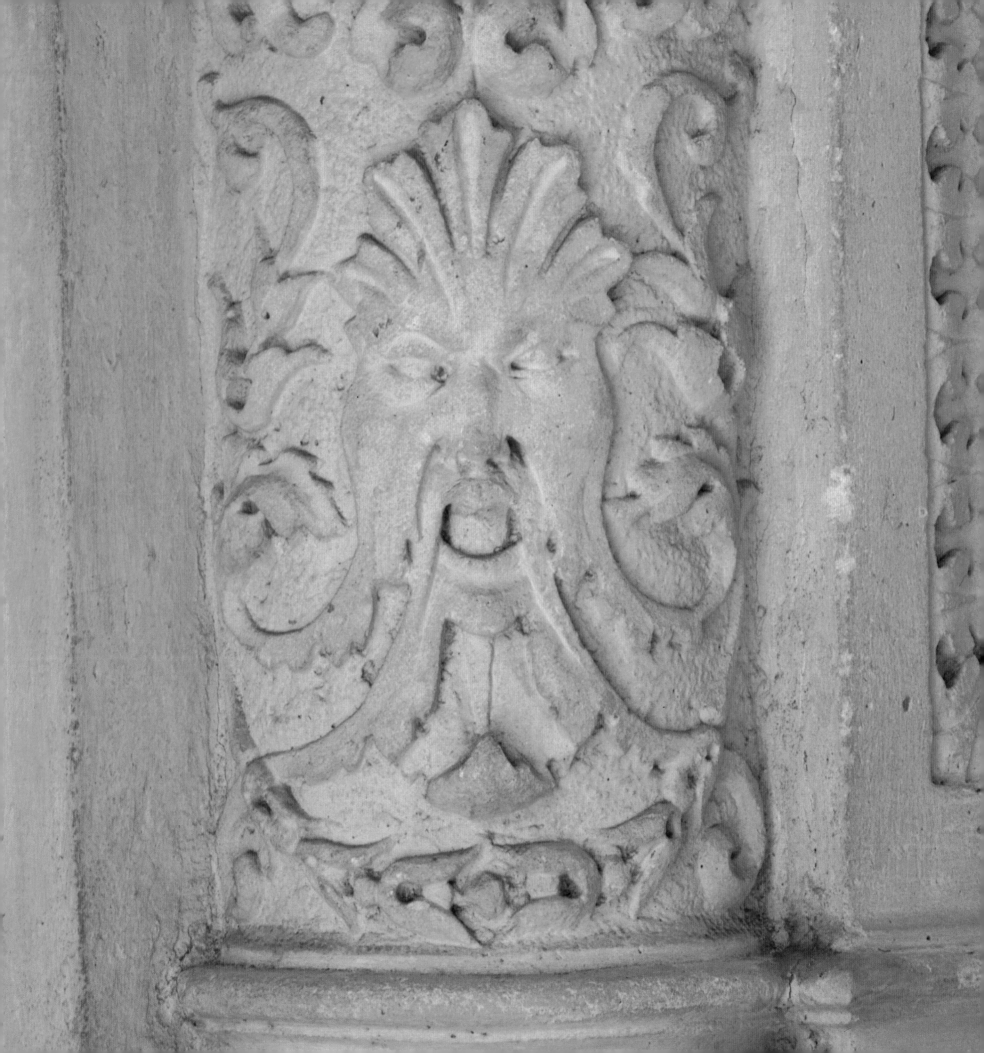

Relief of a woman's face.

Relief mit Frauengesicht.

Guirlande sculptée avec visage féminin.

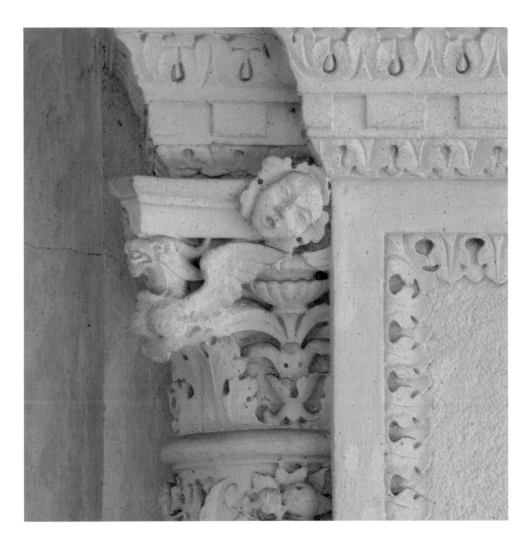

Ornamental column capital.

Verziertes Säulenkapitell.

Chapiteau sculpté.

VIZCAYA HOUSE AND GARDENS

F. Burrall Hoffman, Jr. and Paul Chalfin, architects,
Diego Suarez, landscape architect, 1914–17

Vizcaya was built between 1914 and 1917 as the Miami residence of James Deering, a cofounder of the International Harvester company. The house was primarily the work of F. Burrall Hoffmann Jr., an architect trained at Harvard and the Ecole des Beaux-Arts. Although Deering had originally wanted a Spanish-style house, Hoffmann instead drew a villa from the Veneto.

The house revolves around a courtyard, with arcaded hallways and loggias looking out to the bay. It was designed and furnished – the latter largely by Paul Chalfin – to evoke the feeling of a fifteenth-century villa that had evolved over the course of four centuries, each owner adding to it and transforming it a bit.

Vizcaya sits on a coral rock bluff above Biscayne Bay. To the south of the house are its extraordinary formal gardens – replete with pools, paths, sculptures, walls, and small outbuildings. Diego Suarez, a Colombian-born, Italian-educated landscape architect, spent seven years designing the gardens, which are considered to be among the finest in the world. Beneath the house is a grotto-like pool, and on the bay sits a great stone barge with carved decorations by Alexander Stirling Calder. In the 1950s Vizcaya became a museum; in 1986, in a highly contested move, the house's open courtyard was enclosed with a metal-and-glass "space-frame" roof to allow for air-conditioning.

Today, Vizcaya ranks as one of the most beautiful houses in America; it is at once subtle and brilliant in its design, a composition with architecture and landscape inextricably intertwined.

Vizcaya wurde zwischen 1914 und 1917 als Miami-Residenz von James Deering errichtet. Für den Entwurf des Hauses zeichnete hauptsächlich F. Burrall Hoffman Jr. verantwortlich. Obwohl Deering ein Haus im Spanish Style wünschte, entwarf Hoffman eine Villa aus dem Veneto.

Das Haus ist um einen Innenhof herum angelegt und besitzt Arkadengänge und Loggias mit Blick auf die Biscayne Bay. Entwurf und Möblierung sollten den Eindruck einer Villa aus dem 15. Jahrhundert erwecken, die im Laufe von vier Jahrhunderten von jedem neuen Besitzer ein wenig erweitert und abgewandelt worden war.

Vizcaya liegt auf einer Korallenklippe hoch über der Biscayne Bay. Südlich des Hauses befinden sich die außergewöhnlichen Gärten – mit Teichen, Wegen, Skulpturen, Mauern und kleinen Pavillons. Diego Suarez, ein aus Kolumbien gebürtiger und in Italien ausgebildeter Landschaftsarchitekt, verbrachte sieben Jahre mit der Gestaltung der Gärten, die zu den schönsten Anlagen der Welt gerechnet werden. Unterhalb des Hauses befindet sich ein Wasserbecken mit einer Grotte; in der Bay liegt eine große, steinerne Barke mit Steinmetzdekorationen von Alexander Stirling Calder. In den 50er Jahren wurde Vizcaya in ein Museum umgewandelt.

Heute zählt Vizcaya mit seiner raffinierten wie großartigen Anlage zu den schönsten Villen Amerikas. Architektur und Landschaft vereinen sich zu einer kunstvollen Gesamtkomposition. Der Maler John Singer Sargent schrieb über sie: »[Hier] treffen sich Venedig, Frascati, Aranjuez und all die Orte, die man wahrscheinlich nicht mehr zu sehen bekommt.«

Vizcaya a été construite entre 1914 et 1917 pour James Deering, cofondateur de la société International Harvester. Elle est essentiellement l'œuvre de F. Burrall Hoffman Jr., formé à Harvard et à l'Ecole des Beaux-Arts. Bien que Deering ait à l'origine souhaité une maison de style espagnol, Hoffman lui dessina cette villa vénète.

La maison se développe autour d'une cour intérieure, avec des arcades et des loggias qui donnent sur la baie. Elle fut conçue et meublée (essentiellement par Paul Chalfin) pour évoquer d'une villa du Quatrocento qui aurait évolué au cours des siècles, chacun de ses propriétaires l'ayant agrandie et légèrement transformée.

Vizcaya se dresse sur un rocher de corail au-dessus de Biscayne Bay. Vers le Sud s'étendent ses extraordinaires jardins formels, peuplés de bassins, d'allées, de sculptures, de murs et de petites constructions. Diego Suarez, architecte paysagiste d'origine colombienne mais formé en Italie, passa sept années à créer cet ensemble qui fait partie des plus beaux jardins du monde. Sous la maison, dans une fausse grotte, se trouve une piscine tandis que sur la baie «flotte» une barque de pierre sculptée par Alexander Stirling Calder. Dans les années 50, Vizcaya est devenue un musée. En 1986, la cour intérieure a été recouverte d'un toit de verre et de métal.

Aujourd'hui, Vizcaya est l'une des plus belles demeures d'Amérique, sublime et brillante dans sa composition qui mêle inextricablement l'architecture et le paysage. Comme le peintre John Singer Sargent l'écrivit, à Vizcaya «se retrouvent Venise, Frascati et Aranjuez, et tout ce que l'on ne verra sans doute jamais plus».

RIGHT: Detail of garden sculpture.
OVERLEAF: Vizcaya from Biscayne Bay.

RECHTS: Detail einer Gartenskulptur.
FOLGENDE DOPPELSEITE: Blick auf Vizcaya von der Biscayne Bay aus.

A DROITE: Détail d'une sculpture du jardin.
DOUBLE PAGE SUIVANTE: Vizcaya, vue de Biscayne Bay.

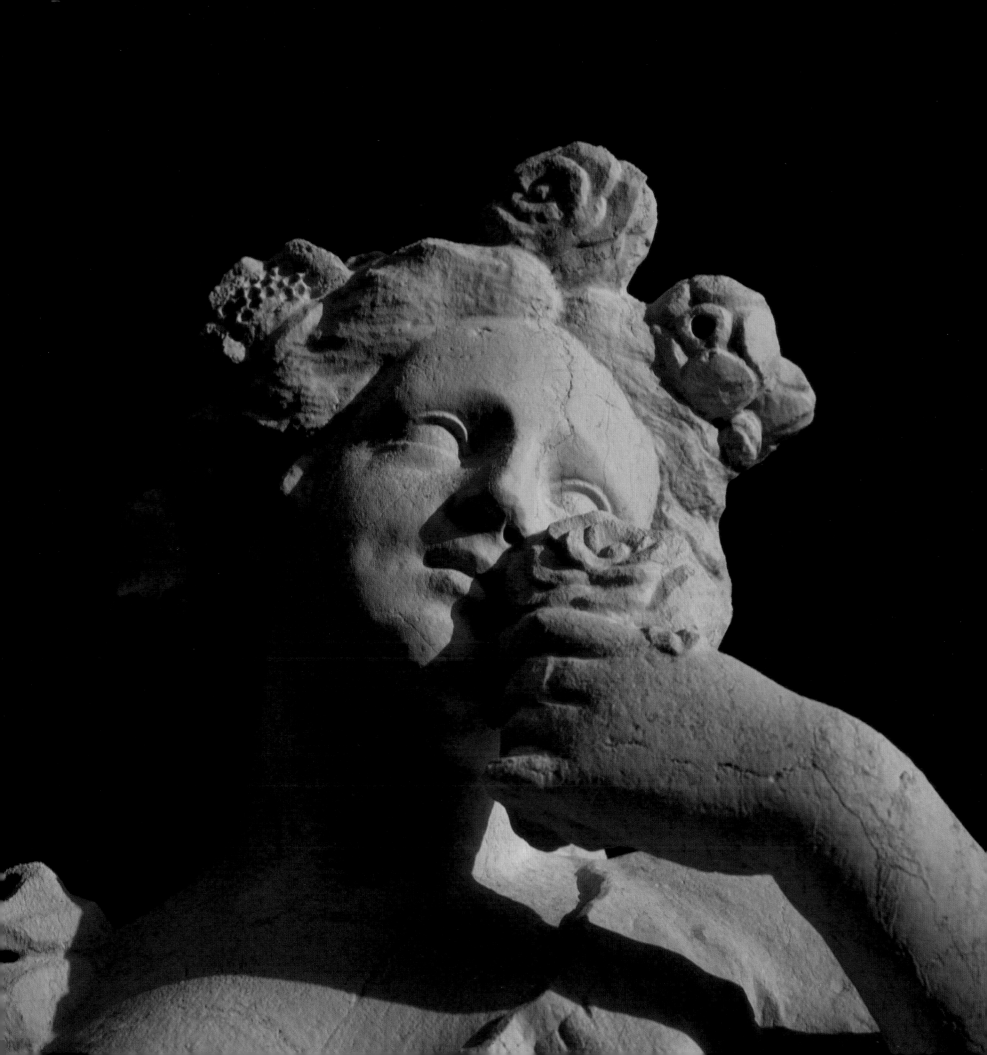

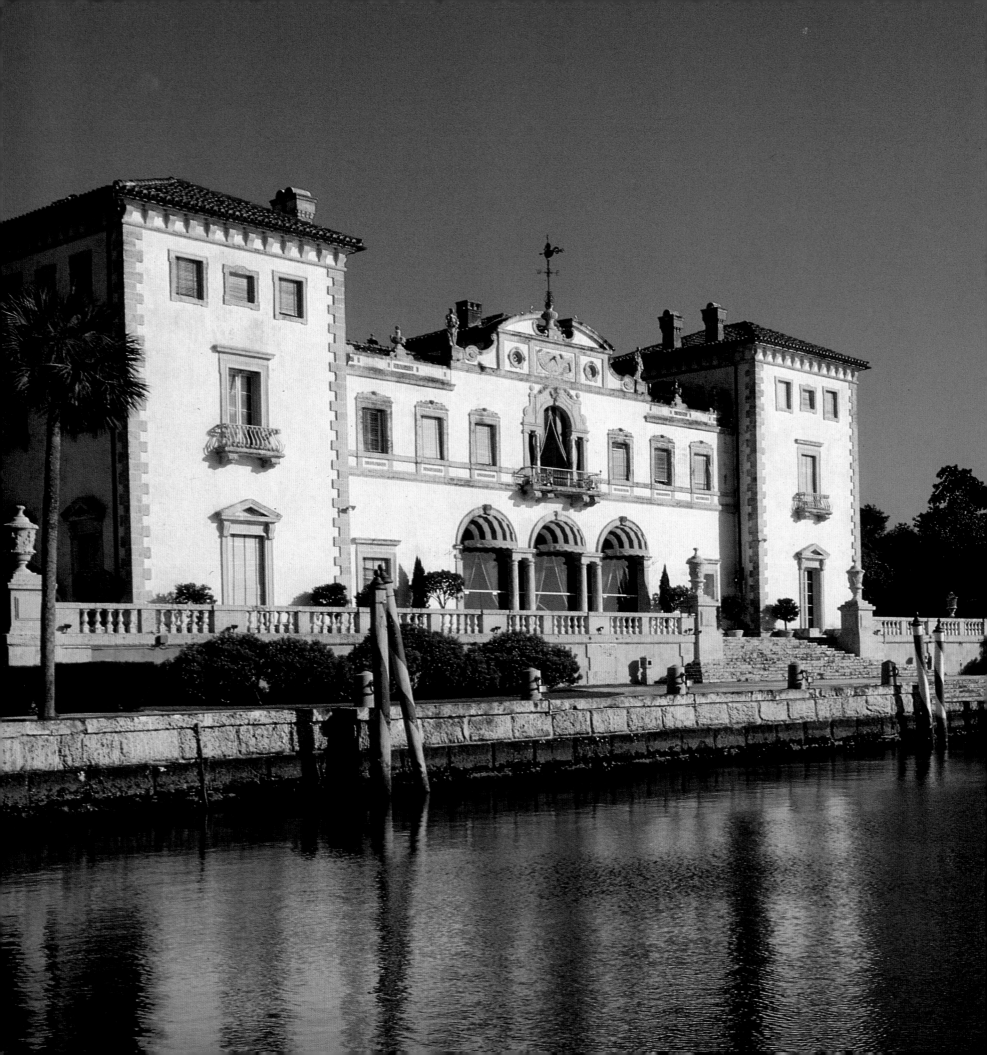

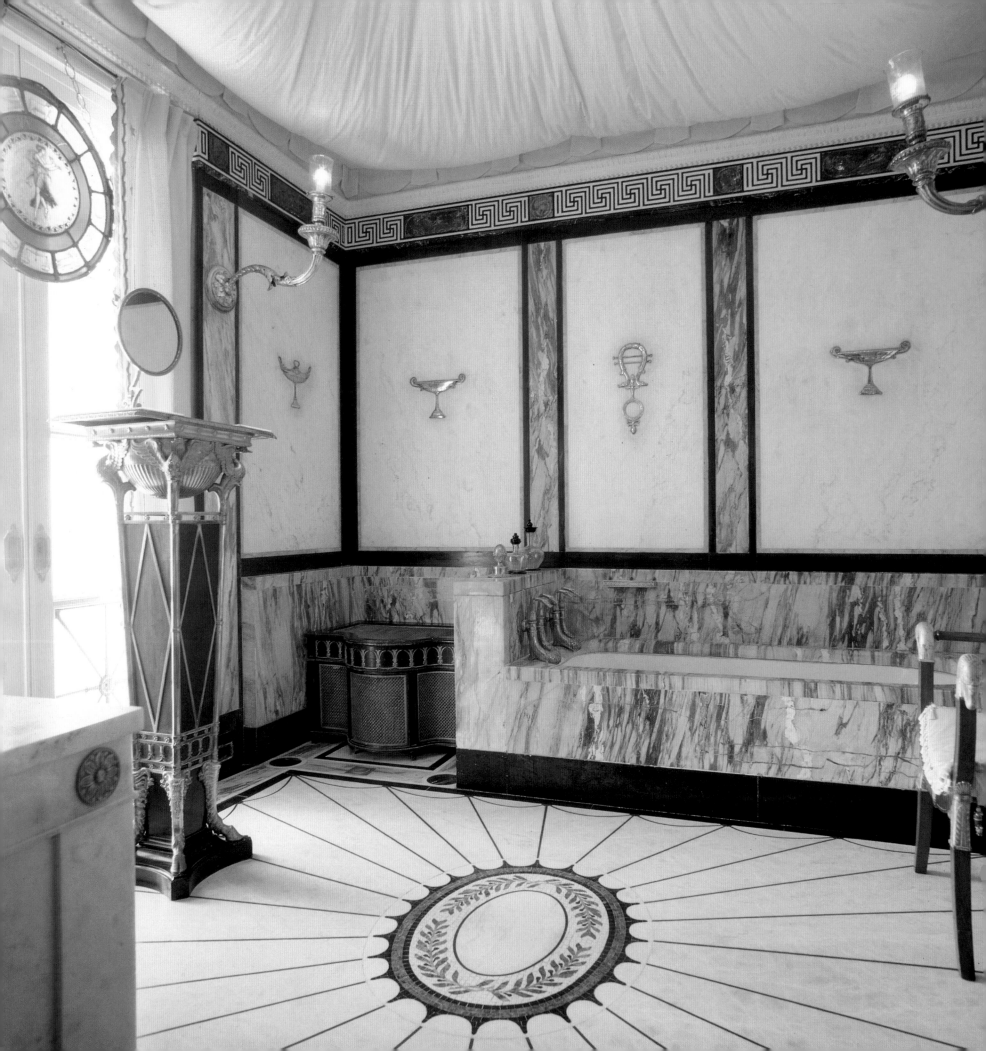

LEFT: Master bathroom of James Deering, Vizcaya's original owner.
ABOVE: Bathroom detail.

LINKS: Das Hauptbadezimmer von James Deering, dem ursprünglichen Besitzer von Vizcaya.
OBEN: Detail des Badezimmers.

A GAUCHE: Salle de bains de James Deering, le premier propriétaire de Vizcaya.
CI-DESSUS: Détail de la salle de bains.

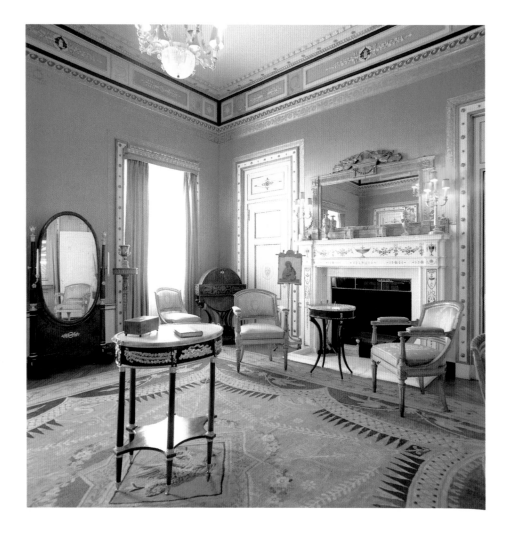

ABOVE: Master bedroom, with an Adam-style fireplace dating to 1790.
RIGHT: Master bedroom, with French Empire furniture and a nineteenth-century Aubusson rug.

OBEN: Hauptschlafzimmer, mit einem Kamin im Adam Style aus dem Jahr 1790.
RECHTS: Hauptschlafzimmer, mit französischen Empiremöbeln und einem Aubusson-Teppich aus dem 19. Jahrhundert.

CI-DESSUS: Chambre de James Deering. Cheminée de style Adam datant de 1790.
A DROITE: La chambre du maître, meublée Empire. Tapis d'Aubusson du XIXe siècle.

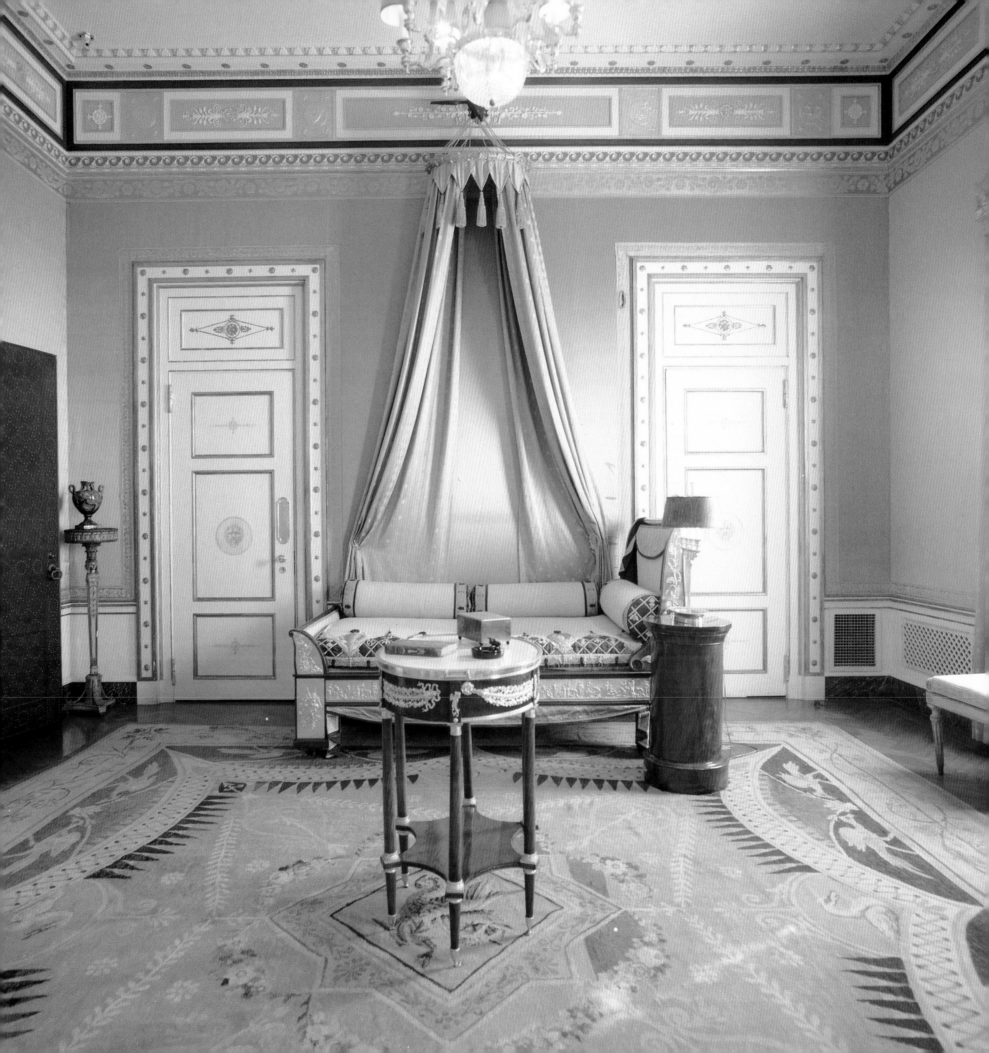

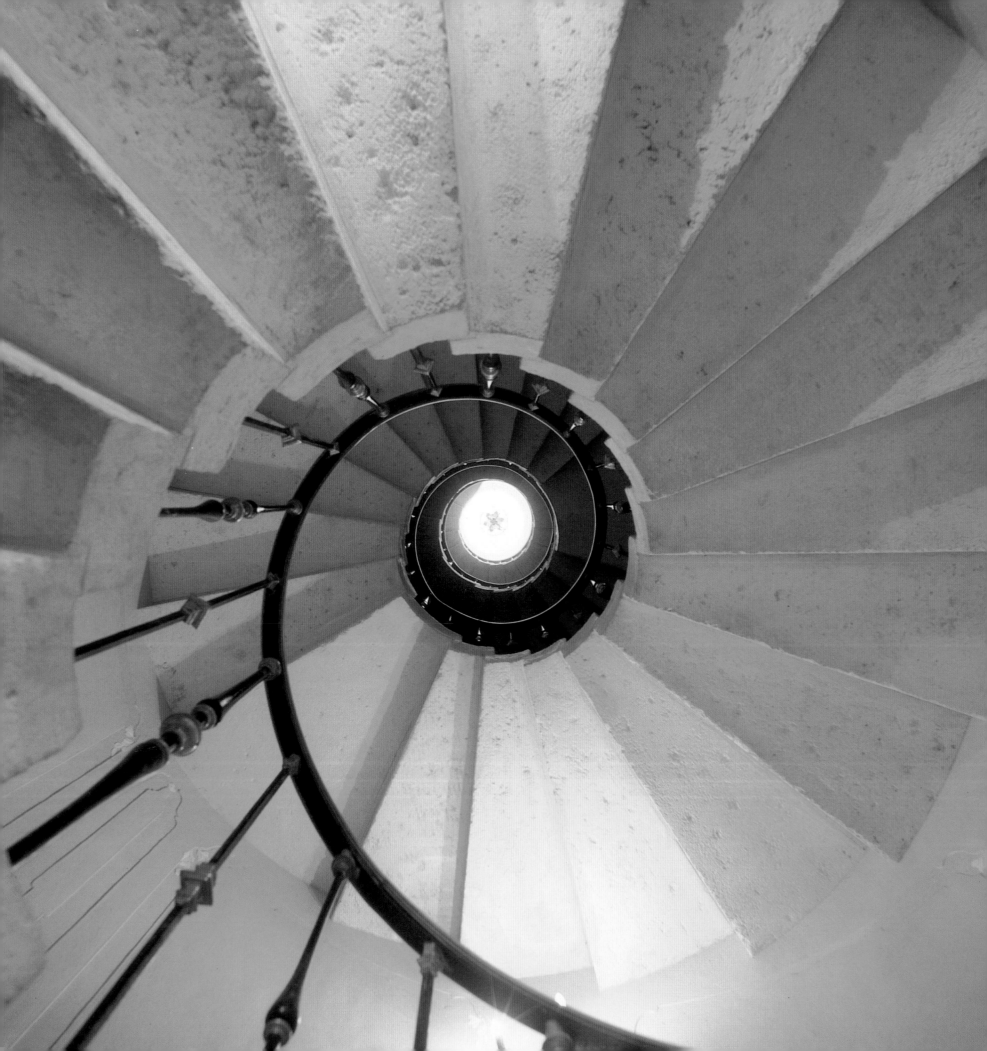

LEFT: Cantilevered spiral staircase.
ABOVE: Sculpture on the garden terrace.
OVERLEAF: Vizcaya from the stone "barge" in Biscayne Bay.

LINKS: Die vorkragende Wendeltreppe.
OBEN: Skulptur auf der Gartenterrasse.
FOLGENDE DOPPELSEITE: Vizcaya, von der steinernen »Barke« in der Biscayne Bay aus gesehen.

A GAUCHE: Escalier en spirale en encorbellement.
CI-DESSUS: Statue de la terrasse du jardin.
DOUBLE PAGE SUIVANTE: Vizcaya vue de la barque de pierre sur Biscayne Bay.

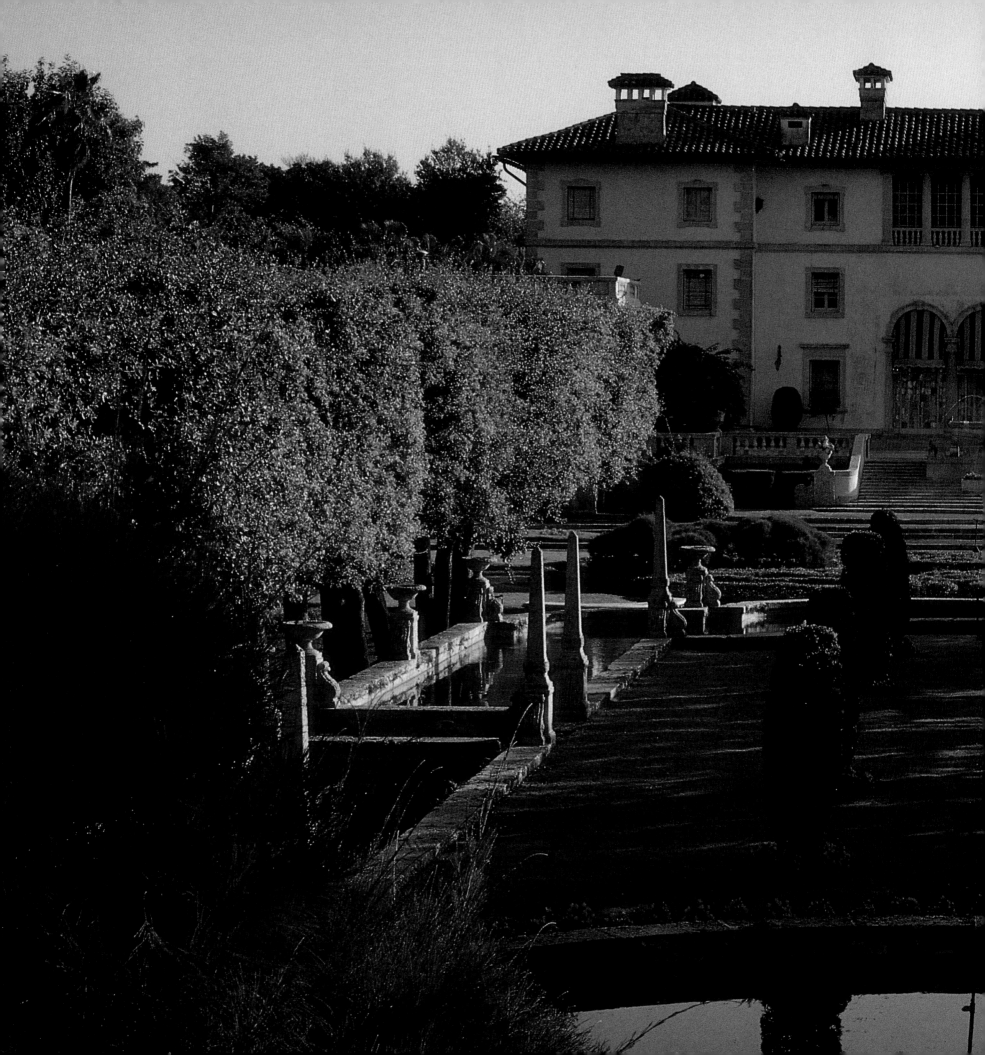

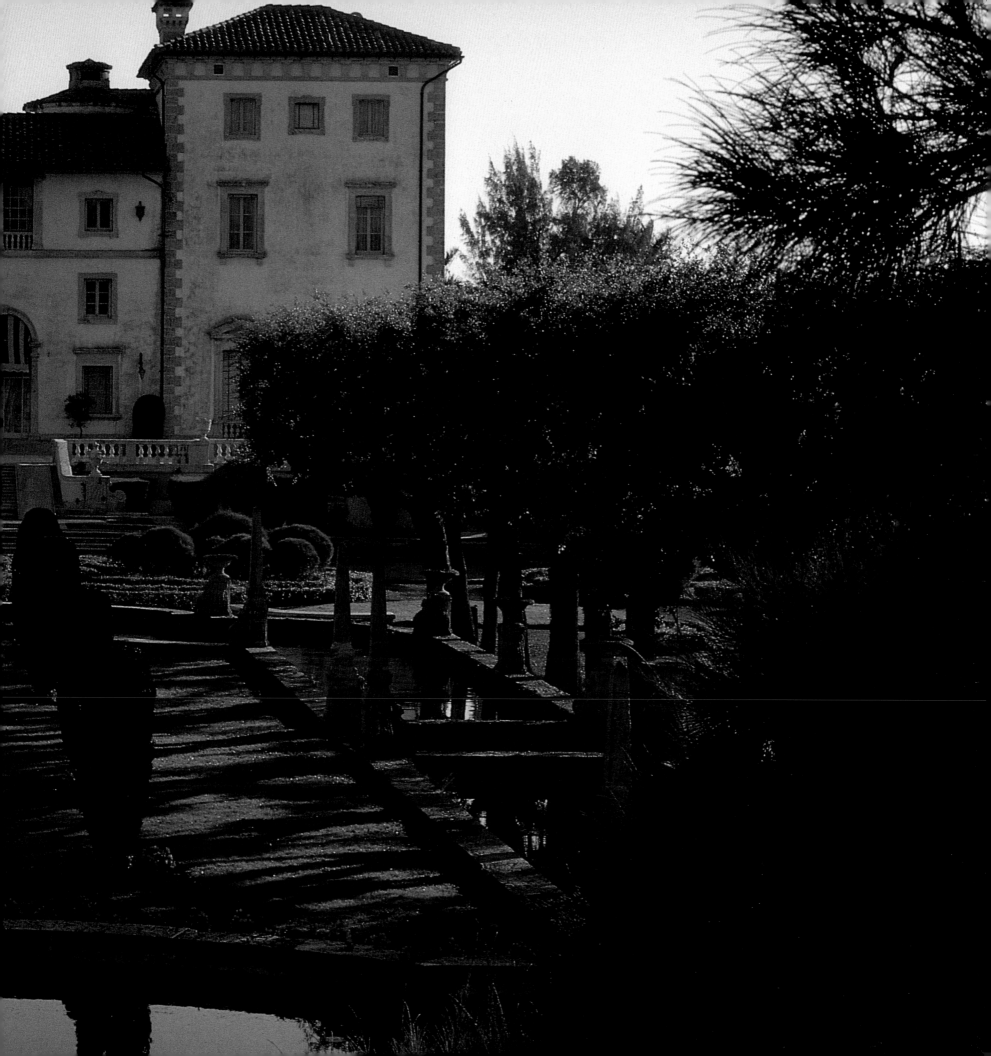

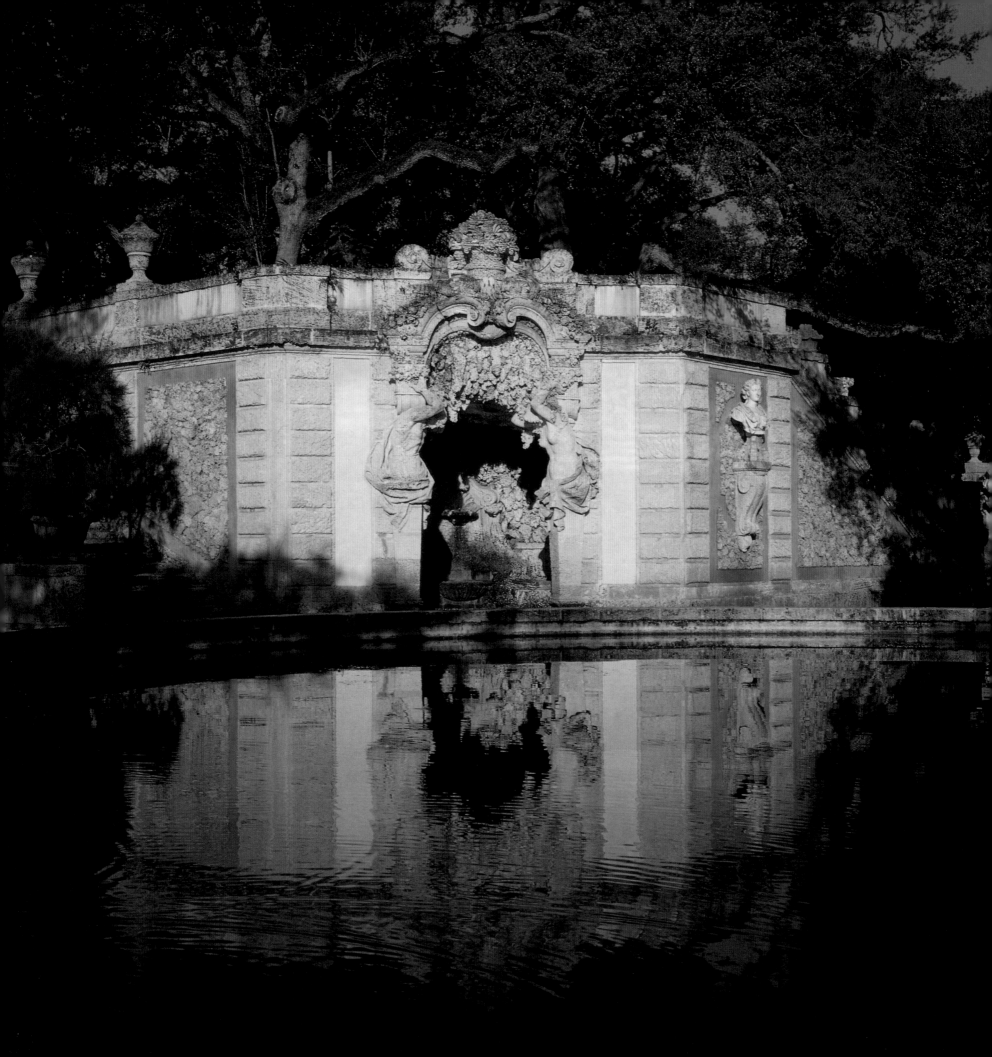

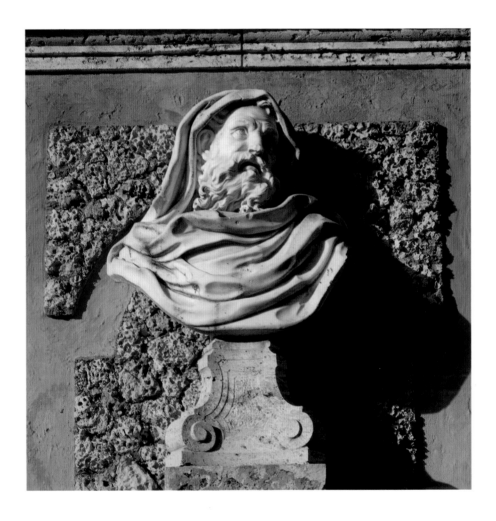

LEFT: Entrance to the grotto at the pool's edge.
ABOVE: Detail of garden sculpture.

LINKS: Eingang zur Grotte am Rande des Wasserbeckens.
OBEN: Detail einer Gartenskulptur.

A GAUCHE: Entrée de la grotte au bord de la piscine.
CI-DESSUS: Détail de la statuaire des jardins.

Detail of stonework in the grotto.

Detail einer Steinmetzarbeit in der Grotte.

Détail du décor sculpté de la grotte.

Detail of sculpture against a rusticated stone wall.

Detail einer Skulptur vor einer mit Bossenwerk rustizierten Steinmauer.

Détail d'une sculpture devant un mur de pierre rustiquée.

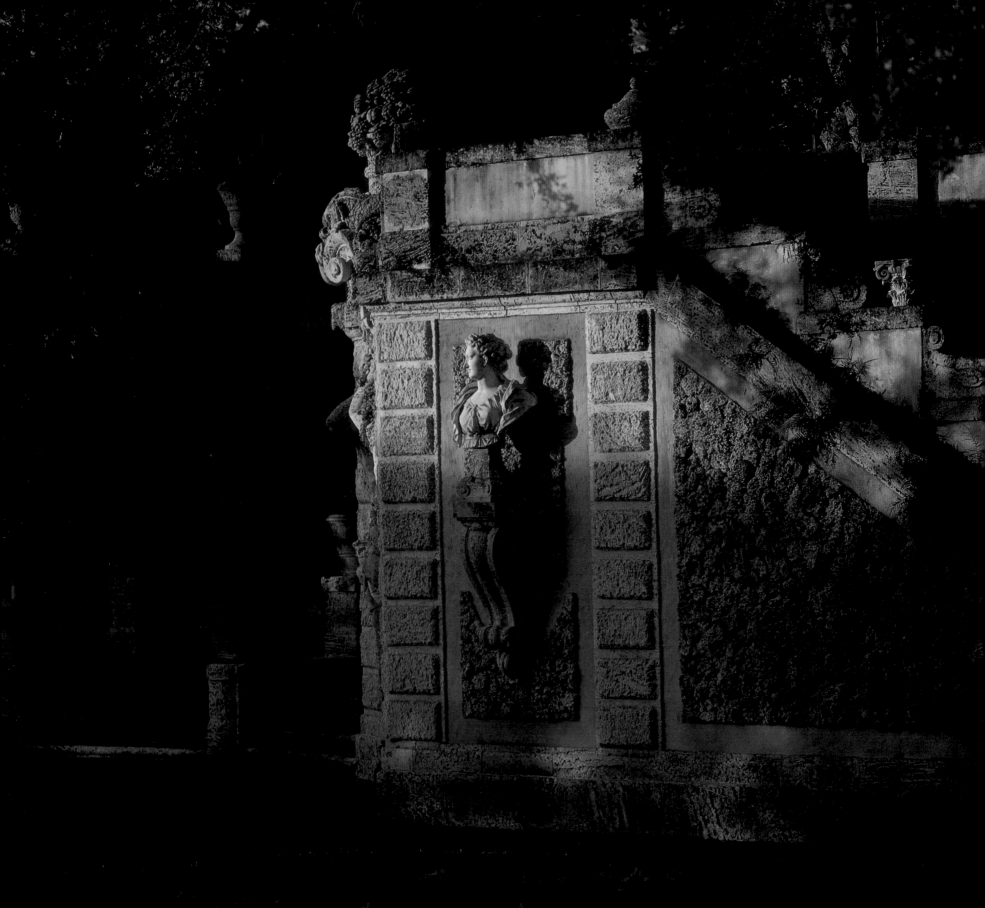

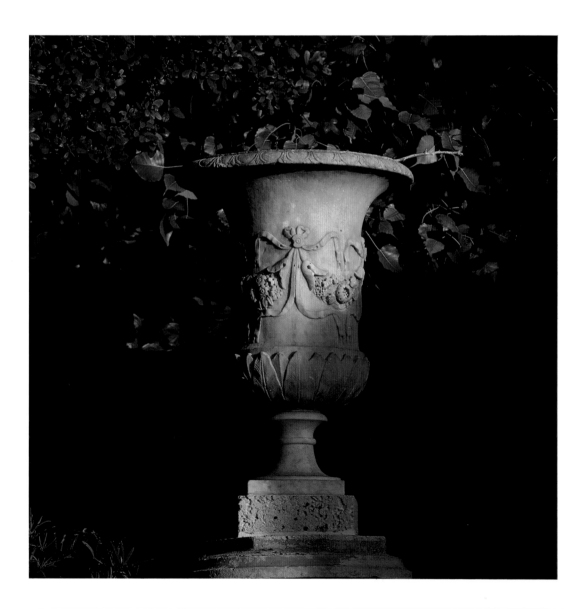

LEFT: Wall of the Mount in Vizcaya's garden.
ABOVE: A decorative urn in the garden.

LINKS: Begrenzungsmauer der Anhöhe im Garten von Viscaya.
OBEN: Eine dekorative Gartenurne.

A GAUCHE: Mur du «Mont», dans le jardin de Vizcaya.
CI-DESSUS: Urne décorative dans le jardin.

ABOVE: Detail of a garden sculpture.
RIGHT: The Mount of the Fountain Garden.
OVERLEAF: View of Diego Suarez's formal garden at Vizcaya.

OBEN: Detail einer Gartenskulptur.
RECHTS: Anhöhe des Brunnengartens.
FOLGENDE DOPPELSEITE: Blick auf Diego Suarez' sehr formal gestaltete Gartenanlage in Vizcaya.

CI-DESSUS: Détail d'une sculpture du jardin.
A DROITE: Le jardin de la fontaine.
DOUBLE PAGE SUIVANTE: Vue du jardin dessiné par Diego Suarez pour Vizcaya.

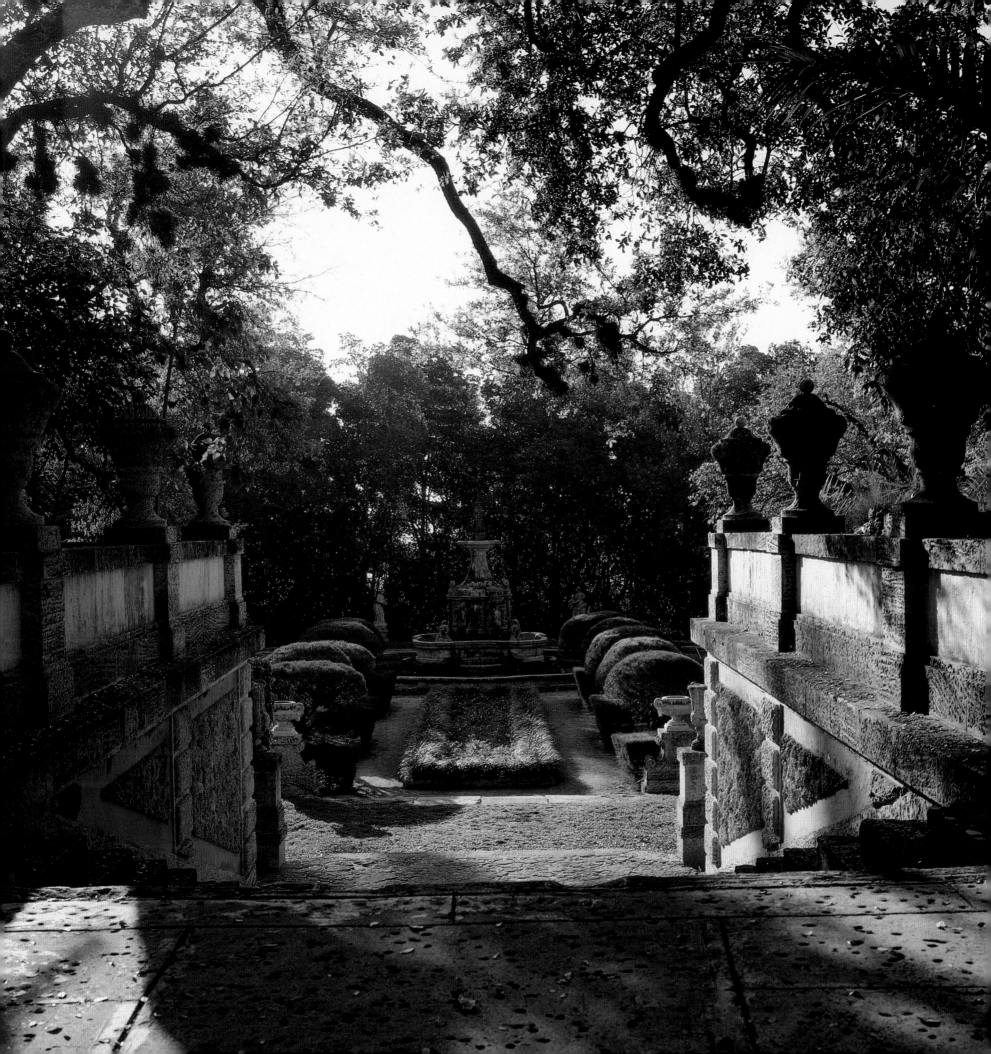

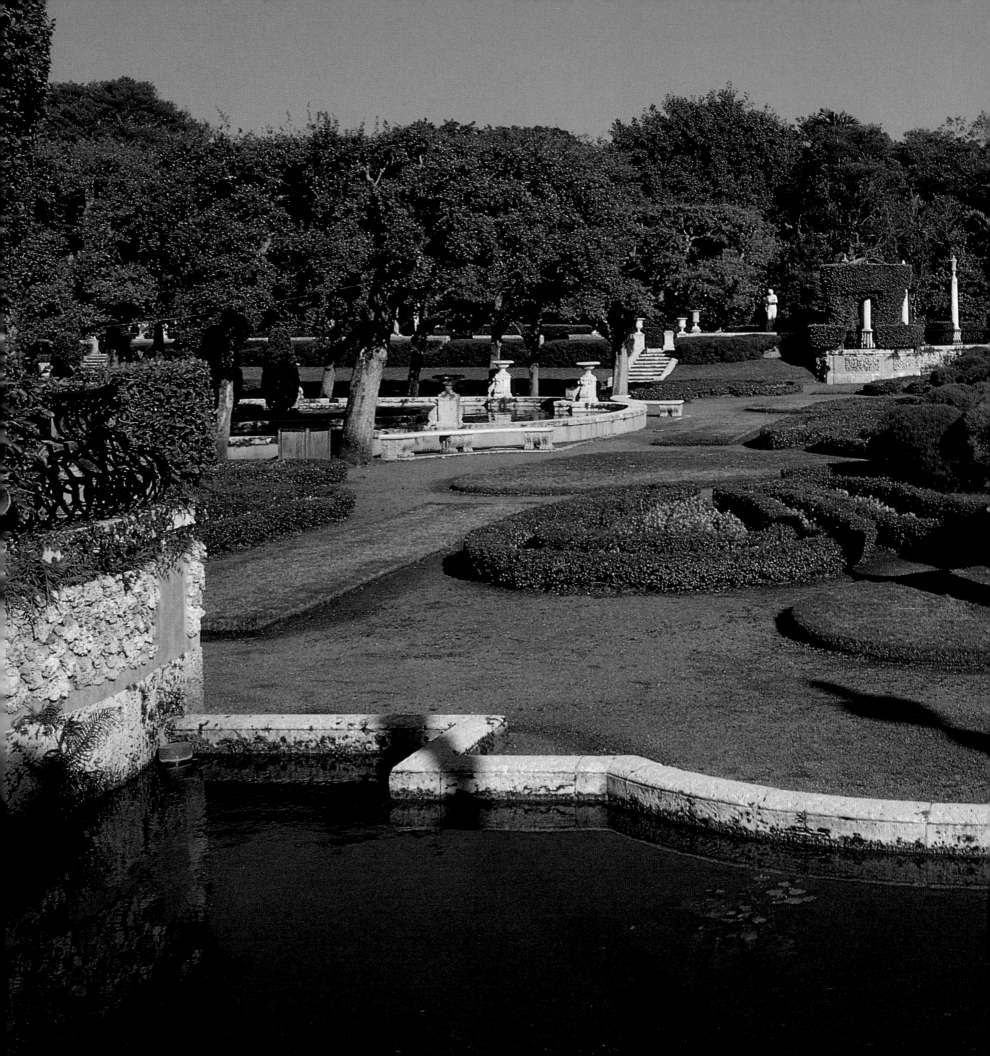

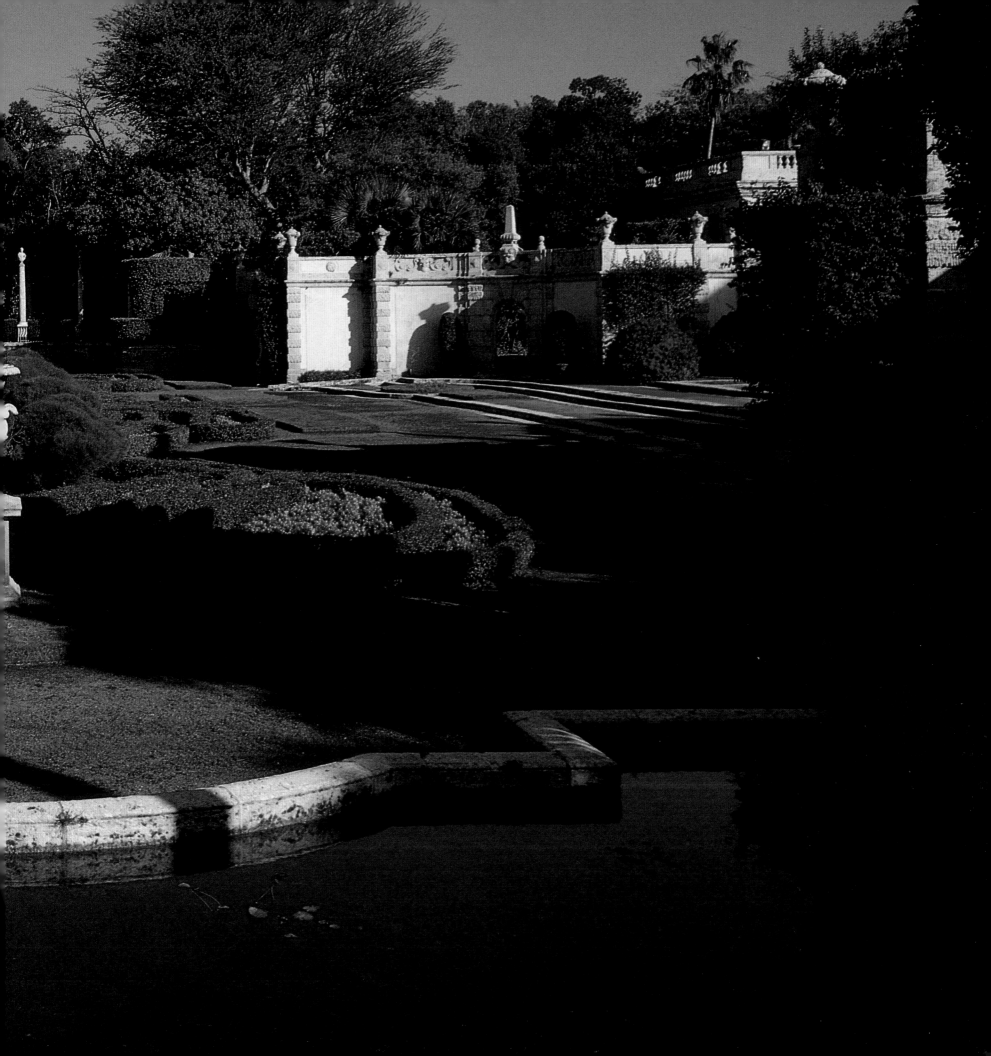

VANDERBILT MANSION
MAYTAG/ROBINSON HOUSE

Maurice Fatio

In the mid-1920s, William Kissam Vanderbilt Jr. traded a yacht to Carl Fisher for an island just off the southern tip of Miami Beach and commissioned Maurice Fatio, a Swiss-born Palm Beach architect, to design a house for him. Fatio had already designed a house for Vanderbilt's brother in Palm Beach, and was later to do the same for his sister.

On Fisher Island, Fatio designed a nineteen-bedroom house, completed in 1928, in the Mediterranean Revival style, which Vanderbilt called "Alva Base," after his 350-foot yacht. For its size and the wealth of its client, the house is surprisingly restrained, a dignified blend of French, Spanish, and Italian Renaissance architecture. Like much of Fatio's work, the house has refinement and a great sense of proportion – Fatio did not spurn ornamentation, but he did not use it gratuitously.

Today, the house has been renovated as a private club, the centerpiece of a Mediterranean-influenced residential development that encompasses much of Fisher Island. Even sitting in the midst of so much activity, its presence is not lessened.

Fatio's house on Sunset Island came a decade later, as a winter residence for heirs to the Maytag fortune. Tucked away in a secluded corner of this private residential Island, it is exuberantly decorative, almost Baroque in some places, Moorish in others.

Mitte der 20er Jahre schenkte William Kissam Vanderbilt Jr. Carl Fisher eine Yacht im Tausch gegen eine Insel vor der Südspitze von Miami Beach und beauftragte Maurice Fatio – einen aus der Schweiz stammenden Architekten in Palm Beach – mit dem Entwurf eines Hauses.

Auf Fisher Island errichtete Fatio ein Gebäude mit 19 Schlafzimmern im Mediterranean Revival Style, das 1928 fertiggestellt und von Vanderbilt nach seiner 115 Meter langen Jacht »Alva Base« getauft wurde. Für seine Größe und den Reichtum seines Besitzers ist das Haus überraschend zurückhaltend – eine sublime Mischung aus französischer, spanischer und italienischer Renaissance-Architektur. Wie die meisten von Fatios Bauten besitzt es Raffinesse und ein wunderbares Gefühl für Proportionen – Fatio verzichtete zwar nicht völlig auf Ornamente und Verzierungen, setzte sie aber auch nicht beliebig ein.

Heute dient das renovierte Gebäude als privates Clubhaus und bildet das Kernstück eines mediterran anmutenden Wohngebiets, das große Teile von Fisher Island umfaßt. Trotz seiner Lage inmitten dieses geschäftigen Treibens hat das Haus nichts von seinem Charme verloren.

Ein Jahrzehnt später entstand Fatios Haus auf Sunset Island – eine Winterresidenz für die Erben des Maytag-Vermögens. Das Gebäude versteckt sich in einer abgelegenen Ecke dieser Privatinsel und erscheint überschwenglich dekoriert – an manchen Stellen nahezu barock und an anderen Stellen eher maurisch-orientalisch.

Au milieu des années 20, William Kissam Vanderbilt Jr. échangea avec Carl Fisher un yacht contre une île à l'extrémité sud de Miami Beach, et demanda à Maurice Fatio, architecte d'origine suisse installé à Palm Beach, de lui construire une maison. Fatio avait déjà conçu une résidence pour le frère de Vanderbilt à Palm Beach, et en élèvera une autre pour sa sœur.

Sur Fisher Island, il créa une maison de dix-neuf chambres, achevée en 1928, dans un style néo-méditerranéen que Vanderbilt appela «Alva Base» d'après le nom de son yacht de 115 mètres. Si l'on considère sa taille et la richesse de son propriétaire, la maison semble étonnamment modeste, mélange sobre d'éléments architecturaux français, espagnols et de la Renaissance italienne. Comme beaucoup de réalisations de Fatio, la maison est raffinée et possède un sens affirmé des proportions. L'architecte n'économisa pas l'ornementation, sans pour autant l'utiliser de façon gratuite.

Aujourd'hui, la maison a été rénovée pour un club privé, autour duquel se développe un lotissement résidentiel d'esprit méditerranéen, et qui couvre la plus grande partie de Fisher Island. Sa présence n'a pas été altérée par ce nouvel environnement.

La maison de Sunset Island a été construite par Fatio dix ans plus tard pour les héritiers de la fortune Maytag. Dissimulée dans un coin retiré de cette île privée résidentielle, elle est décorée avec une exubérance, presque baroque parfois, voire mauresque.

Architectural embellishments at the Vanderbilt Mansion on Fisher Island.

Architektonische Verzierungen am Vanderbilt Mansion auf Fisher Island.

La présence architecturale de la résidence Vanderbilt sur Fisher Island.

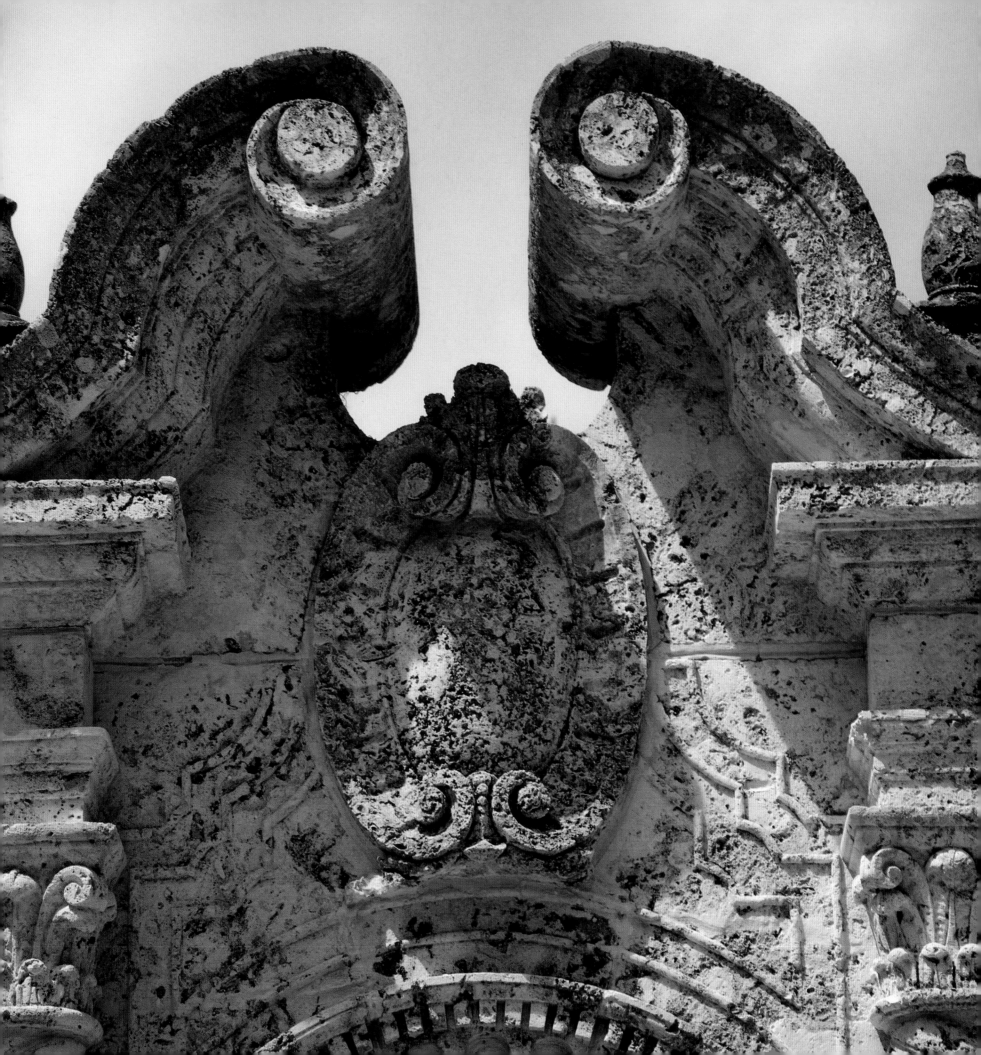

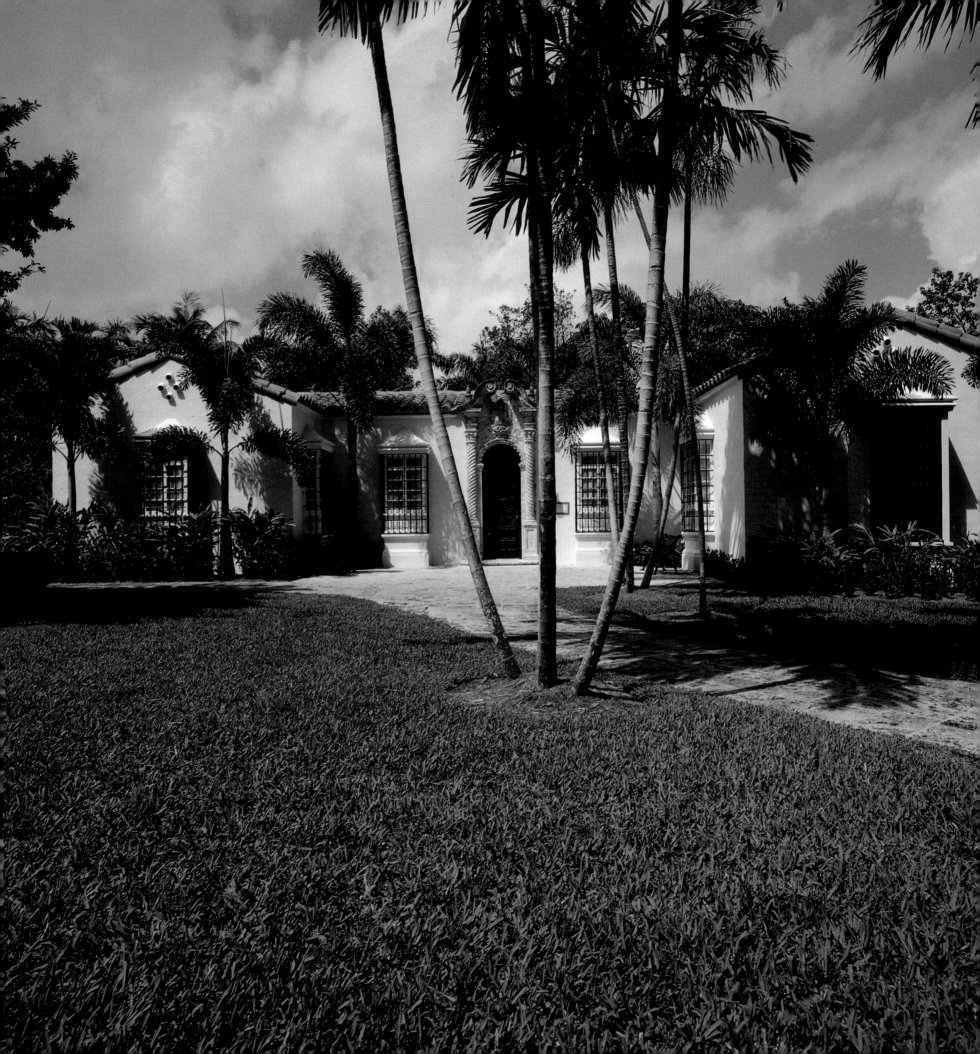

LEFT: Fatio's house for William Vanderbilt is now the centerpiece of a private club.
ABOVE: Detail of a column. The medallion's V is for Vanderbilt.

LINKS: Fatios Villa für William Vanderbilt ist heute das Prunkstück eines Privatclubs.
OBEN: Detailaufnahme einer Säule: Das »V« auf dem Medaillon steht für Vanderbilt.

A GAUCHE: La maison édifiée par Fatio pour William Vanderbilt est aujourd'hui le siège d'un club privé.
CI-DESSUS: Détail de colonnes. Le médaillon porte un «V», pour Vanderbilt.

ABOVE, RIGHT, AND FIRST OVERLEAF: Details of carved and cast-stone ornament at Vanderbilt Mansion.
SECOND OVERLEAF: The pool at Vanderbilt Mansion, now the club's restaurant.

OBEN, RECHTS UND FOLGENDE DOPPELSEITE: Detailaufnahmen von Steinmetz- und Kunststeinornamenten am Vanderbilt Mansion.
DARAUFFOLGENDE DOPPELSEITE: Der Swimmingpool von Vanderbilt Mansion, heute Restaurant des Clubs.

CI-DESSUS, À DROITE ET PREMIÈRE DOUBLE PAGE SUIVANTE: Détails d'ornements sculptés et en pierre moulée de la résidence Vanderbilt.
SECONDE DOUBLE PAGE SUIVANTE: La piscine, aujourd'hui restaurant du club.

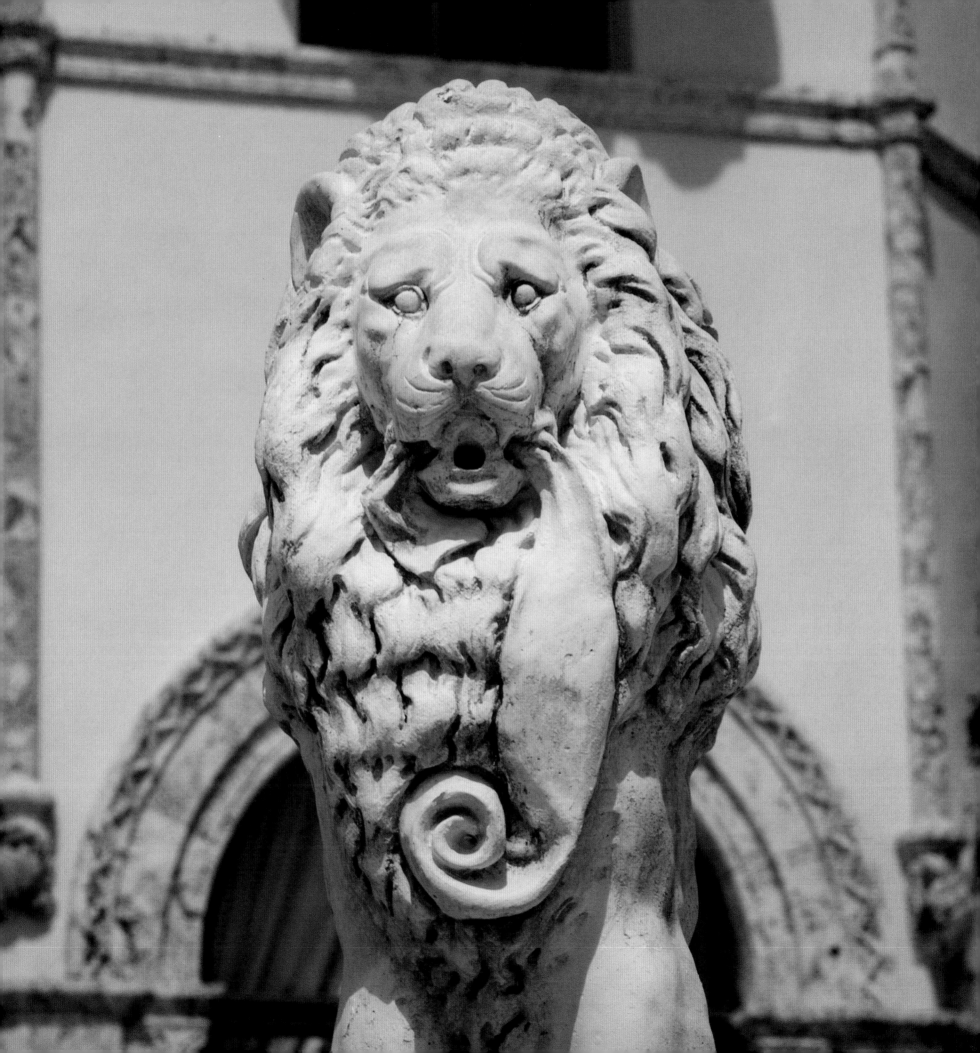

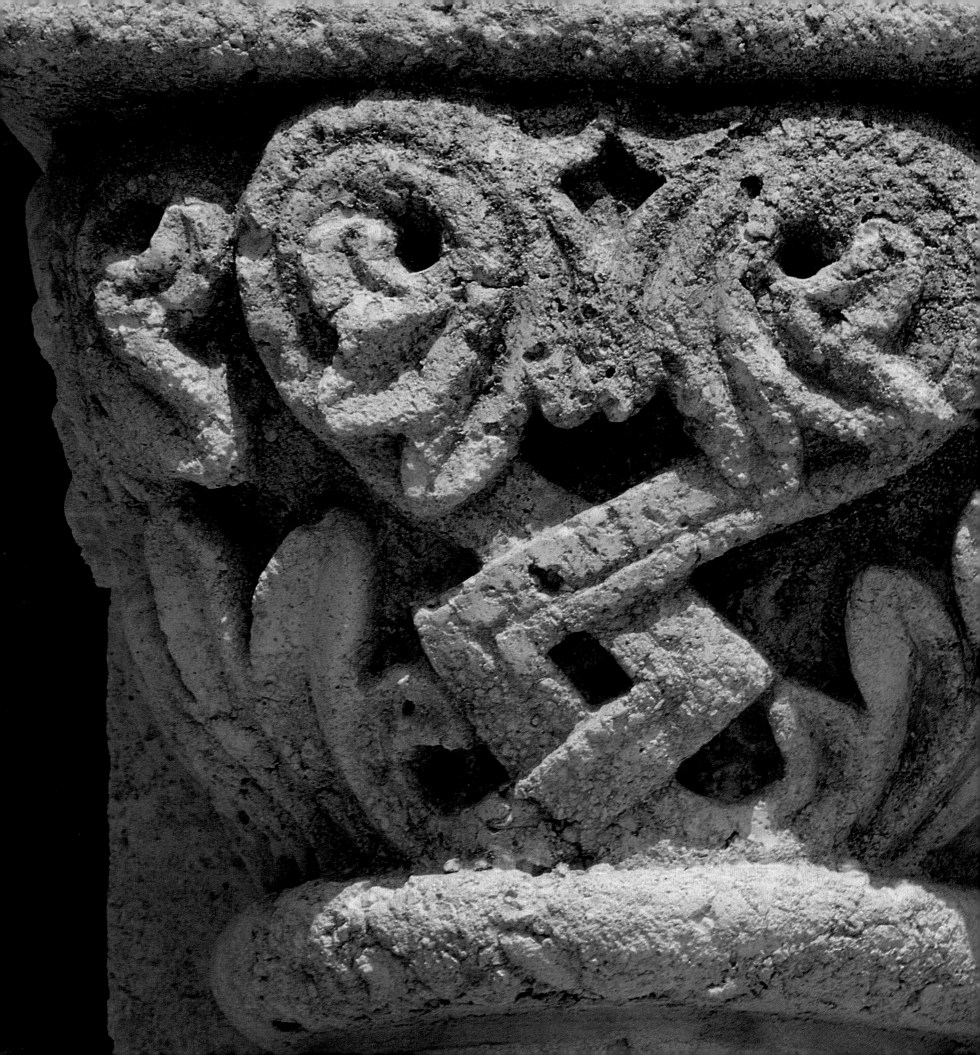

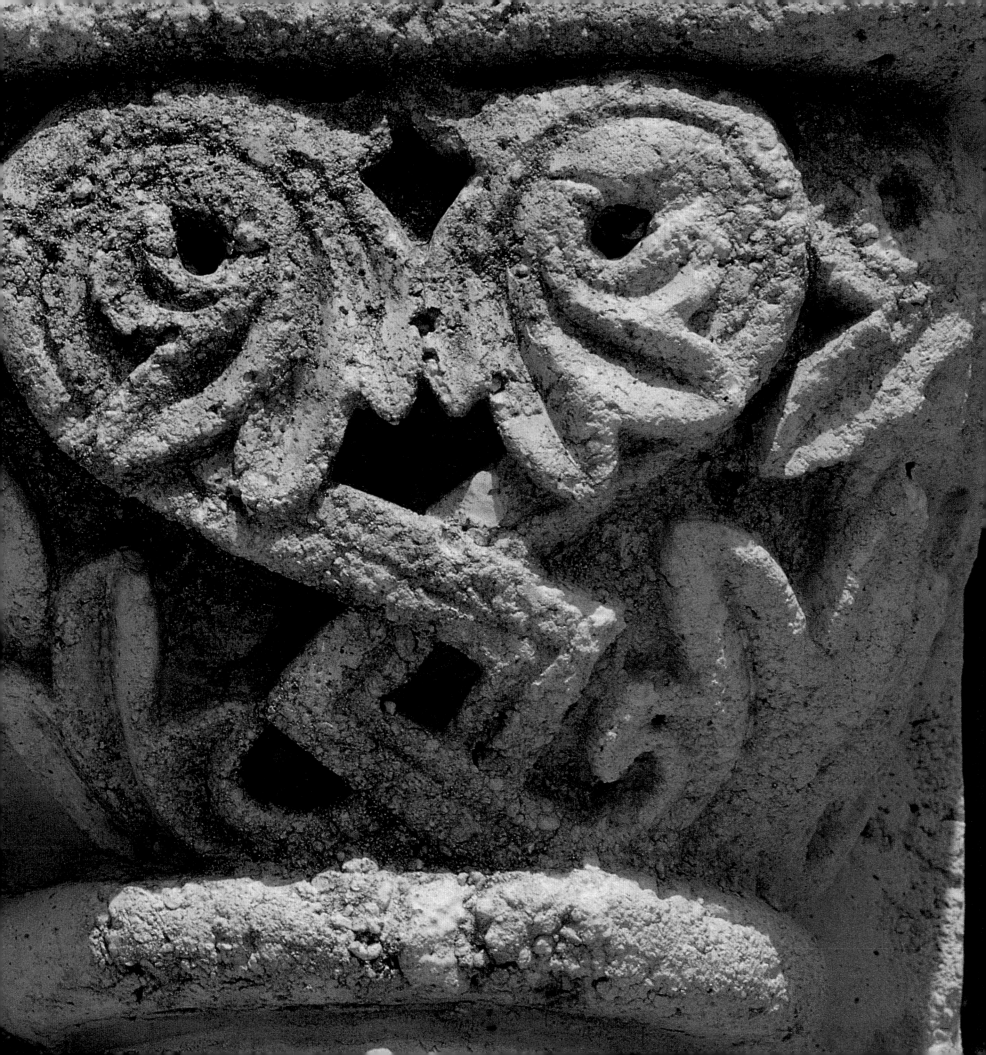

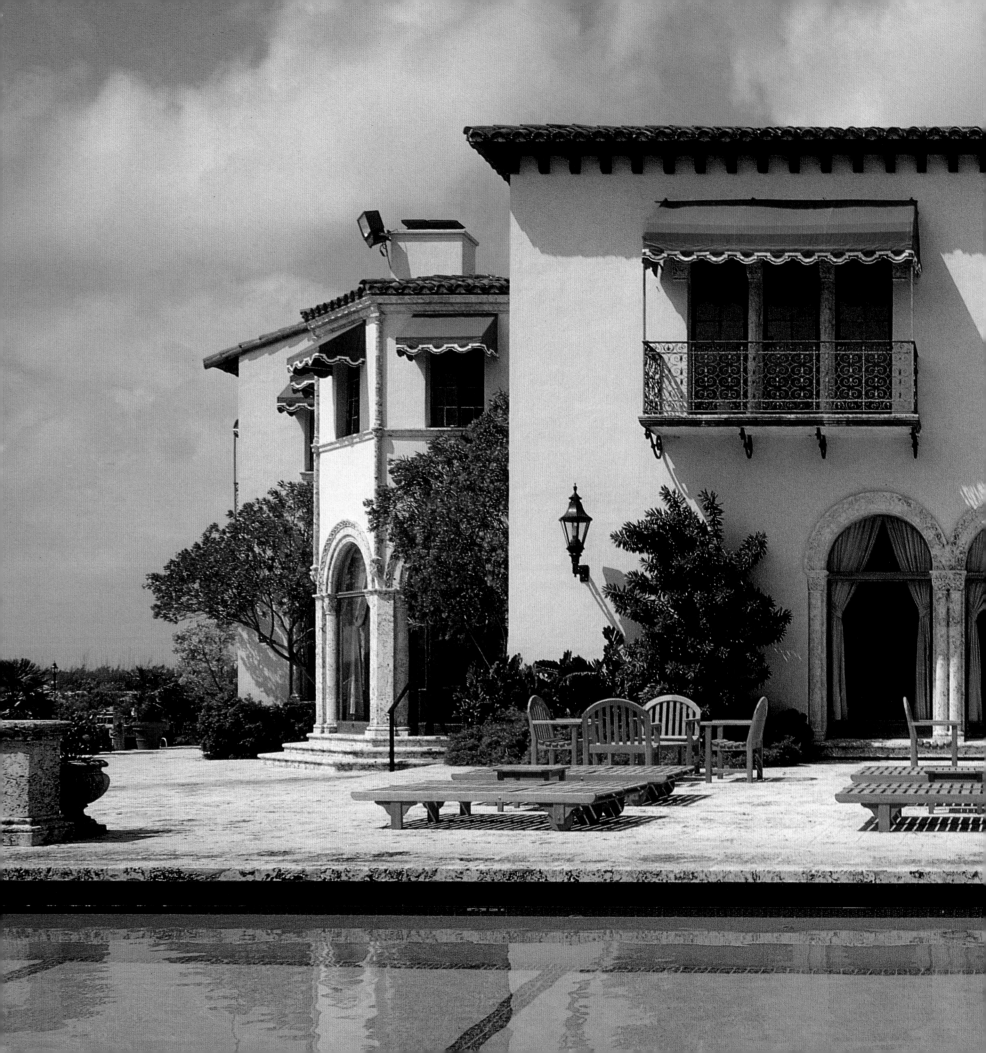

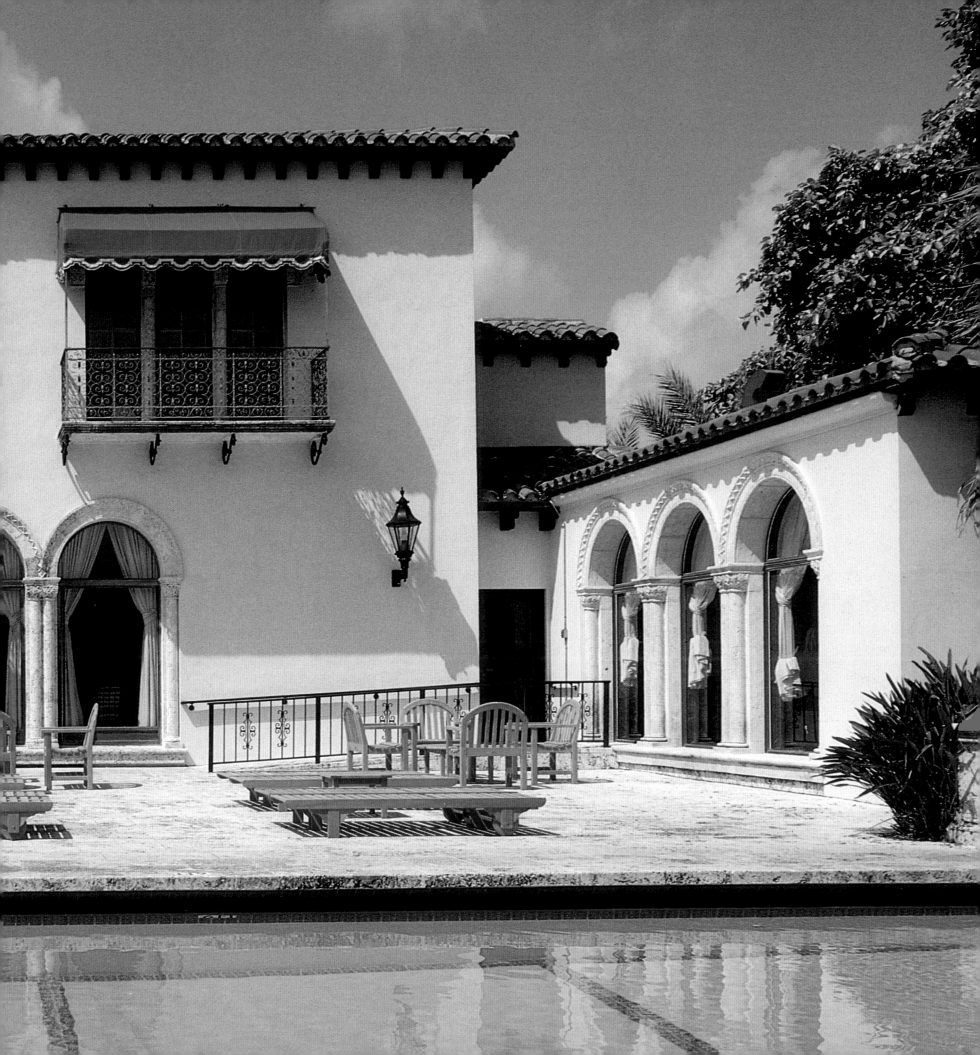

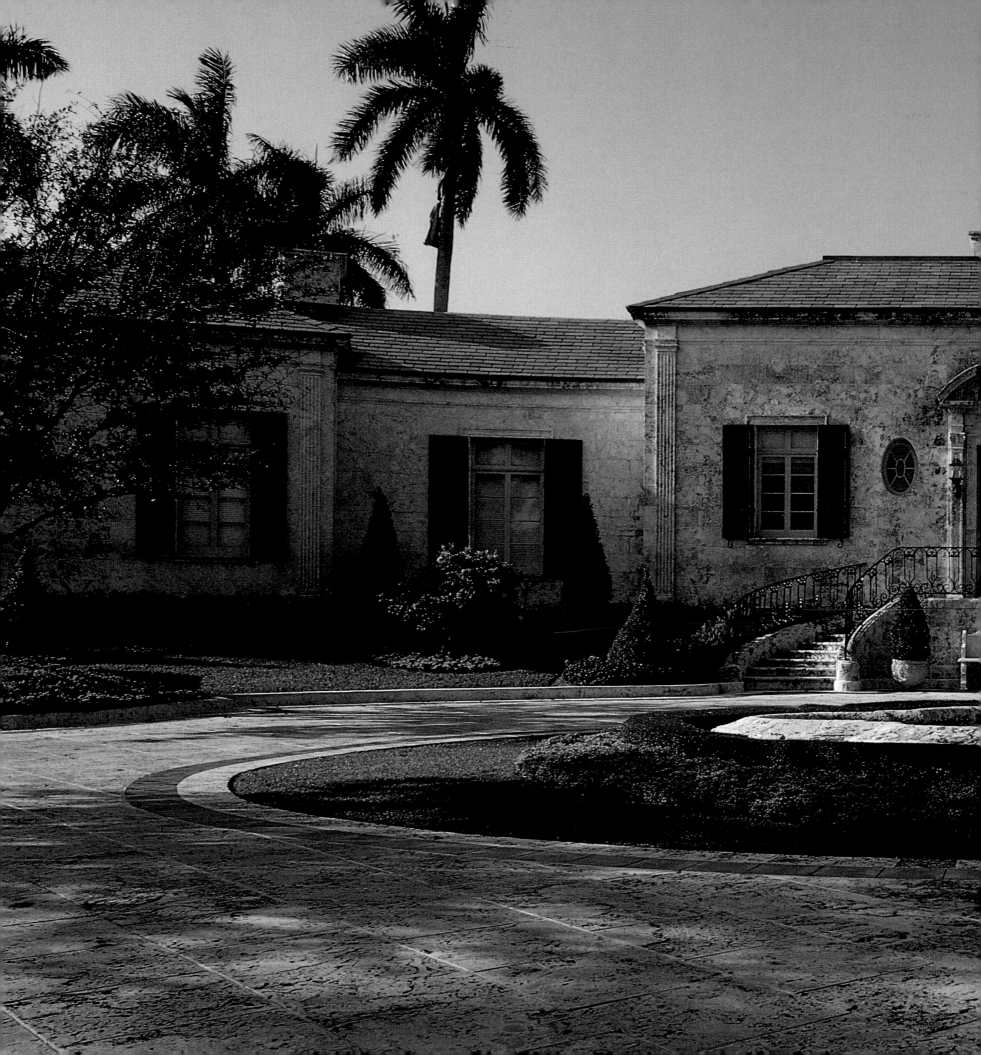

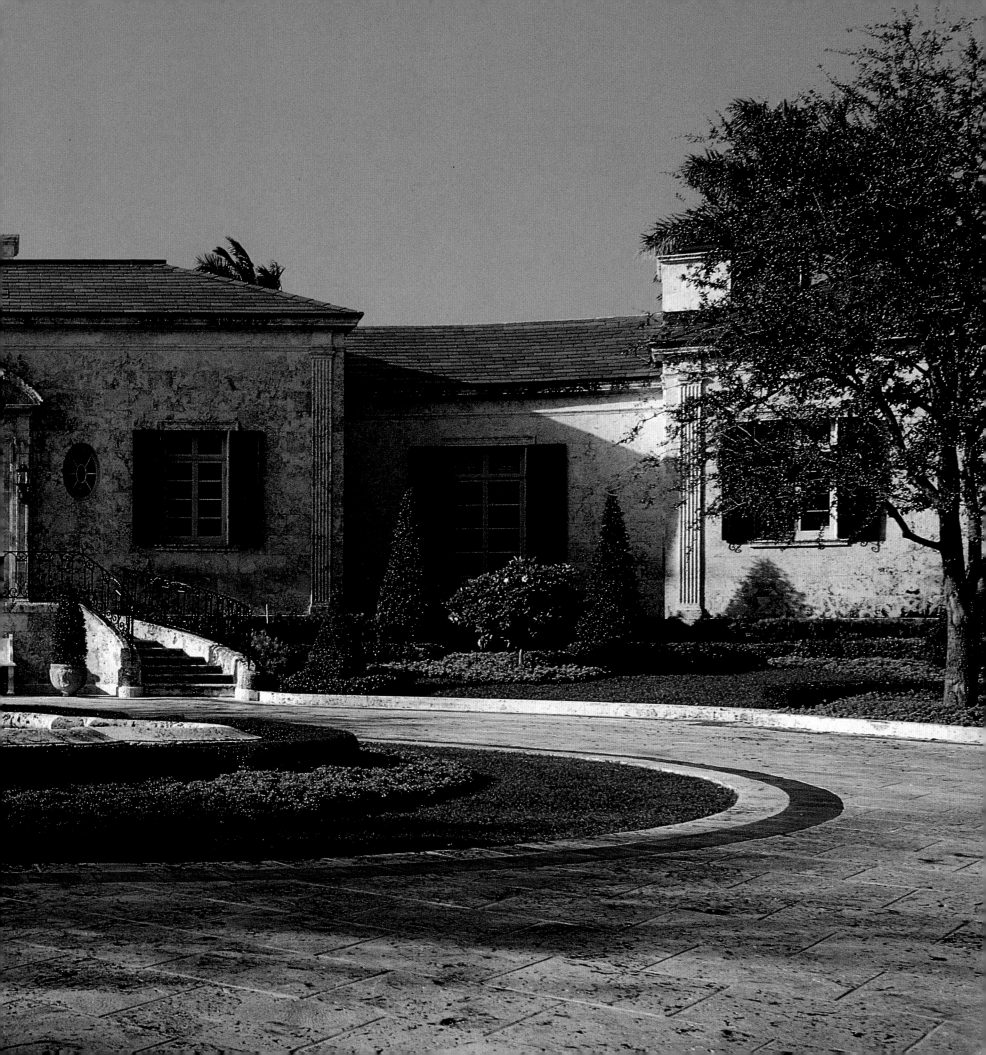

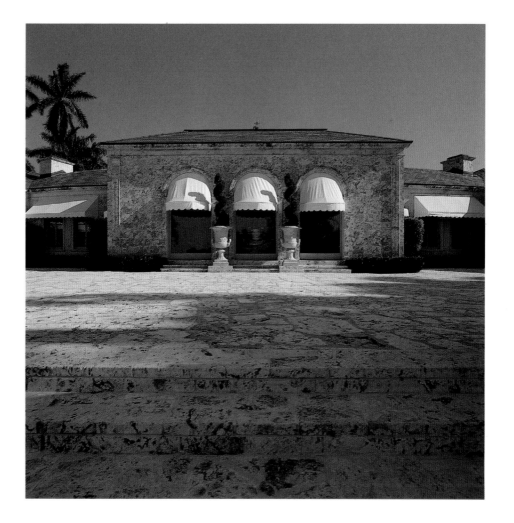

PRECEDING PAGES: View of the Maytag/Robinson House on Sunset Island, a later work by Fatio in Miami.
LEFT: An oval window in the Maytag/Robinson House frames a view of the garden.
ABOVE: Locally quarried keystone terrace.

VORIGE DOPPELSEITE: Ansicht des Maytag/Robinson House auf Sunset Island – eine spätere Arbeit Fatios in Miami.
LINKS: Durch ein ovales Fenster öffnet sich der Blick auf den Garten.
OBEN: Terrasse aus Keystone, einem einheimischen Korallenkalkstein.

DOUBLE PAGE PRECEDENTE: Vue de la Maytag/Robinson House sur Sunset Island, œuvre plus tardive de Fatio.
A GAUCHE: Fenêtre ovale de la Maytag/Robinson House, qui cadre une vue sur le jardin.
CI-DESSUS: Terrasse en pierre de la région.

PEABODY RESIDENCE

Walter de Garmo, 1922

Walter de Garmo, an architect and engineer educated at Swarthmore College and Cornell University and trained by the great classicist John Russell Pope, moved to Miami in 1904. He is believed to have been Florida's first registered architect, and he designed many of the earliest civic buildings in Miami and Coral Gables, almost all of which have been demolished or radically altered. De Garmo's work was imaginative and romantic, at once original and tropical, as Margot Ammidown has pointed out. He combined styles with a narrative sweep, and with a certain intricacy and deftness.

Many of de Garmo's houses, in Coconut Grove, Coral Gables, Miami Beach, and Miami Shores, remain, among them the Don F. Peabody Residence. One of the first new houses in the planned city of Coral Gables, the Peabody Residence is constructed of rough stucco and exposed local coral rock in a style that spans the Spanish, Italian, and Moorish, typical of the pastiche that is Mediterranean Revival. Don Peabody, who owned the Guaranty Title and Abstract Corporation and worked with George Merrick, the developer of Coral Gables, received the house as payment for services. It has been virtually unchanged since 1922.

Der Architekt und Ingenieur Walter de Garmo, der seine Ausbildung am Swarthmore College, an der Cornell University und bei dem großen klassizistischen Baumeister John Russell Pope absolvierte, zog 1904 nach Miami und soll Floridas erster offiziell zugelassener Architekt sein. Zu seinen Werken zählen viele der frühen Verwaltungsbauten in Miami und Coral Gables, von denen die meisten inzwischen jedoch zerstört oder vollkommen verändert sind. De Garmos Bauten waren – Margot Ammidown zufolge – phantasievoll-romantisch und zugleich ursprünglich-tropisch. Er kombinierte Stilrichtungen mit narrativem Schwung und mit einem gewissen Raffinement und Geschick.

Viele von de Garmos Häusern in Coconut Grove, Coral Gables, Miami Beach und Miami Shores sind noch erhalten, darunter auch die Don F. Peabody Residence. Dieses Gebäude zählte zu den ersten Neubauten in der am Reißbrett entworfenen Stadt Coral Gables. Es wurde aus Rauhputz und unverputztem Korallenstein in einem Stil errichtet, der Elemente spanischer, italienischer und maurischer Architektur umfaßt und typisch ist für das Pastiche des Mediterranean Revival Style. Don Peabody – der Besitzer der Guaranty Title and Abstract Corporation, der schon mit George Merrick (dem Stadtplaner von Coral Gables) zusammengearbeitet hatte – erhielt das seit 1922 nahezu unveränderte Haus als Zahlung für geleistete Dienste.

Walter de Garmo, architecte et ingénieur formé à Swarthmore College et Cornell University, élève du grand classiciste John Russell Pope, vint s'installer à Miami en 1904. Il est censé avoir été le premier architecte officiellement reconnu par l'Etat de Floride, et a édifié un grand nombre des bâtiments officiels de Miami et de Coral Gables. Tous été ont été soit détruits soit radicalement transformés. Son œuvre est à la fois romantique et pleine d'imagination, originale et d'inspiration tropicale, comme l'a noté Margot Ammidown. Il savait marier des styles dans un esprit narratif avec un art confirmé de la complexité.

De nombreuses demeures privées qu'il édifia à Coconut Grove, Coral Gables, Miami Beach et Miami Shores subsistent, dont la Don F. Peabody Residence. Celle qui fut l'une des premières maisons construites à Coral Gables (qui n'existait alors que sur plans), est édifiée en stuc brut et pierre de corail apparente dans un style à la fois espagnol, mauresque et italien typique du pastiche néo-méditerranéen. Don Peabody, qui possédait la Guaranty Title and Abstract Corporation et travaillait avec George Merrick, le promoteur de Coral Gables, reçut la maison en paiement de ses services financiers. Elle est restée pratiquement inchangée depuis 1922.

RIGHT: Detail of a column capital.
OVERLEAF: Both Mediterranean and Moorish styles influenced de Garmo's Peabody House.

RECHTS: Detail eines Säulenkapitells.
FOLGENDE DOPPELSEITE: Das Peabody House ist sowohl vom Mediterranean Style als auch vom maurischen Stil beeinflußt.

A DROITE: Détail d'un chapiteau.
DOUBLE PAGE SUIVANTE: Une influence à la fois méditerranéenne et mauresque.

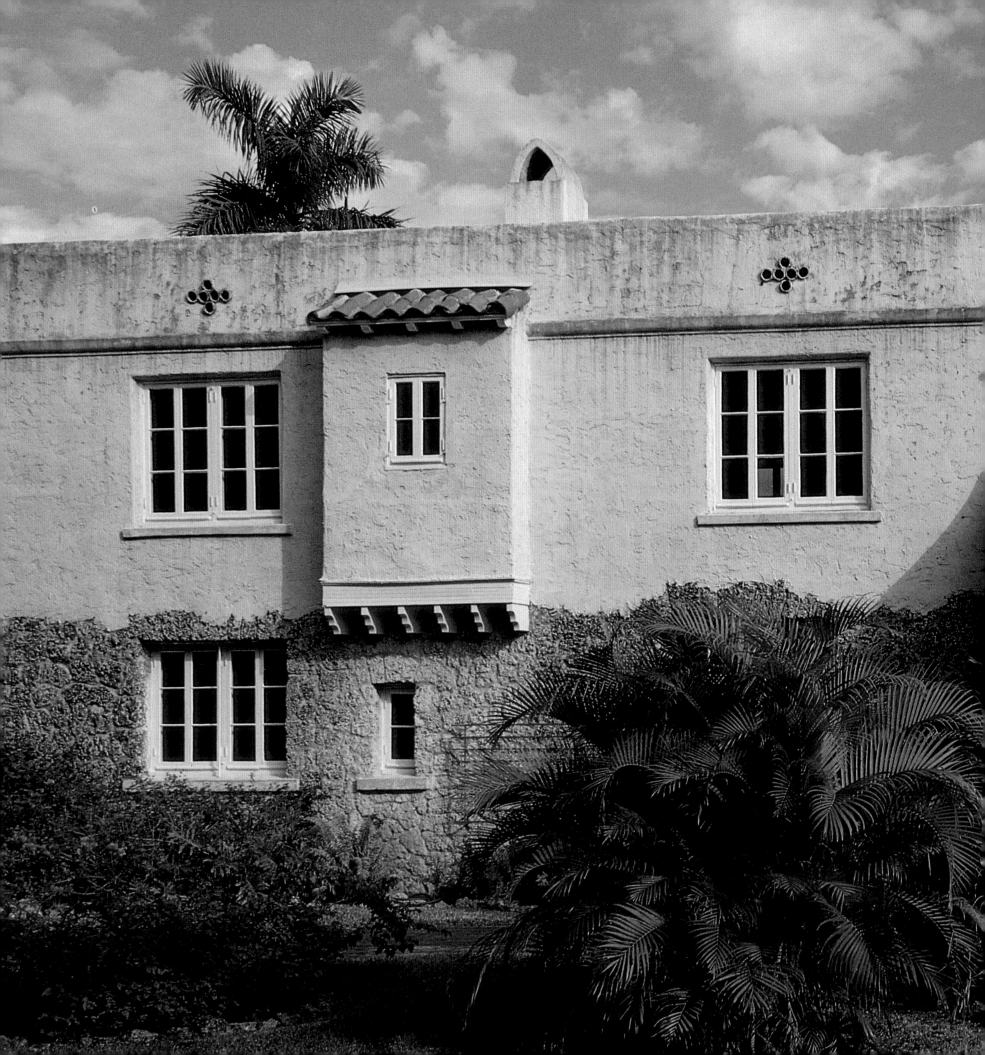

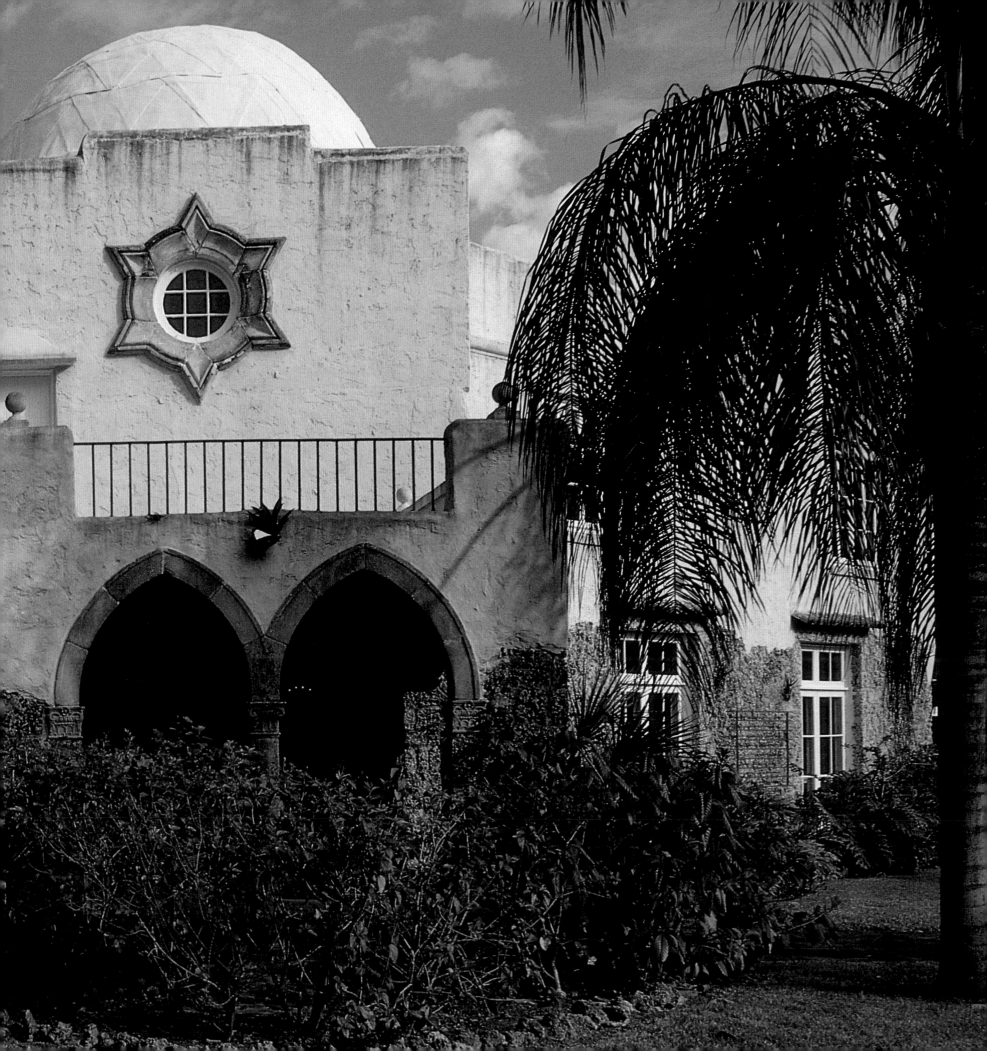

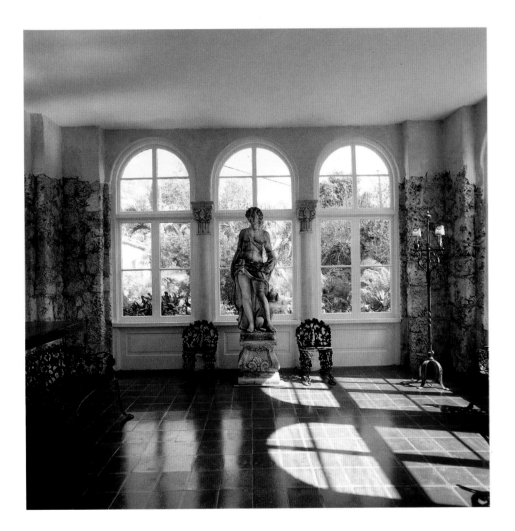

LEFT: A corner of the house shows the rustication achieved with stucco applied over stone.
ABOVE: Interior of the Peabody House.

LINKS: Eine Hausecke mit Bossenwerk, das mit Hilfe von auf den Stein aufgetragenem Putz erzielt wurde.
OBEN: Innenansicht des Peabody House.

A GAUCHE: Partie d'une pièce montrant un effet de pierre rustiquée, recouverte de plâtre à une certaine hauteur.
CI-DESSUS: Intérieur de Peabody House.

SCOTTISH RITE TEMPLE

Kiehnel & Elliot, 1922

The Scottish Rite Temple is a great exercise in Beaux-Arts styling – a striking three-story, pyramidal building with an imposing set of steps leading up to it. Largely classical in its inspiration, it has Doric columns and what one researcher called "Grecian overtones." It was designed three years before the Expositions des Arts Décoratifs in Paris, predating the style now called Art Deco. Yet with its flat, geometric, stylized ornament and its foreshortened "skyscraper" shape, the Scottish Rite is clearly a precursor to the "moderne" buildings that were to follow. Even the four sculpted eagles that rise above the parapet foreshadowed the predilection for using Native American, Aztec, and Mayan motifs in Art Deco architecture.

By the time they designed the Scottish Rite Temple, Kiehnel & Elliot had become well established in Miami, having completed projects such as El Jardin. The temple sits in Lummus Park, in what was a fashionable neighborhood at the turn of the century. Today, although it is a preserve of historic buildings, the neighborhood is in steep decline.

Der Scottish Rite Temple stellt ein großartiges Beispiel für den Beaux-Arts-Stil dar – ein bemerkenswertes, pyramidenförmiges Bauwerk mit einer imposanten Treppenanlage. Das in seiner Konzeption klassisch anmutende Gebäude besitzt dorische Säulen und eine »griechische Note«, wie es ein Architekturtheoretiker einmal formulierte. Der Scottish Rite Temple entstand drei Jahre vor der *Expositions des Arts Décoratifs* in Paris und ging einem Stil voraus, der heute als Art Deco bezeichnet wird. Dessenungeachtet ist das Gebäude mit seiner flachen, geometrischen und stilisierten Ornamentik und seiner verkürzten »Wolkenkratzer«-Form ein deutlicher Vorläufer »moderner« Bauwerke. Selbst die vier Adlerskulpturen, die sich über das Gesims erheben, deuten bereits die Vorliebe für die Verwendung indianischer, aztekischer und der Formensprache der Maya entnommener Motive in der Architektur des Art Deco an.

Zum Zeitpunkt des Entwurfs für den Scottish Rite Temple hatten sich Kiehnel & Elliot in Miami bereits einen Namen gemacht – nicht zuletzt aufgrund solcher Bauten wie des El Jardin. Ihr Scottish Rite Temple befindet sich in Lummus Park, einem vornehmen Stadtviertel der Jahrhundertwende, das heute jedoch (ungeachtet seiner historischen Bauten) einen Niedergang erlebt.

Avec sa construction pyramidale sur trois niveaux et l'imposant emmarchement qui conduit à sa porte principale, ce temple est un superbe exercice de style beaux-arts. D'inspiration en grande partie classique, il affiche des colonnes doriques, et ce qu'un chercheur a appelé des «touches grecques». Dessiné trois ans avant l'Exposition des Arts Décoratifs de Paris, il annonce le style qui allait prendre le nom d'Art Déco. En même temps, avec ses ornements plats, géométriques et stylisés, et sa forme de «gratte-ciel» en raccourci, il est un précurseur des immeubles «modernes» qui suivront. Même les quatre aigles sculptés au-dessus du parapet, anticipent la prédilection pour les motifs indiens, aztèques et mayas de l'architecture Art Déco américaine.

Lorsqu'ils conçoivent ce lieu de culte, Kiehnel & Elliot sont déjà bien installés à Miami, où ils ont réalisé des projets aussi importants que El Jardin. Le temple se trouve à Lummus Park, quartier élégant au tournant du siècle mais qui décline rapidement, bien qu'il soit riche en bâtiments historiques.

RIGHT: The facade of the Scottish Rite Temple shows the building's daring proportions.
OVERLEAF: The angular details of the temple are early examples of Art Deco.

RECHTS: Die Fassade des Scottish Rite Temple zeigt die kühnen Proportionen des Gebäudes.
FOLGENDE DOPPELSEITE: Die kantigen Details des Tempels sind frühe Beispiele des Art Deco.

A DROITE: La façade affiche les proportions audacieuses du bâtiment.
DOUBLE PAGE SUIVANTE: L'ornementation du temple est l'un des premiers exemples de style Art Déco.

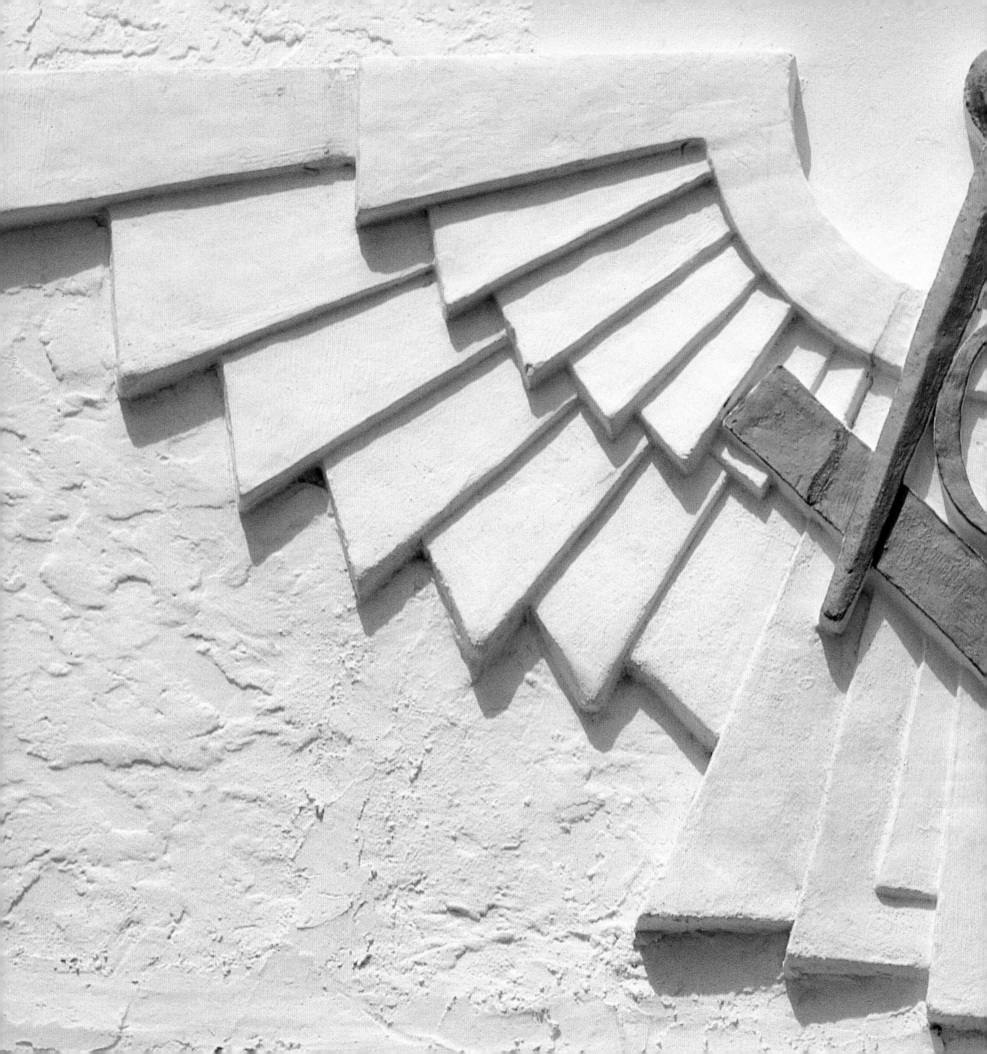

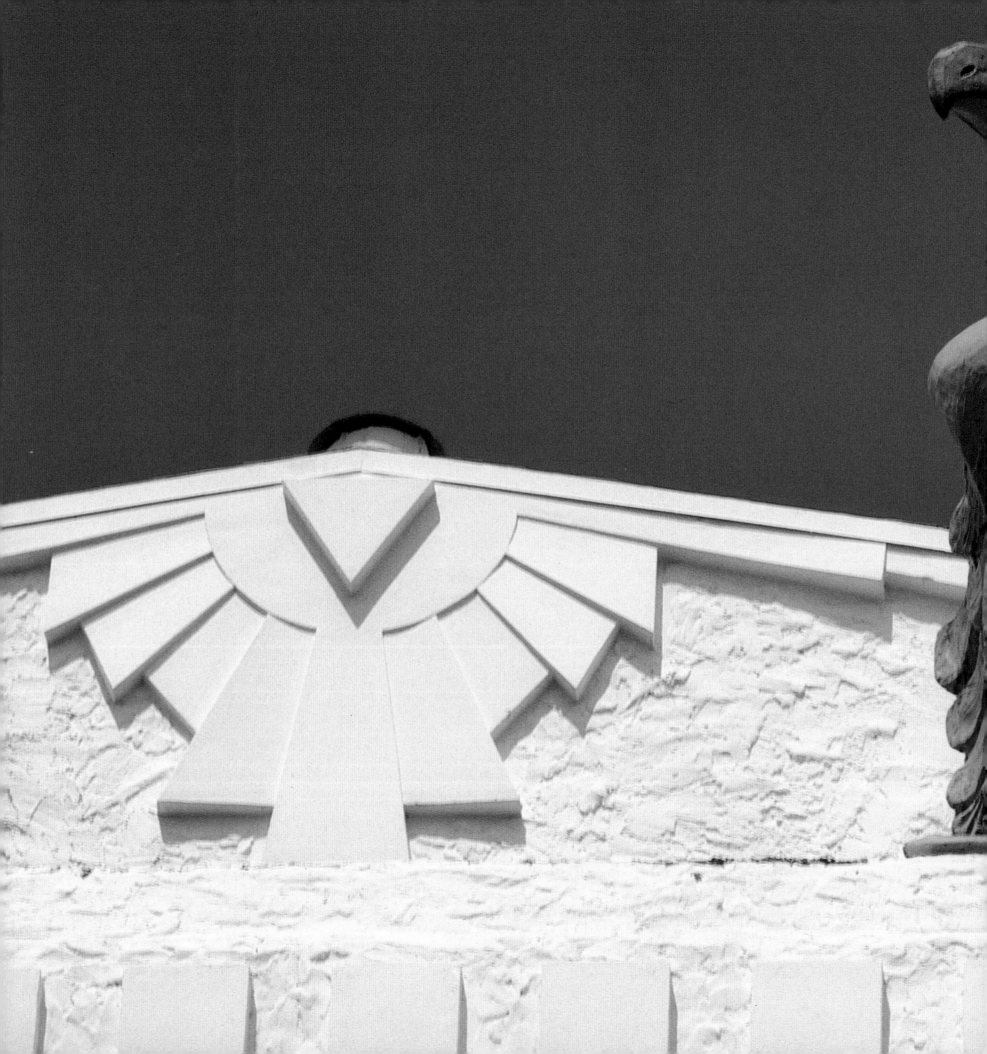

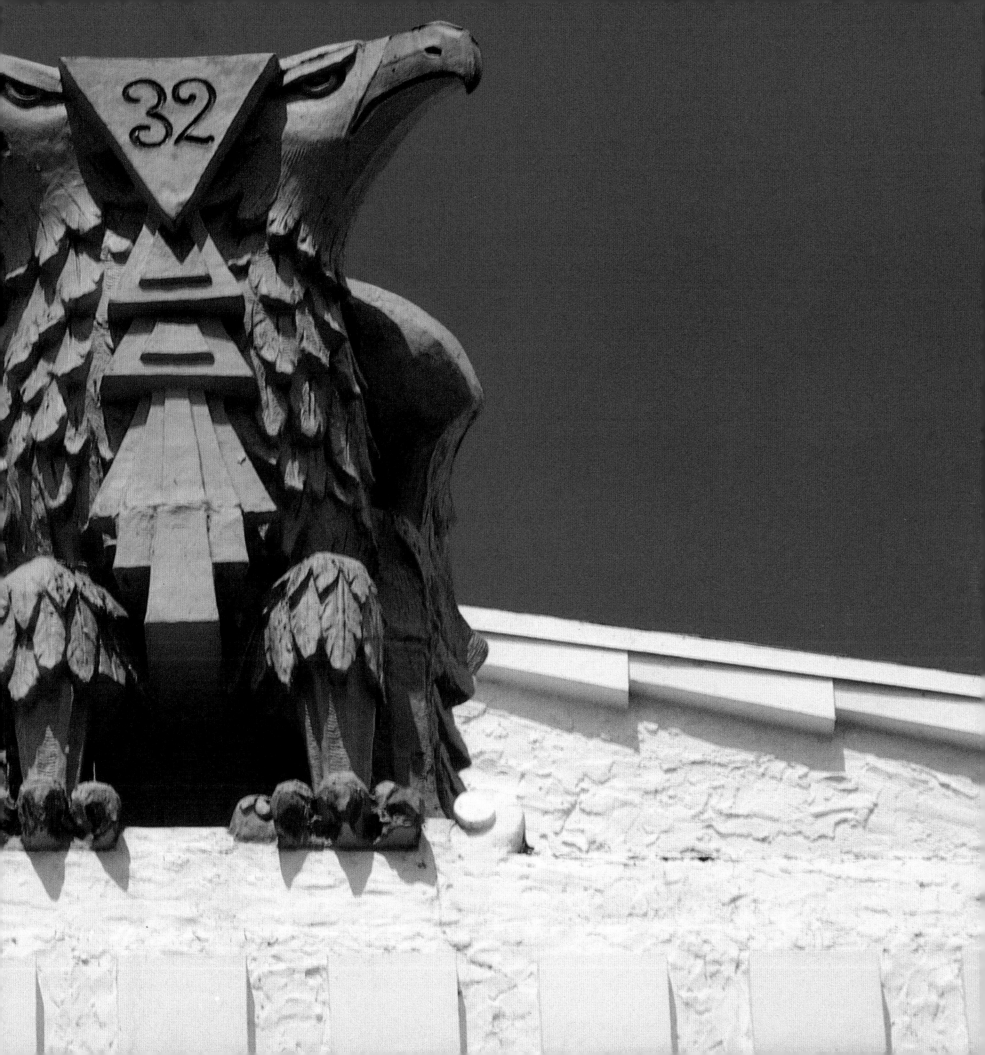

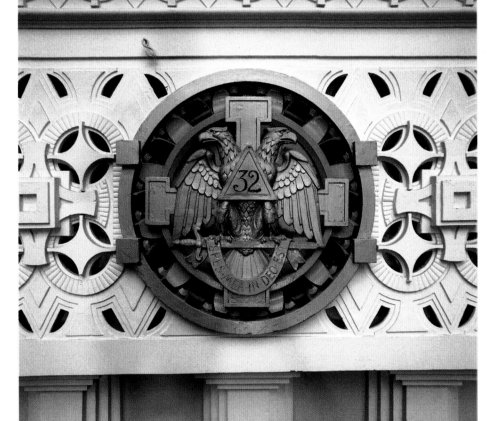

PRECEDING PAGES: A giant stylized eagle perches on the temple's cornice.
LEFT: Ceiling of the main meeting space.
ABOVE: Detail of the temple's geometric ornamentation.

VORIGE DOPPELSEITE: Ein riesiger, stilisierter Adler thront auf dem Gesims des Tempels.
LINKS: Deckenansicht des Hauptraums.
OBEN: Detail der geometrischen Ornamentik des Tempels.

DOUBLE PAGE PRÉCÉDENTE: Un aigle géant stylisé est perché sur la corniche du temple.
A GAUCHE: Plafond de la salle principale.
CI-DESSUS: Détail de l'ornementation géométrique du temple.

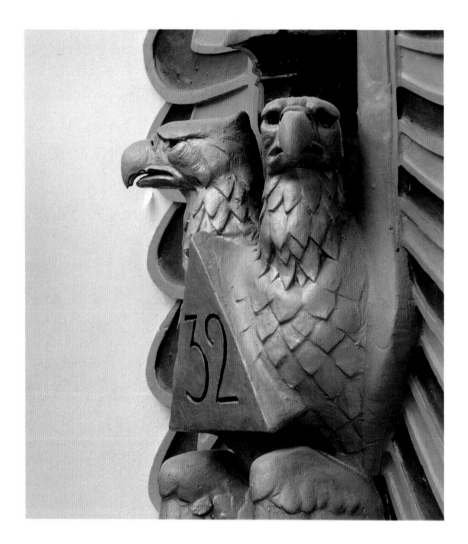

ABOVE: An eagle gargoyle.
RIGHT: The exaggerated detailing of the columns and walls foreshadowed Miami's Art Deco era.
OVERLEAF: Detail of intricate facade stonework.

OBEN: Wasserspeier in Form eines Doppeladlers.
RECHTS: Die übertriebene Durchgestaltung von Säulen und Mauern ist ein Vorbote der Art-Deco-Ära Miamis.
FOLGENDE DOPPELSEITE: Detail des kunstvollen Fassadenmauerwerks.

CI-DESSUS: Gargouille en forme d'aigle.
A DROITE: Le décor fouillé des colonnes et des murs annonce le style Art Déco de Miami.
DOUBLE PAGE SUIVANTE: Détail du complexe travail de la pierre en façade.

JAVA HEAD

James Smith, 1936

Architect James Smith was commissioned to design Java Head as a house that would communicate a sense of adventure, a world to be explored. Its owners, Charles and Pauline Baker, had met on a world cruise and fallen in love – he was a native Floridian artist and an accomplished cook who had signed on as the ship's chef; she was an heiress to the Weyerhauser fortune.

Java Head was designed to be both formal and informal, to accommodate private space and room for entertainment. The wood-paneled living room was intended for hosting guests and for music. Art Deco details occur throughout, many of them influenced by Javanese art and design. A loggia runs along the back of the house, connecting the two wings by "moon gates," an Asian symbol of good fortune.

In the summer of 1936, a New York portrait artist, Christopher Clark, was commissioned to paint the elaborate murals on the dining room walls. He chose to illustrate the exotic and colorful story of Anthony Adverse, the hero of a wildly popular novel written by Hervey Allen, who had a house not far from Java Head.

Der Architekt James Smith erhielt den Auftrag, Java Head als ein Haus zu konzipieren, das einen Hauch von Abenteuer, das Gefühl einer zu erforschenden Welt vermittelt. Seine Besitzer, Charles und Pauline Baker, hatten sich auf einer Kreuzfahrt kennen- und liebengelernt – er ein aus Florida stammender Künstler und perfekter Koch, der auf dem Schiff als Küchenchef angeheuert hatte; sie Erbin des Weyerhauser-Vermögens.

Java Head wurde so konzipiert, daß es zwanglos und zugleich repräsentativ wirkte und sowohl Privatgemächer als auch Räume für Abendgesellschaften und andere Veranstaltungen bot. Das holzgetäfelte Wohnzimmer diente dem Empfang von Gästen und für Musikdarbietungen. Im gesamten Gebäude finden sich Art-Deco-Details, die vielfach von javanischer Kunst inspiriert sind. Entlang der Rückseite des Hauses verläuft eine Loggia, die die beiden Flügel durch »Mondtore« verbindet, ein asiatisches Glückssymbol.

Im Sommer des Jahres 1936 beauftragte man den New Yorker Porträtmaler Christopher Clark mit der Gestaltung der kunstvollen Wandmalereien im Eßzimmer. Clark entschloß sich, die exotische und lebendig geschilderte Geschichte von Anthony Adverse zu illustrieren, dem Helden eines sehr beliebten Romans von Hervey Allen, der nicht weit von Java Head ebenfalls ein Haus besaß.

La commande passée à l'architecte James Smith pour Java House était claire : édifier une maison qui donne un sens de l'aventure, l'envie d'un monde à explorer. Ses propriétaires, Charles et Pauline Baker avaient fait connaissance lors d'une croisière autour du monde : il était un artiste installé en Floride, mais aussi le cuisinier du bateau; elle était l'héritière de la fortune Weyerhauser.

Java Head est à la fois formelle et informelle, et fait coexister avec bonheur espaces intimes et privés et pièces de réception. Le salon lambrissé a été conçu pour recevoir des invités et donner des récitals; Le décor est d'esprit Art Déco, avec de nombreux éléments d'inspiration javanaise. Une loggia court à l'arrière de la maison et réunit les deux ailes par des ouvertures circulaires à la chinoise, symbole asiatique de chance.

Au cours de l'été 1936, un portraitiste new-yorkais, Christopher Clark réalisa les grandes fresques des murs de la salle à manger. Il choisit d'illustrer l'histoire exotique et colorée d'Anthony Adverse, héros d'un roman populaire d'Hervey Allen qui possédait une maison non loin de Java Head.

RIGHT: "Moon gates" frame each end of the loggia.
FIRST OVERLEAF: View of the living room.
SECOND OVERLEAF: The dining room mural is based on Hervey Allen's novel *Anthony Adverse*.

RECHTS: »Mondtore« rahmen die beiden Enden der Loggia ein.
FOLGENDE DOPPELSEITE: Ansicht des Wohnzimmers.
DARAUFFOLGENDE DOPPELSEITE: Das Wandbild im Eßzimmer basiert auf Hervey Allens Roman *Anthony Adverse*.

A DROITE: Deux «portes de la lune» ont été aménagées aux deux extrémités de la loggia.
PREMIÈRE DOUBLE PAGE SUIVANTE: Vue du grand salon.
SECONDE DOUBLE PAGE SUIVANTE: La fresque de la salle-à-manger est inspirée d'un roman d'Hervey Allen.

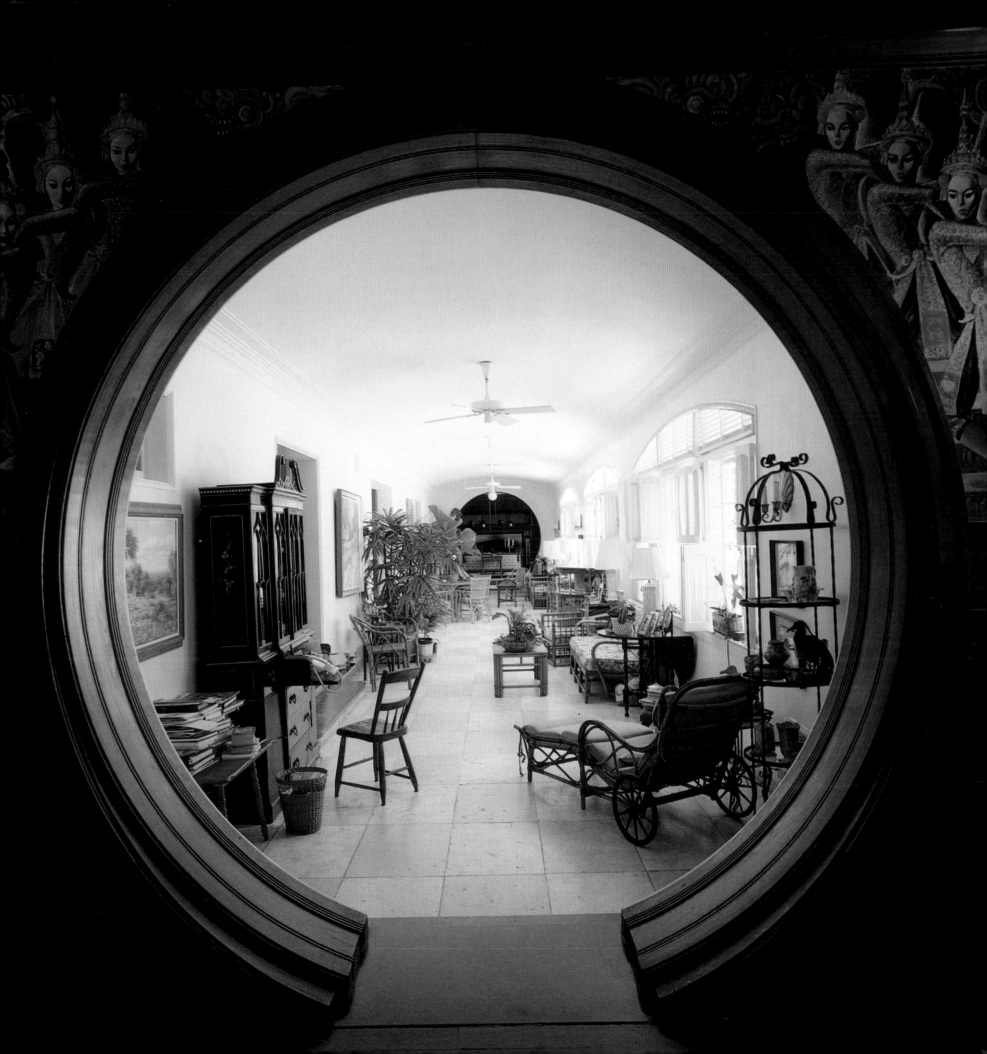

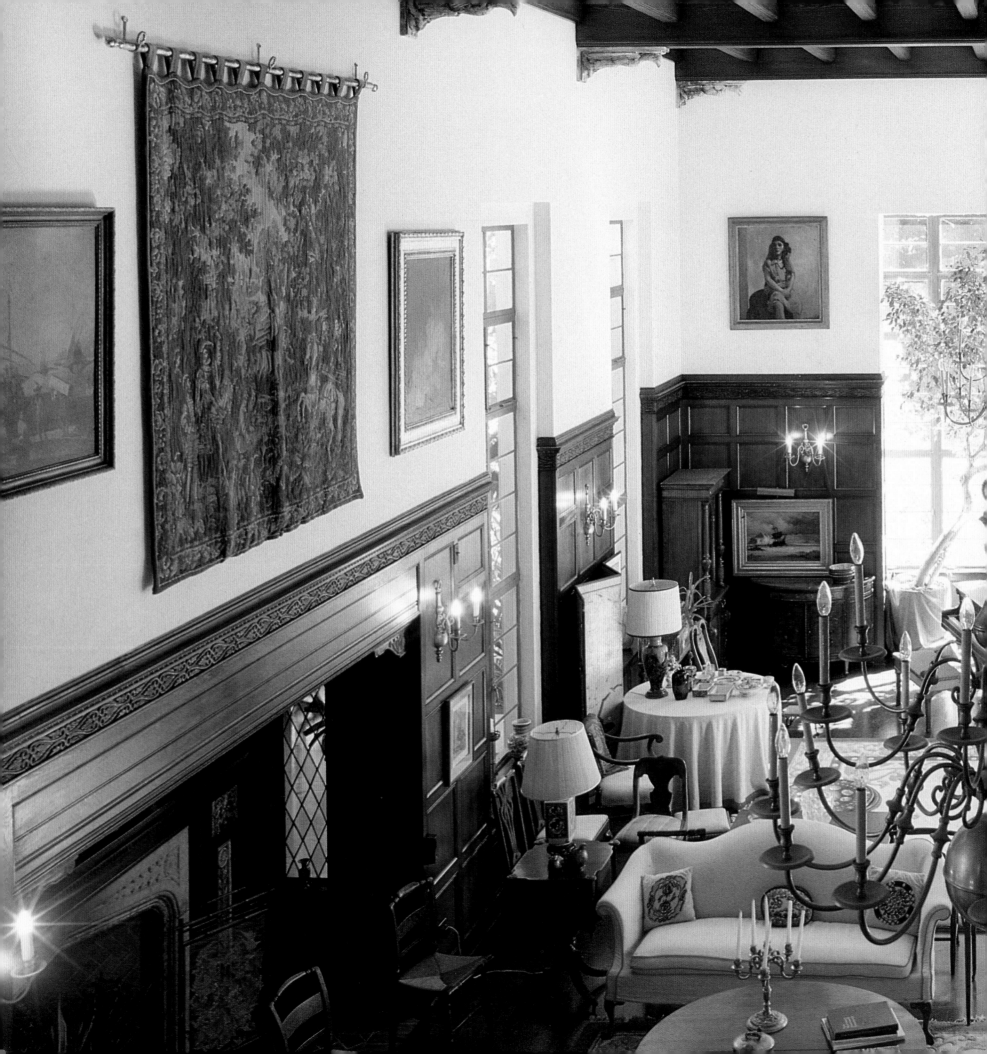

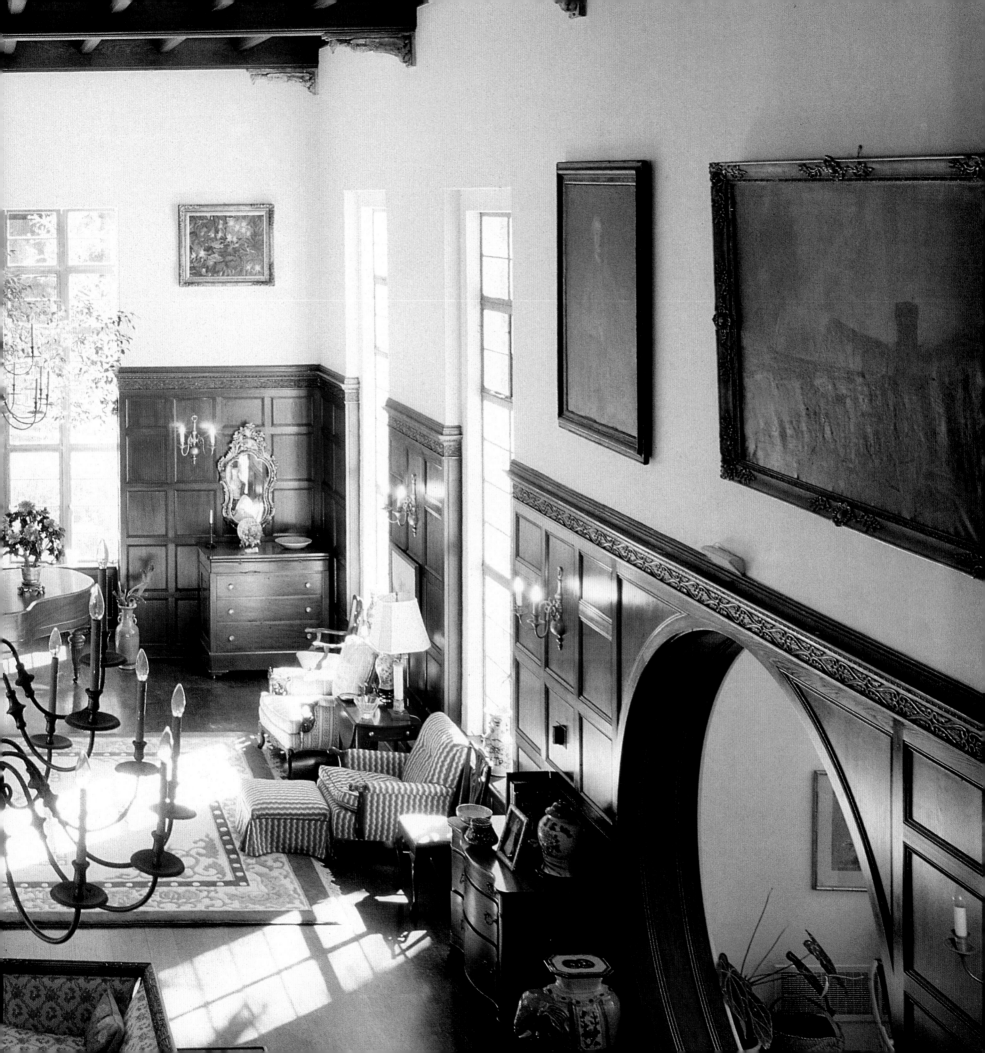

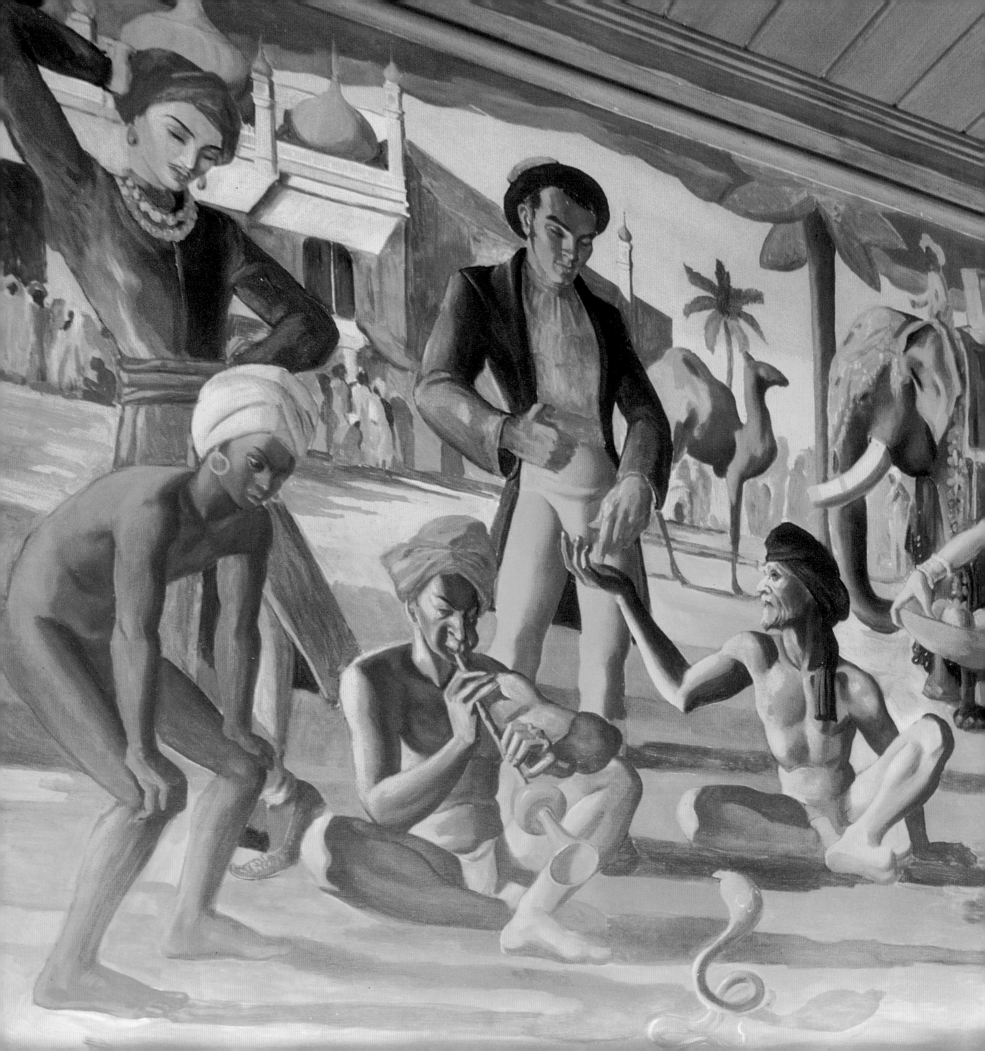

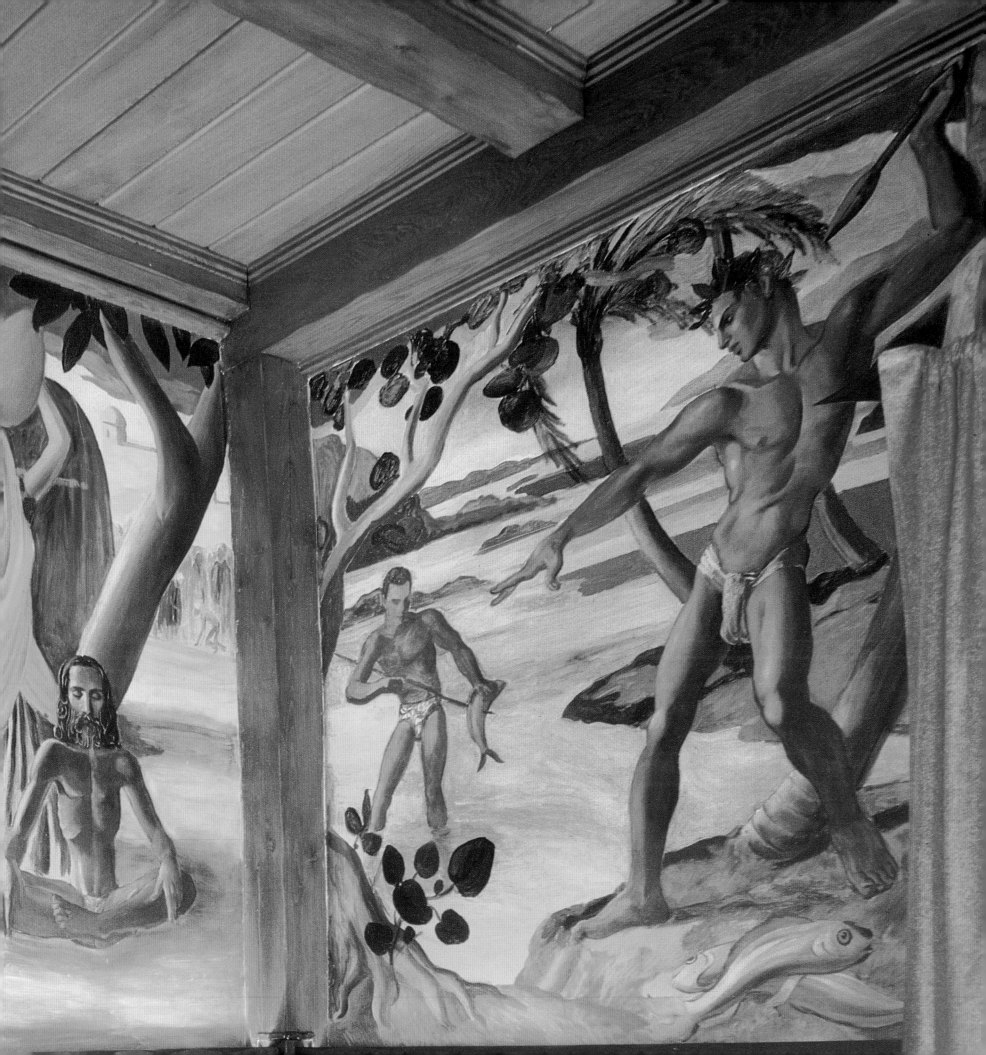

GENERAL ELECTRIC MODEL HOME/ EASTMAN RESIDENCE

Robert Law Weed, 1935

By the time Robert Law Weed designed the General Electric Model Home in Miami Beach, he had already achieved a measure of fame as a "modern" architect. He had designed the Florida Model Home for the 1933 Chicago World's Fair, and along with Russell Pancoast was one of the first architects in Miami to embrace the Art Deco style.

The General Electric Model Home (or Eastman Residence) is a masterpiece of its kind. Streamlined and elegant, it is a mix of expected and unexpected materials. One example is the front door: framed by an elaborately carved stone surround, the door itself is surfaced with Formica.

The house attracted a good deal of attention when it was built. Alan Jackson, writing in the February 1937 issue of *Arts and Decoration,* said: "Miami Beach ... is a particularly fortunate setting for Modern. The sea and tropical flowers complement Modern's polychrome; the sun justifies its brilliance. You have here a house finished in lemon yellow plaster and white and blue lintels ... The house itself has sweep and simplicity; it is lean as a ship."

As might be expected from a GE Model House, it was filled with modern innovations, among them an automatic garage door and a curtain wall that converted into a movie screen. The house was originally occupied by brothers who were decorators in New York; the current owners are collectors of Art Deco objects and have returned it to a state close to the original.

Als Robert Law Weed das General Electric Model Home in Miami Beach entwarf, hatte er sich bereits einen Namen als »moderner« Architekt gemacht und u.a. das Florida Model Home für die Weltausstellung 1933 in Chicago konzipiert. Zusammen mit Russell Pancoast zählte er zu den ersten Architekten in Miami, die sich dem Art Deco zuwandten.

Das General Electric Model Home (oder Eastman Residence) ist ein Meisterwerk. Stromlinienförmig und elegant stellt es eine Mischung aus üblichen und ungewöhnlichen Materialien dar, wie z.B. die Eingangstür belegt: Die von einem kunstvoll verzierten Steinrahmen eingefaßte Tür ist mit einer Beschichtung aus Formica versehen.

Das Haus erregte während seiner Fertigstellung viel Aufmerksamkeit. Alan Jackson schrieb 1937 in der Februar-Ausgabe von *Arts and Decoration*: »Miami Beach ... ist ein besonders gelungener Rahmen für die Moderne. Das Meer und die tropischen Blüten ergänzen die Vielfarbigkeit der Moderne, während die Sonne deren Leuchtkraft zur Geltung bringt. Hier wurde ein Haus mit zitronengelbem Putz und weißen und blauen Fenster- und Türstürzen fertiggestellt ... Das Haus selbst ... ist so schnittig wie ein Schiff.«

Wie nicht anders zu erwarten, war das GE Model House mit modernen Neuerungen ausgestattet; dazu zählten u.a. ein automatisches Garagentor und eine als Filmleinwand nutzbare vorgehängte Wand. Ursprünglich bewohnten zwei Brüder das Haus, die in New York als Dekorateure tätig waren; die heutigen Besitzer sammeln Art-Deco-Kunst und haben annähernd den Originalzustand des Gebäudes wiederhergestellt.

A l'époque ou Robert Law Reed conçoit la maison modèle General Electric à Miami Beach, il possède déjà une certaine réputation d'architecte «moderne». Il a dessiné la maison modèle de Floride pour la Foire Internationale de Chicago en 1933 et, avec Russell Pancoast, il est l'un des premiers architectes de Miami à se convertir au style Art Déco.

La maison modèle General Electric (ou résidence Eastman) est un chef-d'œuvre en son genre. De lignes pures et élégantes, elle marie des matériaux à la fois attendus et surprenants. La porte principale en est un bon exemple : son encadrement est en pierre sculptée, alors que la porte elle même est en Formica.

La maison surprend beaucoup lors de sa construction. Alan Jackson, dans le numéro de février 1937 de *Arts and Decoration,* écrit alors : «Miami Beach... est un cadre particulièrement bienvenu pour le style moderne. La mer et les fleurs tropicales sont complémentaires de la polychromie moderne; le soleil justifie son éclat. Voici une maison en plâtre jaune et à linteaux bleu et blanc... La maison elle-même est simple et nette, aussi effilée qu'un bateau.»

Comme on peut s'y attendre de la part d'une maison modèle conçue pour General Electric, elle est remplie d'innovations alors révolutionnaires, comme une porte de garage automatique et un mur rideau transformable en écran de projection. Elle fut à l'origine occupée par deux frères décorateurs new-yorkais. Les propriétaires actuels sont collectionneurs d'Art Déco et l'ont restaurée dans un état proche de l'original.

RIGHT: Facade of the innovative "modern" house.
OVERLEAF: The cactus garden re-creates the house's original plantings.

RECHTS: Fassade des innovativen »modernen« Hauses.
FOLGENDE DOPPELSEITE: Der Kaktusgarten ist der Originalbepflanzung nachempfunden.

A DROITE: La façade novatrice d'une maison «moderne».
DOUBLE PAGE SUIVANTE: Le jardin de cactées s'inspire des plantations d'origine.

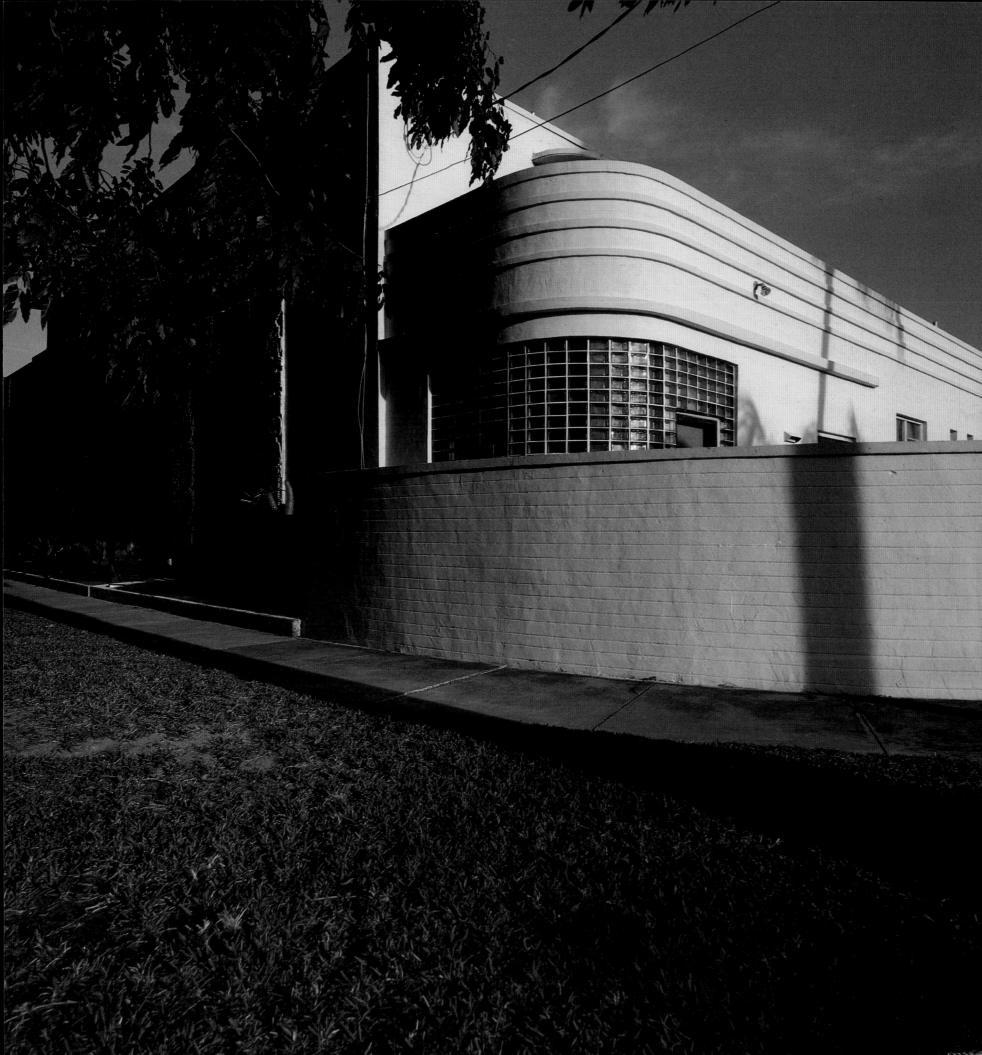

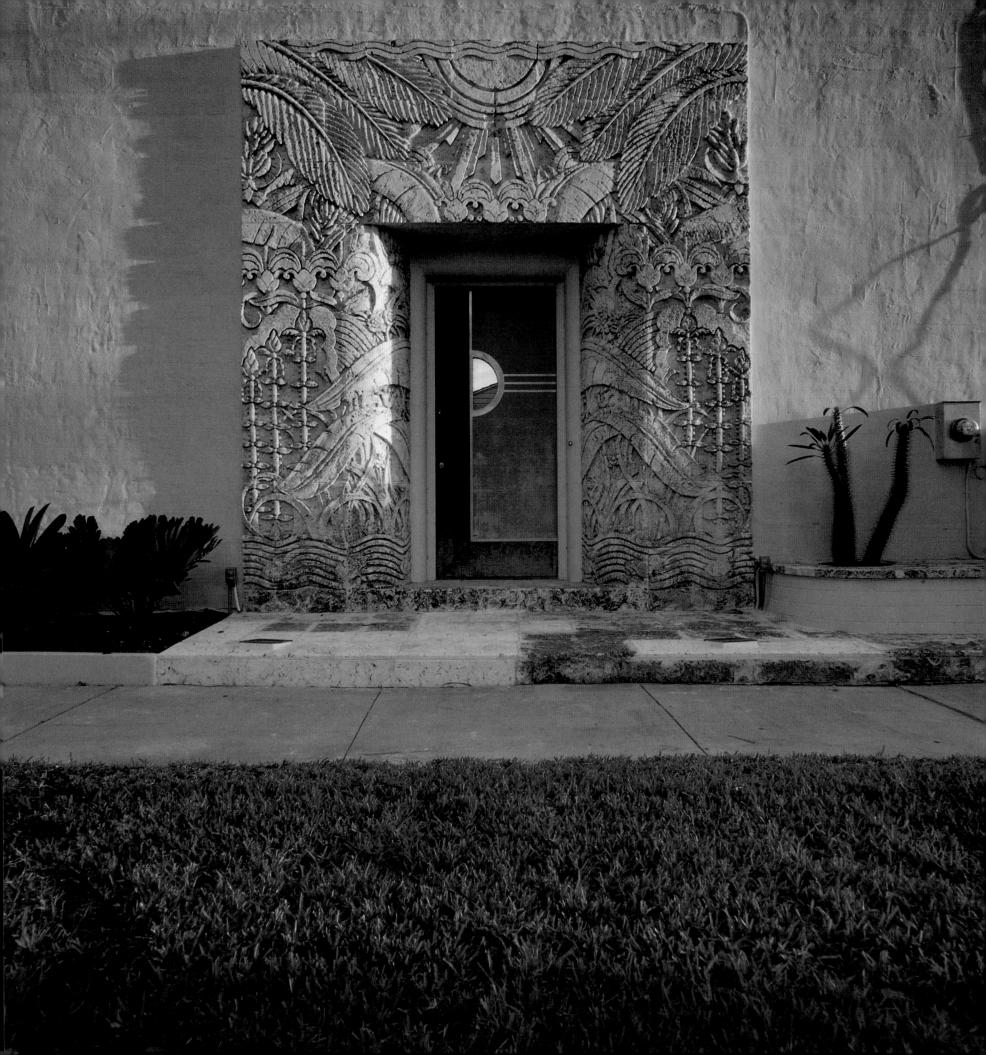

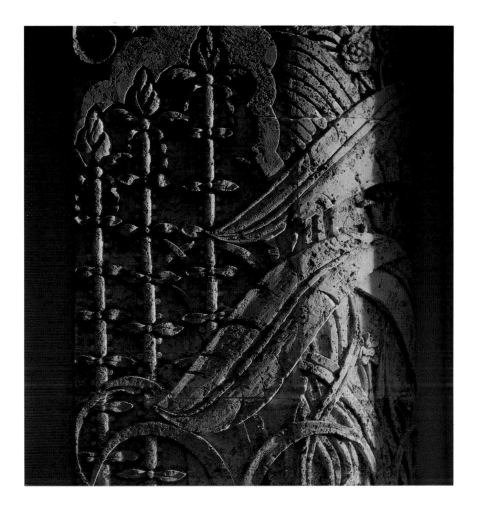

LEFT: The door is framed by elaborate tropical designs carved in local keystone.
ABOVE: Detail of the door surround.

LINKS: Der Türrahmen aus Keystone ist mit kunstvoller tropischer Ornamentik skulptiert.
OBEN: Detail der Türeinfassung.

A GAUCHE: L'encadrement de la porte est en pierre sculptée de motifs tropicaux.
CI-DESSUS: Détail de l'encadrement de la porte.

ABOVE: Interior detail.
RIGHT: View of the living room. The house has been restored and furnished to reflect its original appearance.

OBEN: Detail der Inneneinrichtung.
RECHTS: Das Wohnzimmer. Das Haus wurde restauriert und mit Blick auf seinen Originalzustand möbliert.

CI-DESSUS: Détail de l'intérieur.
A DROITE: Le grand salon. La restauration et le mobilier rappellent l'aspect d'origine de la maison.

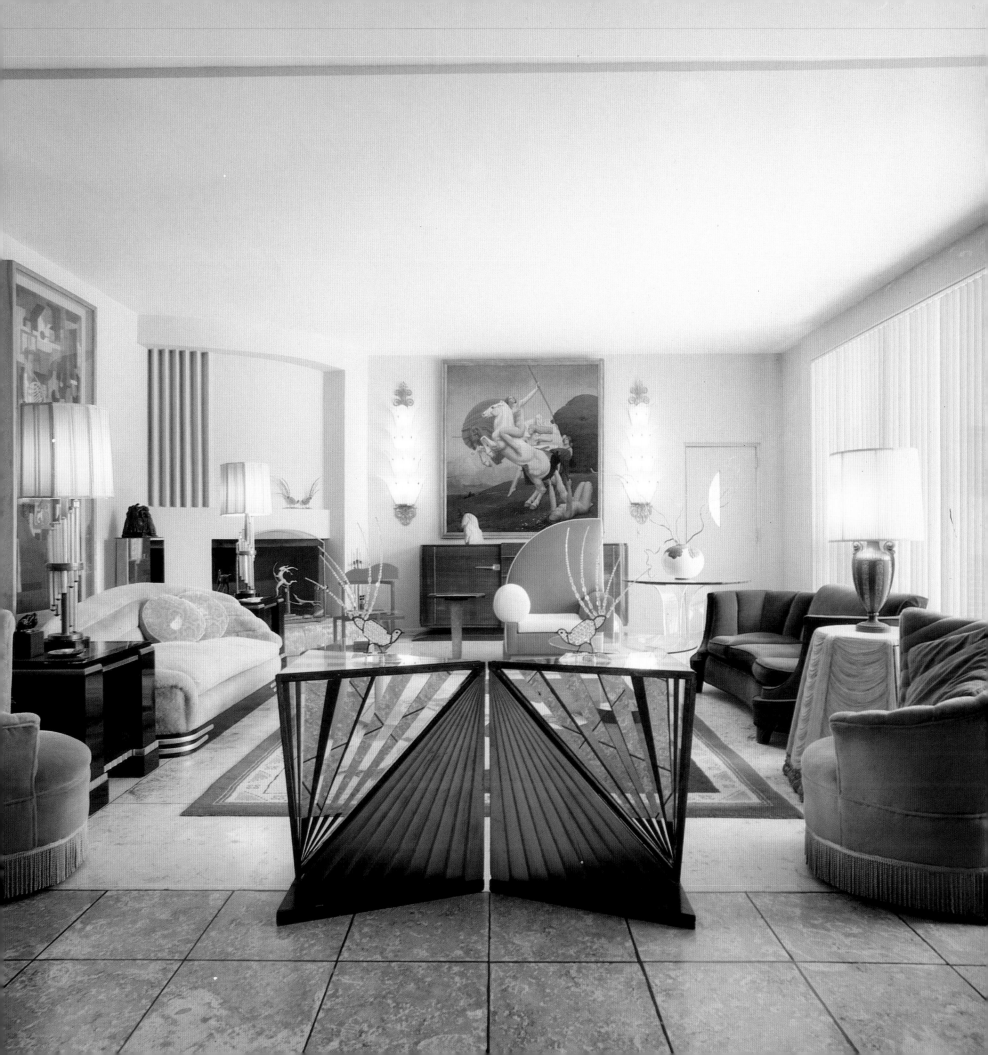

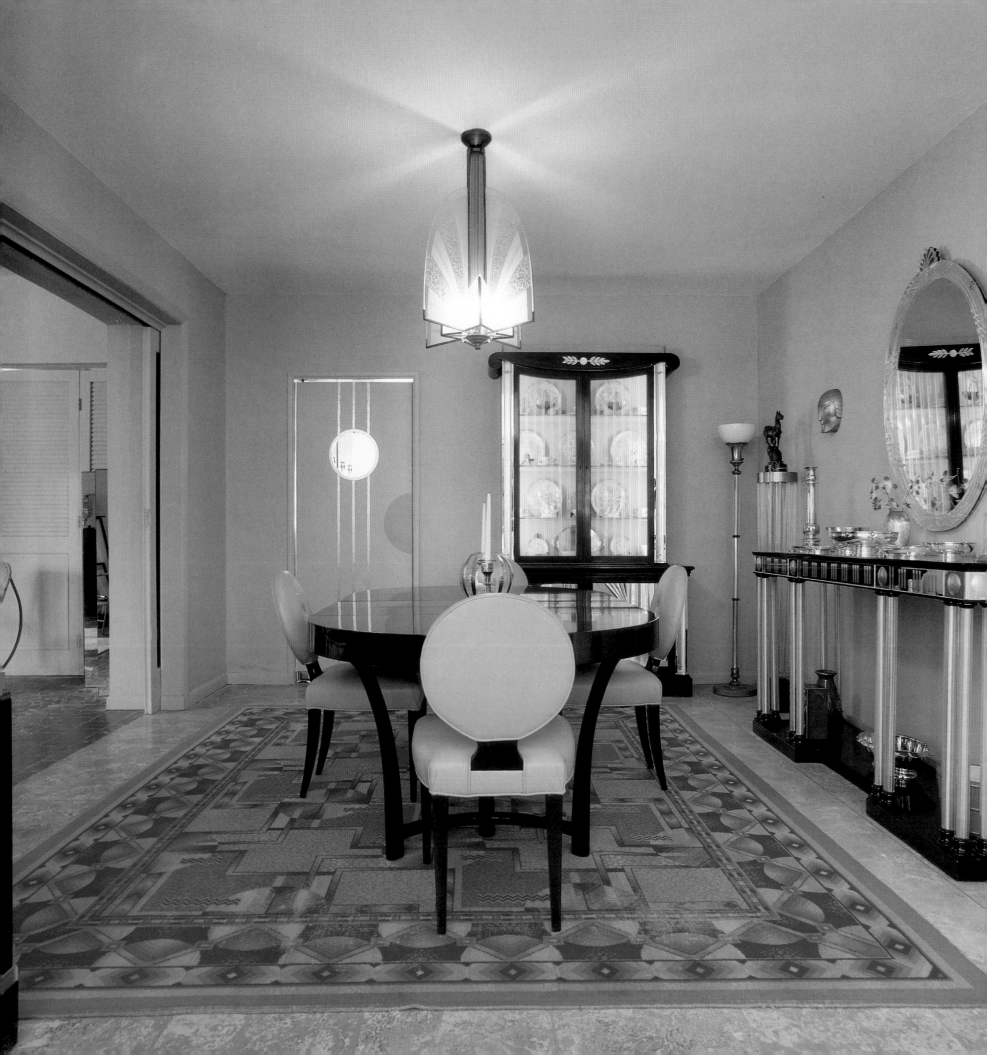

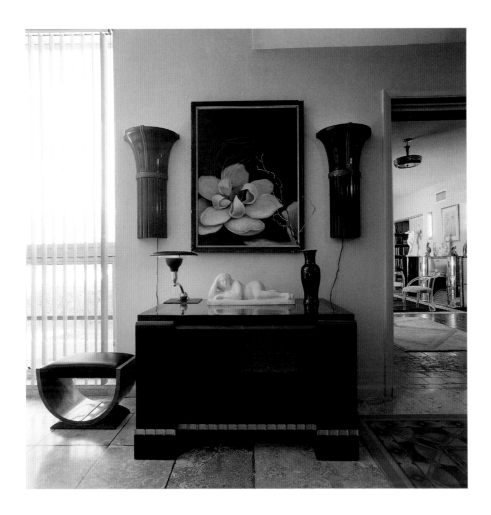

LEFT: View of the dining room.
ABOVE: The house showcases its owner's collection of art and Art Deco furniture.

LINKS: Ansicht des Eßzimmers.
OBEN: Im Haus findet man die Kunstsammlung des Besitzers und viele Art-Deco-Möbel.

A GAUCHE: La salle à manger.
CI-DESSUS: La maison sert de vitrine à la collection d'objets d'art et aux meubles Art Déco de ses propriétaires.

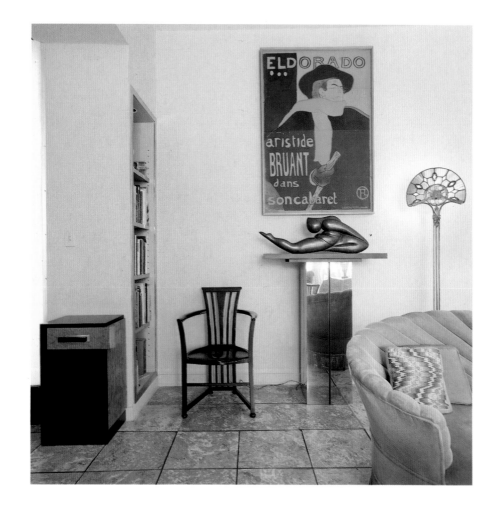

ABOVE: Pieces from the owner's collection in the living room.
RIGHT: The bathroom retains its original vitrolite walls.
OVERLEAF: Ceiling with glass and neon fixtures.

OBEN: Das Wohnzimmer enthält einige Stücke aus der Sammlung des Besitzers.
RECHTS: Im Badezimmer blieben die ursprünglichen »Vitrolite«-Opalglaswände erhalten.
FOLGENDE DOPPELSEITE: Decke mit Glas- und Neon-Installationen.

CI-DESSUS: Dans un coin du salon, quelques pièces de la collection des propriétaires.
A DROITE: La salle de bains a conservé ses murs d'origine en Vitrolite.
DOUBLE PAGE SUIVANTE: Plafond à décor de tubes néon.

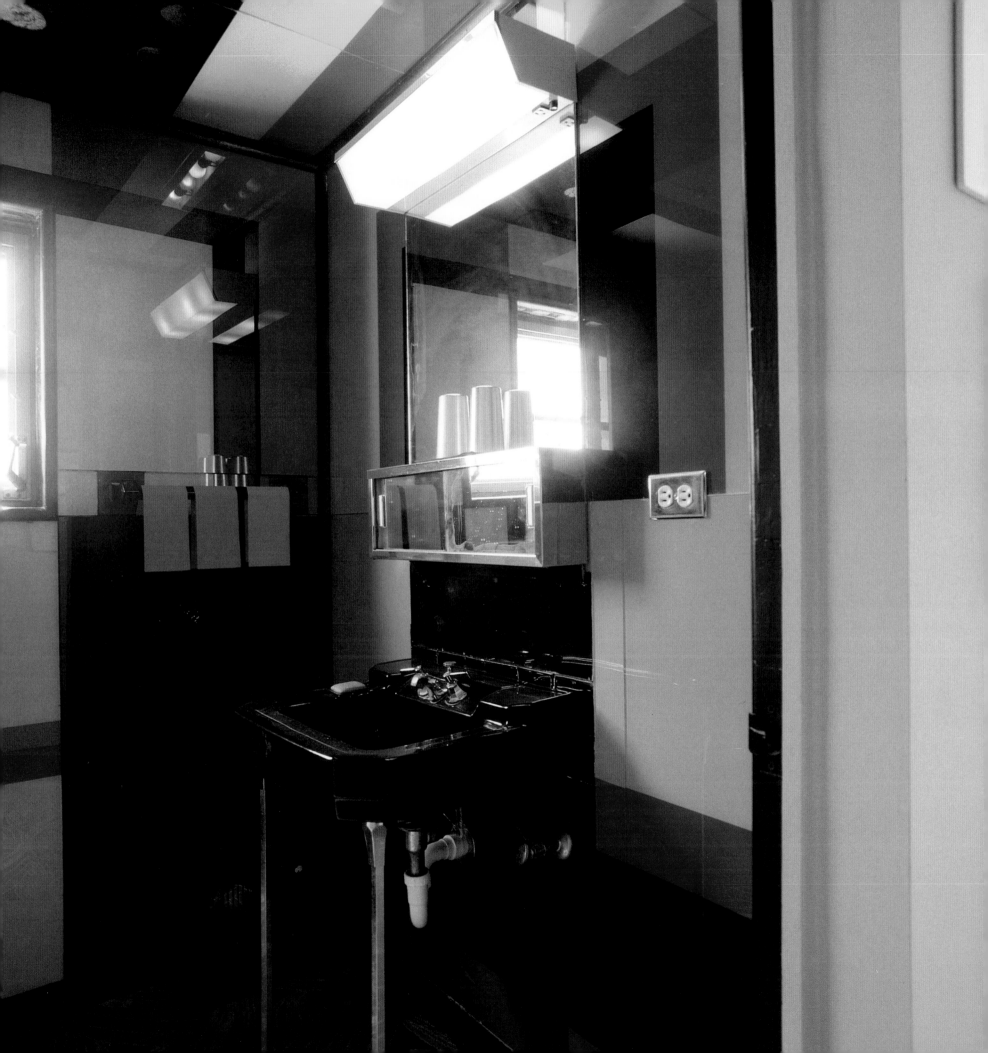

LAPIDUS APARTMENT

Morris Lapidus, 1961

In many ways, Morris Lapidus symbolizes an entire era in Miami Beach. From the opening of the Fontainebleau Hotel in 1954, Lapidus's particular brand of excess became the hallmark of the city. He relied on stairways to nowhere and amorphously shaped ceilings, along with enough gilding and elaborate detail to make Miami Beach an utterly lavish vacationland. More memorable hotels followed the Fontainebleau – the Eden Roc, the Americana (now the Sheraton Bal Harbour) – and then condominiums. At one point, Lapidus estimated that he might have designed as many as half of the buildings along Collins Avenue.

Now in his nineties and in retirement, Lapidus lives in an apartment in a building of his own design. From the time he moved in with his late wife, Bea, Lapidus has never subtracted from this apartment, only added to it. The two-story apartment is filled with memorabilia and an array of furniture in materials ranging from gold brocade to molded plastic.

The apartment is essentially a summary of his career, down to his own never-exhibited paintings on the walls. The typical Lapidus manipulations of space and perception can be seen here; a huge, ornate chandelier hangs in a small dining area, for example. The columns are thin and obviously not structural; in his hotel designs, he liked to call these "bean poles." Lapidus truly created a new style for Miami in the 1950s, and it shows up in both deed and word.

Morris Lapidus gilt in vielerlei Hinsicht als Symbol einer ganzen Ära in Miami Beach. Seit der Öffnung des Fontainebleau Hotels im Jahre 1954 hat sich Lapidus' spezielle Form von Überschwang zu einem Wahrzeichen der Stadt entwickelt. Er verwendete Treppen, die nirgendwohin führten, schuf amorph geformte Decken und setzte Vergoldungen und kunstvolle Details im Überfluß ein. Dem Fontainebleau folgten weitere unvergeßliche Hotels wie das Eden Roc und das Americana (das heutige Sheraton Bal Harbour) sowie verschiedene Eigentumswohnanlagen. Lapidus erklärte einmal, er sei schätzungsweise für die Hälfte aller Gebäude an der Collins Avenue verantwortlich.

Heute bewohnt Lapidus – mit über neunzig Jahren – ein Appartement in einem von ihm selbst entworfenen Gebäude. Die zweigeschossige Wohnung ist mit zahlreichen Erinnerungsstücken und Andenken und einer Fülle von Möbeln ausgestattet, deren Materialien von Goldbrokat bis Formkunststoff reichen.

Das Appartement (inklusive seiner nie öffentlich ausgestellten eigenen Gemälde an den Wänden) stellt im Grunde eine Zusammenfassung seiner Karriere dar. Die für Lapidus typischen Manipulationen von Raum und Wahrnehmung finden sich auch hier wieder – beispielsweise hängt ein riesiger, verzierter Kronleuchter über einem kleinen Eßbereich. Die Säulen – die er bei seinen Hotelentwürfen gerne als »Bohnenstangen« bezeichnete – sind sehr dünn und offensichtlich nicht tragfähig. Während der 50er Jahre schuf Lapidus, in Worten wie in Taten, einen wahrhaft neuen Stil in Miami.

De multiples façons, Morris Lapidus symbolise toute une époque de Miami Beach. Après l'ouverture du Fontainebleau Hotel en 1954, son goût si particulier pour l'excès stylistique devient la marque de la ville. Avec des escaliers ne menant nulle part, des plafond aux découpes étranges, des dorures et des détails élaborés, il réussit à faire de Miami Beach une villégiature de rêve. Des réalisations hôtelières plus étonnantes encore suivirent le Fontainebleau : l'Eden Roc, l'Americana (aujourd'hui Sheraton Bal Harbour), puis des immeubles d'appartements en copropriété. A un certain moment, Lapidus estimait qu'il avait dessiné pratiquement la moitié des immeubles de Collins Avenue.

Aujourd'hui âgé de plus de quatre-vingt-dix ans et retraité, Lapidus occupe un appartement dans un immeuble qu'il a conçu. Depuis le jour où il s'y est installé avec son épouse, Bea, il n'en a jamais retiré quoi que ce soit, mais l'a au contraire enrichi. Sur deux niveaux, l'appartement est rempli de souvenirs et d'une foule de meubles réalisés dans les matériaux les plus divers, allant du brocart doré au plastique moulé.

Cet appartement résume la carrière de l'architecte, y compris ses propres peintures qu'il n'a jamais exposées. Les manipulations et la perception de l'espace si typiques de Lapidus se retrouvent ici concentrées : par exemple, un énorme lustre accroché dans une petite salle à manger. Les colonnes sont minces et ne supportent rien. Dans ses plans d'hôtels, il les appelle des «rames de haricots». Lapidus a créé un style nouveau pour le Miami des années 50 et l'a traduit en paroles et en actions.

Morris Lapidus designed every detail of his apartment in Miami Beach.

Morris Lapidus entwarf jedes Detail seines Appartements in Miami Beach.

Morris Lapidus a conçu chaque détail de son appartement de Miami Beach.

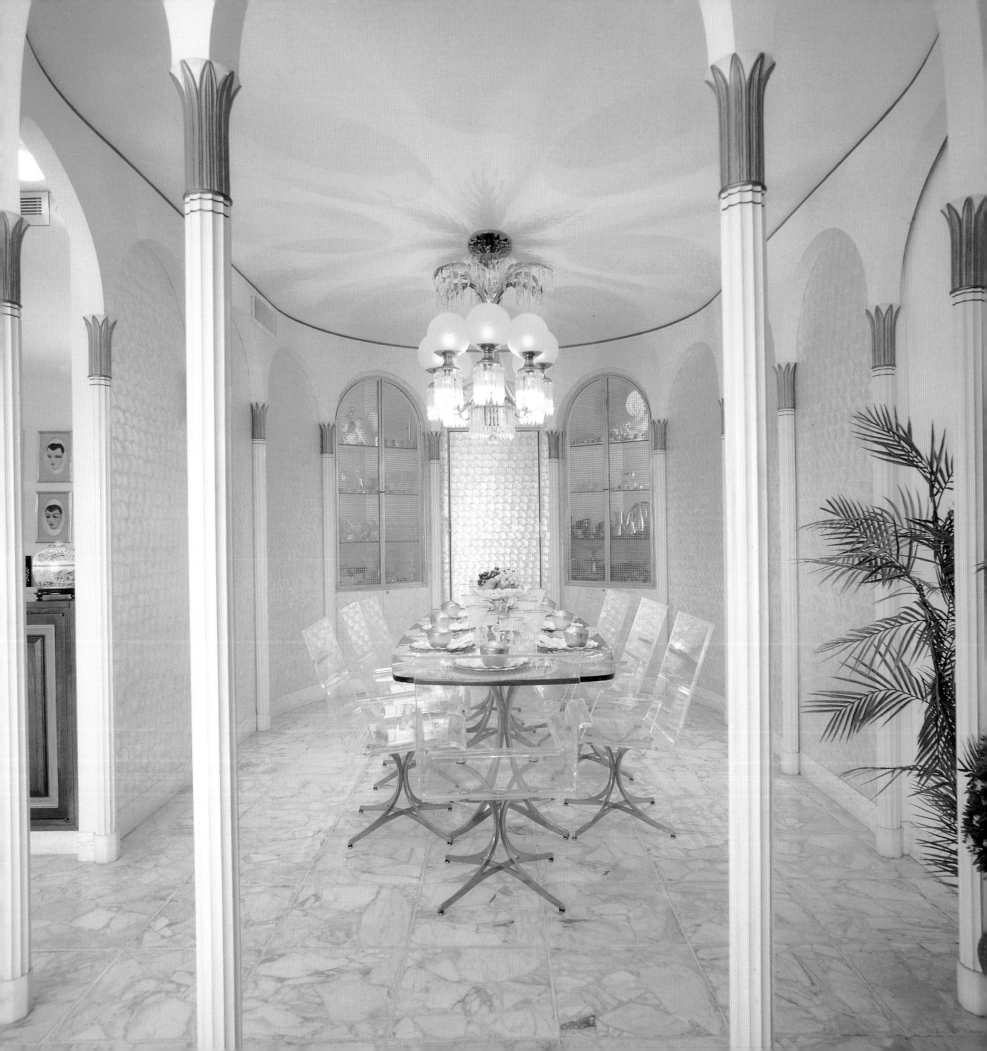

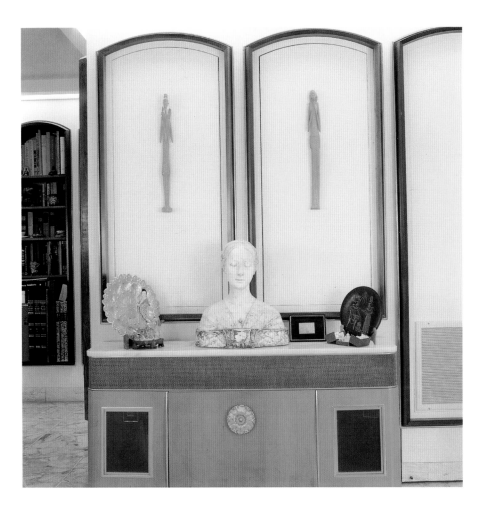

LEFT: The dining room features narrow columns and eclectic furniture.
ABOVE: Interior detail.

LINKS: Das Eßzimmer mit seinen schlanken Säulen und seiner eklektischen Möblierung.
OBEN: Detail der Inneneinrichtung.

A GAUCHE: Colonnes minces et mobilier éclectique pour la salle à manger.
CI-DESSUS: Détail de l'intérieur.

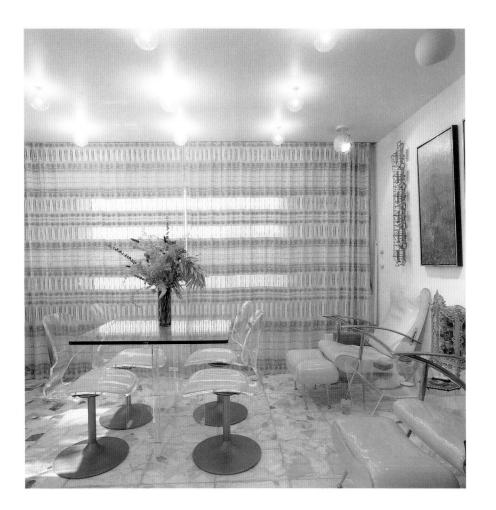

ABOVE: Lapidus's breakfast area includes stylistic elements of the 1950s, 1960s, and 1970s.
RIGHT: The living room shows Lapidus's love of gentle curves, ornament, and objects.

OBEN: Lapidus' Frühstücksbereich enthält Stilelemente der 50er, 60er und 70er Jahre.
RECHTS: Das Wohnzimmer zeigt Lapidus' Vorliebe für sanfte Rundungen, Ornamente und Objekte.

CI-DESSUS: La salle du petit déjeuner avec ses divers éléments de style des années 50, 60 et 70.
A DROITE: Le salon témoigne du goût de Lapidus pour les courbes douces, l'ornementation et les objets.

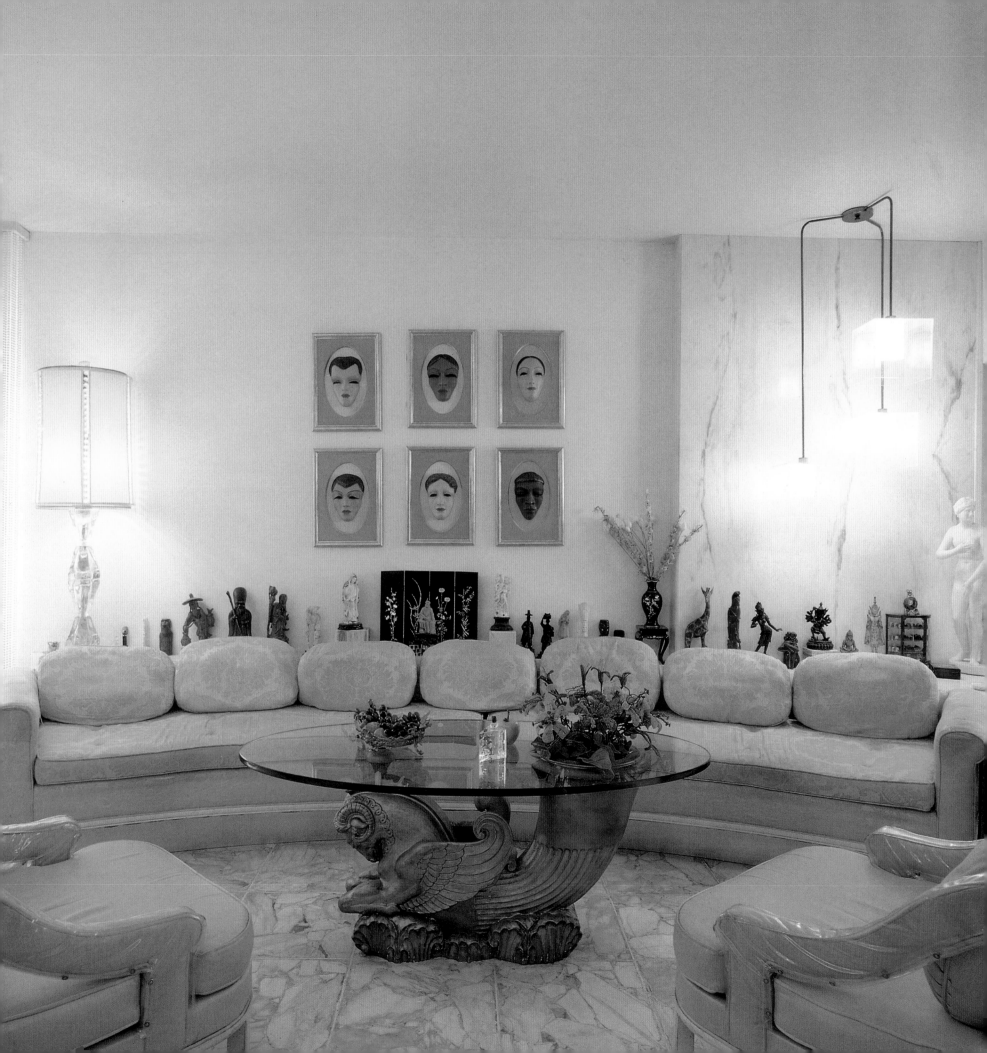

LEFT: Detail of the bathroom, with cherub and Venetian glass soap dish.
ABOVE: Lapidus's bedroom.

LINKS: Detailansicht des Badezimmers, mit einem Cherub und einer Seifenschale aus venezianischem Glas.
OBEN: Das Schlafzimmer.

A GAUCHE: Détail de la salle de bains, avec chérubin et porte-savon en verre vénitien.
CI-DESSUS: La chambre à coucher de M. Lapidus.

RIGHT: Lapidus and his late wife, Bea, collected crafts and art as souvenirs of their travels.
ABOVE: A spiral staircase leads to another, more casual level of the duplex apartment.

RECHTS: Lapidus und seine verstorbene Frau Bea sammelten auf ihren Reisen Kunst und Kunsthandwerk.
OBEN: Eine Wendeltreppe führt in die obere, zwanglosere Etage der Maisonnettewohnung.

A DROITE: Lapidus et son épouse, Bea, collectionnaient les objets d'art populaire et des souvenirs qu'ils rapportaient de leurs voyages.
CI-DESSUS: Un escalier en spirale conduit au second niveau – plus banal – de l'appartement en duplex.

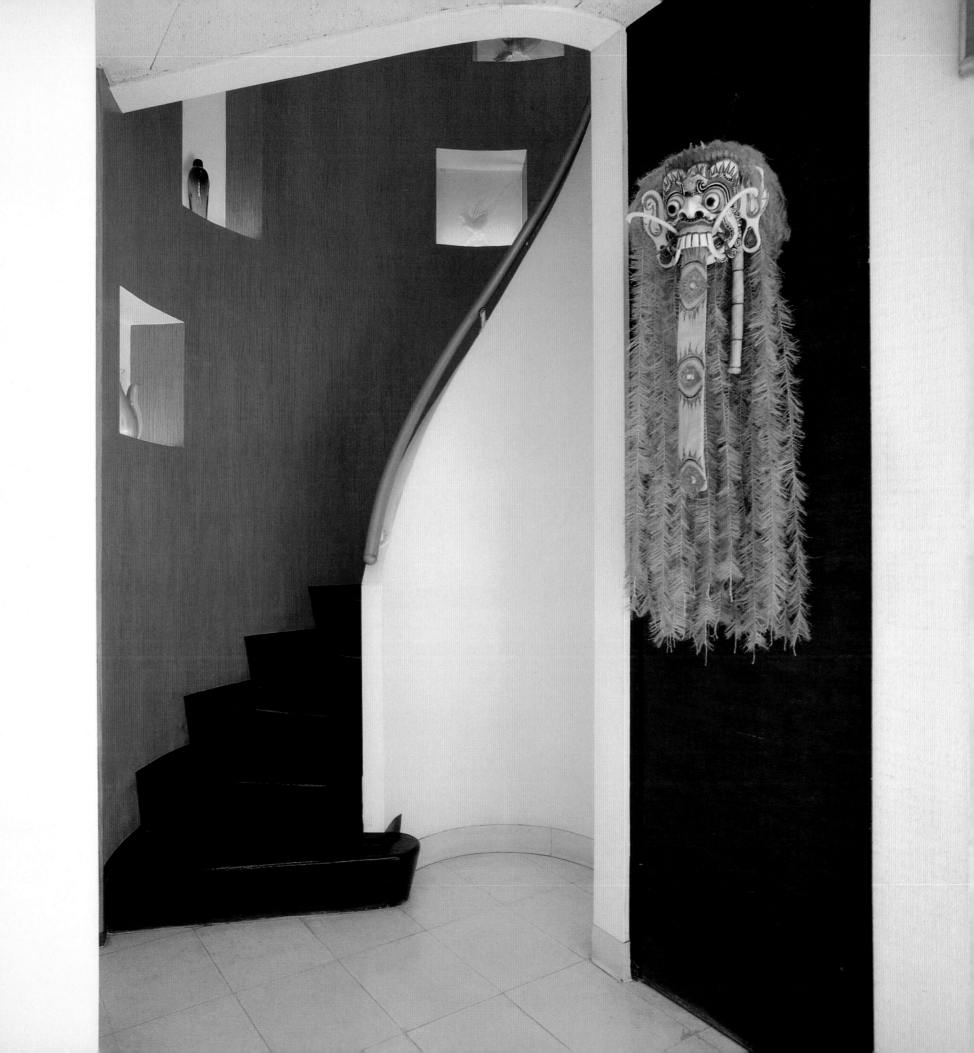

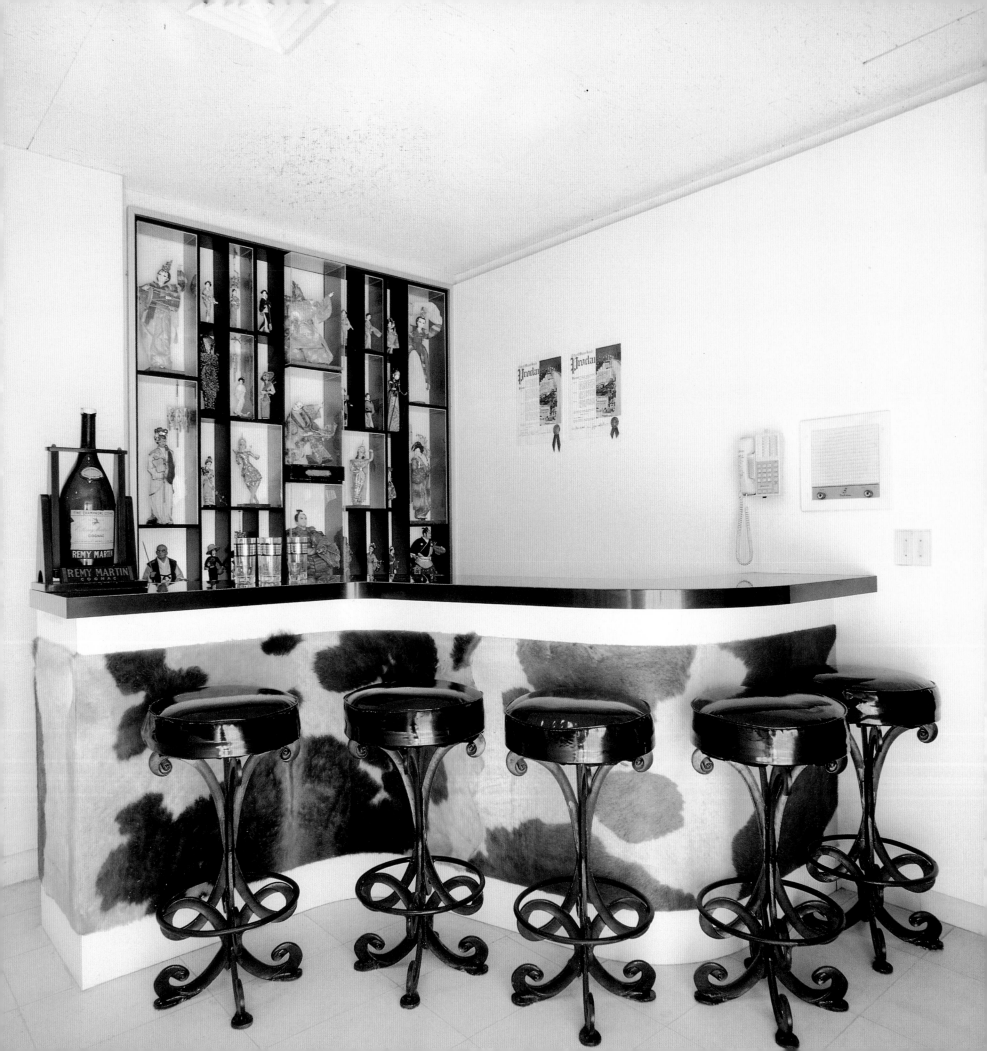

LEFT: The curving, pony skin-clad bar is evidence of Lapidus's penchant for more, rather than less.
ABOVE: Lapidus's office.

LINKS: Die gekurvte, mit Ponyfell bezogene Bar ist typisch für Lapidus' Hang zur Überschwenglichkeit.
OBEN: Lapidus' Arbeitszimmer.

A GAUCHE: Le bar incurvé et tendu de poney illustre le goût de Lapidus pour la surabondance plutôt que l'économie.
CI-DESSUS: Le bureau de M. Lapidus.

EIG/SMITH HOUSE

George F. Reed, 1962–63

George Reed's work is consciously tropical, featuring airy pavilions with louvered windows raised off the ground to allow breezes to flow over, under, and through them. His sources include the chickees built by the Seminole Indians – open huts with sloped, overhanging palm frond roofs – and the airy homes of some of Miami's early pioneers. Typically, Reed worked in wood; in many ways, he and several of his contemporaries were the true inheritors of the pioneer craftsman tradition of Miami architecture.

The Eig/Smith House in Coconut Grove particularly reflects that tradition. The legacy of the early builders was not merely an innate understanding of the climate and the relationship of buildings to the natural environment, it was also conscientious and sturdy craftsmanship. This much-honored house has stood the test of time, both in its durability and its aesthetic.

The house sits on a flat bluff near, but not on, Biscayne Bay, nestled amid clusters of palms. To allow it to fit gently into the site, Reed designed separate pavilions, each just one room deep. This approach allows for both natural ventilation and an intimate relationship with the landscape. Broad roofs protect the house from sun and rain.

George Reeds Bauten sind bewußt tropisch konzipiert und präsentieren luftige Pavillons mit erhöhten winddurchlässigen Jalousiefenstern. Als Inspirationsquelle dienten ihm u.a. die Palmenhütten der Seminole-Indianer – offene Hütten mit schrägen, überhängenden Dächern aus Palmwedeln – und die luftigen Häuser der ersten Siedlerfamilien in Miami. Dementsprechend arbeitete Reed hauptsächlich mit Holz. In vielerlei Hinsicht waren er und verschiedene seiner Zeitgenossen die wahren Nachfolger der alten Handwerkstradition in der Architektur Miamis.

Das Eig/Smith House in Coconut Grove spiegelt diese Tradition in besonderem Maße wider. Das Vermächtnis der ersten Baumeister bestand nicht nur in einem tiefen Verständnis für das Klima und die Beziehung zwischen Gebäuden und ihrer natürlichen Umgebung, sondern auch in der gewissenhaften und entschlossenen Ausübung ihres Handwerks. Daher konnte dieses hochgelobte Gebäude dem Zahn der Zeit sowohl in qualitativer als auch in ästhetischer Hinsicht widerstehen.

Das Haus befindet sich auf ebenem Terrain an einer Steilküste in der Nähe der Biscayne Bay und versteckt sich in einem Palmenhain. Damit sich das Gebäude nahtlos in seine Umgebung einpaßt, entwarf Reed mehrere Pavillons, die aus jeweils nur einem Raum bestehen. Auf diese Weise wurde sowohl eine natürliche Belüftung als auch eine enge Beziehung zur Landschaft geschaffen, während breite Dächer die Gebäude vor Sonne und Regen schützen.

L'œuvre de George Reed est consciemment tropicale, avec ses pavillons à persiennes, surélevés du sol pour permettre à la brise de mieux les ventiler. Parmi ses sources se retrouvent les *chickees* des Séminoles – huttes ouvertes recouvertes de palmes – et les maisons aérées de certains pionniers. Typiquement, Reed construisait en bois. A de multiples égards, lui et quelques-uns de ses contemporains sont les héritiers authentiques des traditions des premiers artisans constructeurs de Miami.

La maison Eig/Smith à Coconut Grove reflète particulièrement cette tradition. L'héritage de ces pionniers ne tenait pas seulement à la compréhension du climat et des relations entre le construit et l'environnement naturel, mais également à un artisanat consciencieux et plein de vigueur. Cette maison célèbre a passé le test du temps, aussi bien en termes d'esthétique que de durabilité.

Nichée parmi les palmiers, elle s'élève sur un escarpement près de – et non sur – Biscayne Bay. Pour respecter le site, Reed a dessiné des pavillons séparés, chacun d'une pièce seulement. Cette approche permet à la fois une ventilation naturelle et une relation intime avec le paysage. Des toits débordants protègent la maison du soleil et de la pluie.

The pool pavilion.

Der Pool-Pavillon.

Le pavillon de la piscine.

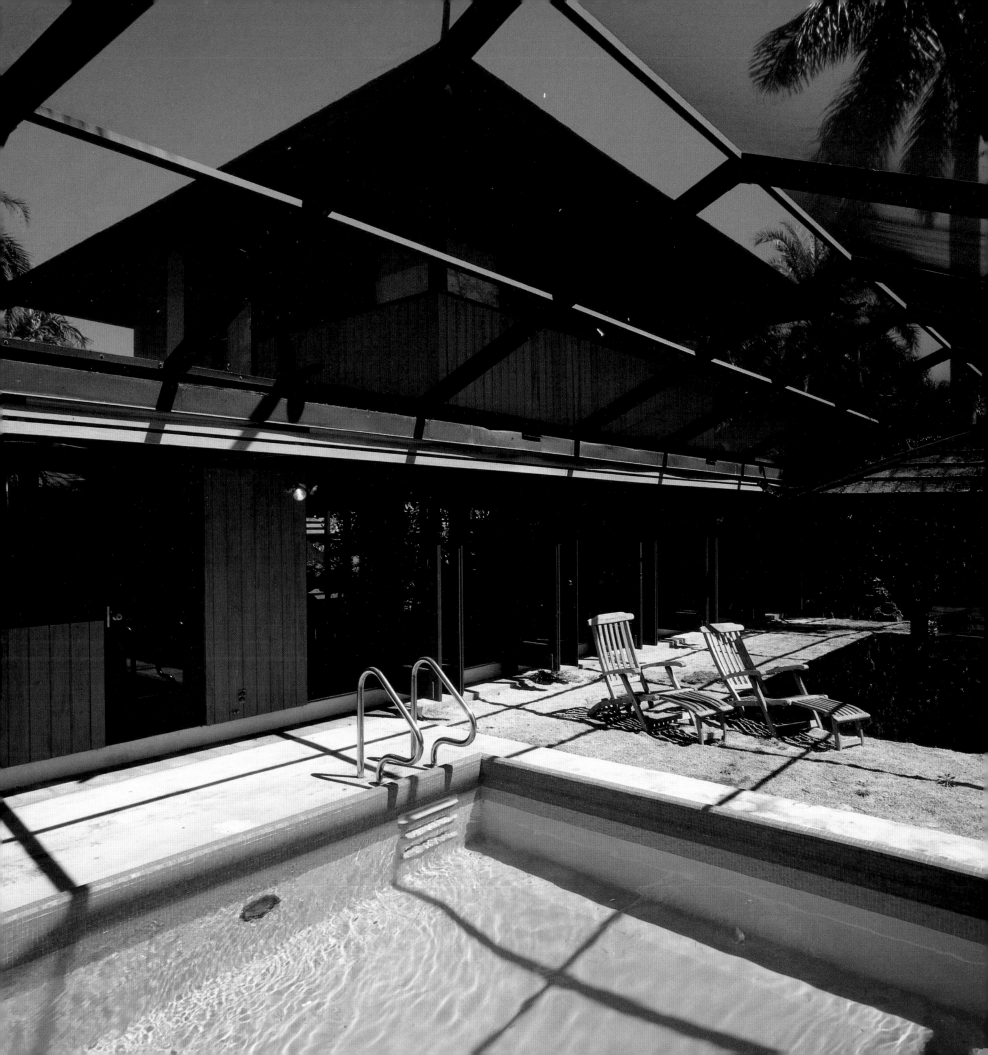

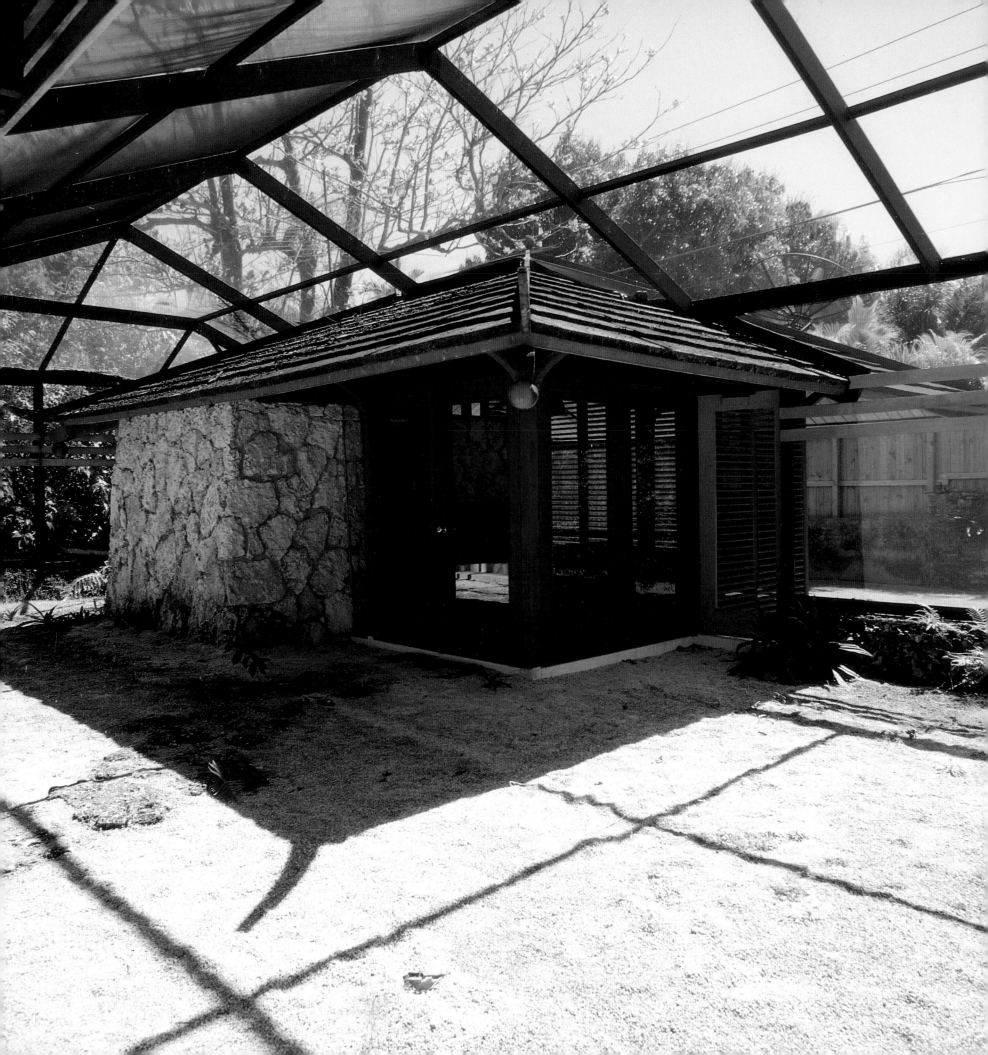

LEFT: Natural materials were used throughout the Eig/Smith House.
ABOVE: Wood bracing becomes an elegant structural detail.

LINKS: Für den Bau des Eig/Smith Hauses wurden ausschließlich Naturmaterialien verwendet.
OBEN: Die Holzverstrebung wirkt wie ein elegantes bauliches Detail.

A GAUCHE: Toute la maison est édifiée en matériaux naturels.
CI-DESSUS: Un simple entretoisement en bois devient un élégant détail structurel.

ABOVE AND RIGHT: Reed designed small pavilions in order not to disturb the flow of the natural landscape.

OBEN UND RECHTS: Reed entwarf kleine Pavillons, um so den natürlichen Fluß der Landschaft nicht zu unterbrechen.

CI-DESSUS ET A DROITE: Reed créa de petits pavillons pour ne pas troubler le rythme du paysage naturel.

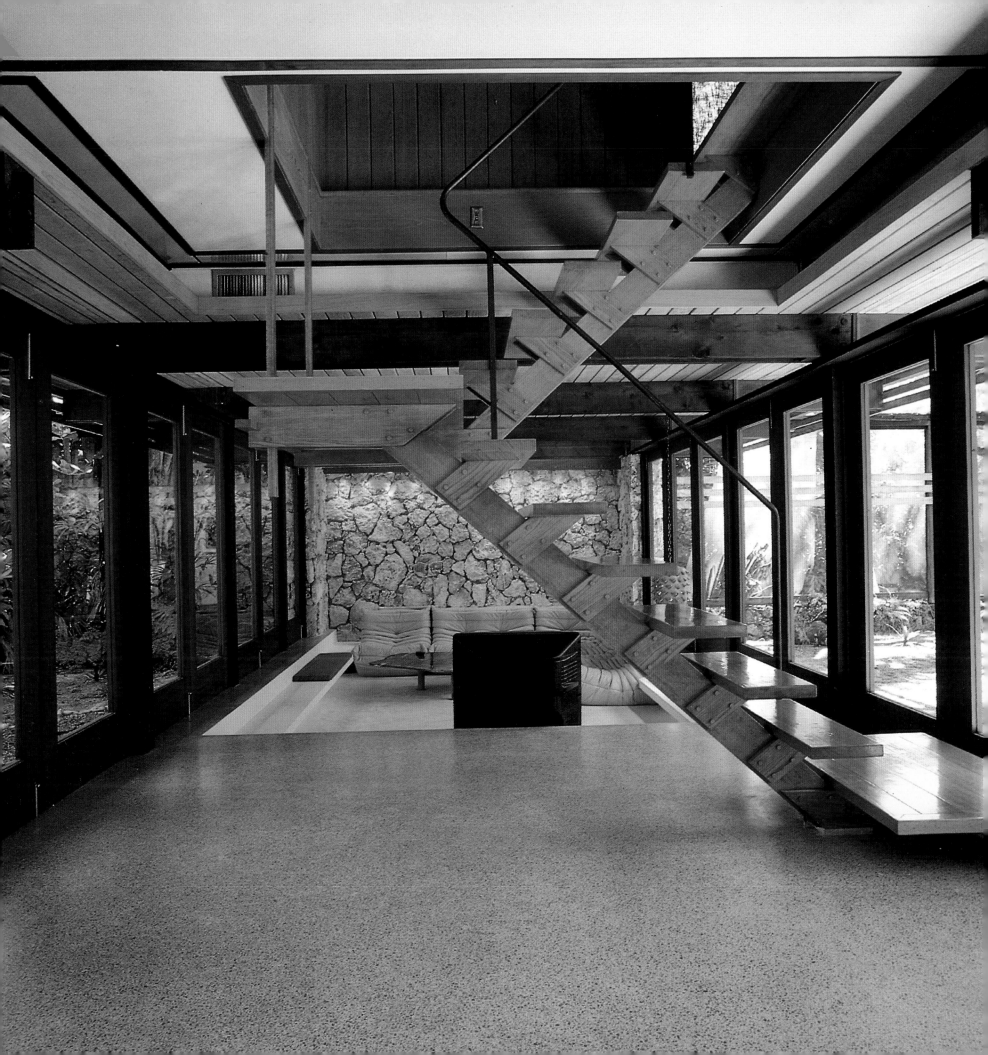

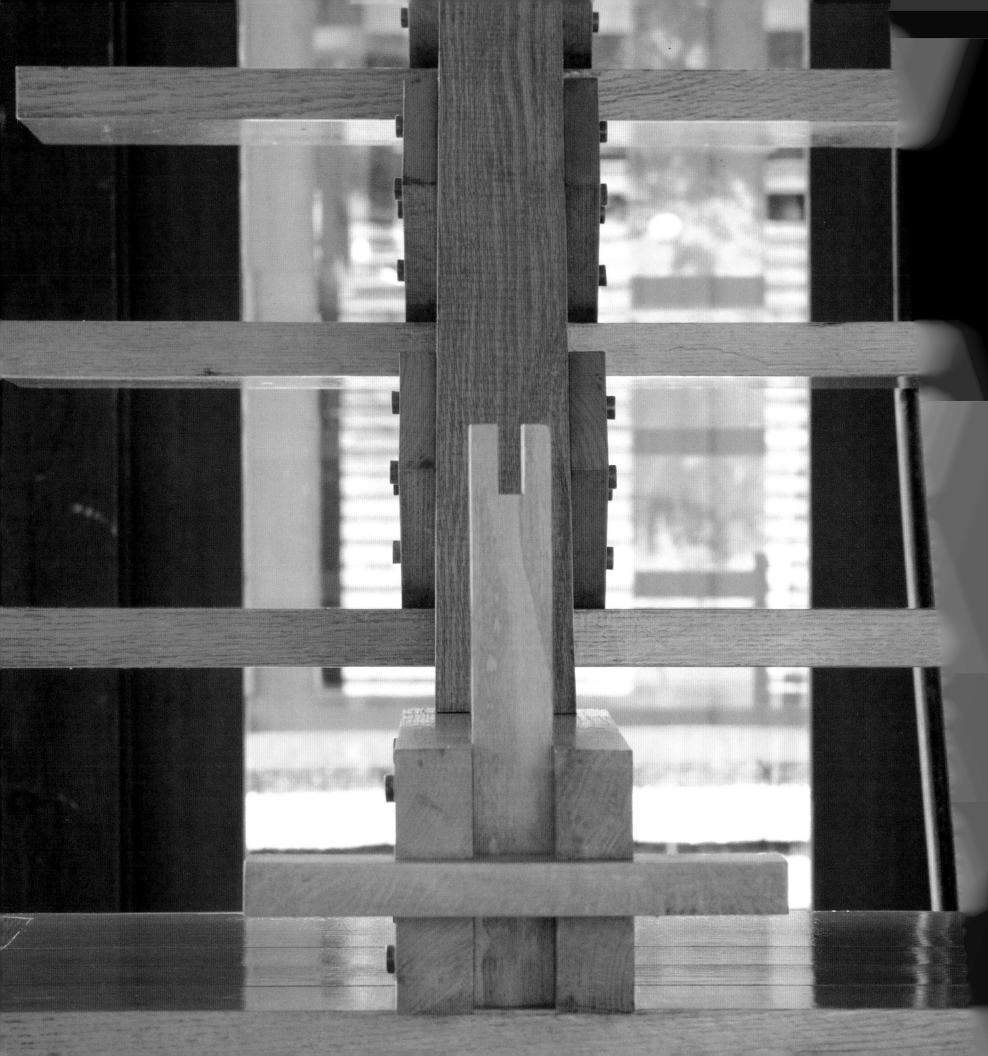

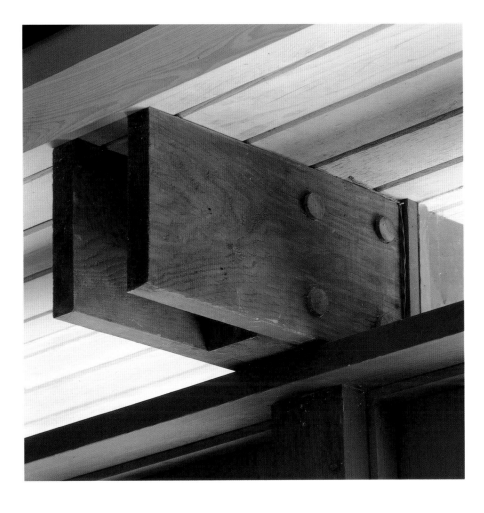

LEFT: A built-in wooden stairway allows structural transparency.
ABOVE: Detail of ceiling construction.

LINKS: Die Holztreppe im Hausinneren bietet strukturelle Transparenz.
OBEN: Detail der Dachkonstruktion.

A GAUCHE: L'escalier en bois ne gêne pas la transparence structurelle.
CI-DESSUS: Détail du montage du plafond.

PACESETTER HOUSE

Alfred Browning Parker, 1965

Alfred Browning Parker was, to a certain extent, a disciple of Frank Lloyd Wright, but to say only that would give him short shrift. A Miami native, Parker evolved his own distinct style in the course of a more-than-fifty-year career. In the 1950s and 1960s his work was widely recognized and published, houses that were at once rugged and "organic," in the Wrightean sense, and elegant, tropical, and universal – lavish homes imbued with a certain practicality.

In some ways, this house is the Miami equivalent of the great lodges of the Western national parks, making the best of the natural setting and using – or rather, celebrating – local materials. This house, set on Biscayne Bay in Coral Gables, was *House Beautiful's* Pacesetter House of 1965. The magazine devoted almost an entire issue to a detailed scrutiny of the house, terming it "a fortress in a storm … a serene and magical pavilion on a blamy evening." Parker originally designed it for his own family but subsequently sold it, though it remains virtually unchanged three decades later.

The house is constructed of native keystone and wood with tile cladding and copper trim. Louvered shutters close over bronzed glass windows; the interior spaces are protected from sun and rain by steeply overhanging roofs. Each room – most are on different levels – opens out onto the water. The house is linear, though not lean; it looms along the bay.

Alfred Browning Parker war sicherlich ein Schüler Frank Lloyd Wrights; aber diese Beschreibung allein wird ihm nicht gerecht. Parker wurde in Miami geboren und entwickelte im Laufe seiner über fünfzigjährigen Karriere seinen eigenen charakteristischen Stil. Er entwarf Häuser, die im Sinne Wrights robust und »organisch« waren und zugleich elegant, tropisch und universal – luxuriöse, von einer bestimmten Zweckmäßigkeit erfüllte Häuser.

In gewisser Hinsicht stellt dieses Haus Miamis Pendant zu den großartigen Baulichkeiten der amerikanischen Nationalparks dar, da hier die natürliche Umgebung einbezogen und bewußt ortstypische Baumaterialien verwendet wurden. Das Gebäude befindet sich auf einem Gelände an der Biscayne Bay in Coral Gables und erhielt 1965 von der Zeitschrift *House Beautiful* den Titel »Pacesetter House«. Parker hatte das Haus für seine Familie gebaut, verkaufte es später jedoch. Gleichwohl blieb es in den folgenden drei Jahrzehnten nahezu unverändert.

Das Pacesetter House wurde aus Keystone (einer im Keystone County gewonnen Steinart) und Holz mit Kupfereinfassungen errichtet. Jalousiefensterläden schützen die braungetönten Glasscheiben der Fenster, während die Innenräume durch weit herabgezogene Dächer vor Regen und Sonne geschützt sind. Jeder der Räume – die sich größtenteils auf unterschiedlichen Ebenen befinden – öffnet sich zum Wasser hin. Das Haus ist linear und doch nicht schmal, seine Silhouette erstreckt sich entlang der Biscayne Bay.

Dans une certaine mesure, Alfred Browning Parker est un disciple de Frank Lloyd Wright, ce qui ne suffit cependant pas à le définir. Né à Miami, il développa un style spécifique tout au long d'une carrière de plus de cinquante ans. Dans les années 50 et 60, son œuvre était reconnue, et l'on publia fréquemment ses maisons d'aspect à la fois brut et organique – au sens de Wright –, qui n'en étaient pas moins d'élégantes demeures tropicales, non dénuées de sens pratique et de qualités universelles.

A certains égards, cette maison est l'équivalent pour Miami des grandes «lodges» des parcs nationaux de l'Ouest, intelligemment implantées dans un cadre naturel et faisant appel, en sachant les célébrer, aux matériaux régionaux. Cette maison sur Biscayne Bay à Coral Gables est la fameuse «Pacesetter House» 1965 de *House Beautiful*. Le magazine consacra presque la totalité d'un numéro à l'analyser dans tous ses détails, la qualifiant de «forteresse dans une tempête... de pavillon serein et magique dans un soir embaumé». Parker l'avait dessinée à l'origine pour sa propre famille, mais la vendit par la suite. Elle est restée pratiquement inchangée.

La maison est construite en pierre locale et bois, est revêtue de tuiles et possède des éléments de cuivre. Des volets masquent ses fenêtres en verre couleur bronze. Les espaces intérieurs sont protégés par de très généreux avant-toits. Chaque pièce – la plupart se trouvent à des niveaux différents – donne sur l'eau. La maison est linéaire, mais sans impression d'étalement. Elle se découpe sur le fond de la baie.

RIGHT: The long, narrow swimming pool runs perpendicular to the house.
OVERLEAF: The house exhibits the strong influence of Frank Lloyd Wright, although it uses tropical materials.

RECHTS: Der langgezogene Swimmingpool verläuft rechtwinklig zum Haus.
FOLGENDE DOPPELSEITE: Trotz der Verwendung tropischer Materialien wird bei diesem Haus der starke Einfluß Frank Lloyd Wrights deutlich.

A DROITE: La piscine longue et étroite est perpendiculaire à la maison.
DOUBLE PAGE SUIVANTE: La maison montre la forte influence de Frank Lloyd Wright, bien qu'elle fasse appel à des matériaux tropicaux.

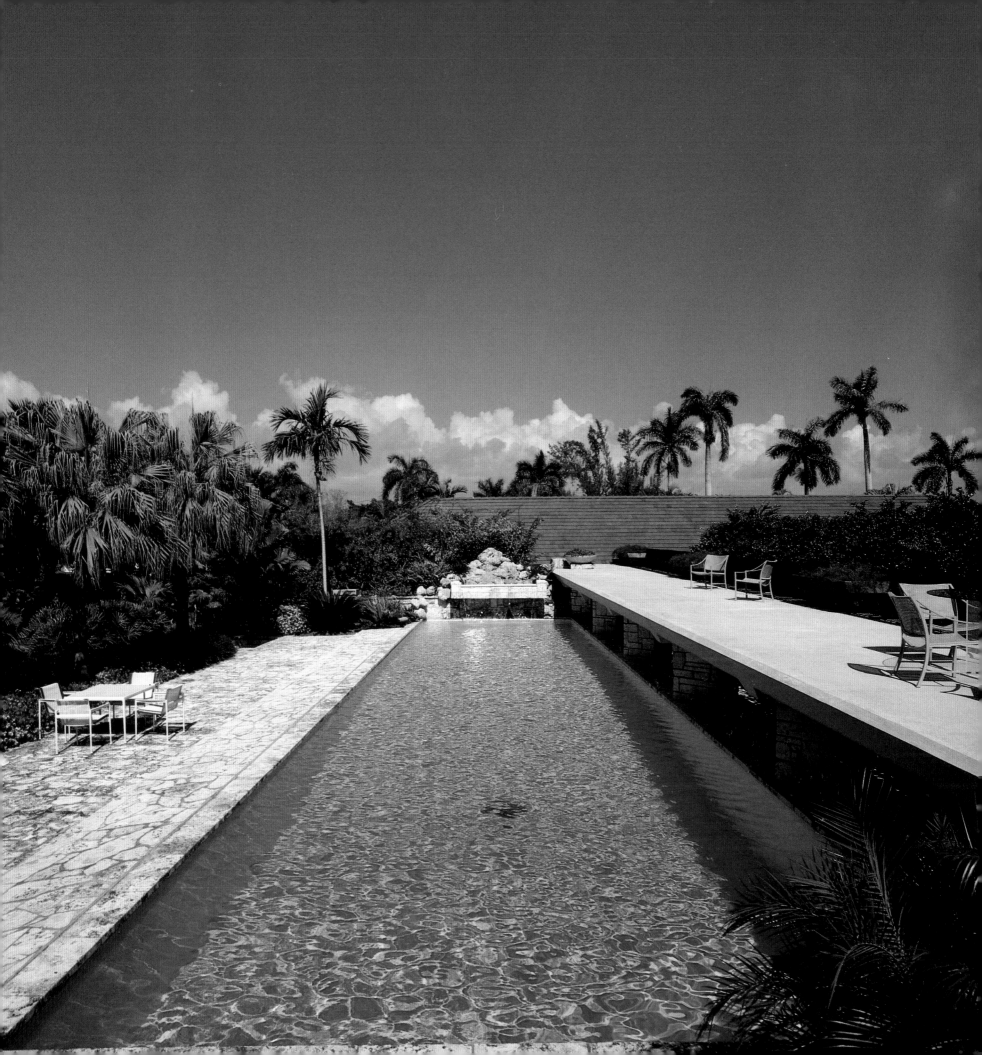

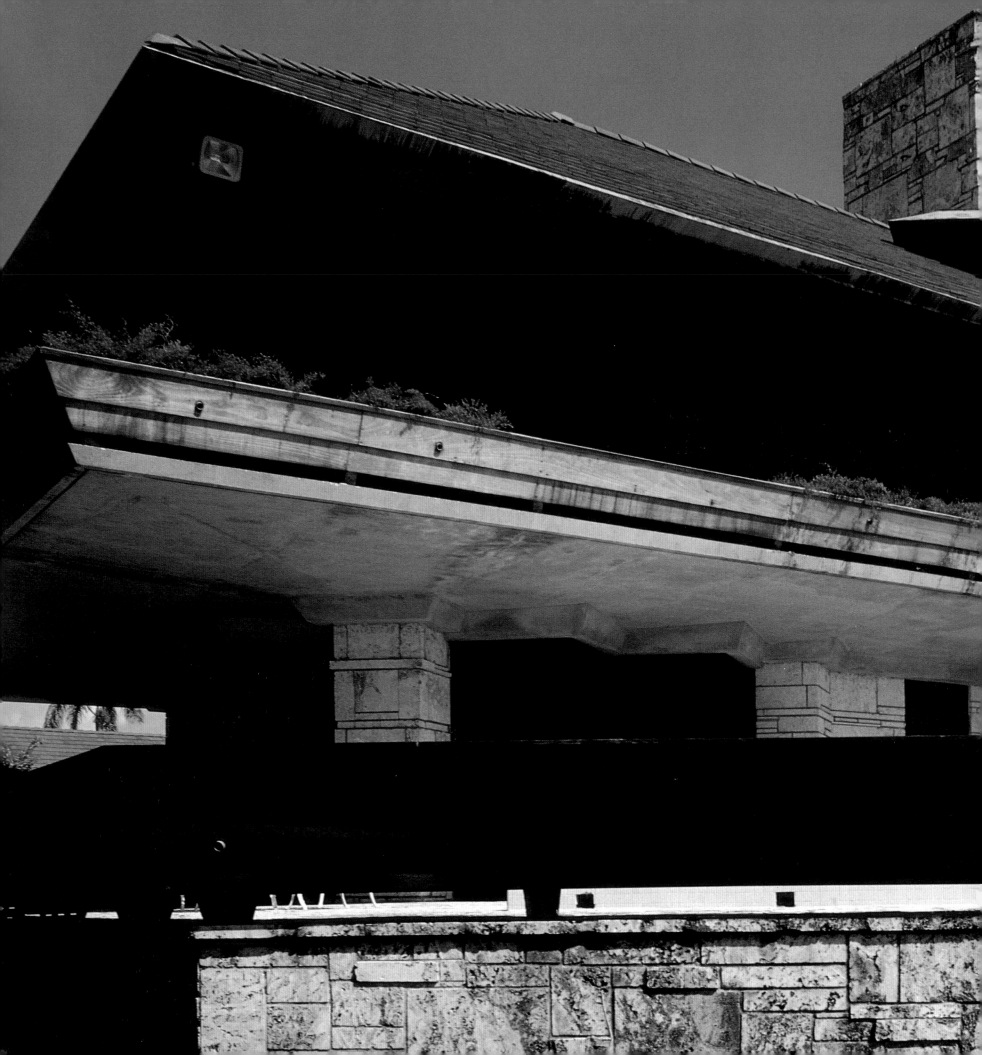

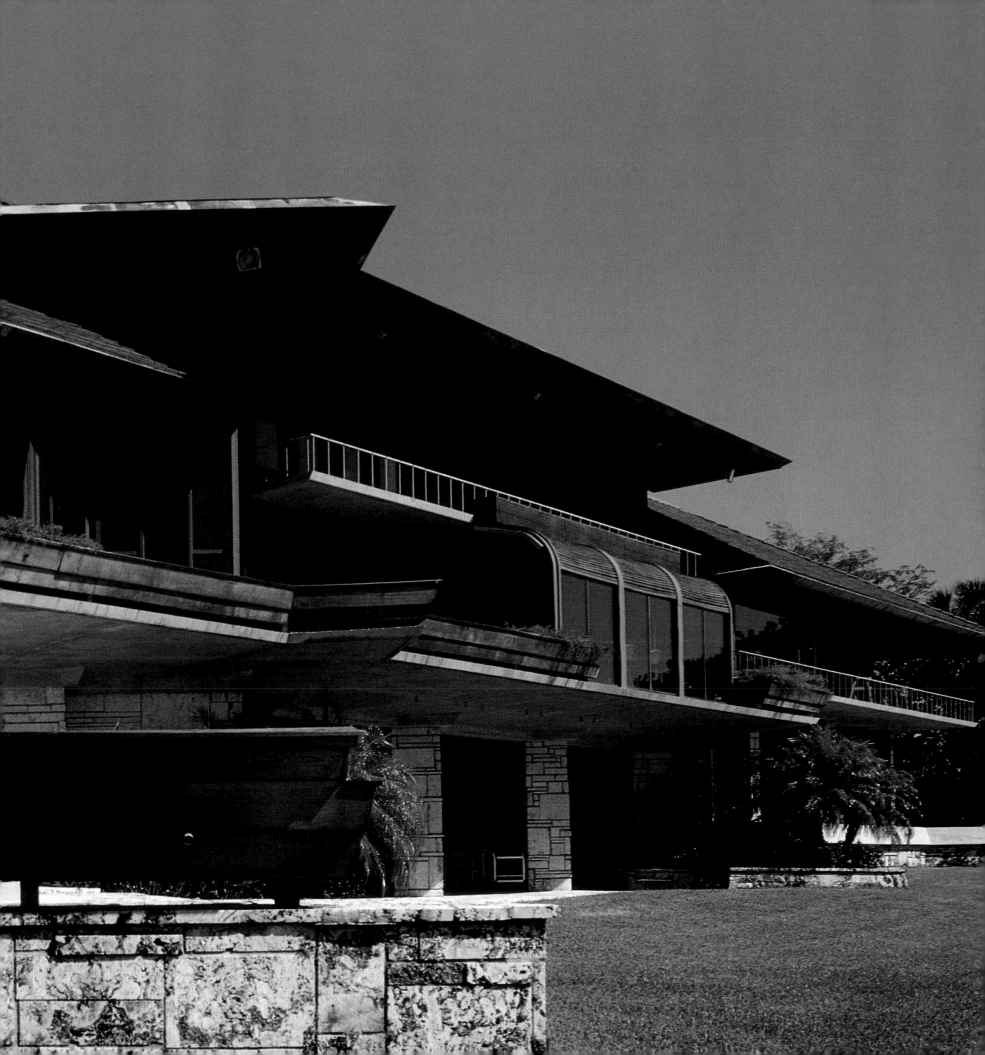

OTTO COHEN HOUSE

Rufus Nims, 1950

In the years following World War II, Rufus Nims was in the forefront of a group of architects who simultaneously embraced and spurned moderne technology. These architects experimented with new structural systems in order to build lightweight, airy houses that didn't have to rely on air-conditioning, but caught the prevailing winds for ventilation.

Nims, along with Robert Bradford Browne and Peter Jefferson, was fascinated by the ways modern architecture could free houses to be closer to the natural environment; if it had ever become a movement, it might have been called Tropical Modernism. These architects – whose work is still much admired three and four decades later – were committed to designing houses for the tropics, adapted to the sun and the heat. The oldest principles of tropical design – raising the house off the ground and letting breezes flow through – held sway.

The Otto Cohen house, built in Miami Beach in 1950, is one such house. Nims used a flat-plate concrete system and post-and-beam construction to give the house "thin" walls, allowing it to breathe a bit. The living quarters and even the pool were placed on the second floor, reached by a highly sculptural spiral staircase, for greater access to cooling breezes.

In den Jahren nach dem Zweiten Weltkrieg gehörte Rufus Nims zu einer Gruppe von Architekten, die die moderne Technologie zugleich willkommen hießen und ablehnten. Diese Architekten experimentierten mit neuen Konstruktionssystemen, um leichte, luftige Häuser zu entwerfen, die keine Klimaanlage benötigten, sondern durch den Wind auf natürliche Weise belüftet werden konnten.

Neben Bradford Browne und Peter Jefferson war auch Nims fasziniert von den Möglichkeiten, die die moderne Architektur bot, um Häuser stärker in ihre natürliche Umgebung zu integrieren. Wenn sich daraus eine Architekturströmung entwickelt hätte, wäre sie wahrscheinlich »Tropische Moderne« genannt worden. Diese Architekten – deren Arbeiten noch drei und vier Jahrzehnte später viele Bewunderer finden – widmeten sich ganz dem Entwurf von Häusern für die Tropen, die der Sonne und der Hitze besonders angepaßt waren. Dabei griffen sie auf das älteste Bauprinzip der Tropen zurück – die Errichtung erhöhter Häuser, unter denen der Wind hindurchstreichen kann.

Das 1950 in Miami Beach gebaute Otto Cohen House ist dafür ein typisches Beispiel. Nims verwendete ein Betonplattensystem sowie eine Ständerbauweise, um mittels dünnwandiger Mauern eine bessere Belüftung zu gewährleisten. Die Wohnräume und sogar der Swimmingpool wurden in den zweiten Stock verlegt, um den kühlenden Wind besser nutzen zu können und sind über eine stark skulpturale Wendeltreppe erreichbar.

Au cours des années qui suivent la Seconde Guerre mondiale, Rufus Nims figure à l'avant-garde d'un groupe d'architectes qui adopte la technologie moderne tout en la critiquant. Ils expérimentent de nouvelles solutions structurelles pour construire des maisons légères qui ne font pas appel à l'air conditionné, mais se servent des vents dominants pour leur ventilation.

Nims, comme Robert Bradford Browne et Peter Jefferson, était fasciné par la manière dont l'architecture moderne pouvait permettre aux maisons de mieux s'intégrer à leur environnement. Si ce mouvement avait su s'organiser, il aurait pu porter le nom de «modernisme tropical». Ces architectes – dont l'œuvre est encore admirée trente ou quarante ans plus tard – voulaient dessiner des maisons réellement adaptées aux Tropiques, au soleil et à la chaleur. Des anciens principes régionaux – surélever la maison par rapport au sol et laisser la brise la traverser – ils avaient fait leurs dogmes.

La maison Otto Cohen, construite à Miami Beach en 1950, est l'une des réalisations les plus exemplaires de Nims; Il combina des panneaux en béton et une ossature en bois pour créer des murs «minces», qui permettent à la maison de mieux respirer. La partie réservée à la vie privée, et même la piscine, se trouvent au second niveau, en haut d'un spectaculaire escalier en spirale, ce qui offre un meilleur accès aux brises dominantes.

RIGHT: A sculptural stairway curves beneath a skylight.
OVERLEAF: New construction technology allowed the house to be both modern and well-suited to the tropical climate.

RECHTS: Die skulpturale Treppe windet sich einem Oberlicht entgegen.
FOLGENDE DOPPELSEITE: Dank neuartiger Bautechniken konnte dieses Haus den Vorstellungen der Moderne entsprechend und gleichzeitig dem tropischen Klima angepaßt errichtet werden.

A DROITE: Un escalier sculptural s'incurve sous une verrière.
DOUBLE PAGE SUIVANTE: Une nouvelle technologie de construction permet à la maison d'être à la fois moderne et adaptée au climat tropical.

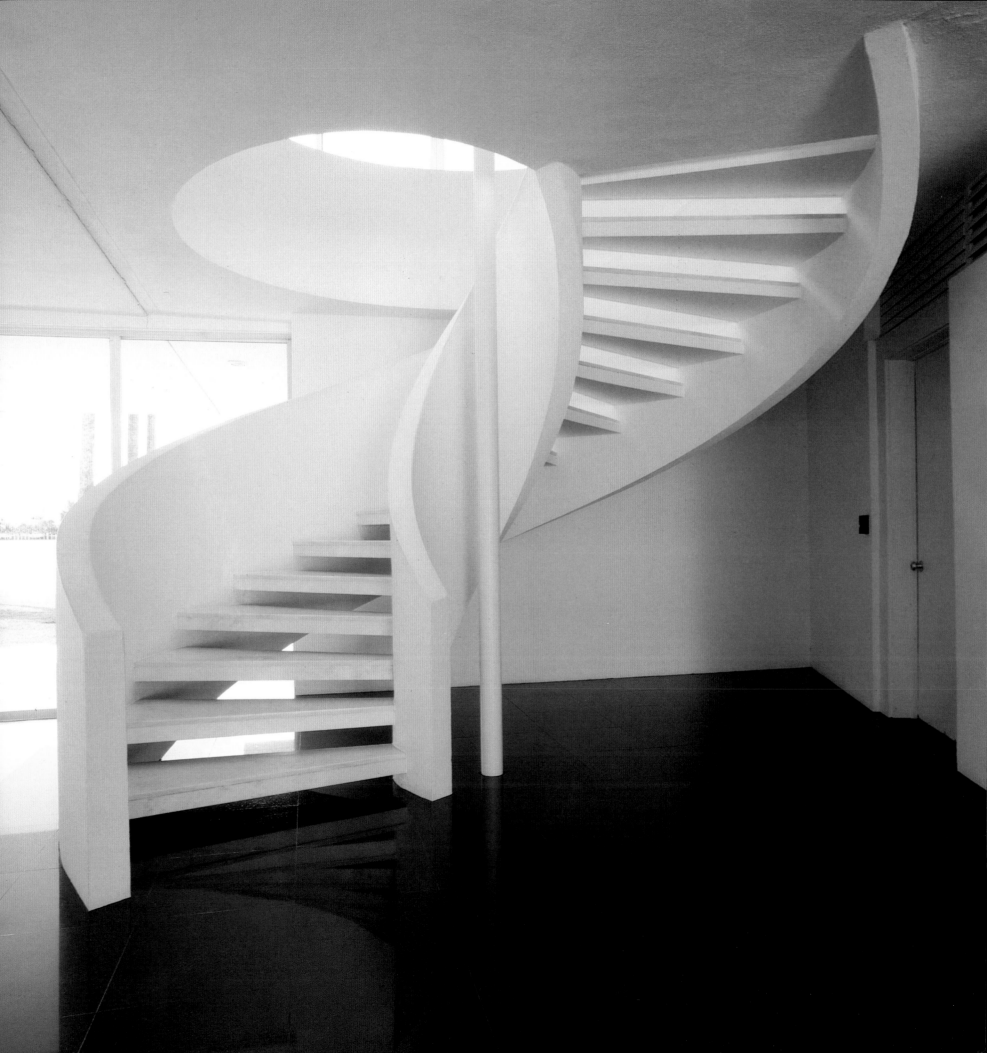

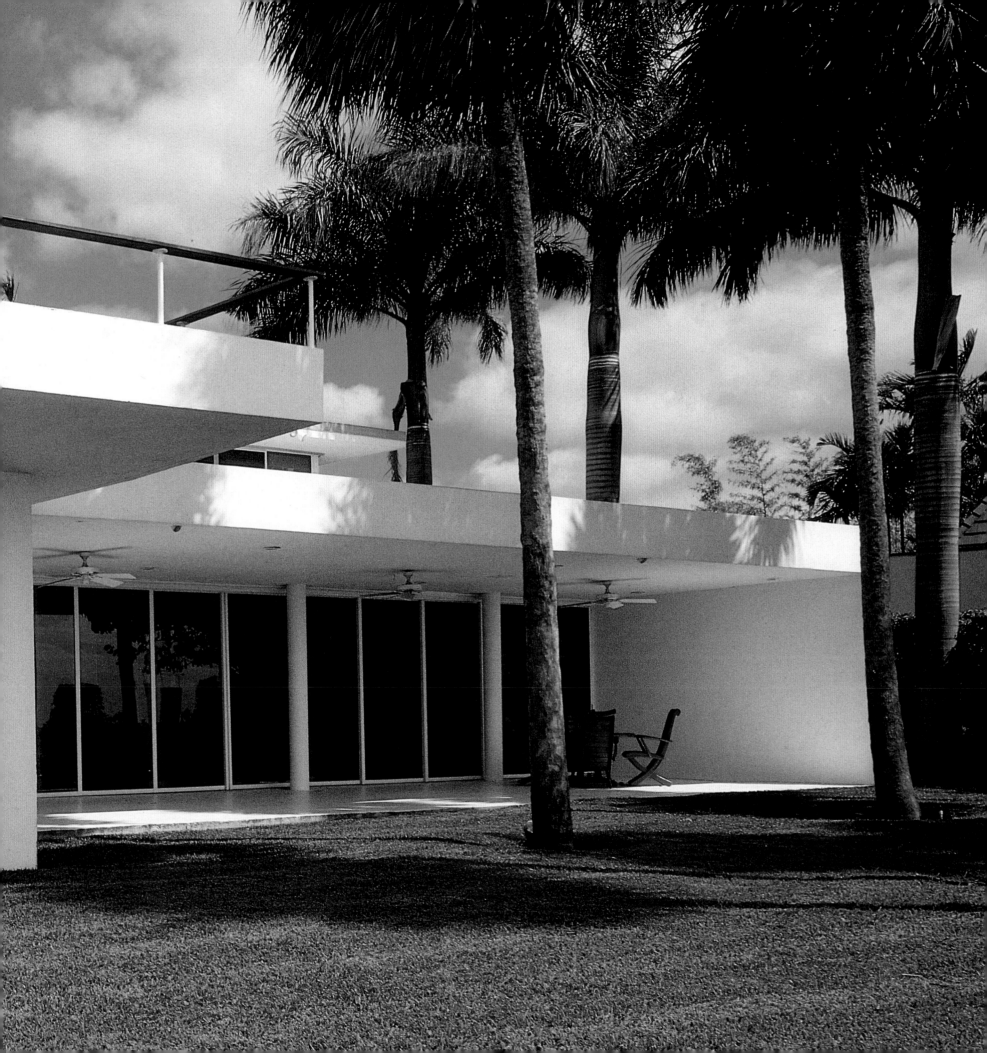

SPEAR HOUSE

Arquitectonica, 1976–78

In many ways, Arquitectonica is synonymous with Miami's coming-of-age as a sophisticated city. The firm – its two principals are the husband-and,wife team of Bernardo Fort-Brescia and Laurinda Spear – pioneered the use of bold colors and improbable geometry that has become a hallmark of the city. The firm's high-rise apartment buildings on Brickell Avenue – the Palace, the Imperial, and the Atlantis – gave expression and identity to a prominent but otherwise nondescript street.

The Spear House, commonly called the Pink House, was Arquitectonica's first completed work, originally designed for Laurinda Spear's parents. It was conceived as a tropical urban house although the setting is actually at the end of a dead-end street on the Biscayne Bay edge of a 1920s suburban town, Miami Shores. The house achieved instant recognition for Arquitectonica, primarily because of its bold use of color. Its five different shades of pink have subsequently become almost synonymous with Miami, but were shocking in the 1970s, when the city's predominant hues ranged from white to beige.

Arquitectonica's work is seldom (though one could not say never) referential, yet the references to Miami's Modernist traditions in the Pink House are clear. It is a long, thin house, designed to maximize its bayfront vantage point and to allow breezes to flow through it. The house steps down on the city side and up on the bay side, giving it more prominence from afar.

In vielerlei Hinsicht ist die Firma Arquitectonica gleichbedeutend mit der Entwicklung Miamis zu einer kultivierten Stadt. Das von dem Architektenehepaar Bernardo Fort-Brescia und Laurinda Spear gegründete Büro, trieb die Verwendung kräftiger Farben und ungewöhnlicher geometrischer Formen voran, heute typische Merkmale der Stadt. Die von Arquitectonica an der Brickell Avenue errichteten Appartementhochhäuser – das Palace, das Imperial und das Atlantis – verliehen einer bis dahin zwar bekannten, aber ansonsten nichtssagenden Straße Ausdruckskraft und eine eigene Identität.

Das Spear House – auch als Pink House bezeichnet – ist das erste fertiggestellte Bauwerk der Firma Arquitectonica. Es wurde ursprünglich für Laurinda Spears Eltern entworfen und als tropisches Stadthaus konzipiert, obwohl es sich am Ende einer Sackgasse am Rande der Biscayne Bay in Miami Shores befindet, einer in den 20er Jahren angelegten Vorstadt. Durch dieses Haus machte Arquitectonica sofort auf sich aufmerksam – hauptsächlich aufgrund der kühnen Verwendung von Farben.

Obwohl die Werke von Arquitectonica nur selten stilistische Bezüge aufweisen, sind die Verweise auf Miamis moderne Tradition beim Pink House deutlich erkennbar. Es handelt sich um ein langes, schmales Haus, dessen Entwurf darauf abzielt, die Lage an der Biscayne Bay optimal zu nutzen. Das Gebäude wurde zur Stadt hin stufig angelegt und steigt auf der Wasserseite an – wodurch es aus größerer Entfernung besser zu erkennen ist. Seitlich des Hauses erstreckt sich ein halbumschlossener, teilweise überdachter Swimmingpool.

A de nombreux égards, le nom d'Arquitectonica est synonyme d'un Miami plus mûr, en route vers la sophistication. L'agence – dont les responsables sont un couple marié, Bernardo Fort-Brescia et Laurinda Spear – a été la première à faire appel à des couleurs vives, et ses audacieuses compositions géométriques sont devenues un des symboles de la cité. Les barres d'appartements qu'ils ont construites sur Brickell Avenue – le Palace, l'Imperial et l'Atlantis – ont donné une identité et une force expressive à cet axe important jusque-là bien impersonnel.

La Spear House, souvent appelée Pink House (la maison rose) est la première réalisation d'Arquitectonica. Elle a été conçue à l'origine pour les parents de Laurinda Spear, et pensée comme une maison de ville sous les Tropiques, bien qu'elle se trouve en fait au fond d'une impasse en bordure de Miami Shores, une cité de banlieue des années 20 édifiée au bord de Biscayne Bay. Par ses couleurs éclatantes, elle a instantanément attiré l'attention sur Arquitectonica. Ses cinq tons différents de rose, qui font maintenant partie de l'image de Miami, choquèrent dans les années 70, lorsque la ville en était encore au blanc et au beige.

Il est difficile de rattacher les travaux d'Arquitectonica à une tendance architecturale particulière, et pourtant, ici, les références aux traditions modernistes de Miami sont claires. La maison semble assez basse côté ville et beaucoup plus élevée côté baie, ce qui lui donne une allure assez proéminente, vue de loin.

RIGHT: The Spear Houses's defining materials are stucco, concrete, and glass block.
OVERLEAF: In an era when most of Miami was white or beige, Arquitectonica used several hues of pink for their first house.

RECHTS: Putz, Beton und Glasbausteine sind die charakteristischen Baumaterialien des Spear House.
FOLGENDE DOPPELSEITE: Für ihr erstes Haus verwendeten Arquitectonica verschiedene Schattierungen von Rosa und Pink – und dies zu einer Zeit, in der in Miami die Farben Weiß und Beige vorherrschten.

A DROITE: Spear House se définit également par ses matériaux: le stuc, le béton et les pavés de verre.
DOUBLE PAGE SUIVANTE: A une époque où la plus grande partie de Miami était restée fidèle au blanc et au beige, Arquitectonica n'a pas hésité à utiliser plusieurs tons de rose pour sa première réalisation.

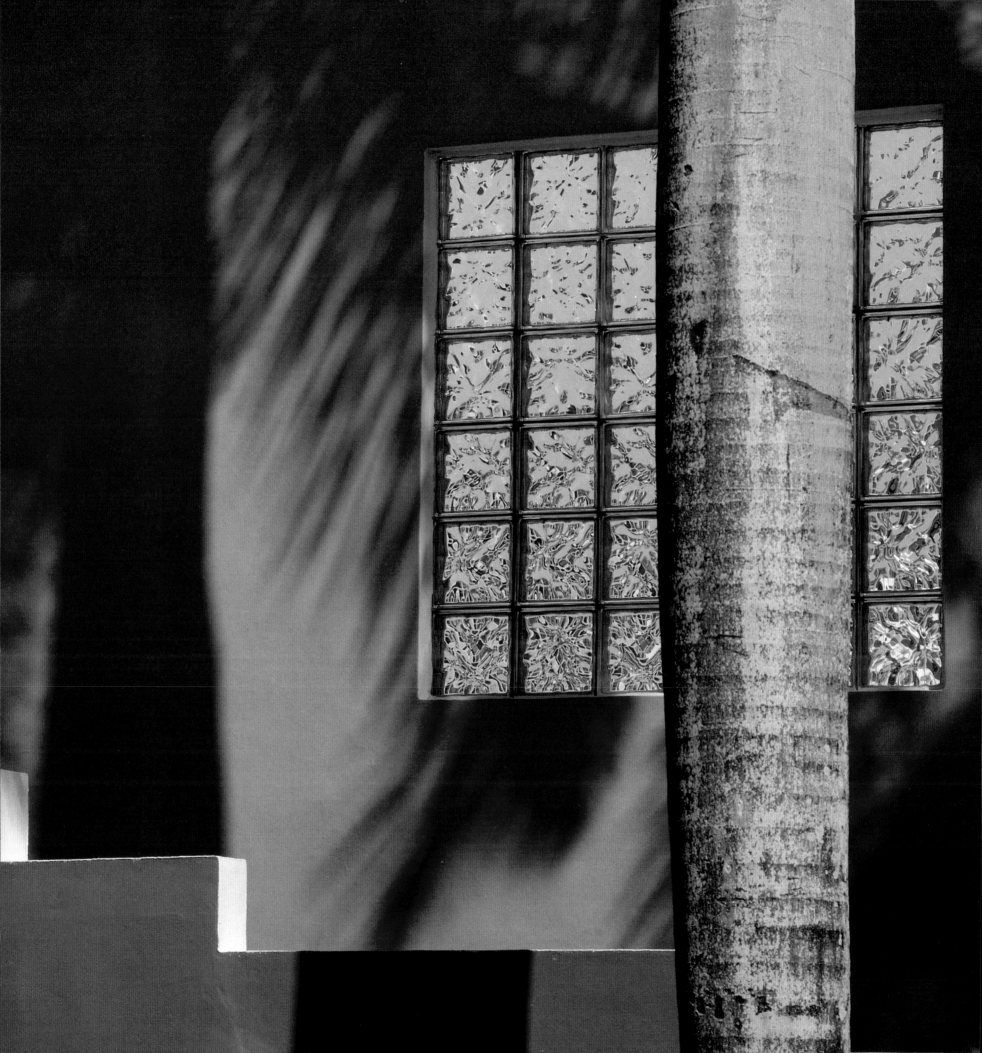

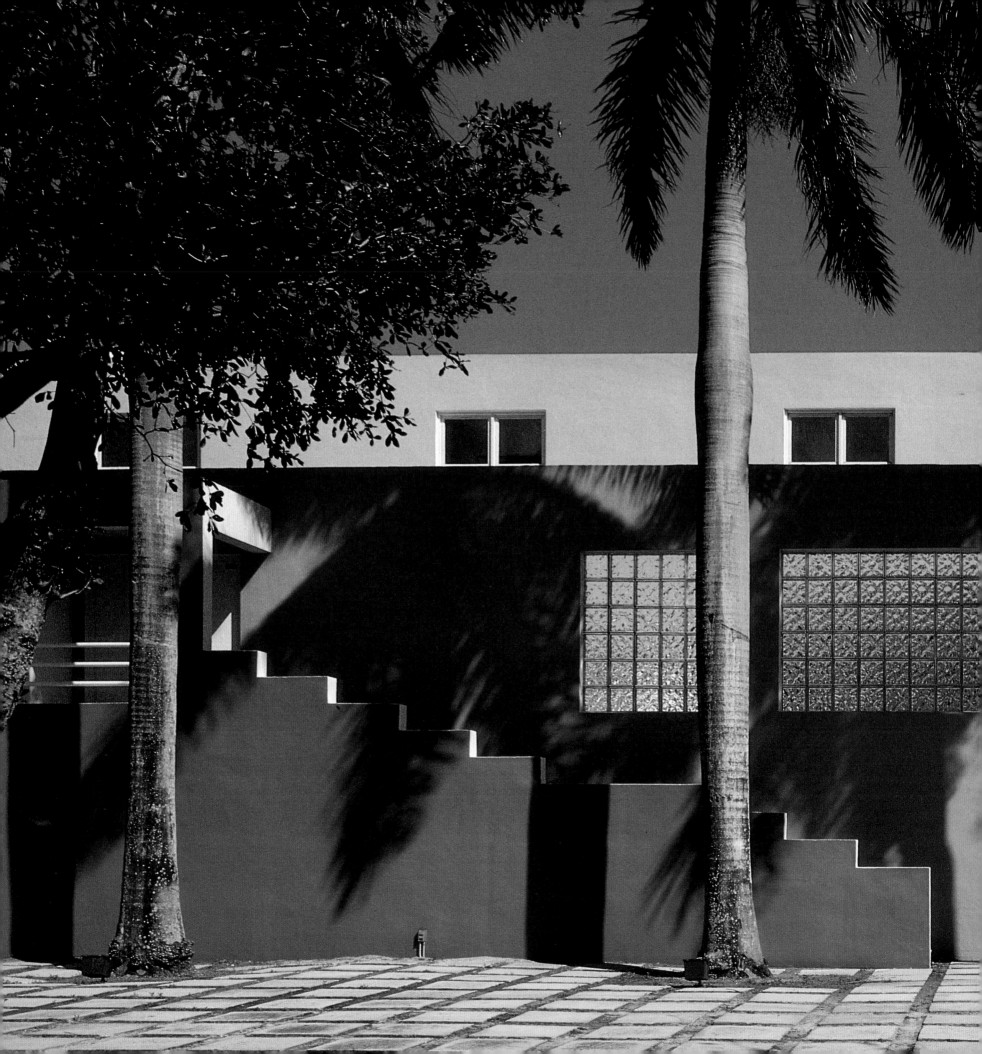

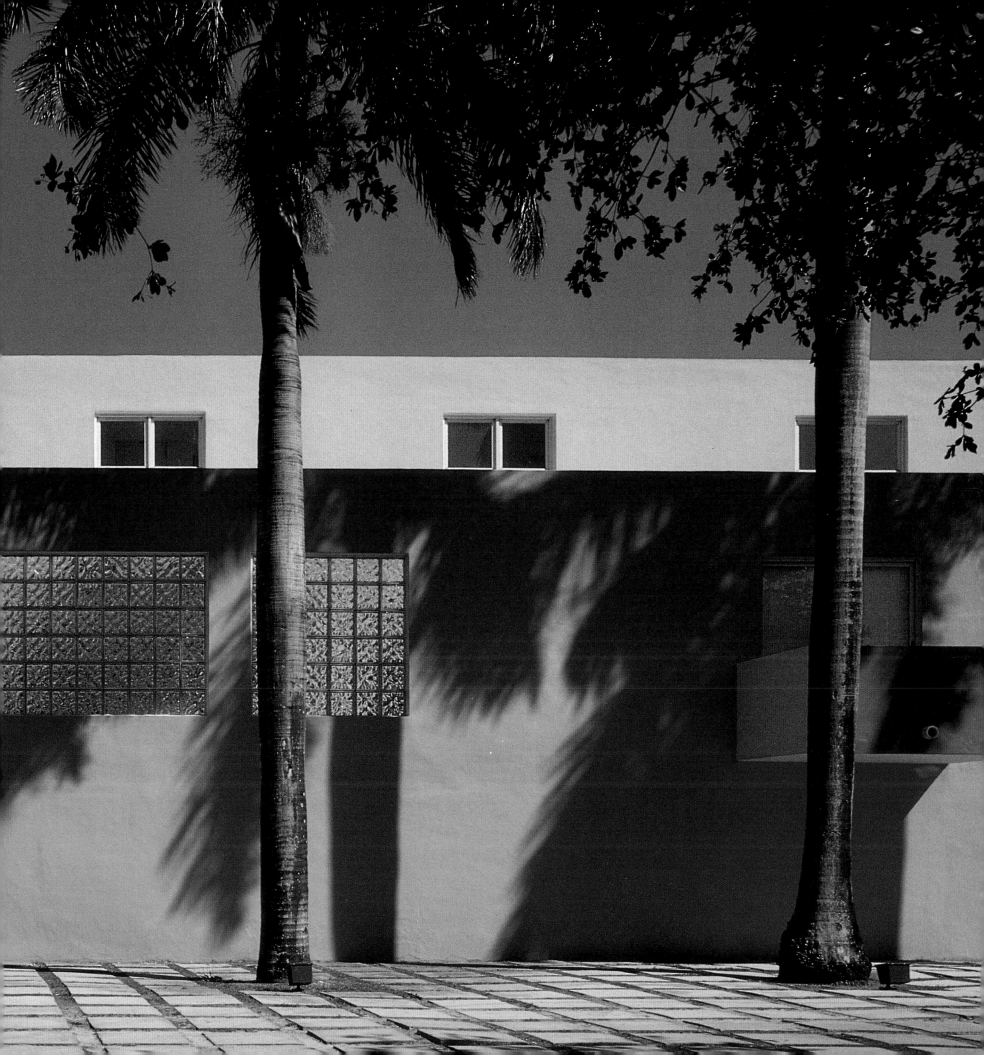

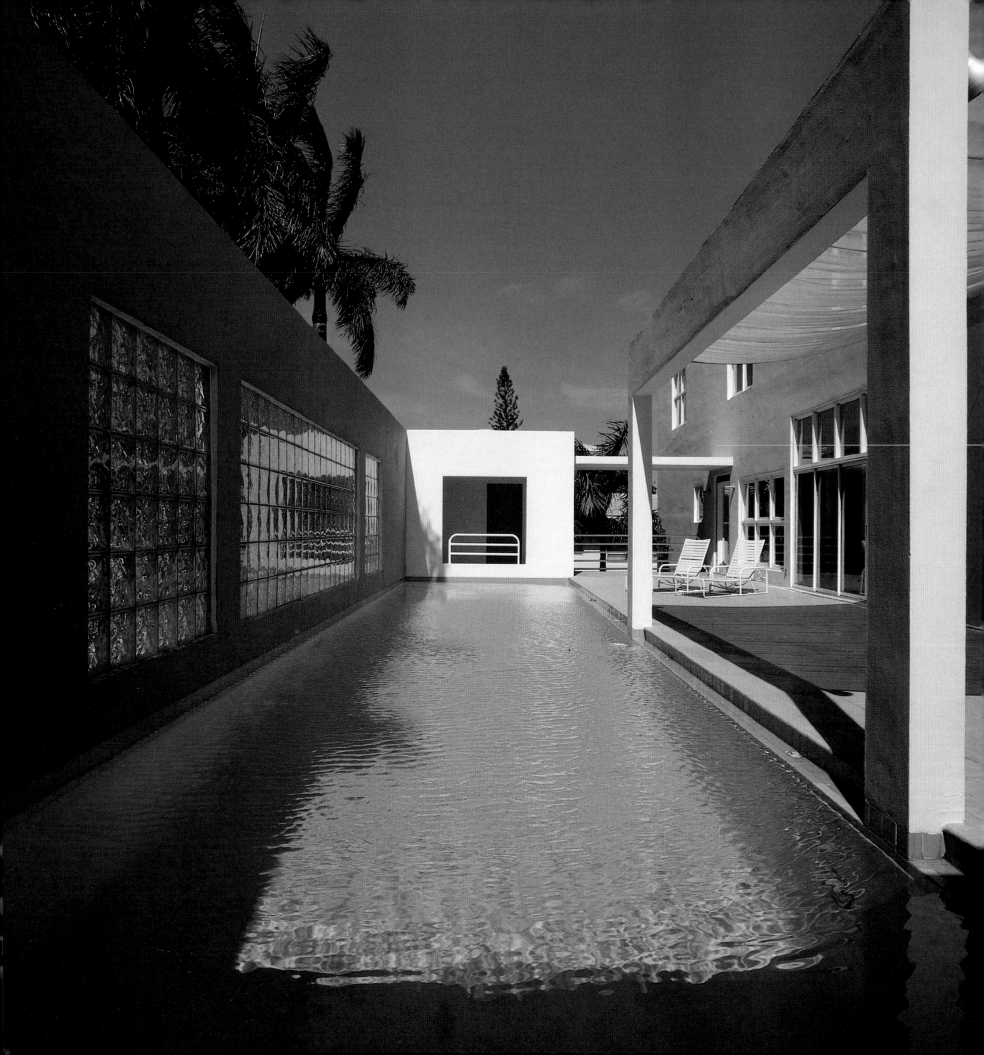

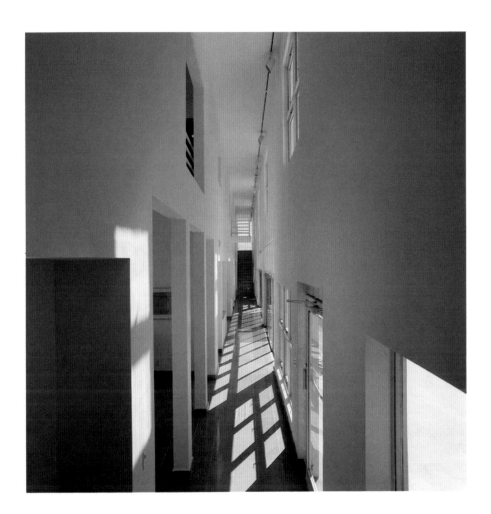

LEFT: The pool sits inside the house.
ABOVE: A narrow hallway connects rooms and helps link the interior spaces with the exteriors.

LINKS: Der Swimmingpool befindet sich im Innenhof des Hauses.
OBEN: Ein schmaler Gang verbindet die einzelnen Räume und das Hausinnere mit den Außenbereichen.

A GAUCHE: Le bassin pénètre dans la maison.
CI-DESSUS: Une galerie étroite réunit les pièces et fait le lien entre les espaces intérieurs et extérieurs.

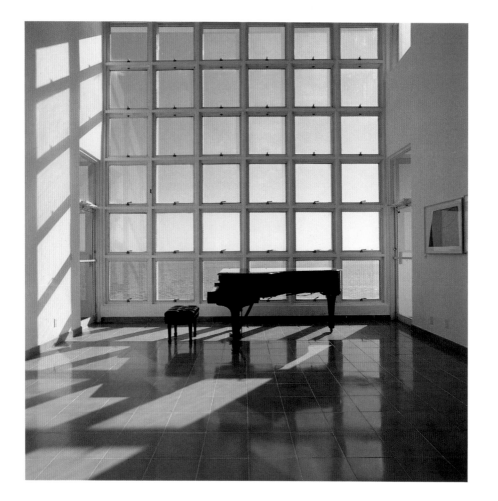

ABOVE: A grand piano stands in the living room's gridded sunlight.
RIGHT: The bay side of the house is more powerful, and more villa-like.

OBEN: Ein Flügel im gerasterten Sonnenlicht des Wohnzimmers.
RECHTS: Die zum Meer gewandte Seite des Hauses wirkt ausdrucksstärker und erinnert an eine Villa.

CI-DESSUS: Un piano à queue dans le salon, devant la trame d'une vaste baie vitrée.
A DROITE: La façade sur Biscayne Bay est plus puissamment dessinée, plus proche de celle d'une villa.

VARIOUS BUILDINGS

Andres Duany and Elizabeth Plater-Zyberk, 1988–96

Andres Duany and Elizabeth Plater-Zyberk have garnered world renown for their pioneering work in town planning; starting with the resort town of Seaside, on the Florida panhandle, they have designed more than one hundred traditional towns around the world. Together they have spearheaded the movement known as New Urbanism, and they are considered to be leaders in the development of what architectural historian Vincent Scully has termed the "School of Miami."

Less well known is their architectural work, which is rooted in both Classicism and the idea of synthesis. Early on in their careers in Miami, Duany and Plater-Zyberk began to explore ways in which the region's three dominant architectural traditions could be intertwined to create a new style appropriate for an ever more complex and sophisticated city. Their work began to embrace the vernacular (alternatively called "Cracker" or craftsman), the Mediterranean Revival, and the Modern. Typical of this exploration is their Tahiti Beach House, which sits on a bayfront site in Coral Gables. Like its Cracker predecessors, the house places living spaces on the second floor and like its Mediterranean ancestors, it is organized around an atrium. Yet the house is ultimately Modern, a clear exercise in regular geometry.

The projects shown here display a range of Duany and Plater-Zyberk's work, from their own office – a converted airplane machine shop, which draws its inspiration from Classical sources and its colors from Pompeii – to two houses designed for the new town of Windsor in Vero Beach, which allude to early buildings in St. Augustine and in the Caribbean.

Andres Duany und Elizabeth Plater-Zyberk haben sich aufgrund ihrer Pionierarbeit auf dem Gebiet der Stadtplanung international einen Namen geschaffen. Nach dem Entwurf des Seebades Seaside im Nordwesten Floridas planten sie auf der ganzen Welt über einhundert Städte und Gemeinden. Darüber hinaus gelten sie als die Vorreiter einer Strömung namens »New Urbanism« und als treibende Kraft bei der Entwicklung einer Bewegung, die der Architekturhistoriker Vincent Scully als »School of Miami« bezeichnete.

Ihre architektonischen Werke, deren Wurzeln sowohl im Klassizismus als auch in der Idee der Synthese liegen, sind dagegen weniger bekannt. Zu Beginn ihrer Karriere suchten Duany und Plater-Zyberk nach Wegen, die drei in der Region vorherrschenden Architekturtraditionen zu einem neuen Stil zu verbinden, passend zu einer ständig komplexer und moderner werdenden Stadt. Ihre Arbeiten begannen, die einheimische Architektur (auch als »Cracker« oder »Craftsman« bezeichnet) ebenso wie den Mediterranean Revival Style und die Moderne zu umfassen.

Die hier gezeigten Projekte zeigen einen kleinen Querschnitt der Arbeiten von Duany und Plater-Zyberk – angefangen von ihrem eigenen Büro (einem umgebauten Flugzeughangar, bei dem sie sich von klassisch-antiken Quellen und den Farben der Stadt Pompeji inspirieren ließen) bis hin zu zwei Häusern für die neu angelegte Stadt Windsor in Vero Beach, die auf frühere Gebäude in St. Augustine und in der Karibik anspielen.

La réputation internationale d'Andres Duany et Elizabeth Plater-Zyberk tient à leurs interventions d'avant-garde dans le domaine de l'urbanisme. Ils ont dessiné plus de cent «villes» dans le monde. Ensemble, ils ont pris la tête d'un mouvement appelé «Nouvel urbanisme», et sont considérés comme les leaders du développement de ce que l'historien de l'architecture Vincent Scully a baptisé «l'école de Miami».

Nourrie de classicisme et de syncrétisme, leur œuvre architecturale est moins bien connue. Au début de leur carrière à Miami, ils se sont intéressés à la manière dont les trois principales traditions architecturales de la région pouvaient être associées pour créer un style neuf, approprié à une ville de plus en plus complexe, de plus en plus sophistiquée. Leur œuvre fut peu à peu marquée par le vernaculaire (appelé style «Cracker» ou artisanal), le style néo-méditerranéen et le modernisme. Leur Tahiti Beach House est typique de cette appropriation. Elle se situe sur la baie, à Coral Gables. Comme chez ses prédécesseurs «Cracker», les pièces à vivre se trouvent au premier étage de façon à mieux profiter de la ventilation naturelle. Brillant exercice de géométrie, elle s'organise autour d'un atrium comme ses ancêtres méditerranéennes. Cette maison n'en est pas moins totalement moderne.

Les projets présentés ici montrent plusieurs aspects de l'œuvre des architectes de leurs propres bureaux – un ancien magasin de moteurs d'avion qui s'inspire de sources classiques et des couleurs de Pompéi – à deux maisons dessinées pour la ville nouvelle de Windsor à Vero Beach, qui font allusion à des constructions anciennes de St. Augustine et des Caraïbes.

The reception hall of the DPZ office.

Empfang des DPZ-Büros.

La hall de réception de l'agence DPZ.

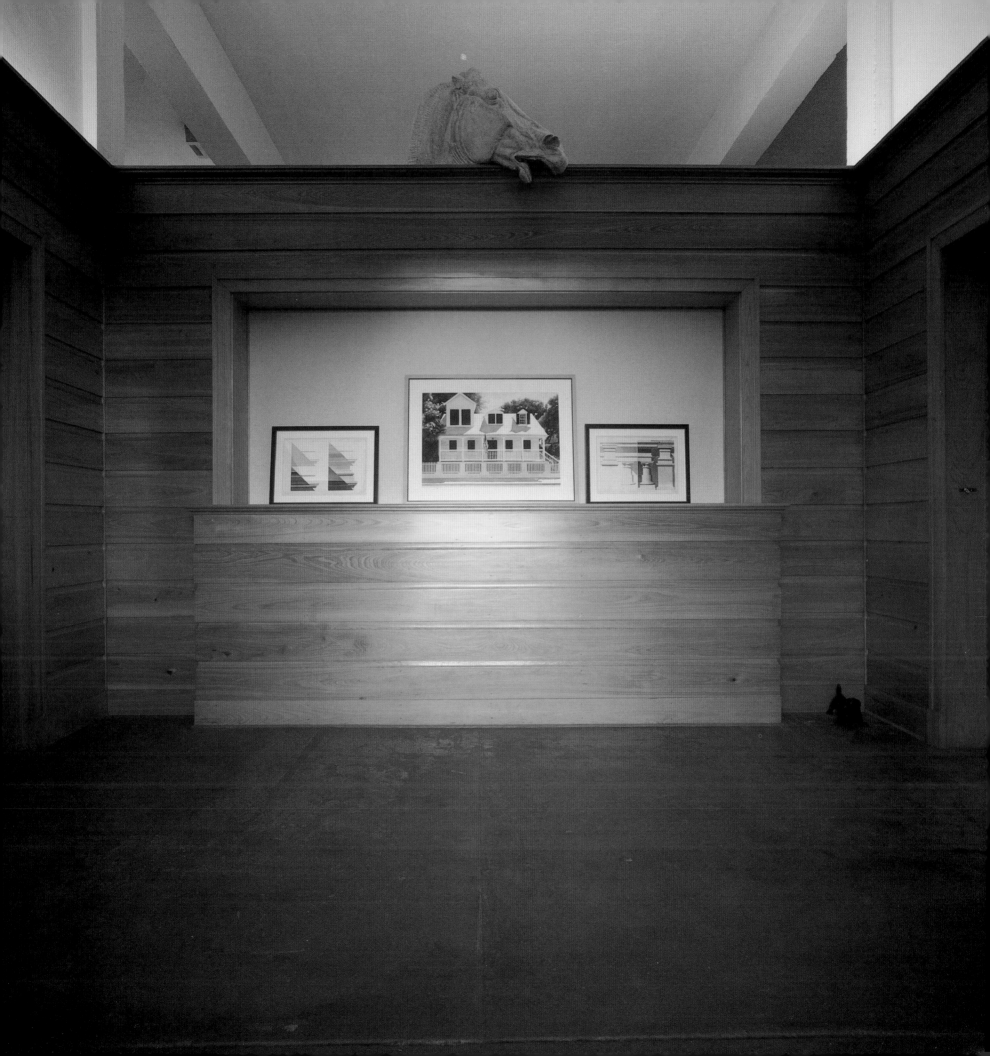

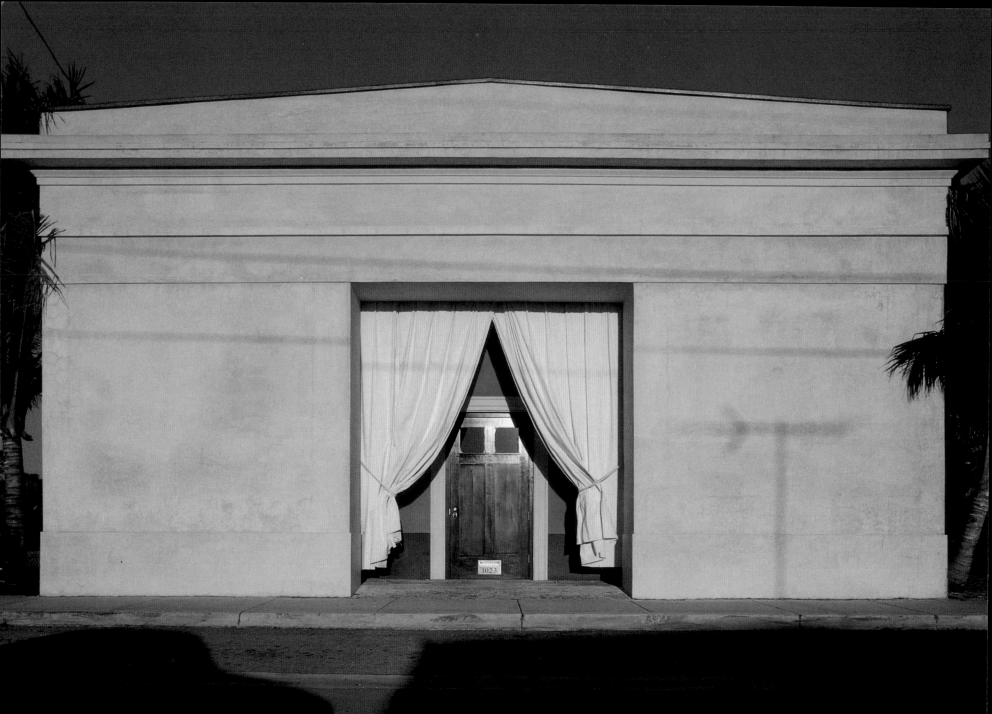

LEFT: The office is a converted airplane machine shop.
ABOVE: Office detail.

LINKS: Das DPZ-Büro befindet sich in einem umgebauten ehemaligen Hangar.
OBEN: Detail des Büros.

A GAUCHE: L'agence est un ancien magasin de moteurs d'avion reconverti.
CI-DESSUS: Détail de l'agence.

ABOVE: A column capital at the Sheftal House. RIGHT: The house was inspired by Genoese designs.
FIRST OVERLEAF: This house in Windsor exhibits the influence of three architectural traditions.
SECOND OVERLEAF: DPZ's first house in Windsor alludes to the early architecture of St. Augustine.

OBEN: Ein Säulenkapitell des Sheftal House. RECHTS: Das Haus wurde nach Genueser Vorbildern entworfen.
FOLGENDE DOPPELSEITE: Dieses Haus in Windsor zeigt den Einfluß dreier Architekturtraditionen.
DARAUFFOLGENDE DOPPELSEITE: DPZs erstes Haus in Windsor erinnert an die frühe Architektur von St. Augustine.

CI-DESSUS: Chapiteau de colonne, Sheftal House. A DROITE: La maison s'inspire de dessins génois.
PREMIERE DOUBLE PAGE SUIVANTE: Cette maison de Windsor montre l'influence de trois traditions architecturales.
SECONDE DOUBLE PAGE SUIVANTE: La première maison construite par DFZ à Windsor fait allusion à l'architecture
ancienne de St. Augustine.

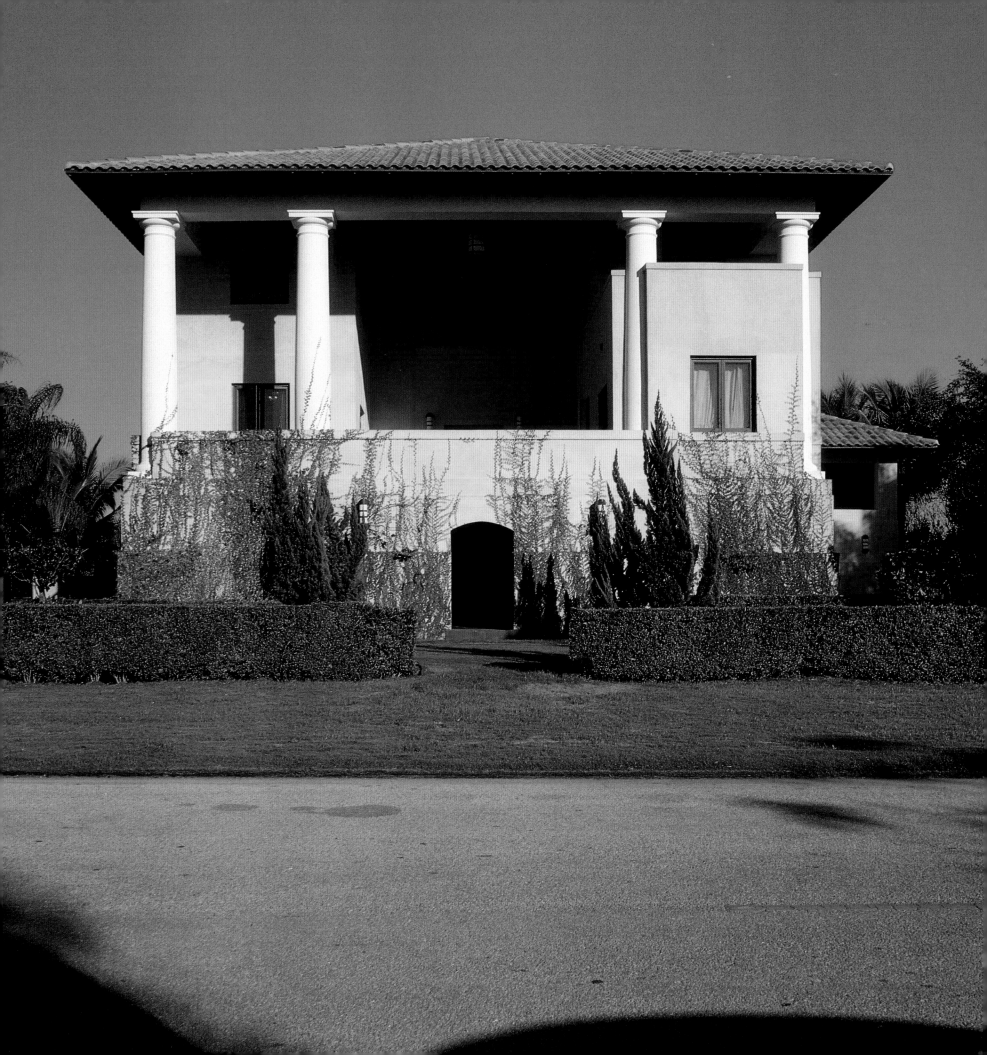

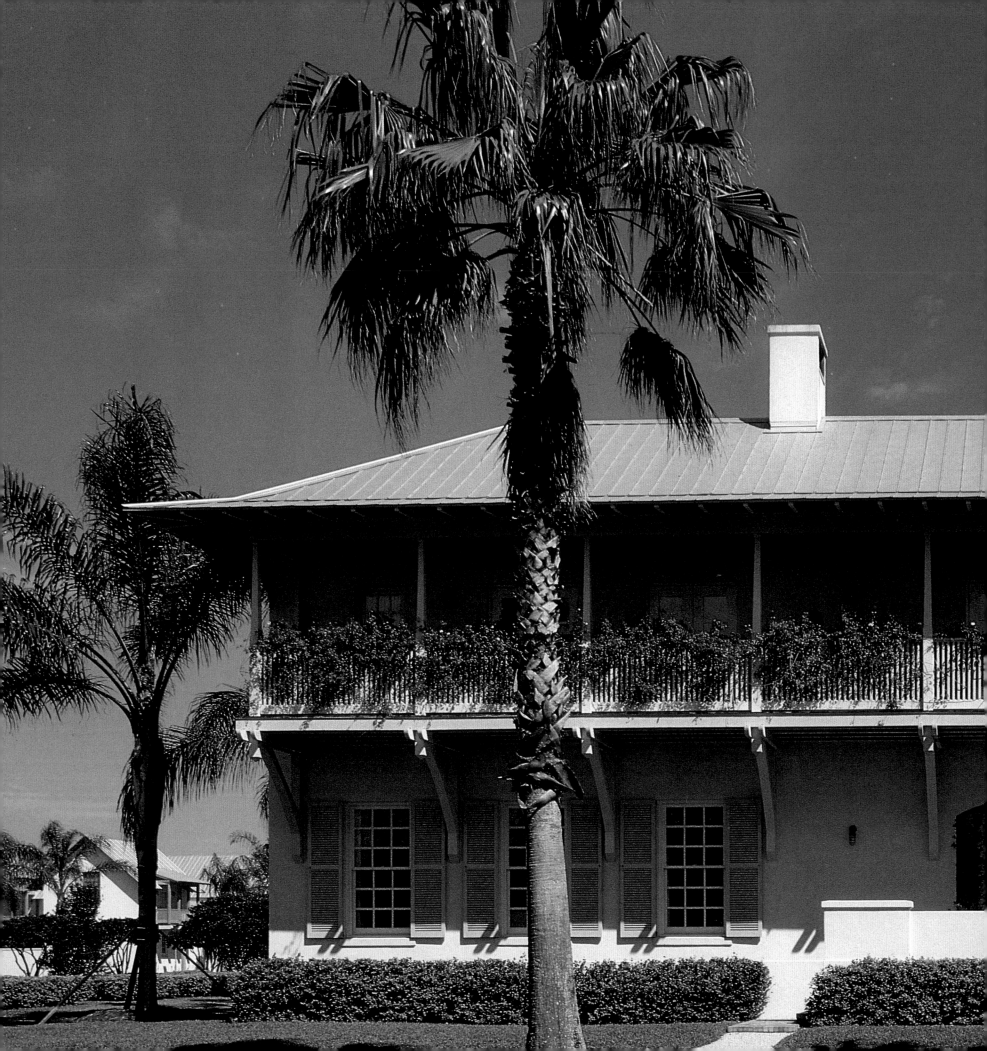

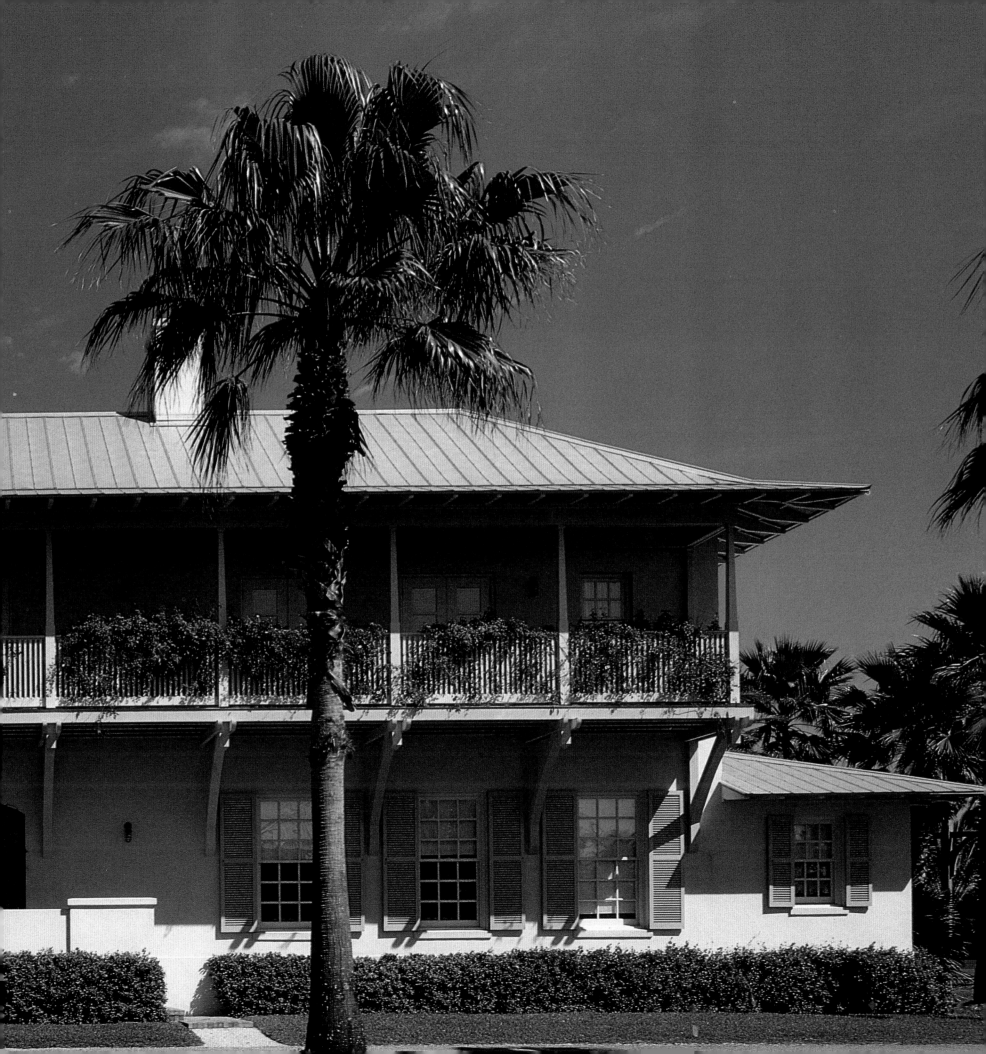

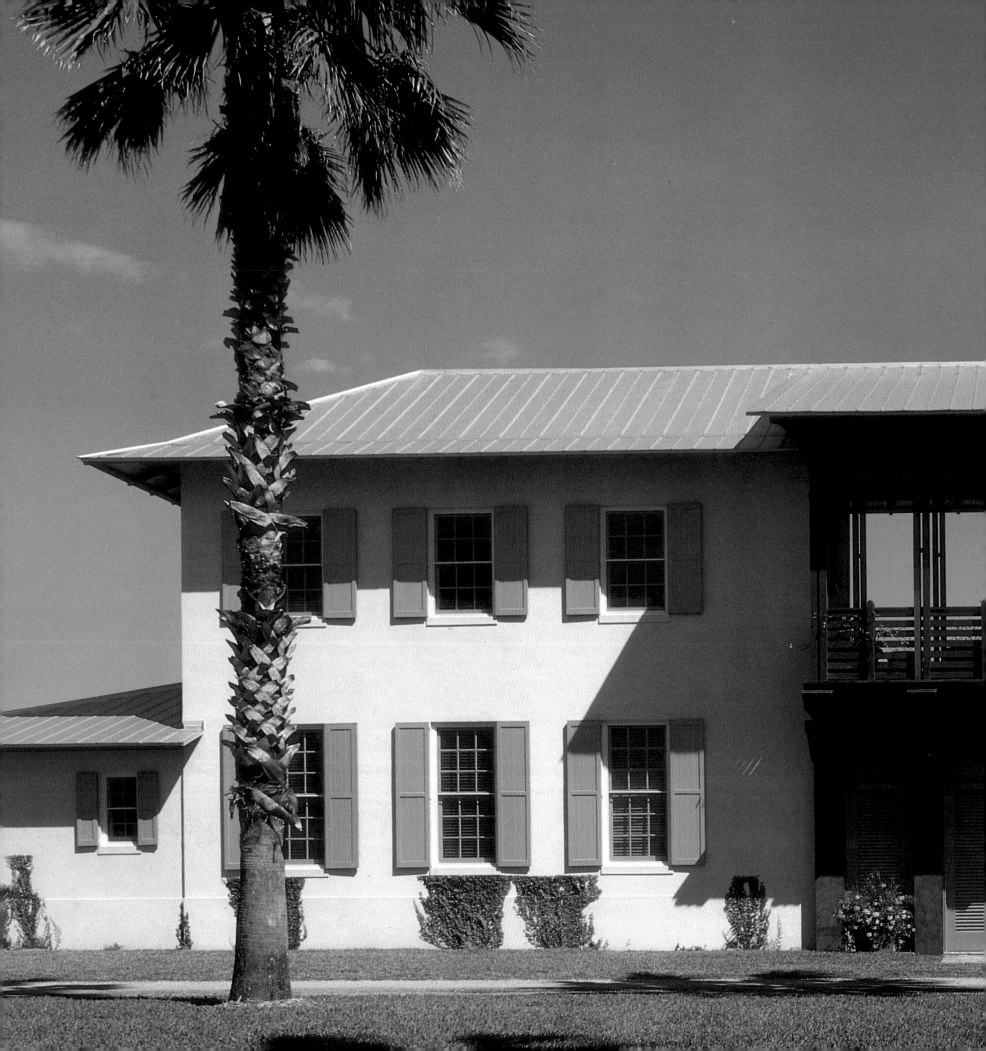

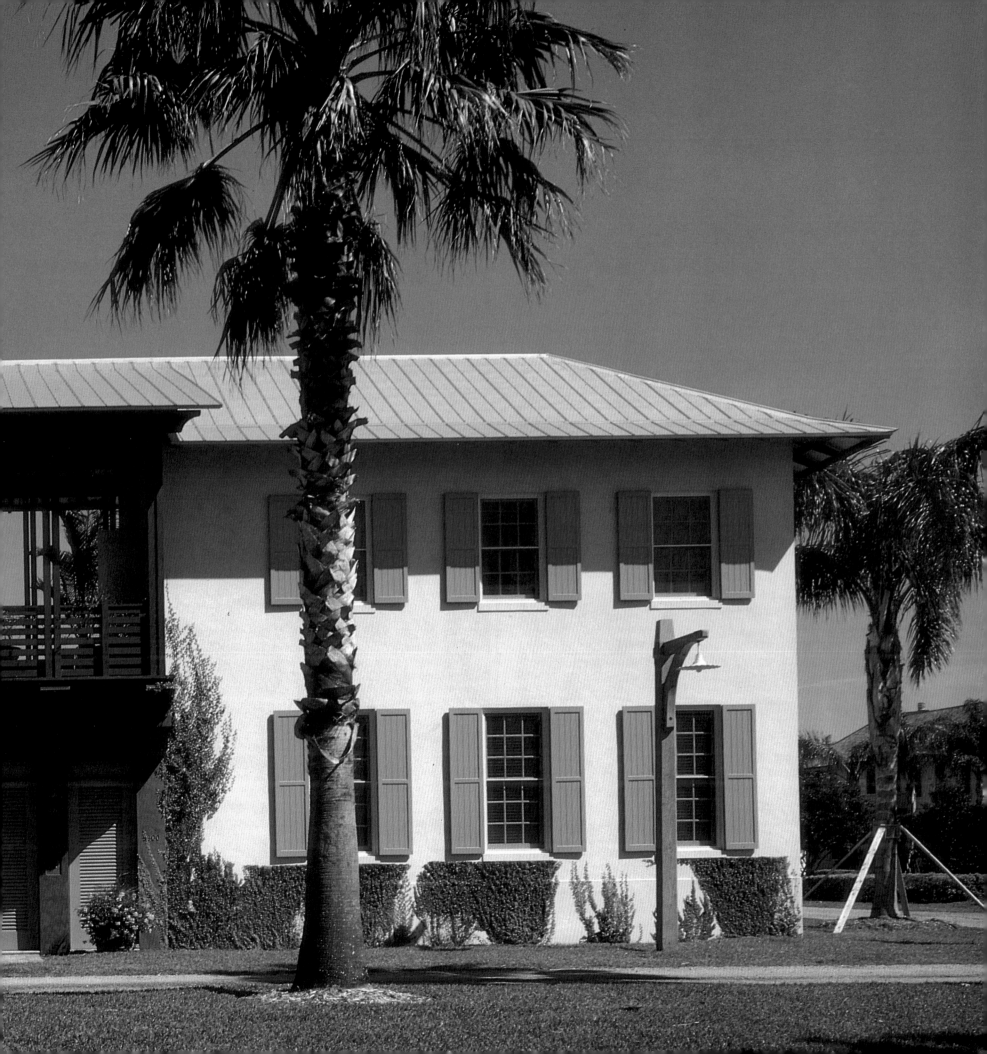

WINDSOR HOUSES

Scott Merrill, 1992–95

Scott Merrill has never lived in Miami, nor has he designed a building there. Yet in a way, he is proof of the spreading influence of the "School of Miami." In his relatively short but noteworthy career, Merrill has worked in two Florida towns, Seaside and Windsor. Both towns are the product of Andres Duany and Elizabeth Plater-Zyberk's Miami planning firm, DPZ, and both have strict architectural codes governing the nature, scale, and style of the houses built within them. It was under this aegis that Merrill came of age as an architect.

Merrill's work in Windsor draws from several specific sources, primarily St. Augustine and the colonial Caribbean, but also, particularly for the side-yard house, Charleston. These are picturesque houses, designed to be seen at a distance and examined close up. Merrill is both a farsighted and nearsighted architect, extremely attentive to detail and very aware of the larger stylistic and social goals of the planned town. He is also a fastidious architect for whom art and craft are inextricable, and this gives his work a finished quality seldom seen in architecture today.

Obwohl Scott Merril weder in Miami gelebt noch hier etwas gebaut hat, ist er Beweis für den sich ausbreitenden Einfluß der »School of Miami«. Während seiner relativ kurzen, aber bemerkenswerten Karriere war Merrill hauptsächlich in zwei Städten Floridas – Seaside und Windsor – tätig. Bei beiden Städten handelt es sich um Produkte von Andres Duany und Elizabeth Plater-Zyberks Stadtplanungsbüro DPZ, und in beiden gelten strikte architektonische Bestimmungen in bezug auf Größe, Stil und Charakter der hier errichteten Häuser. Unter dieser Ägide entwickelte sich Merrill zu einem anerkannten Architekten.

Für seine Häuser in Windsor nutzte er verschiedene Inspirationsquellen – hauptsächlich die Architektur in St. Augustine und die Kolonialbauten der Karibik –, aber auch Charleston lieferte ihm manche Anregung, insbesondere bei den zur Grundstücksseite ausgerichteten Häusern. Bei diesen »side-yard houses« handelt es sich um pittoreske Häuser, die so konzipiert sind, daß sie schon von Weitem gesehen werden sollen, um dann aus der Nähe betrachtet zu werden. Merrill ist ein Architekt mit einem besonderen Blick fürs Detail, der aber auch das zugrunde liegende stilistische und soziale Konzept der geplanten Stadt nicht aus dem Auge verliert. Darüber hinaus gilt er als sehr anspruchsvoller Baumeister, für den Kunst und Handwerk unentwirrbar miteinander verwoben sind – wodurch seine Arbeiten eine vollendete Qualität erhalten, die man in der heutigen Architektur nur selten findet.

Scott Merrill n'a jamais vécu à Miami, et n'y a pas construit la moindre maison. Cependant, d'une certaine façon, il est la preuve de l'influence de «l'école de Miami». Dans sa carrière relativement brève, mais remarquable, il a travaillé dans deux villes de Floride, Seaside et Windsor, toutes deux conçues par l'agence d'urbanisme d'Andres Duany et Elizabeth Plater-Zyberk, DPZ, et toutes deux déterminées par l'application d'un code architectural strict à l'échelle et au style des constructions. C'est dans le cadre de ces contraintes que Merrill s'est fait remarquer.

L'œuvre de Merrill à Windsor s'inspire de plusieurs sources spécifiques, essentiellement St. Augustine et les îles Caraïbes, mais aussi (en particulier pour une maison d'amis), de Charleston. Ce sont des maisons pittoresques, conçues pour être vues de loin, et examinées de très près. Merrill est un architecte à la fois myope et presbyte, extrêmement attentif aux détails et très conscient des enjeux stylistiques et sociaux d'une ville d'urbaniste. Il est également un praticien minutieux, pour lequel l'art et la façon de faire sont inséparables, ce qui donne à ses œuvres une qualité de finition rarement observée dans l'architecture contemporaine.

RIGHT: Rath House courtyard.
OVERLEAF: Windsor townhouses.

RECHTS: Innenhof von Rath House.
FOLGENDE DOPPELSEITE: Stadthäuser in Windsor.

A DROITE: La cour de Rath House.
DOUBLE PAGE SUIVANTE: Les maisons de ville de Windsor.

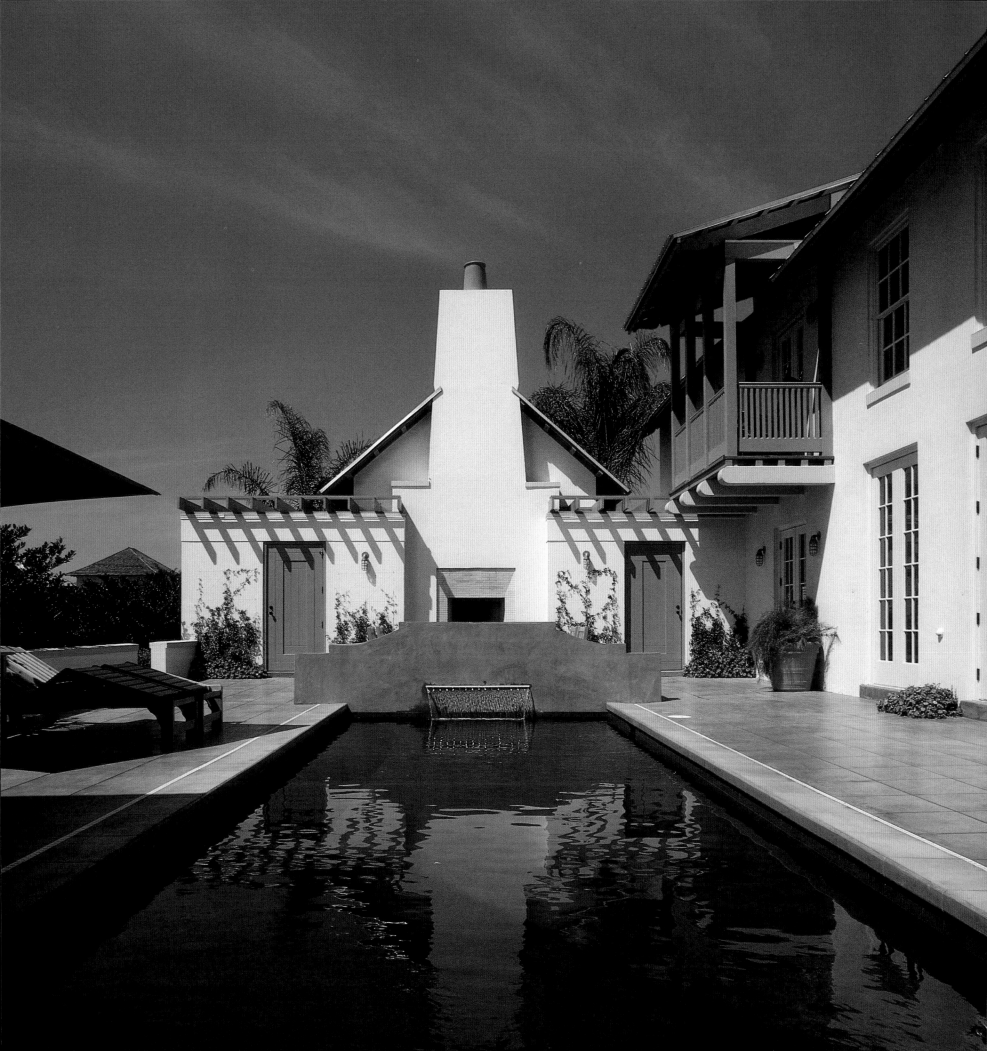

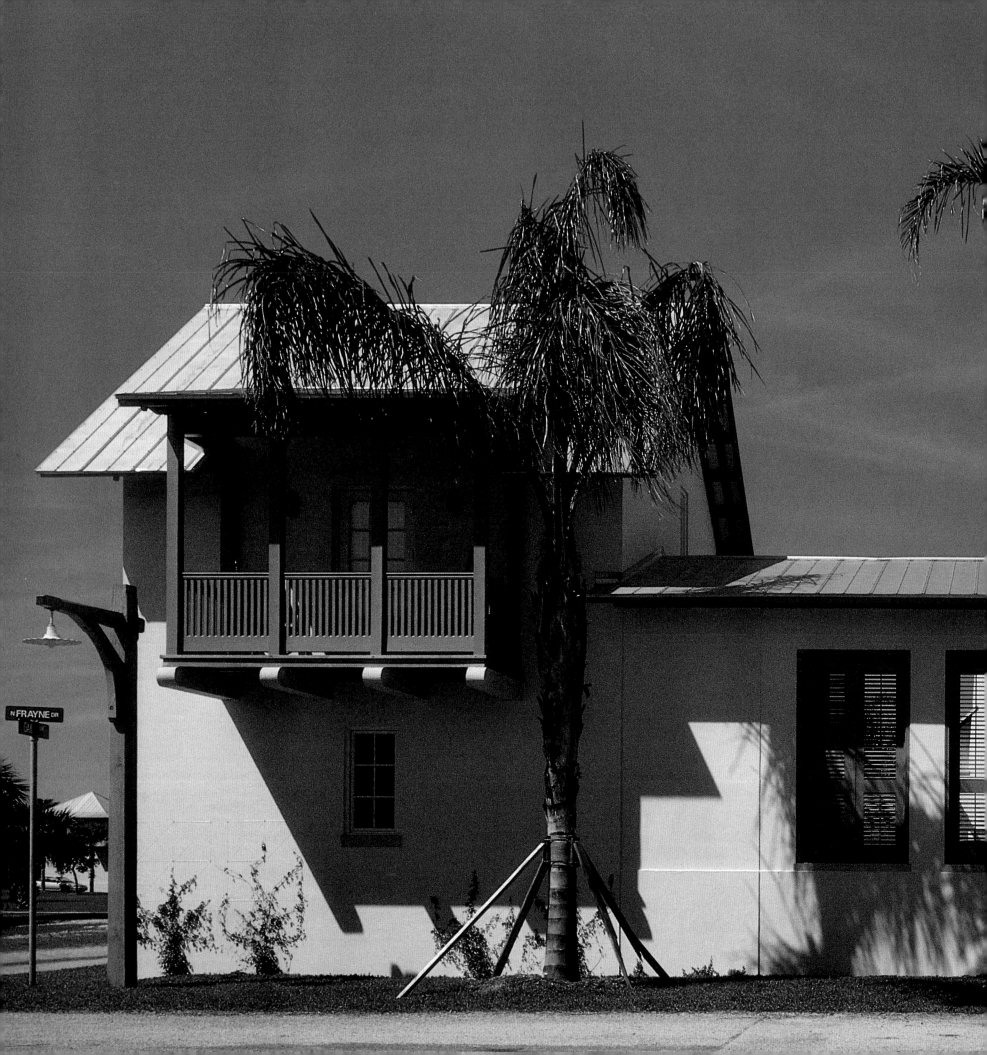

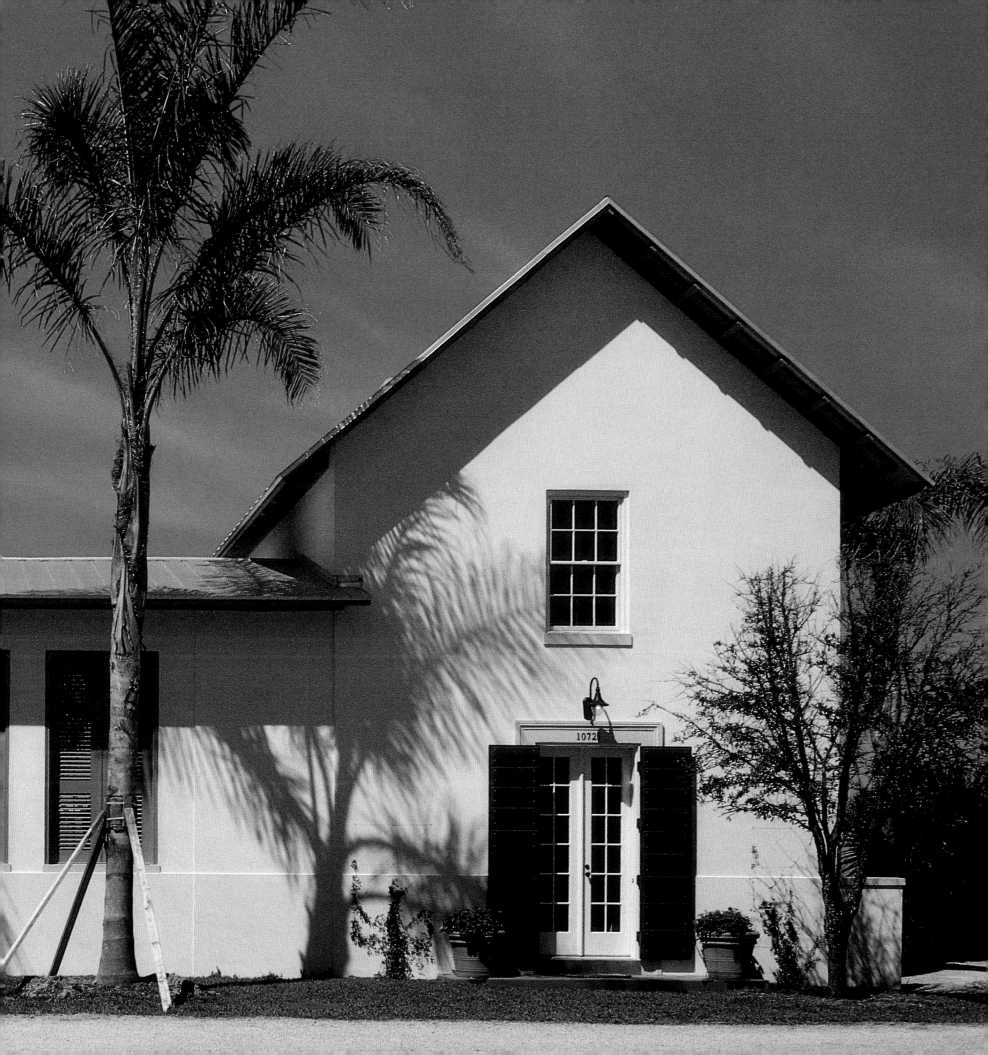

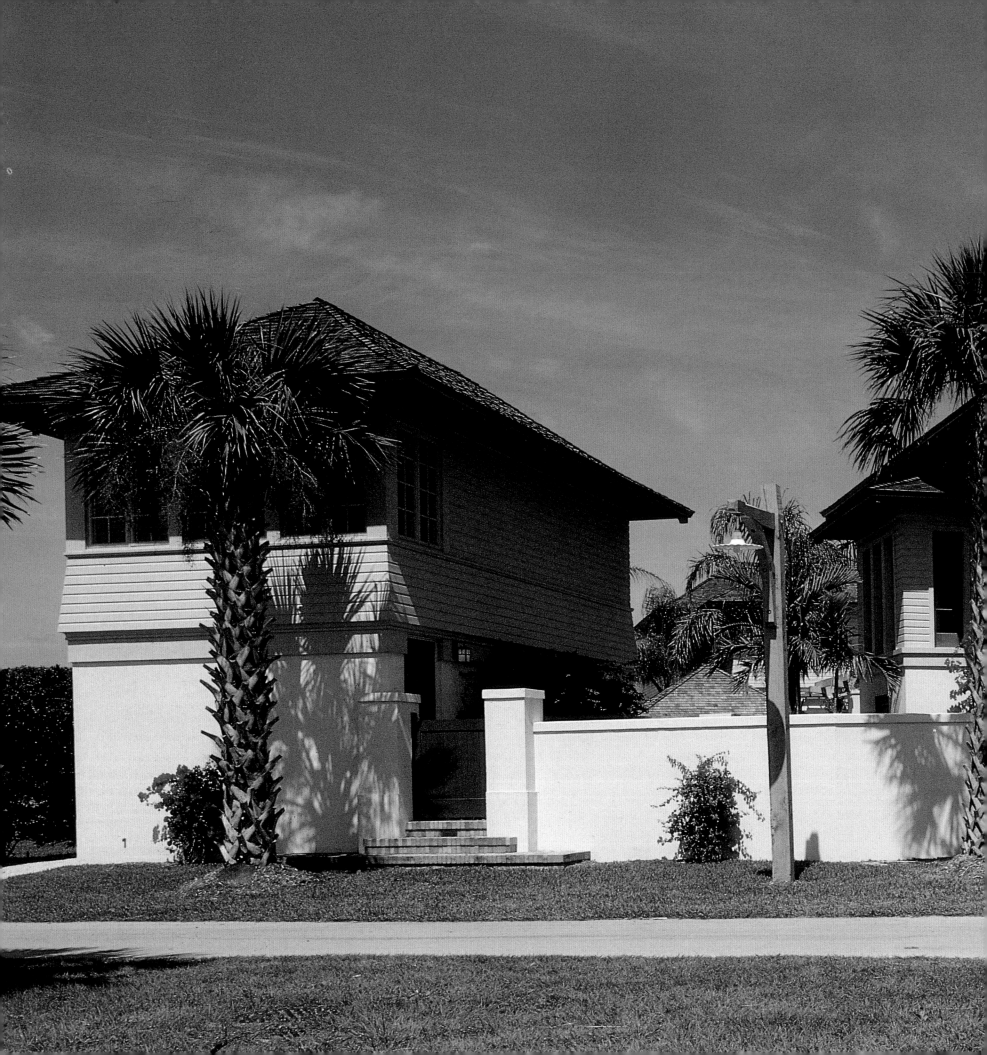

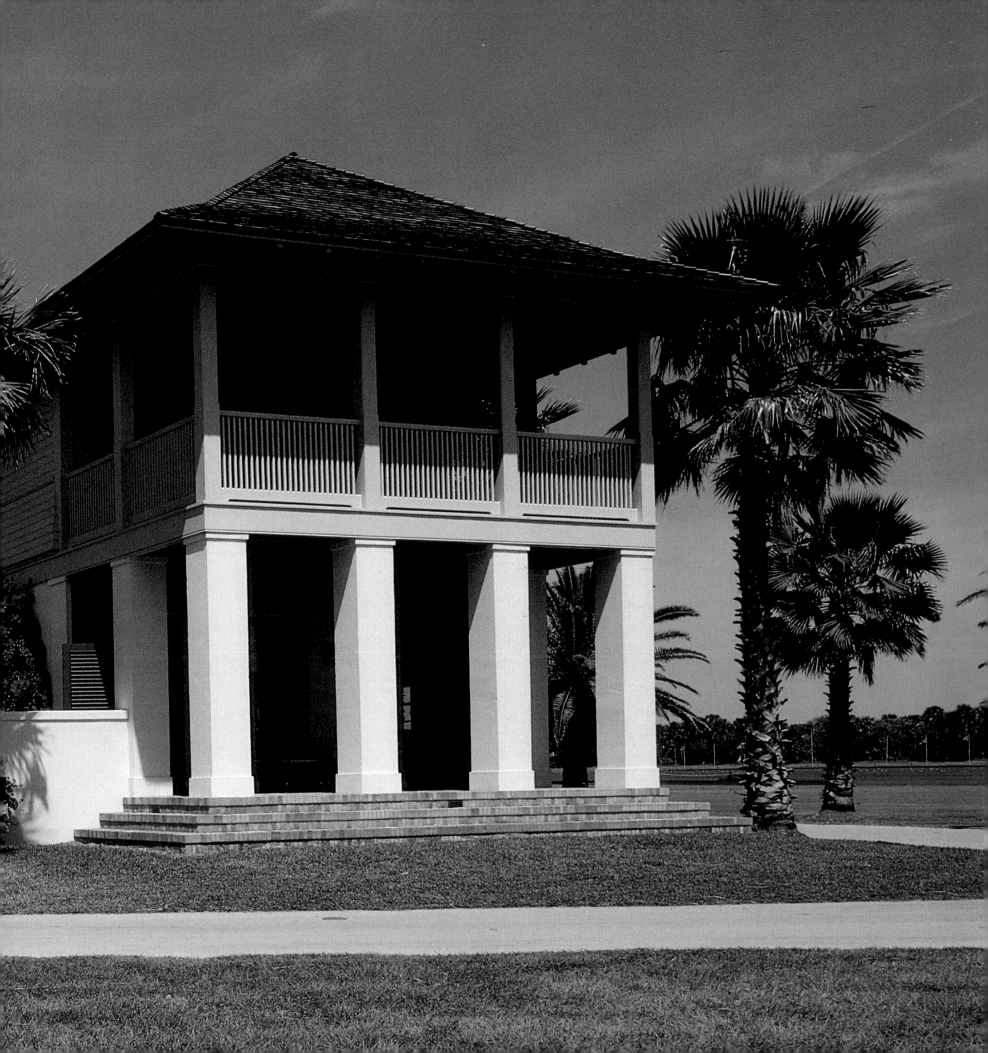

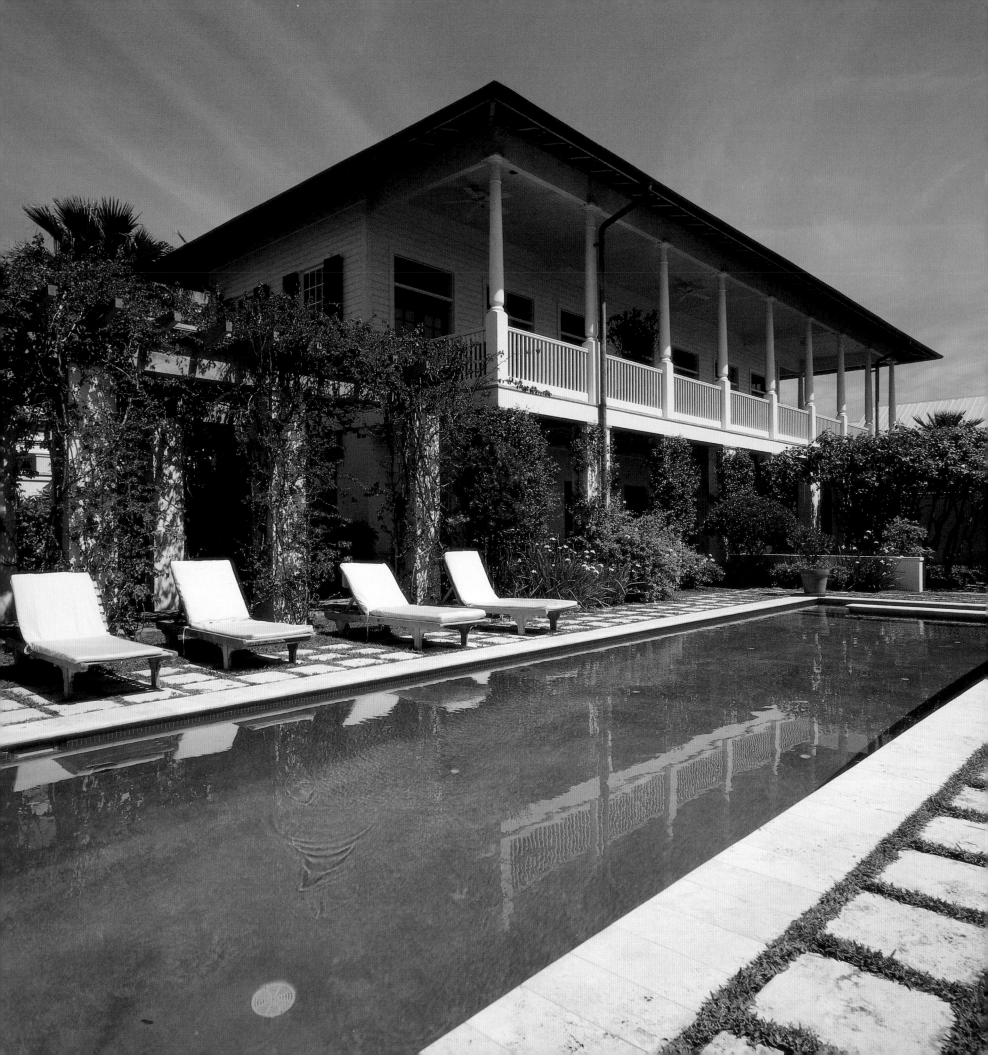

PRECEDING PAGES: View of the tennis cottage, guest house, and main house.
LEFT: Pool and garden facade of the side-yard house.
ABOVE: Second-floor loggia of side-yard house.

VORIGE DOPPELSEITEN: Ansicht des Tenniscottage, des Gästehauses und des Haupthauses.
LINKS: Swimmingpool und Gartenansicht des side-yard house.
OBEN: Loggia im Obergeschoß des side-yard house.

PAGES PRECEDENTES: Vue du pavillon de tennis, de la maison d'amis et de la maison principale.
A GAUCHE: Façade sur le jardin et la piscine de la maison d'amis.
CI-DESSUS: La loggia du second étage de la maison d'amis.

TIGERTAIL HOUSE

Luis, Jorge and Mari Tere Trelles, 1990

Tigertail House is the product of brothers Luis and Jorge Trelles and Jorge's wife, Mari Tere. It was conceived as a new townhouse, of a size and scale appropriate for its setting in a densely populated and vegetated section of Coconut Grove. The precedents they turned to were found in such traditional places as Georgetown, Charleston, and Caribbean cities, where urban houses are also houses with gardens.

The house, too, is an attempt to gather into one structure several of the dominant building traditions of its immediate neighborhood in particular and of South Florida in general. The house is built of block and stucco, a tradition that started with simple Florida bungalows and has lived on. The master bedroom suite at the rear of the house, however, is constructed as the homes of early pioneers were: based on Coconut Grove's first school house, it is a board-and-batten structure. The garden walls allude to nearby Vizcaya's much grander ones.

Many of the materials used in the Tigertail House are those found throughout Miami's past, including the cast-concrete Cuban tile for the floors and the lime-based paint on the stucco walls. For this house, the Trelles – all three Cuban born but reared in Miami – also sought to evoke a memory of the Spanish Caribbean. The balcony is decorated with a motif of sugar canes.

Das Tigertail House entstand in Zusammenarbeit der Brüder Luis und Jorge Trelles und Jorges Frau Mari Tere und wurde als neues Stadthaus konzipiert, dessen Größe und Form seiner Lage in einem dichtbesiedelten und üppig bepflanzten Wohngebiet in Coconut Grove angepaßt ist. Als Inspiriationsquelle dienten den Architekten solch traditionsreiche Orte wie Georgetown und Charleston sowie verschiedene karibische Städte, in denen Stadthäuser meistens von einem Garten umgeben sind.

Das Haus selbst stellt ebenfalls den Versuch dar, verschiedene der vorherrschenden Bautraditionen seiner unmittelbaren Nachbarschaft im besonderen und Südfloridas im allgemein unter einem Dach zu vereinen. Es wurde aus Betonsteinblöcken errichtet und verputzt – eine Tradition in Florida, die mit schlichten Bungalows begann und bis heute lebendig blieb. Allerdings ist die Schlafzimmersuite auf der Rückseite des Gebäudes entsprechend den Häusern der ersten Siedler konzipiert: Wie bei Coconut Groves erstem Schulgebäude handelt es sich um eine traditionelle Holzkonstruktion. Die Gartenmauern spielen auf die wesentlich pompöseren Mauern der nahegelegenen Vizcaya-Gärten an.

Viele der beim Bau des Tigertail House eingesetzten Materialien fanden in Miami auch früher schon Verwendung, einschließlich der in Gußbeton verlegten kubanischen Kachelböden und des Tünchkalks für die verputzten Wände. Darüber hinaus bemühten sich die Architekten – die alle auf Kuba geboren und in Miami aufgewachsen sind –, diesem Haus ein spanisch-karibisches Flair zu verleihen: So verzierten sie den Balkon mit einem Zuckerrohr-Motiv.

Tigertail House est une création des frères Luis et Jorge Trelles, et de l'épouse de Jorge, Mari Tere. Elle a été conçue comme une maison de ville, d'une taille et d'une échelle appropriée à son site dans un quartier vert et très peuplé de Coconut Grove. Les précédents qu'elle évoque viennent de lieux traditionnels comme Georgetown, Charleston et les villes des caraïbes, dans lesquelles les maisons possèdent encore des jardins.

Tigertail est une tentative de marier en une seule structure plusieurs des traditions architecturales dominantes de son voisinage immédiat en particulier, et de la Floride du Sud en général. La maison est construite en parpaings et stuc, tradition qui remonte aux premiers bungalows de Floride et s'est perpétuée depuis lors. A l'arrière, la chambre du maître en panneaux de contreplaqué s'inspire des maisons des pionniers de la première école de Coconut Grove. Le mur du jardin est une allusion à ceux – certes plus impressionnants – de Vizcaya toute proche.

De nombreux matériaux de cette maison sont utilisés à Miami depuis très longtemps, y compris les carrelages en ciment cubains pour les sols, et la peinture à la chaux sur les murs de plâtre. Pour cette maison, les Trelles – tous trois d'origine cubaine mais installés à Miami – ont cherché à ranimer le souvenir des Caraïbes espagnoles. Le balcon est décoré d'un motif de canne à sucre.

Arcades passageway along the side of the Tigertail House.
Arkadengang an einer Seite des Tigertail House.
Passages sous arcades au flanc de Tigertail House.

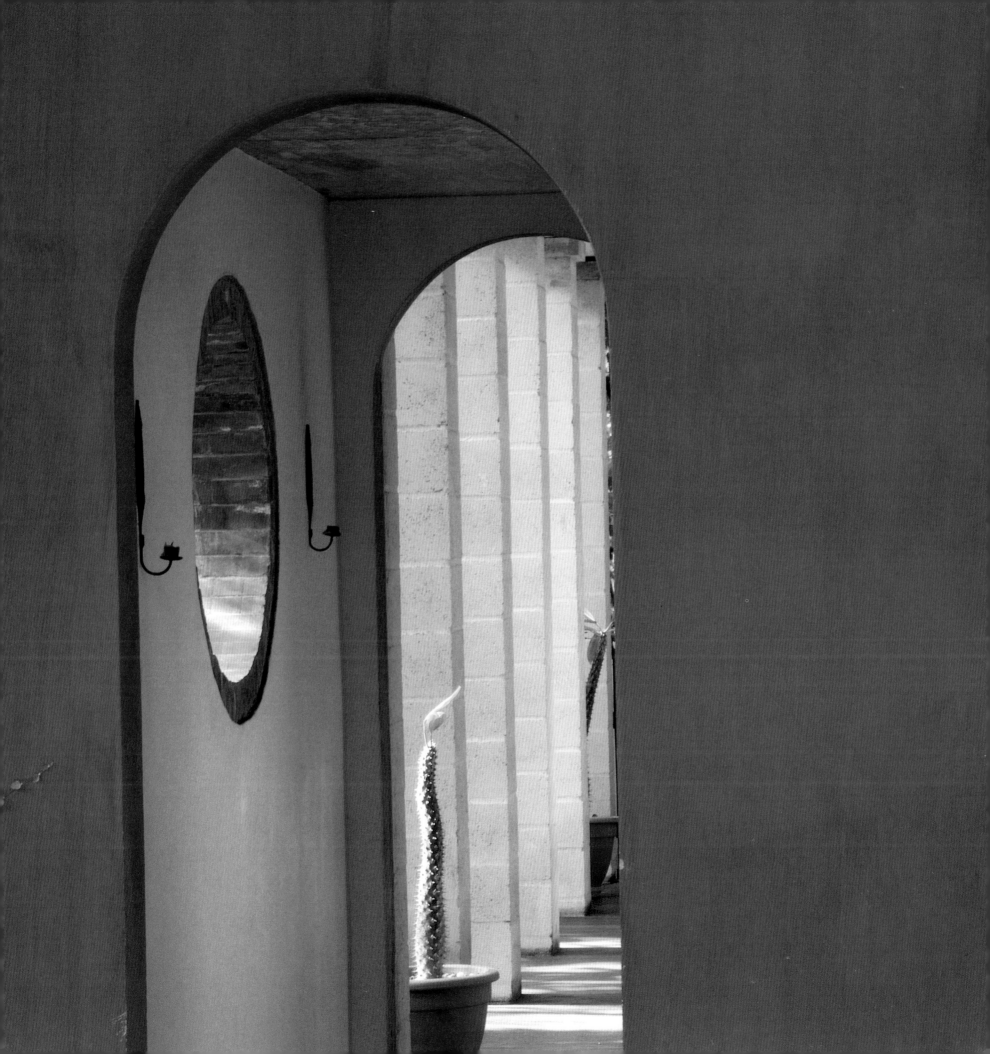

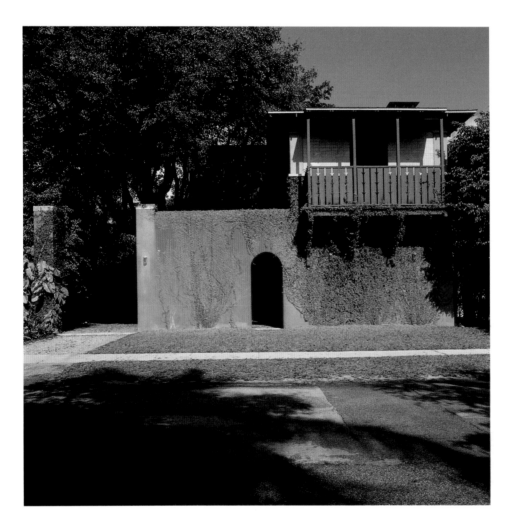

ABOVE: View from the street.
RIGHT: A narrow passage and hand-hewn ladder lead to the "mirador," a Caribbean version of a widow's walk.

OBEN: Straßenansicht.
RECHTS: Eine schmale Passage und eine handgefertige Leiter führen zum »Mirador«, der karibischen Version eines neu-englischen »Widow's Walk« (einer schiffsdeckartigen Aussichtsplattform).

CI-DESSUS: Vue de la rue.
A DROITE: Un étroit passage et une échelle rustique permettent de grimper au mirador, version caraïbe d'un belvédère.

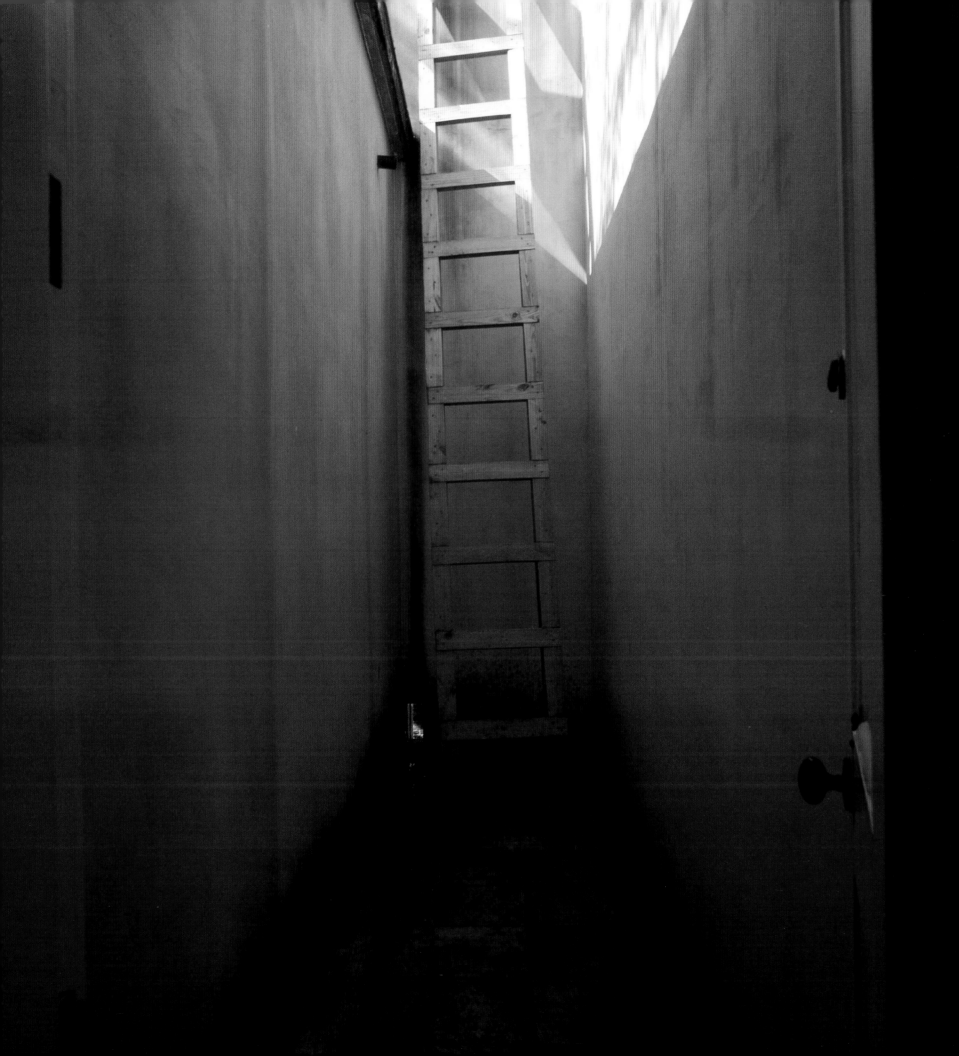

POINCIANA HOUSE/VILLA GUTIERREZ/ HIDALGO HOUSE

Jorge Hernandez

Jorge Hernandez is both an architect and a scholar, a student of Classical and Renaissance architecture. His work is informed both by his profound sense of place and his understanding of architectural history. As a Miamian, he is interested in the idea of fictive history – the kind written in the Mediterranean city of Coral Gables – and its narrative possibilities. As a scholar, he is interested in how Classicism has been expressed and re-expressed over the centuries – "not as a high, scholarly, orthodox language but in its being used in a more expressive way." And he finds particular fascination in such architects as Gunnar Asplund, who was able to use classical elements in inventive ways even at the cusp of the Modernist era.

For the 1995 Poinciana Housee, at the end of a street that terminates at Biscayne Bay, Hernandez wanted to evoke the idea of a found place, a house with the scale and presence of a ruin. It is almost severe on its street face, then opens more gently out onto the water. Villa Gutierrez, built in 1990, makes more direct references; in it, Hernandez was exploring the ways in which Palladio might translate to South Florida – thus tapered angular piers appear from a distance as large columns but seem to change dimension, from oversized to relatively slender, as one approaches.

Hernandez conceived the Hidalgo House of 1995 as much as a piece of the powerful Coral Gables landscape – almost as a garden pavilion set amid the trees – as a house, exploring many of South Florida's architectural ideas in ways that are both reminiscent of the past and fresh and new.

Jorge Hernandez ist nicht nur Architekt, sondern auch Architekturtheoretiker, der sich eingehend mit der Baukunst der Antike und der Renaissance beschäftigte. Seine Arbeiten sind erfüllt von seinem tiefgreifenden Verständnis für den jeweiligen Ort und seiner fundierten Kenntnis der Architekturgeschichte.

Jedes seiner drei (für Grundstücke in Coconut Grove und Coral Gables entworfenen) Häuser reflektiert diesen Hintergrund. Sie erscheinen in ihrer Konzeption von der italienischen Renaissance beeinflußt, mit subtilen Bezügen zu Palladio oder zu Vizcaya – etwa beim Portikus, der Form eines Fensters oder bei der Rundung einer Mauer. Der modernistische Aspekt der Häuser kommt eher dadurch zum Ausdruck, daß sie aufgrund ihres Entwurfs aus der Ferne den Eindruck erzeugen, als gehörten der Portikus oder eine Reihe von Säulen nicht zum Gebäude. Kommt man jedoch näher, fügen sich die einzelnen Teile zu einem Ganzen.

Bei dem 1995 fertiggestellten Poinciana House wollte Hernandez den Eindruck eines zufällig entdeckten Ortes erwecken, eines Hauses mit den Abmessungen und der Ausstrahlung einer Ruine. Die von Hernandez 1990 gebaute Villa Gutierrez besitzt direktere Bezüge; hier erkundete der Architekt die Möglichkeiten, für Palladio typische Elemente auf Südflorida zu übertragen.

Hernandez entwarf das 1995 fertiggestellte Hidalgo House als Teil der beeindruckenden Landschaft von Coral Gables – fast wie einen Gartenpavillon unter Bäumen – und schuf damit ein Bauwerk, das viele architektonische Ideen Südfloridas auf eine Weise auslotet, die sowohl an die Vergangenheit erinnert als auch frisch und neu ist.

Jorge Hernandez est à la fois architecte, chercheur et étudiant en architecture classique et de la Renaissance. Son œuvre se nourrit d'un sens profond du lieu et d'une prise en compte de l'histoire de l'architecture. Habitant Miami, il s'intéresse à l'histoire fictive de la ville et à ses possibilités narratives. Chercheur, il s'intéresse à la manière dont le classicisme s'est exprimé et ré-exprimé au cours des siècles.

Ces trois maisons sont, pourrait-on dire, d'inspiration italianisante, avec de subtiles références à Palladio ou à Vizcaya dans un portique, la forme d'une fenêtre ou l'arrondi d'un mur. De façon plus moderne, elles sont conçues pour être «lues» de loin, comme si le portique ou l'alignement des colonnes ne faisait pas réellement partie de la construction, mais s'y fondait au fur et à mesure que l'on s'en rapproche.

Pour Poinciana House (1995), Hernandez souhaitait évoquer l'idée d'une découverte, la présence d'une ruine. Elle se dresse, presque sévère, du côté de la rue, mais s'ouvre avec plus de douceur vers l'eau. Villa Gutierrez (1990) offre des références plus directes. Hernandez y explore la manière dont Palladio pourrait avoir été transféré en Floride du Sud, d'où des demi-piliers qui, vus à distance, font penser à de lourdes colonnes avant de passer à une finesse presque élancée lorsque l'on s'en approche.

Hidalgo House (1995), se trouve entre la Piscine vénitienne, la fontaine de Grenade et le Biltmore Hotel de Coral Gables. Hernandez l'a conçue aussi bien par rapport au paysage – un pavillon de jardin – que comme une maison, qui explore les multiples formes architecturales appréciées en Floride du Sud, et qui rappelle le passé tout en annonçant l'avenir.

The Poinciana house was designed to seem like a found ruin.

Das Poinciana House soll an eine zufällig entdeckte Ruine erinnern.

Poinciana House a été conçue pour évoquer une ruine que l'on découvrirait au détour d'un chemin.

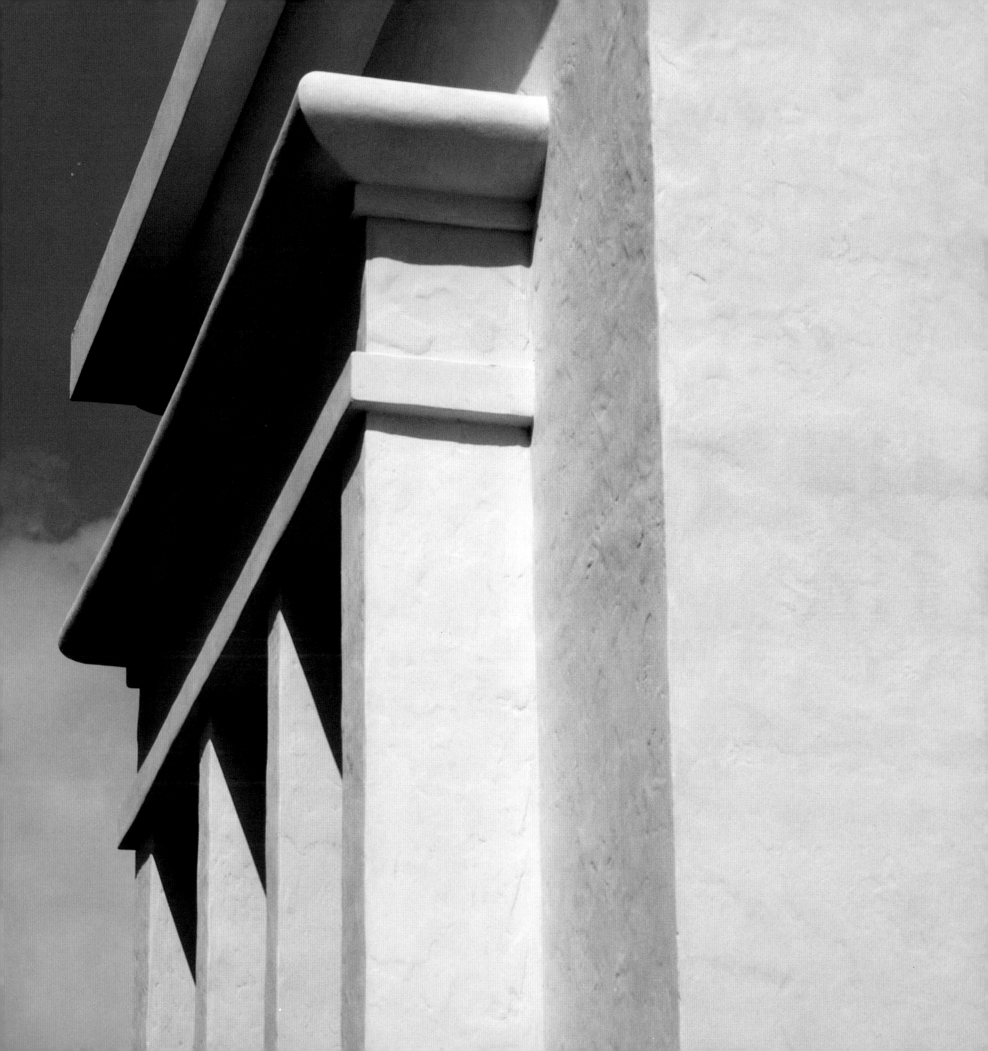

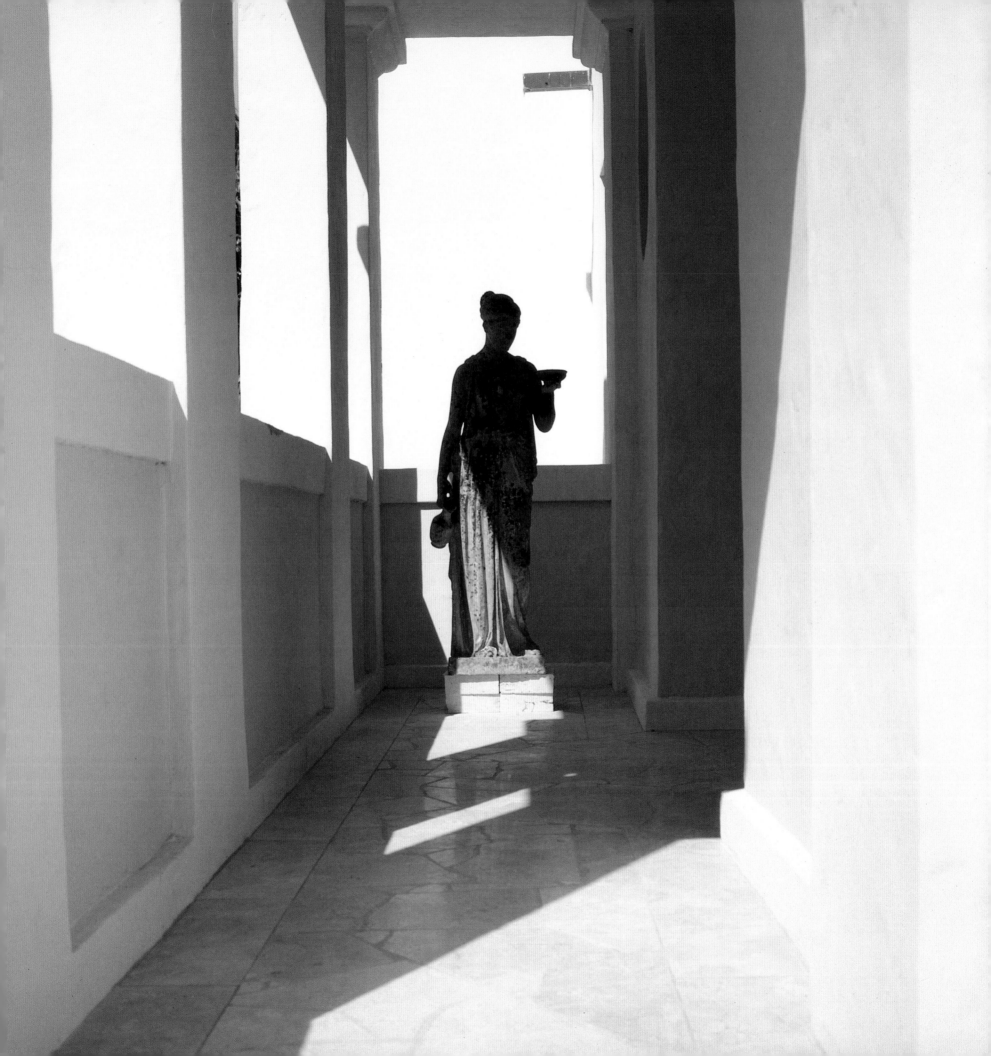

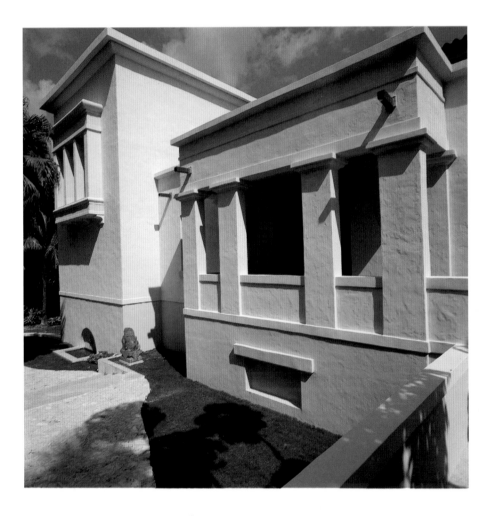

LEFT: Classical sculpture on the upper loggia.
ABOVE: View from the water.

LINKS: Eine klassische Skulptur auf der oberen Loggia.
OBEN: Ansicht vom Wasser aus.

A GAUCHE: Sculpture classique sur la loggia supérieure.
CI-DESSUS: Vue de l'eau.

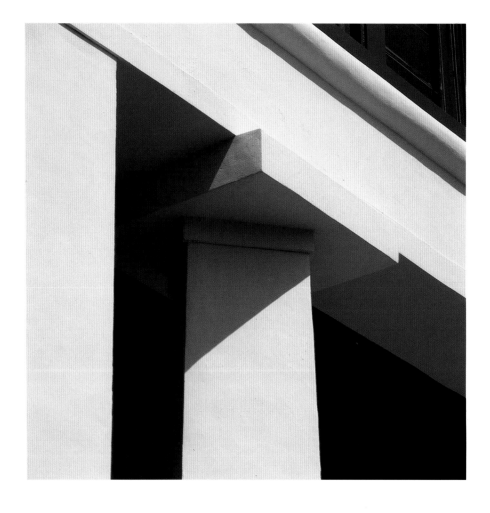

ABOVE: Detail of a squared column.
RIGHT: Villa Gutierrez unites Palladian themes and tropical traditions.

OBEN: Detailansicht einer viereckigen Säule.
RECHTS: Die Villa Gutierrez vereinigt palladianische Motive und tropische Traditionen.

CI-DESSUS: Détail d'une colonne carrée.
A DROITE: La Villa Gutierrez associe des thèmes palladiens aux traditions des Tropiques.

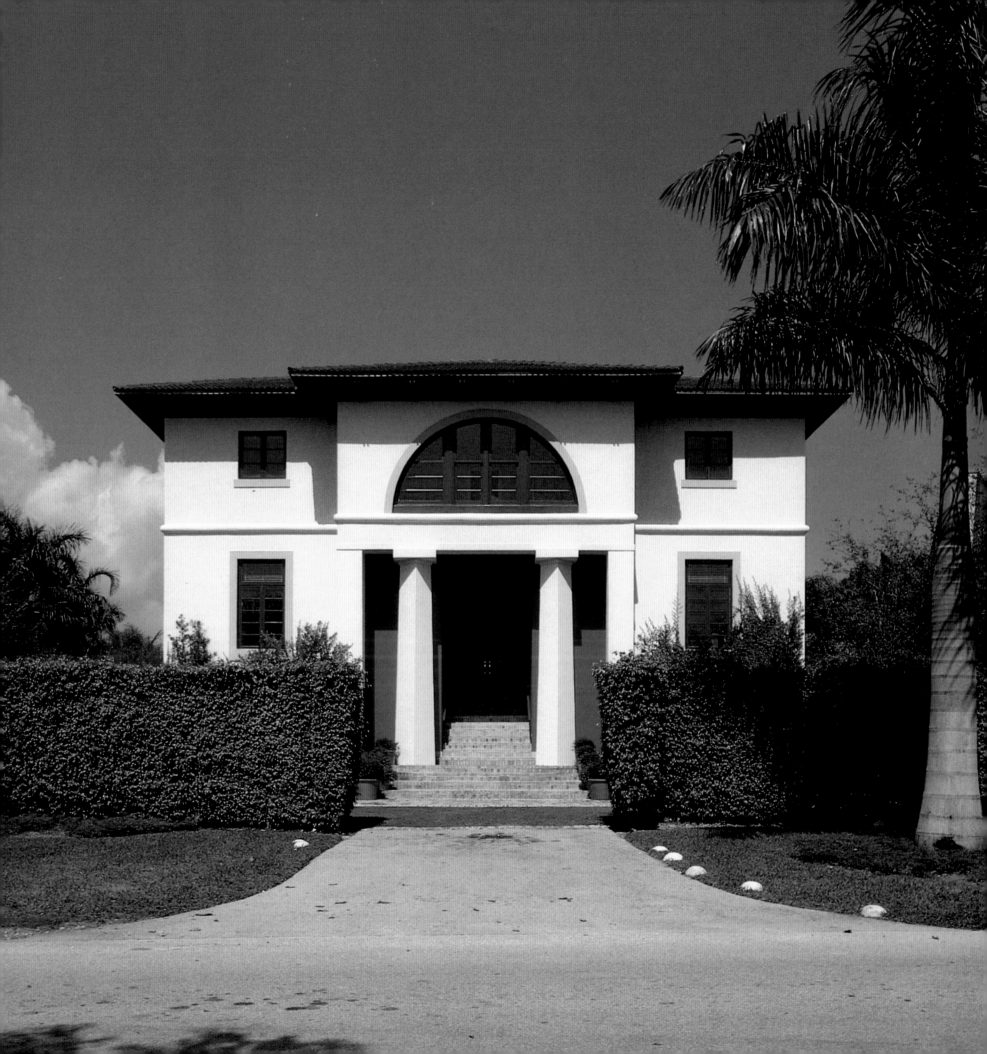

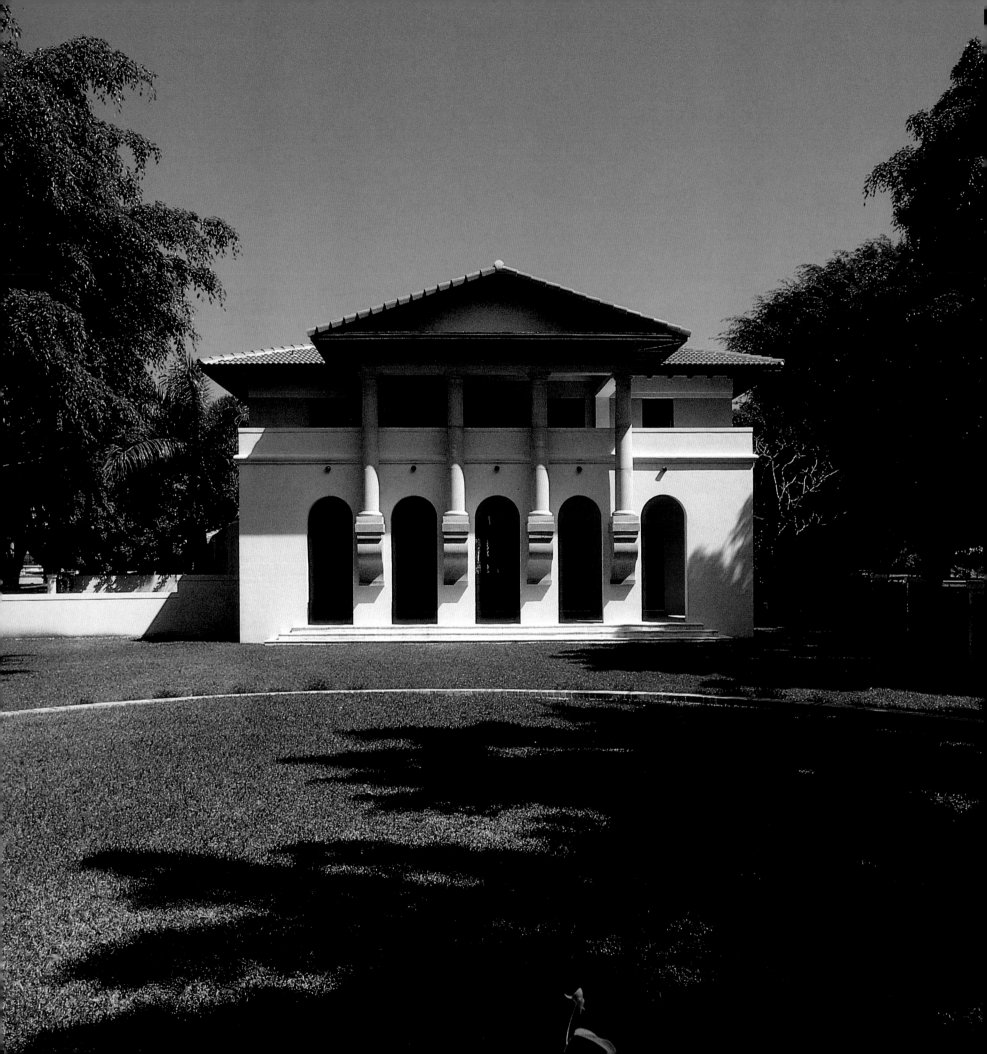

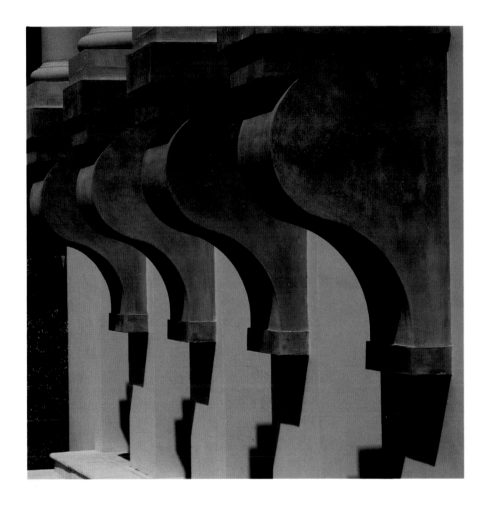

LEFT: From a distance, the Hidalgo House appears to be a garden pavilion.
ABOVE: Detail of the arcade porch.

LINKS: Aus der Entfernung wirkt das Hidalgo House wie ein Gartenpavillon.
OBEN: Detail des Arkadenvorbaus.

A GAUCHE: Vue de loin, Hidalgo House fait penser à un pavillon de jardin.
CI-DESSUS: Détail du porche à arcade.

CA' ZIFF

Maria de la Guardia and Teofilo Victoria, 1990

The inscription on the front gate of the Ca' Ziff reads *Urbis Facit* – Latin for "to build a city." The phrase is a motto and a mandate that Maria de la Guardia and Teofilo Victoria took to heart.

Ca' Ziff's setting, just south of Vizcaya on Biscayne Bay, at the edge of a public park, is at once prominent and secluded, urban and bucolic. To design this house, de la Guardia and Victoria went back to the roots of architecture in Miami and in the Caribbean. The idea was to mediate between the water's edge and the jungle-like vegetation that grows along the bluff above the bay. The result is a powerful synthesis of architectural ideas.

In some ways, Ca' Ziff is a Venetian townhouse, drawing directly from Venice rather than from the other Northern Italian-style buildings in Miami and Palm Beach, such as Vizcaya and numerous houses by Addison Mizner. It has the hard, rich flatness of a Venetian house, yet it also has an unexpected depth and warmth more typically found in Miami's Mediterranean houses.

Ca' Ziff includes a main house overlooking the bay and, across a lawn behind it, a separate guest house. The main house is square and centered on an atrium with a painted blue ceiling dotted with stars.

Die Inschrift über der Haupteinfahrt von Ca' Ziff lautet *Urbis Facit* – lateinisch für »eine Stadt erbauen«. Dabei handelt es sich um einen Wahlspruch und Auftrag, den Maria de la Guardia und Teofilo Victoria beherzigt haben.

Ca' Ziff liegt auf einem Gelände – etwas südlich von Vizcaya an der Biscayne Bay, am Rande eines öffentlichen Parks –, das markant und abgeschieden, urban und idyllisch zugleich ist. Für den Entwurf dieses Hauses kehrten die Architekten zu den Wurzeln der Architektur Miamis und der Karibik zurück und entwickelten ein Konzept, das zwischen der Uferlage und der dschungelartigen Vegetation entlang der Steilküste über der Bucht vermitteln soll. Auf diese Weise entstand eine machtvolle Synthese architektonischer Ideen.

In mancherlei Hinsicht erinnert Ca' Ziff an ein venezianisches Stadthaus, mit direkten Bezügen zu Venedig – und weniger zu anderen Gebäuden im norditalienischen Stil in Miami oder Palm Beach, wie etwa Vizcaya und zahlreiche Häuser von Addison Mizner. Das Gebäude besitzt die strenge, eindrucksvolle Schmucklosigkeit venezianischer Villen, zeichnet sich aber auch durch eine unerwartete Tiefe und Wärme aus, die für Miamis mediterrane Häuser eher typisch ist.

Ca' Ziff umfaßt ein Haupthaus, das über die Bay blickt, und ein separates, jenseits des Rasens hinter dem Haus liegendes Gästehaus. Das Haupthaus besitzt einen quadratischen Grundriß und umgibt ein zentrales Atrium, das von einer blau gestrichenen Decke mit aufgemalten Sternen überdacht wird.

Sur le portail d'entrée de la Ca' Ziff se lit une inscription en latin qui signifierait «construire une ville», devise et mission que Maria de la Guardia et Teofilo Victoria ont prises à cœur.

La situation de Ca' Ziff, juste au sud de Vizcaya, sur Biscayne Bay et à la lisière d'un parc public, est à la fois évidente et cachée, urbaine et bucolique. Pour concevoir cette maison, les deux architectes sont retournés aux racines de l'architecture de Miami et des Caraïbes. Ils ont recherché une solution qui puisse faire médiation entre le rivage et la végétation luxuriante de l'escarpement qui domine la baie. Le résultat relève d'une puissante synthèse de concepts architecturaux.

A sa façon, Ca' Ziff est une maison de ville, directement inspirée de Venise plutôt que des autres modèles de l'Italie du Nord que l'on trouve à Miami et Palm Beach, comme Vizcaya et de nombreuses réalisations d'Addison Mizner. Elle possède l'aspect lisse d'une maison vénitienne, tout en offrant une profondeur et une chaleur inattendues, plus caractéristiques des maisons néo-méditerranéennes de Miami.

Ca' Ziff comprend une maison principale qui domine la baie, et, à l'autre extrémité d'une pelouse, une maison d'amis autonome. La maison principale est carrée, centrée autour d'un atrium au plafond bleu illuminé d'étoiles.

RIGHT: The western facade of Ca' Ziff shows its simple geometry and elegant proportions.
OVERLEAF: The second-floor loggia.

RECHTS: Die Westfassade des Ca' Ziff zeichnet sich durch schlichte Geometrie und elegante Proportionen aus.
FOLGENDE DOPPELSEITE: Die Loggia im Obergeschoß.

A DROITE: La façade ouest de Ca' Ziff affiche sa géométrie épurée et d'élégantes proportions.
DOUBLE PAGE SUIVANTE: La loggia de l'étage.

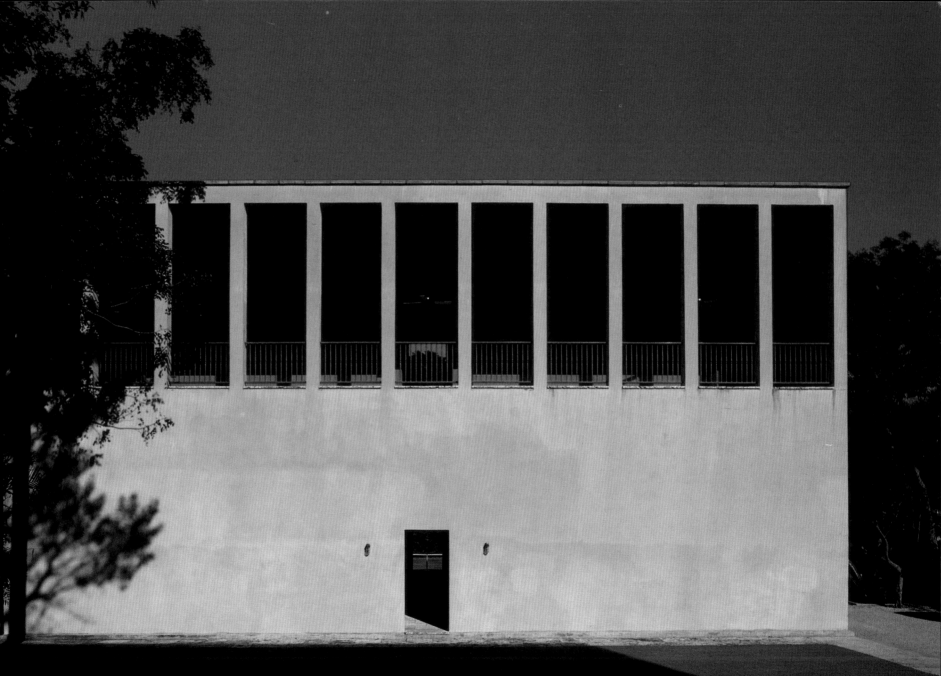

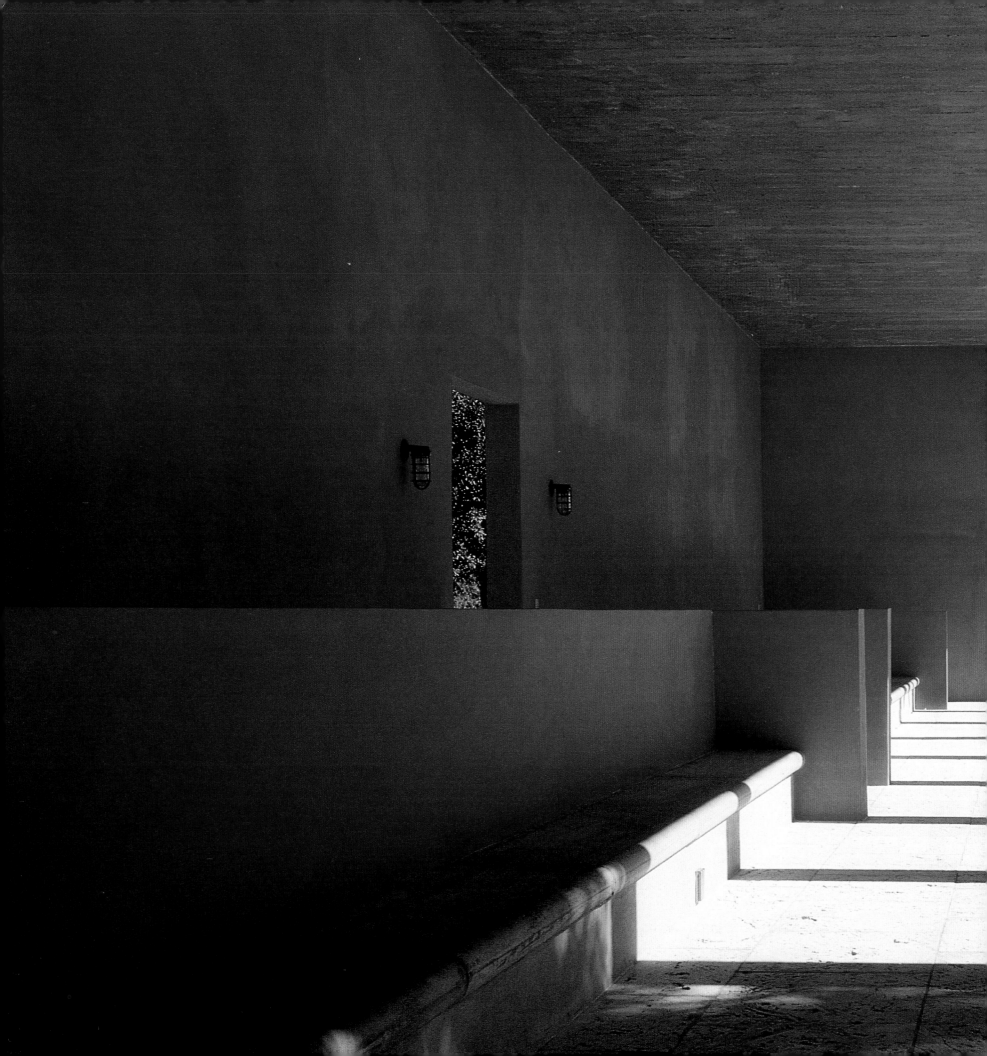

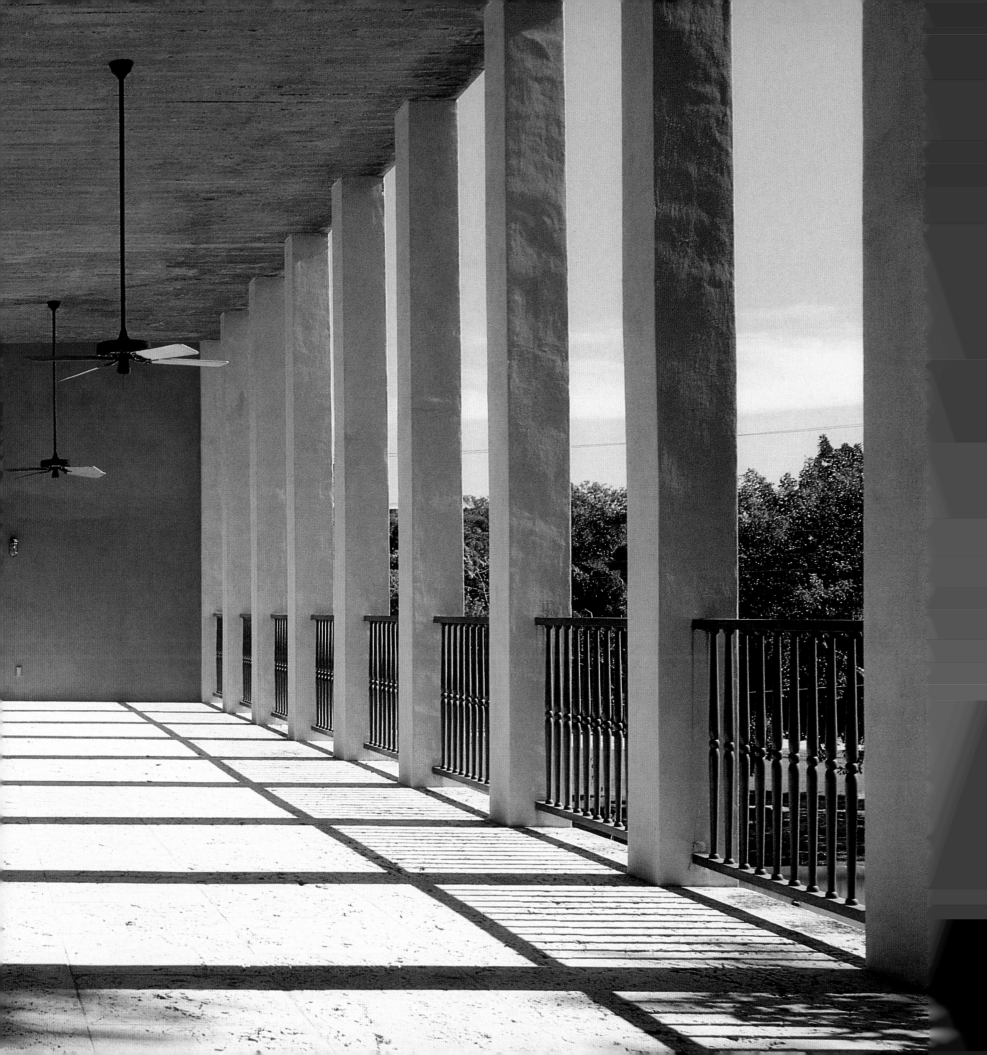

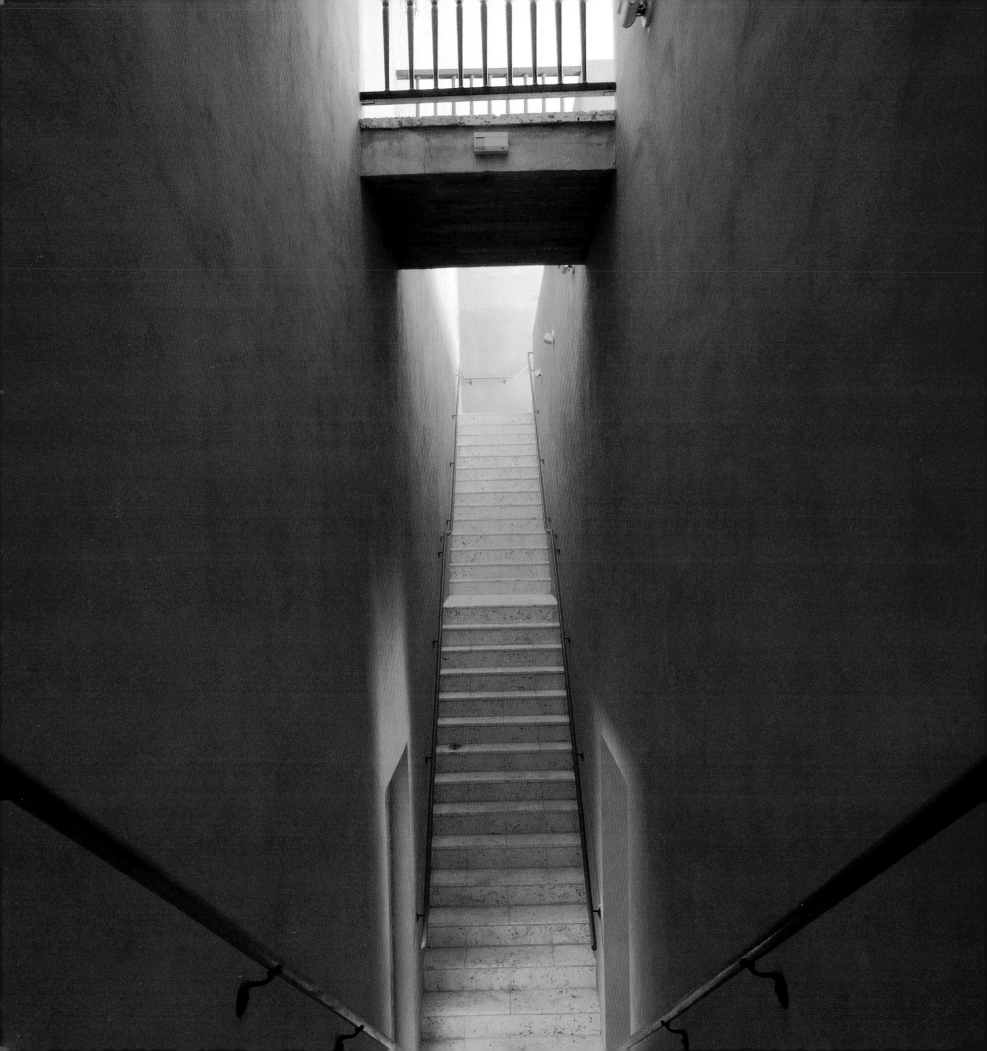

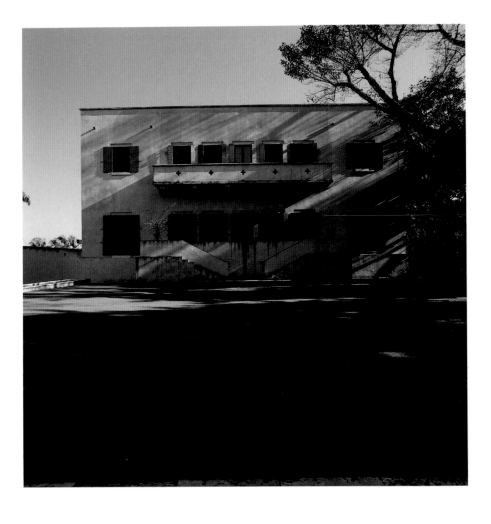

LEFT: A narrow stairway of local keystone.
ABOVE: The guest house.

LINKS: Eine schmale Treppe aus Korallenkalk.
OBEN: Das Gästehaus.

A GAUCHE: L'étroit escalier en pierre régionale.
CI-DESSUS: La maison d'amis.

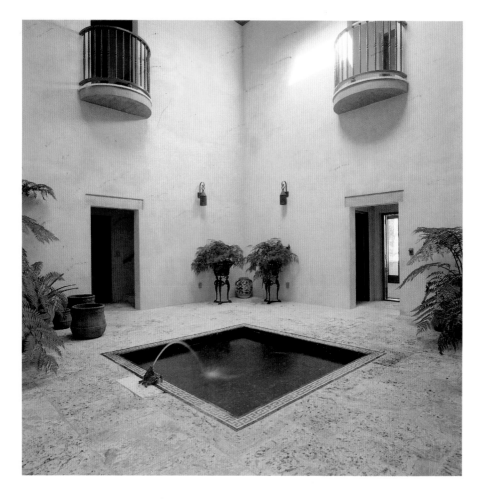

ABOVE: View of the atrium.
RIGHT: The atrium ceiling, with trompe l'oeil stars.
OVERLEAF: The view to the bay, with columns reminiscent of Venice and Vizcaya.

OBEN: Blick in das Atrium.
RECHTS: Die Decke des Atriums mit Trompe-l'œil-Sternen.
FOLGENDE DOPPELSEITE: Blick auf die Bay; die Säulen erinnern an Venedig und Vizcaya.

CI-DESSUS: Vue de l'atrium.
A DROITE: Le plafond de l'atrium aux étoiles en trompe-l'œil.
DOUBLE PAGE SUIVANTE: Vue vers la baie, avec des lampadaires rappelant Venise et Vizcaya.

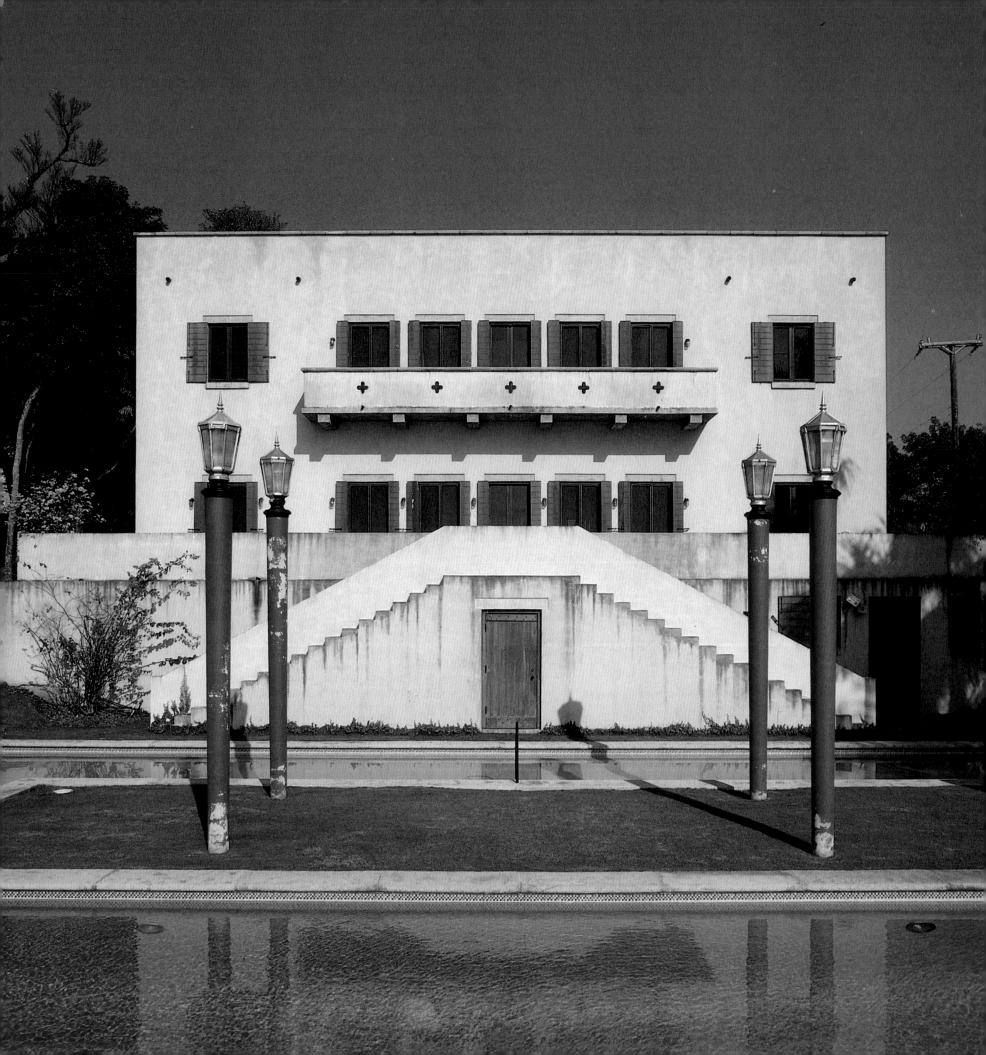

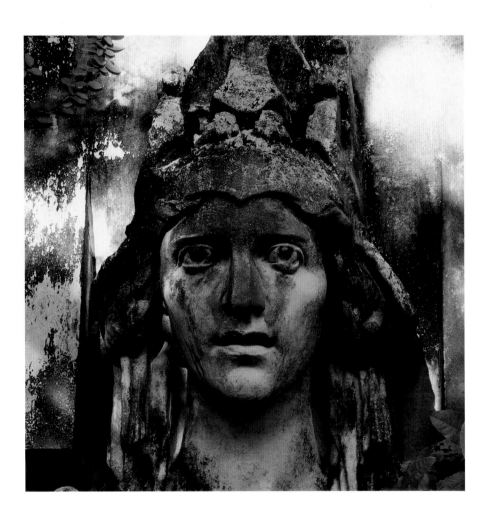

LEFT: Ca' Ziff was intentionally aged, a long-standing Miami tradition.
ABOVE: Detail of a sculpture.

LINKS: Ca' Ziff wurde bewußt künstlich gealtert – eine langjährige Tradition Miamis.
OBEN: Detail einer Skulptur.

A GAUCHE: Ancienne tradition de Miami, la peinture de Ca' Ziff a été intentionnellement vieillie.
CI-DESSUS: Détail d'une sculpture.

GOLDEN BEACH HOUSE

Carlos Zapata, 1994

Carlos Zapata is a young architect whose work is often experimental, exploring both abstraction and construction. For this house, Zapata, who was born in Venezuela, reared in Ecuador, and educated in the United States, wanted to communicate the almost opposing feelings of energy and restraint.

Golden Beach House sits just behind the dune line on the Atlantic Ocean in a beachfront community north of Miami Beach; Zapata followed the perimeter of the original house on the site – a much-altered Mediterranean Revival building – but beyond the proportions, there is almost no acknowledgment of what was there before.

The street facade is of white onyx. The roof is copper and is intended to look as if it is floating above the structure. Other walls, both exterior and interior, tilt and curve to give the house its controlled dynamic. The house looks over a long, flat swimming pool designed to fade into the horizon, a visual trick that connects house and ocean.

Carlos Zapata ist ein junger Architekt, dessen Arbeiten häufig experimentell sind und sowohl Abstraktion als auch Konstruktion erkunden. Bei diesem Haus bemühte sich Zapata – der in Venezuela geboren wurde, in Ecuador aufwuchs und in den Vereinigten Staaten studierte –, die nahezu gegensätzlichen Gefühle von Tatkraft und Zurückhaltung zum Ausdruck zu bringen.

Das Golden Beach House liegt in einer Strandgemeinde nördlich von Miami Beach, direkt hinter den Dünen am Atlantik. Bei seinem Entwurf orientierte sich Zapata zwar an den Umrissen des ursprünglichen Gebäudes auf diesem Grundstück – einem mehrfach umgebauten Haus im Mediterranean Revival Style –, aber außer den Proportionen weist das heutige Gebäude nur wenige Bezüge zu seinem Vorgänger auf.

Ein Teil der Straßenfassade besteht aus weißem Onyx; das Dach wurde mit Kupfer gedeckt und soll den Eindruck erwecken, es schwebe über der Konstruktion. Mehrere Außen- und Innenwände zeichnen sich durch ungewöhnliche Neigungswinkel und Rundungen aus, die dem Golden Beach House eine kontrollierte Dynamik verleihen. Vom Haus aus blickt man über einen langen, flachen Swimmingpool, der scheinbar in den Horizont übergeht – ein optischer Trick, der das Haus mit dem Ozean verbindet.

Carlos Zapata est un jeune architecte né au Vénézuela, grandi en Equateur et qui a fait ses études aux Etats-Unis. Son œuvre relève souvent de l'expérimentation, et il aime explorer à la fois l'abstraction et la force de la forme construite. A travers cette maison, il souhaitait communiquer des sentiments presque opposés : énergie et retenue.

Golden Beach House se trouve juste derrière la ligne de dunes de l'Océan atlantique face au bord de mer, au nord de Miami Beach. Zapata a respecté le périmètre d'une maison jadis construite au même endroit, (une construction néo-méditerranéenne très modifiée), mais en dehors de certaines proportions, on n'en retrouve presqu'aucune trace.

Une partie de la façade sur rue est en onyx blanc. Le toit en cuivre semble flotter au-dessus de la structure. D'autres murs, aussi bien intérieurs qu'extérieurs, se penchent ou s'incurvent pour créer un effet dynamique très contrôlé. La maison donne sur une longue piscine à débordement, effet visuel réussi qui la relie à l'océan.

RIGHT: The Golden Beach House's stairway has a stark simplicity and strong form.
OVERLEAF: One wall of the cityside facade is onyx.

RECHTS: Die Treppe des Golden Beach House zeichnet sich durch strenge Schlichtheit und kraftvolle Form aus.
FOLGENDE DOPPELSEITE: Eine Wand der zur Stadt zeigenden Fassade besteht aus Onyx.

A DROITE: L'escalier de Golden Beach House aux formes nettes et puissantes.
DOUBLE PAGE SUIVANTE: Un des murs côté ville est en onyx.

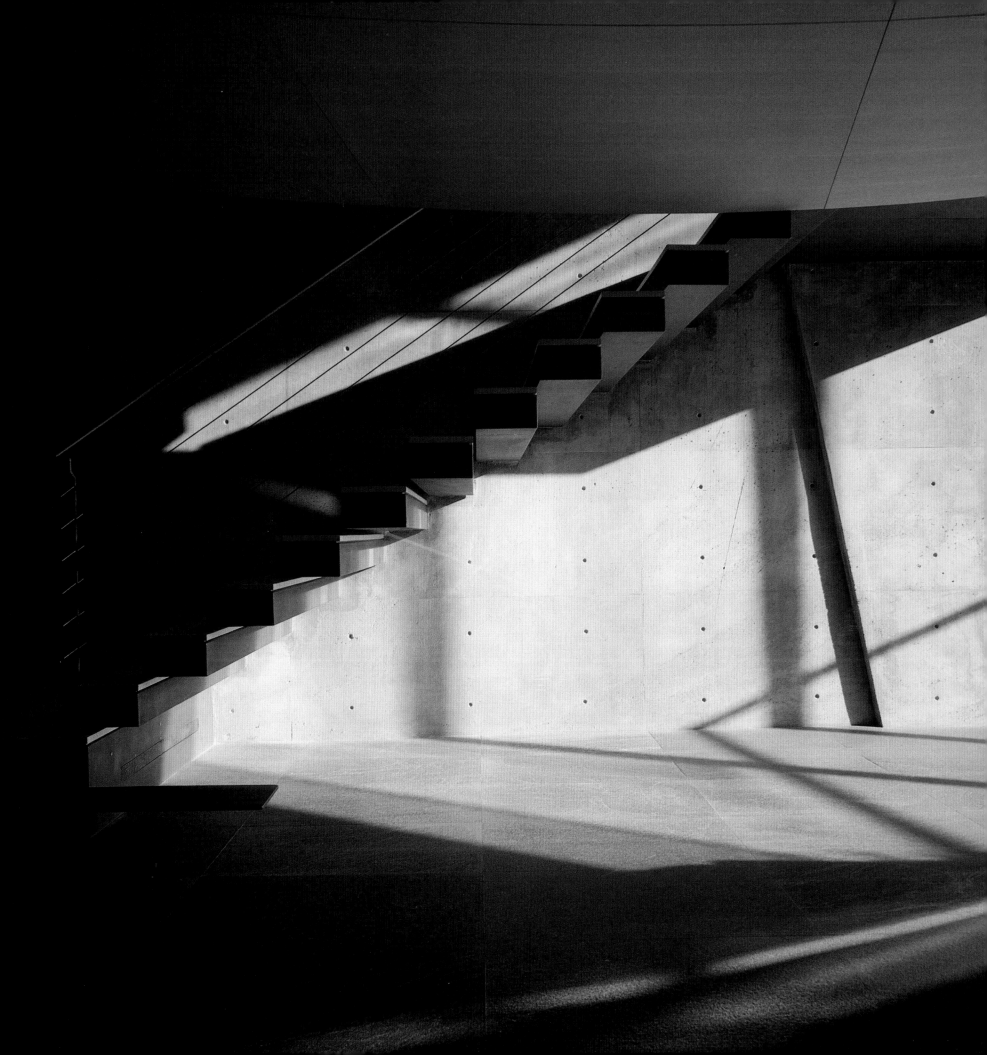

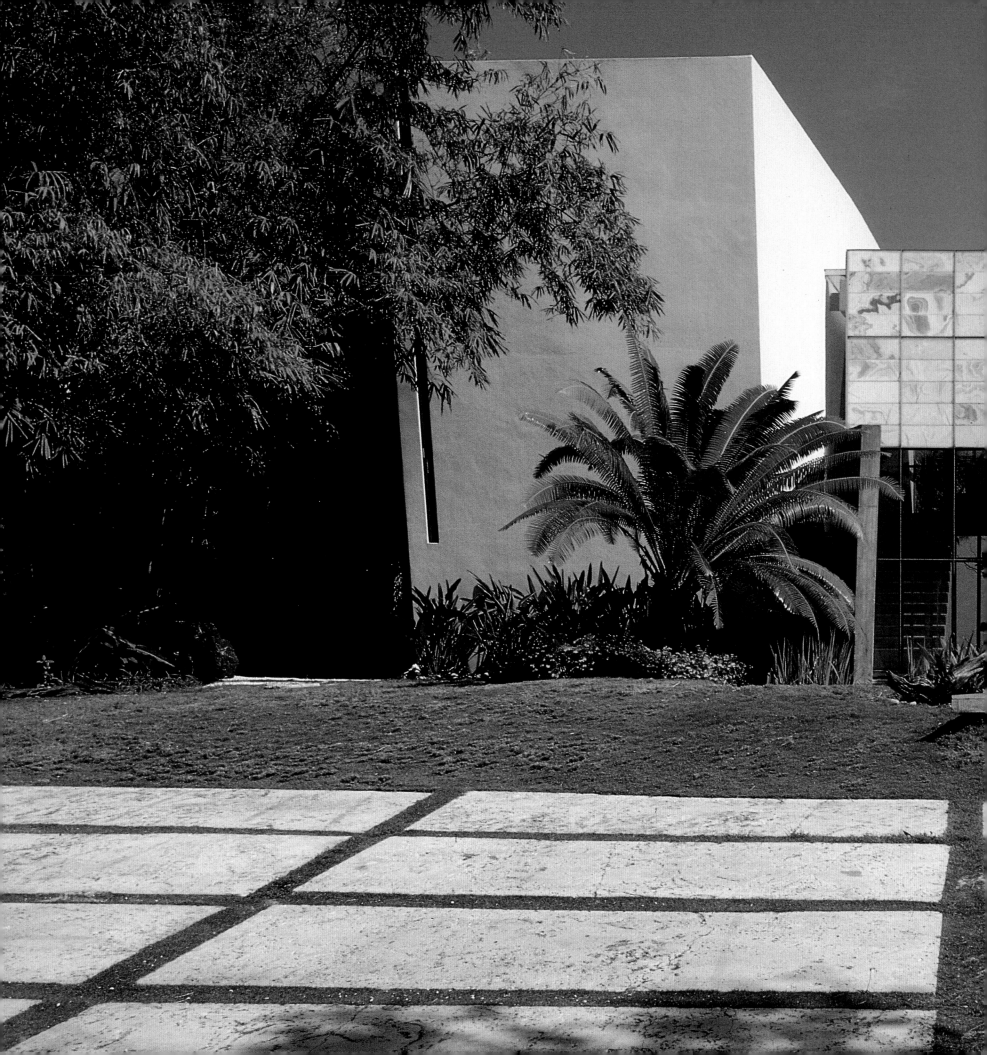

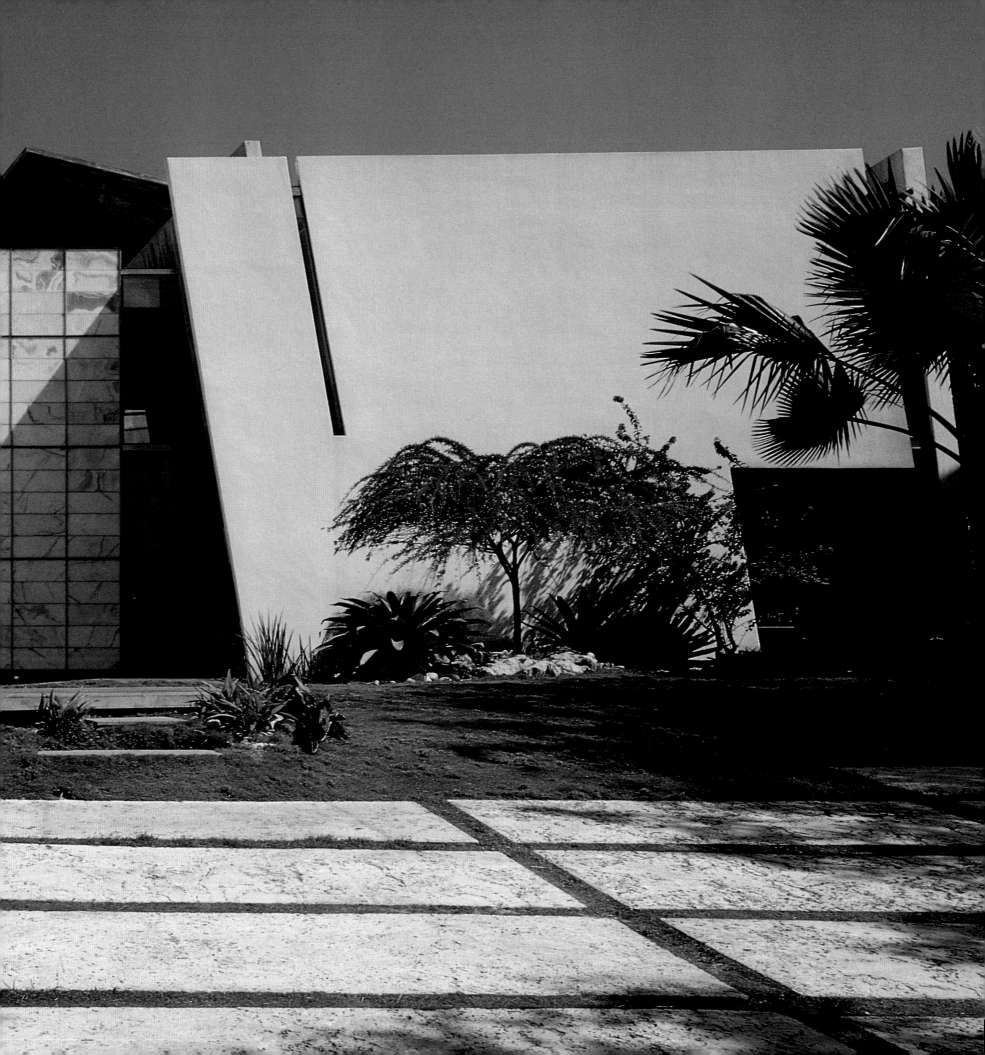

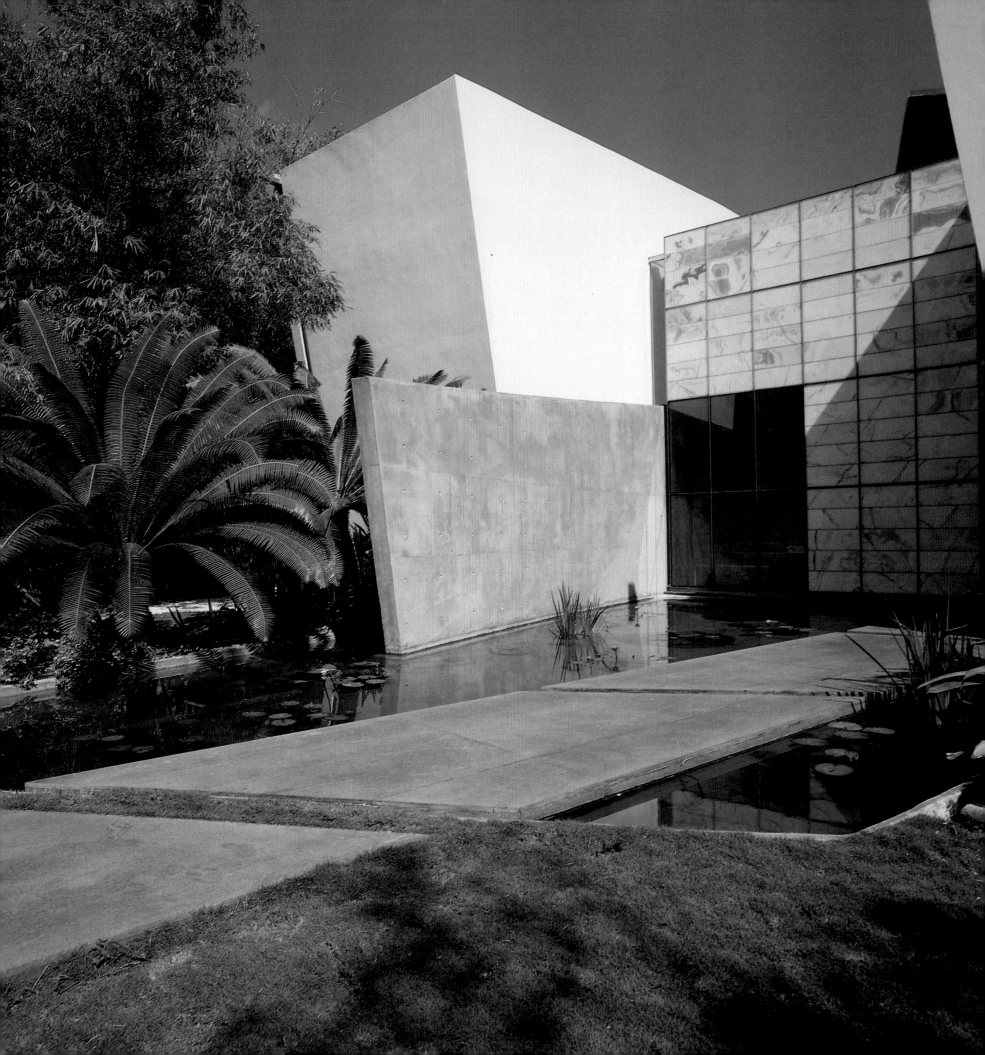

LEFT: Entrance to the Golden Beach House.
ABOVE: The doorway is trapezoidal.
OVERLEAF: Slender cables support the stairway.

LINKS: Eingang zum Golden Beach House.
OBEN: Die trapezförmige Türöffnung.
FOLGENDE DOPPELSEITE: Dünne Drahtseile tragen die Treppe.

A GAUCHE: Entrée de Golden Beach House.
CI-DESSUS: La porte d'entrée est trapézoïdale.
DOUBLE PAGE SUIVANTE: Des câbles fins soutiennent l'escalier.

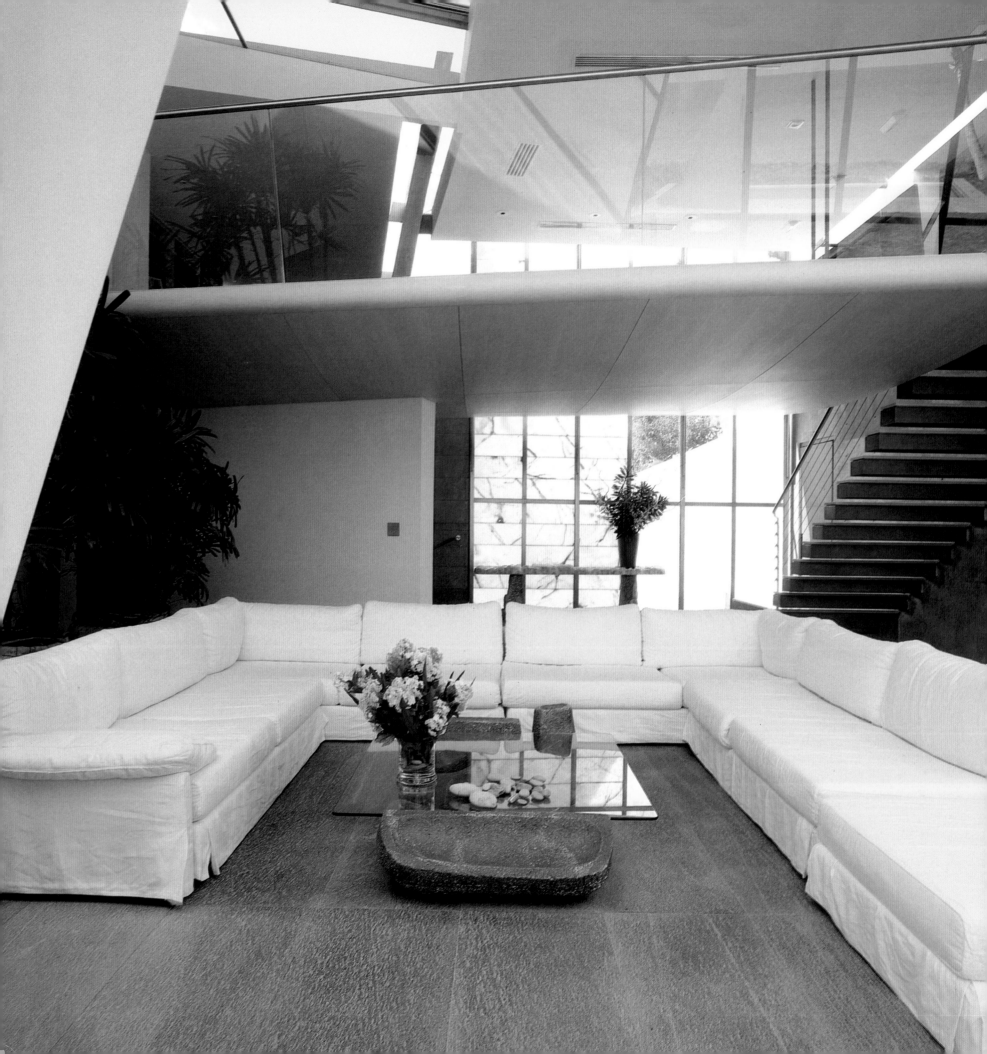

LEFT: The living room, with a mezzanine "catwalk" connecting to the bedroom wing.
ABOVE: View to the second floor.

LINKS: Das Wohnzimmer ist durch einen »Laufsteg« im Zwischengeschoß mit dem Schlafzimmerflügel verbunden.
OBEN: Blick in das Obergeschoß.

A GAUCHE: Le salon, avec une coursive en mezzanine qui conduit à l'aile des chambres.
CI-DESSUS: Vue de l'étage.

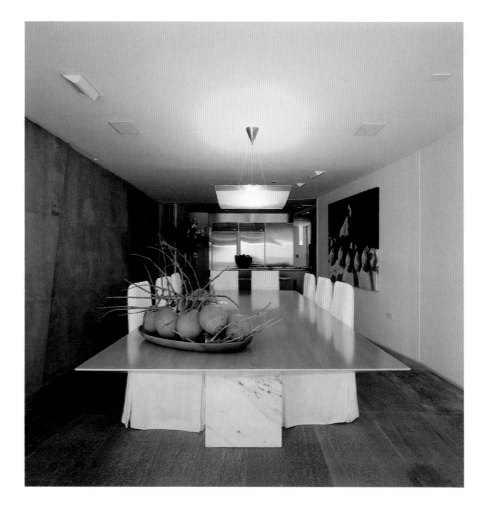

ABOVE: Dining room.
RIGHT: The kitchen has high clerestory windows and wood and steel cabinetry.
OVERLEAF: View from the pool.

OBEN: Eßzimmer.
RECHTS: Die Küche ist mit Obergadenfenstern und einer Inneneinrichtung aus Holz und Stahl ausgestattet.
FOLGENDE DOPPELSEITE: Ansicht vom Swimmingpool aus.

CI-DESSUS: Salle à manger.
A DROITE: La cuisine est dotée de hautes fenêtres et de rangements en bois et acier.
DOUBLE PAGE SUIVANTE: Vue de la piscine.

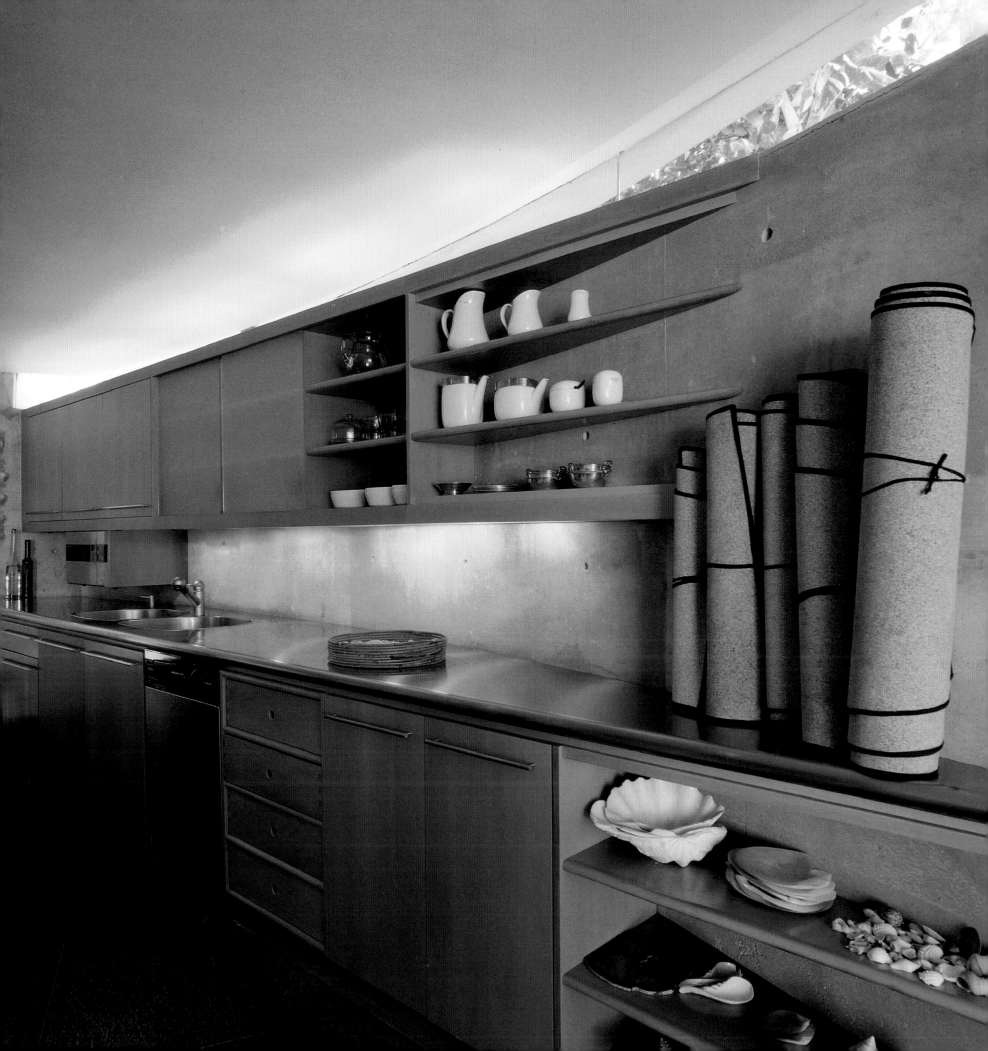

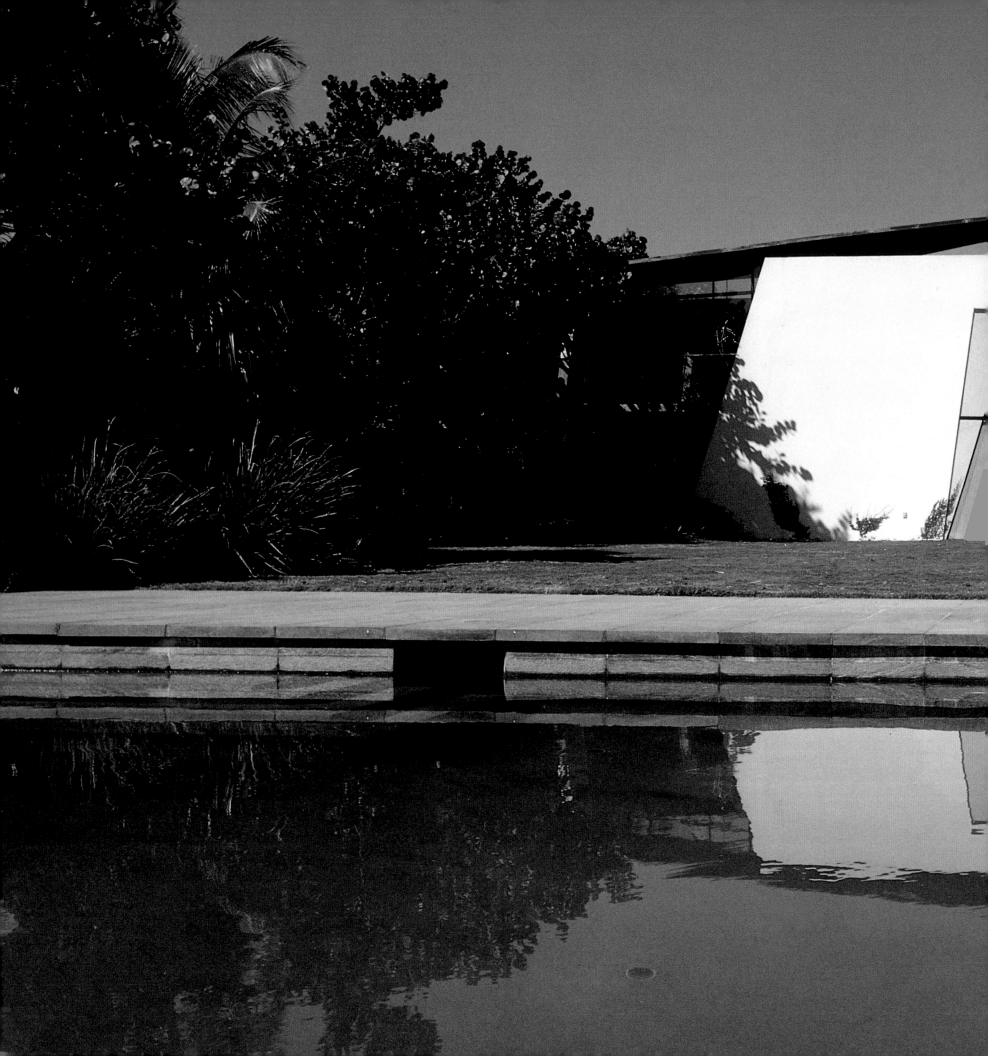

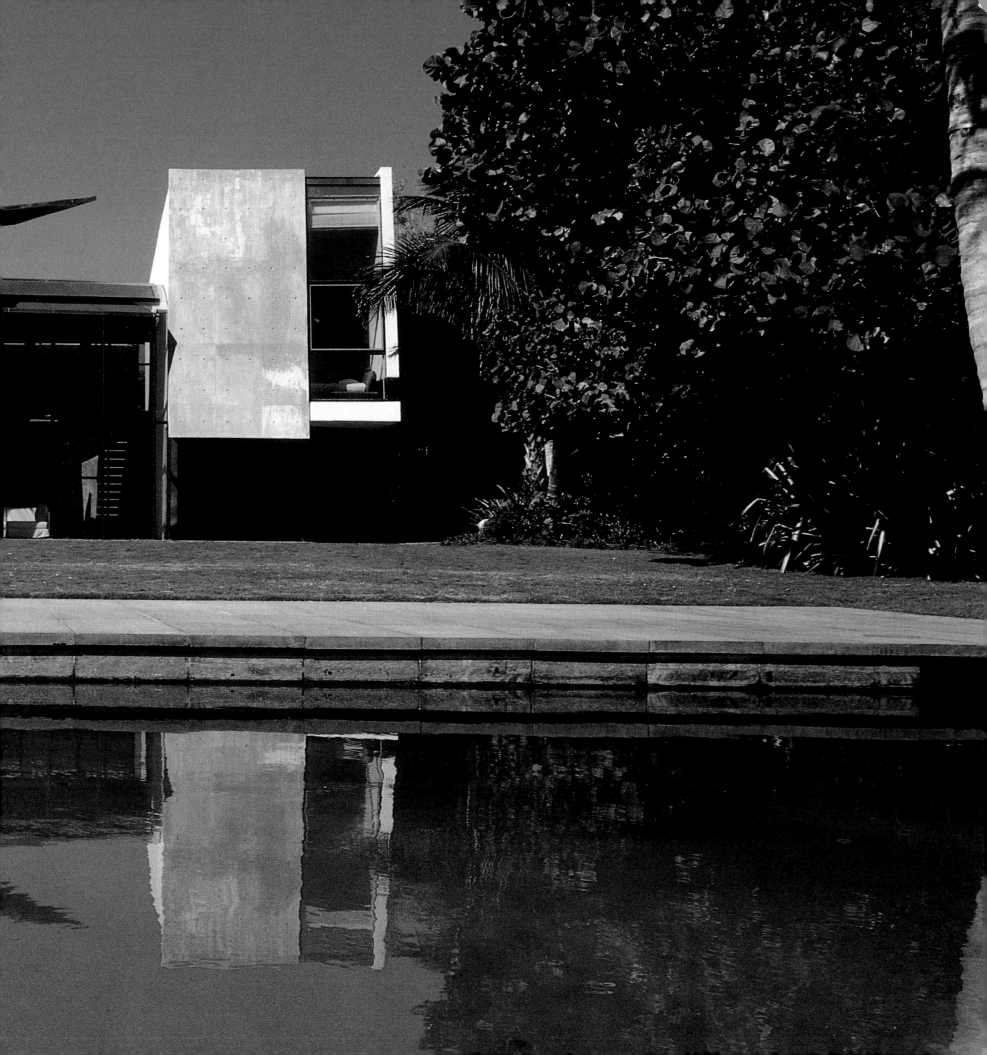

RUBELL FAMILY COLLECTION

Thomas Sansone and Mira Rubell, 1995

Housed in a building that used to be a police warehouse for stolen property, on a side street in Miami's garment district, is a private art museum that pushes Miami ever more toward the avant-garde. For the Rubell family, the building offered large column-free spaces to show contemporary paintings and sculptures of significant size.

To adapt this stolen-goods warehouse, a central staircase was punched through, leading visitors up from street level to the galleries. The building was left bare-bones, much as it was, so as not to detract from the art's impact. The big, challenging pieces that comprise the Rubell Collection need a minimalist setting, one where architecture doesn't argue with art.

Conceived by the New York architect Thomas Sansone but executed by the Rubells, the museum is based on earlier notions of a "picture gallery" in which a collection is at once stored and displayed. What is pertinent here in many ways is the bold nature of both the space – including its pioneering location away from Miami's trendier neighborhoods – and the paintings and sculpture within the space. They, more than any building could, speak directly to the Miami that is often in conflict with itself.

In einer Seitenstraße von Miamis Textil-Distrikt befindet sich in einem Gebäude, das der örtlichen Polizei früher als Lagerhaus für Diebesgut diente, ein privates Kunstmuseum, das Miami einen weiteren Schritt in Richtung Avantgarde bringt. Die Familie Rubell nutzt dieses Gebäude mit seinen weitläufigen, stützenfreien Räumen für die Ausstellung großformatiger zeitgenössischer Gemälde und Skulpturen.

Für den Umbau zu einer Galerie wurde in das Gebäude ein zentrales Treppenhaus eingezogen, das die Besucher vom Erdgeschoß zu den Ausstellungsräumen führt. Ansonsten blieb das ehemalige Lagerhaus fast unverändert und kahl, um die Aufmerksamkeit nicht von den Kunstgegenständen abzulenken. Die großen, herausfordernden Objekte der Rubell Collection benötigten einen minimalistischen Rahmen, bei dem Architektur und Kunst nicht miteinander konkurrieren.

Das von dem New Yorker Architekten Thomas Sansone entworfene, aber von der Rubell-Familie ausgeführte Museum basiert auf dem früheren Konzept einer Gemäldegalerie, in der eine Sammlung zugleich aufbewahrt und ausgestellt wird. Dabei fallen nicht nur die markante Beschaffenheit des Museumsraumes – einschließlich seiner zukunftsträchtigen Lage außerhalb der als schick geltenden Stadtviertel Miamis –, sondern auch die Kunstobjekte in diesem Raum ins Auge, die mehr als jedes Gebäude in der Lage sind, ein häufig mit sich selbst haderndes Miami direkt anzusprechen.

Installé dans un ancien dépôt pour objets volés de la police, dans une petite rue latérale du quartier de la mode de Miami, se trouve un musée privé qui fait beaucoup pour la réputation de Miami sur la scène de l'avant-garde. Pour la famille Rubell, ce bâtiment avait l'avantage d'offrir de vastes espaces sans colonne qui permettaient de présenter des peintures et des sculptures contemporaines de taille importante.

Un escalier central a été créé pour adapter cet entrepôt à sa nouvelle fonction. Il mène les visiteurs du niveau de la rue à celui des galeries. L'immeuble a été totalement vidé, pour que rien ne puisse nuire à l'impact des œuvres exposées. Les importantes et audacieuses pièces de la collection Rubell exigent un cadre minimaliste, qui limite les conflits entre l'art et l'architecture.

Conçu par l'architecte new-yorkais Thomas Sansone, mais réalisé par les Rubell, le musée s'inspire du concept ancien de «galerie de tableaux» dans laquelle les grands collectionneurs présentaient jadis leurs acquisitions. Tout ici est provocant : la situation du musée loin des quartiers à la mode, l'esprit des œuvres exposées. C'est un résumé brillant du conflit permanent que la ville entretient avec elle-même.

RIGHT: Street facade of the former police storage facility.
OVERLEAF: Galleries accommodate large paintings from such artists as Gilbert and George, left, and Keith Haring, right.

RECHTS: Straßenansicht des früheren Lagerhauses der Polizei.
FOLGENDE DOPPELSEITE: In den Austellungsräumen hängen großformatige Gemälde von Künstlern wie Gilbert and George (links) und Keith Haring (rechts).

A DROITE: Façade sur rue de l'acien entrepôt de la police.
DOUBLE PAGE SUIVANTE: Dans les galeries, des œuvres de grandes dimensions d'artistes comme Gilbert and George, à gauche, ou Keith Haring, à droite.

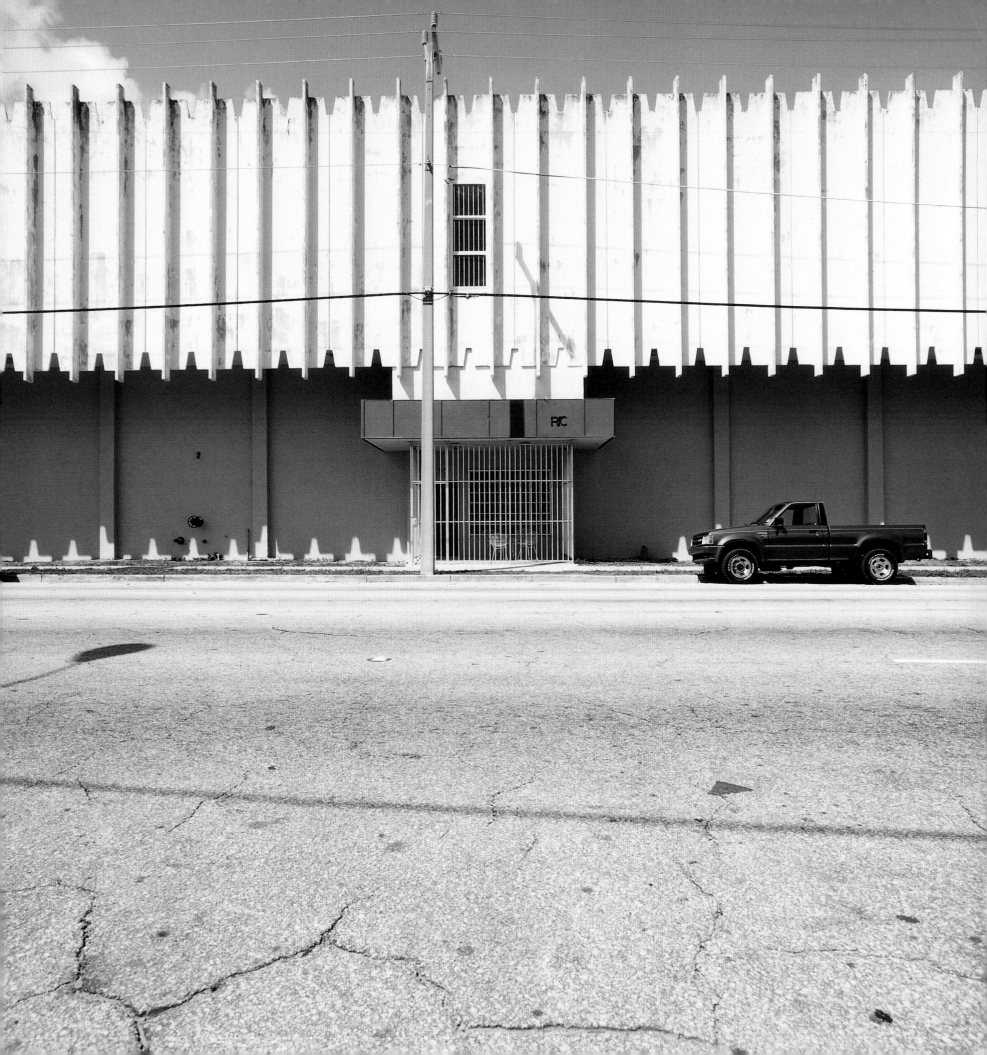

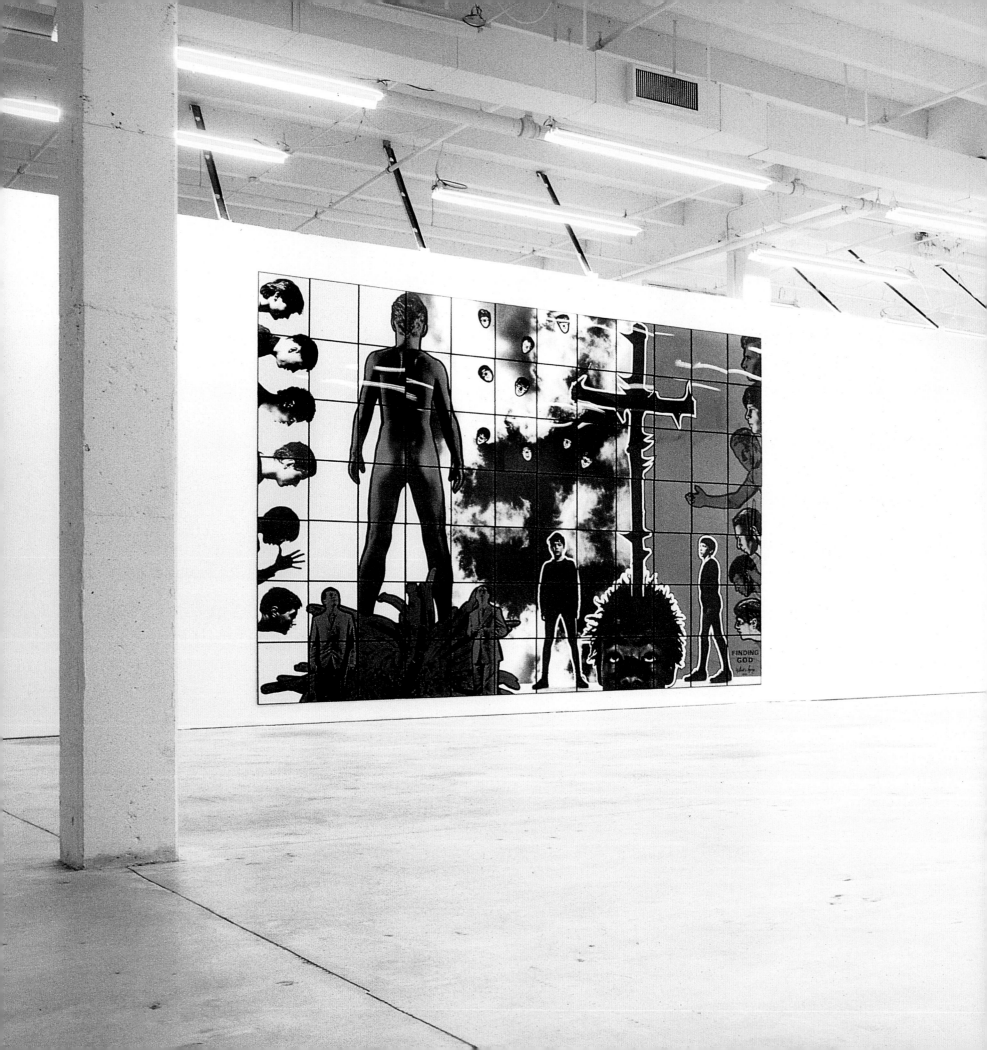

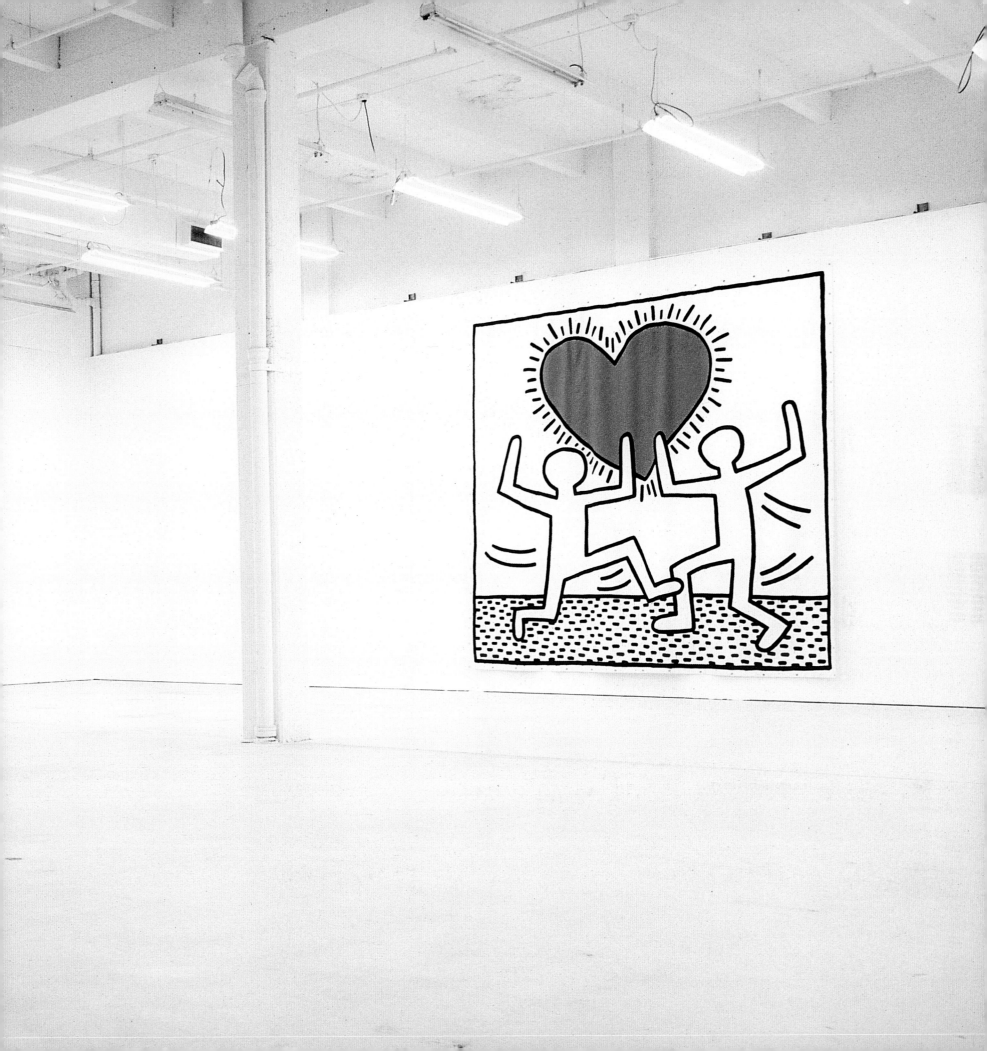

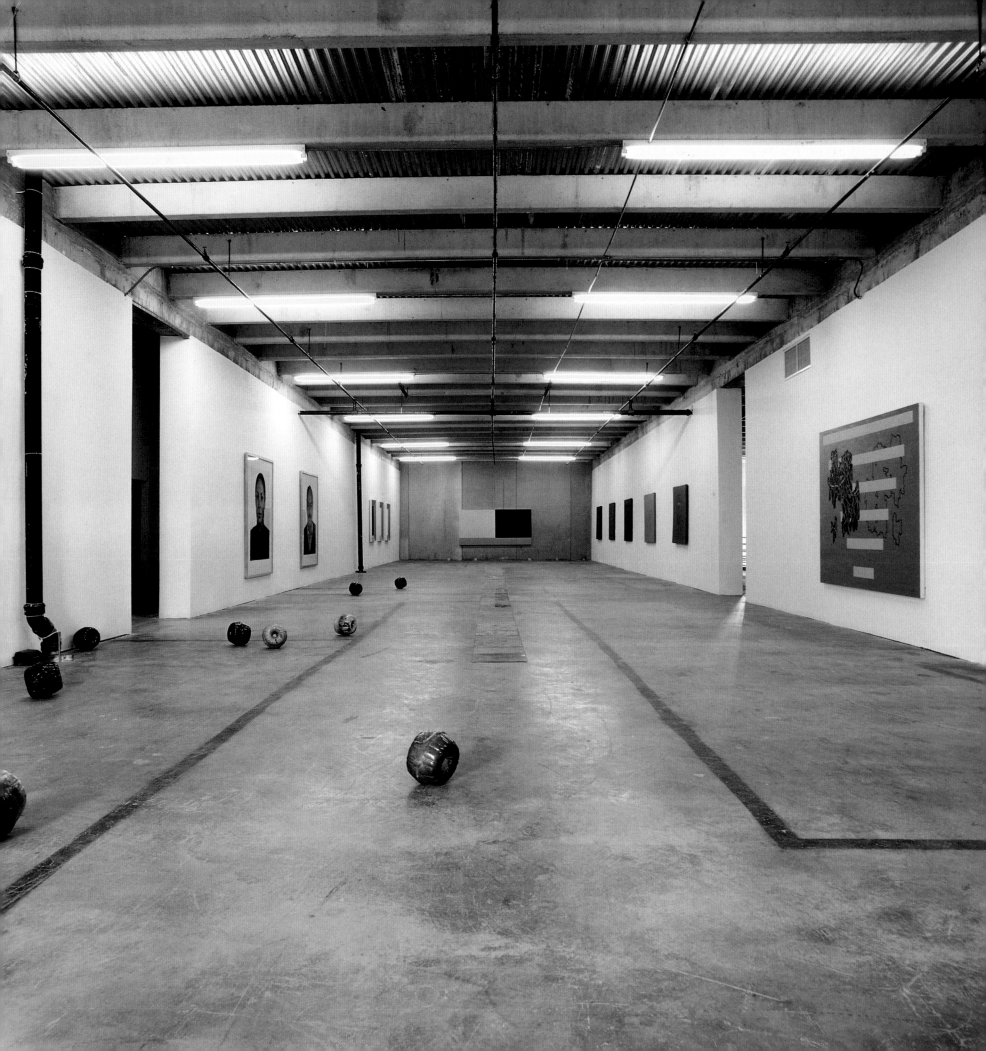

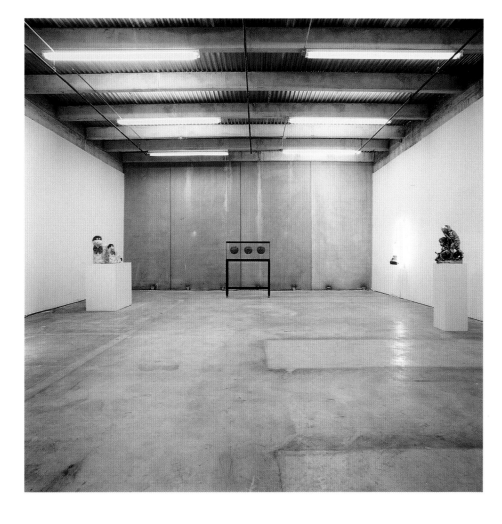

LEFT: Long, open spaces provide ample room for the artworks in the Rubell collection.
ABOVE: A piece by Jeff Koons provides a focus in one gallery.

LINKS: Die langgestreckten, offenen Räume bieten ausreichend Platz für die Kunstwerke der Rubell Collection.
OBEN: Eine Arbeit von Jeff Koons steht im Mittelpunkt dieses Raumes.

A GAUCHE: Les longs espaces ouverts se prêtent bien aux œuvres de la collection Rubell.
CI-DESSUS: Une œuvre de Jeff Koons, attire le regard.

ABOVE: The as-found warehouse spaces provide an appropriate backdrop for the contemporary art.
RIGHT: A work by Leonard Drew defines the spaces of one gallery.
OVERLEAF: A piece by José Bedia deals with "balseros," or Cuban rafters.

OBEN: Die unveränderten Räume des ehemaligen Lagerhauses bilden den passenden Hintergrund für die zeitgenössischen Kunstwerke.
RECHTS: Eine Arbeit von Leonard Drew dominiert diesen Ausstellungsraum.
FOLGENDE DOPPELSEITE: Dieses Werk von José Bedia hat die »balseros« – die kubanischen Floßflüchtlinge – zum Thema.

CI-DESSUS: Les espaces sont restés tels qu'ils avaient été trouvés et offrent un cadre approprié à l'art contemporain.
A DROITE: Une œuvre de Leonard Drew qui définit l'espace d'une des galeries.
DOUBLE PAGE SUIVANTE: Une pièce de José Bedia traite des balseros, les réfugiés cubains en radeaux.

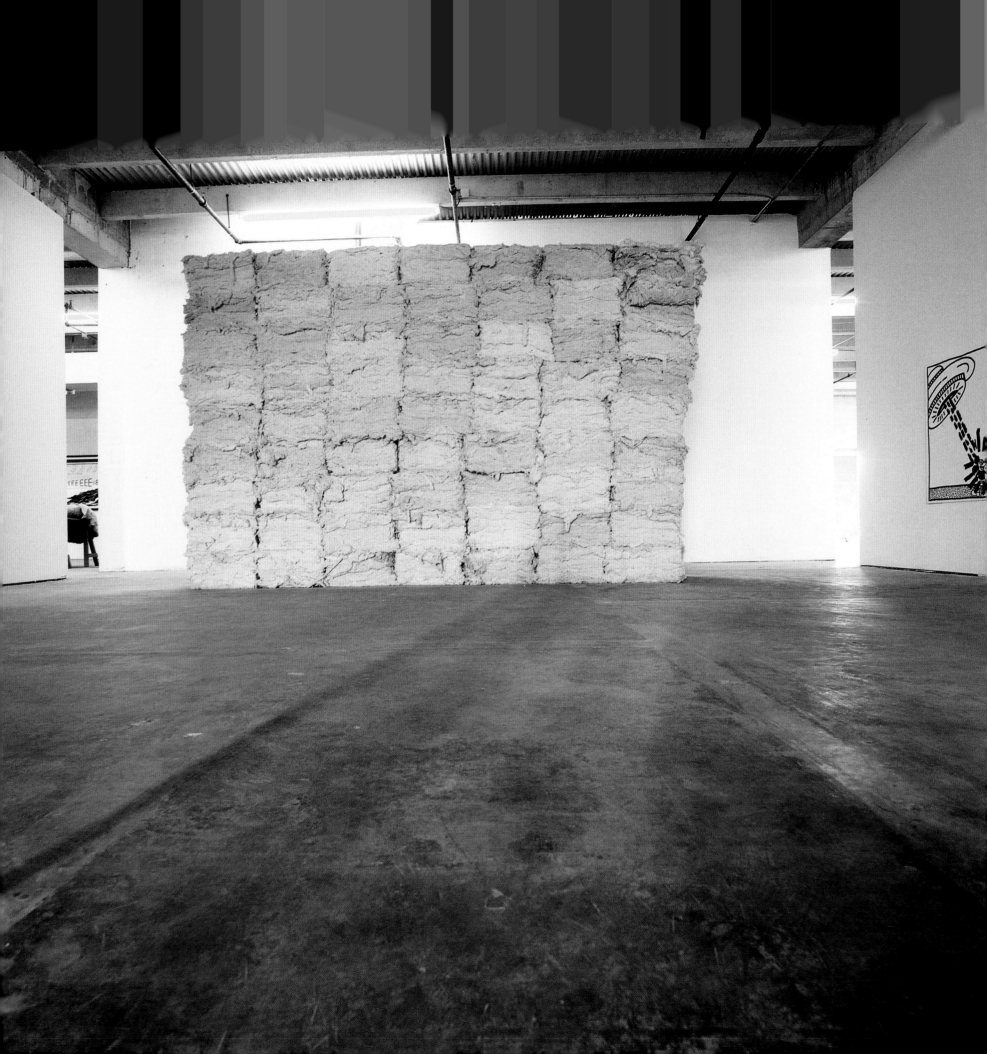

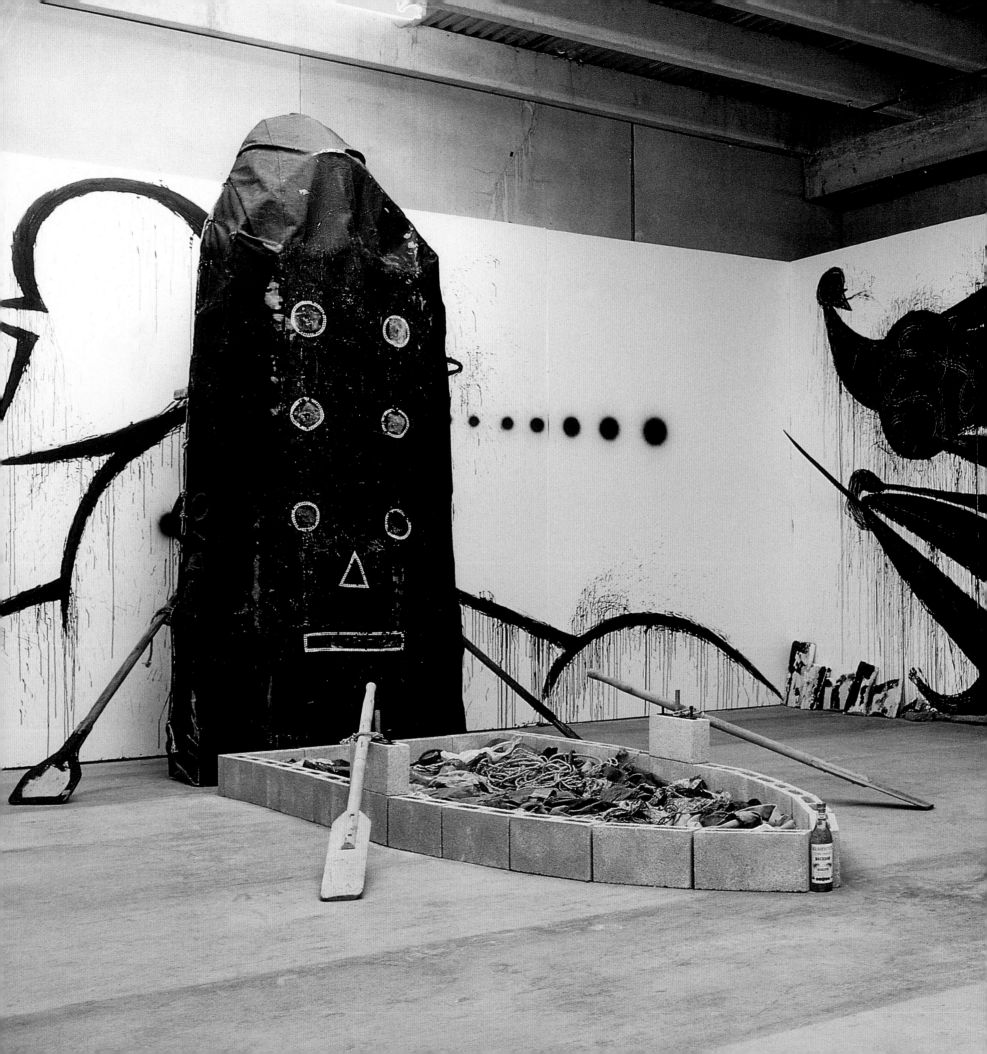

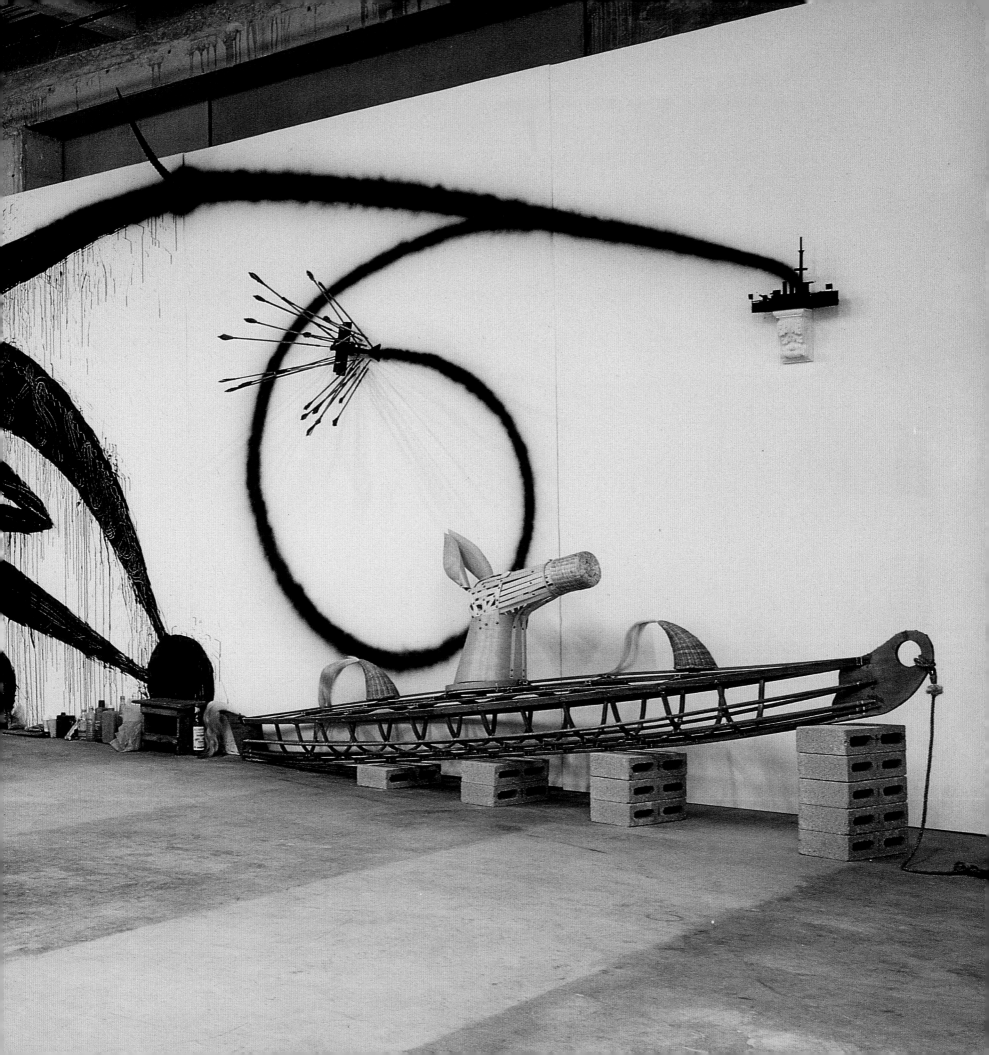

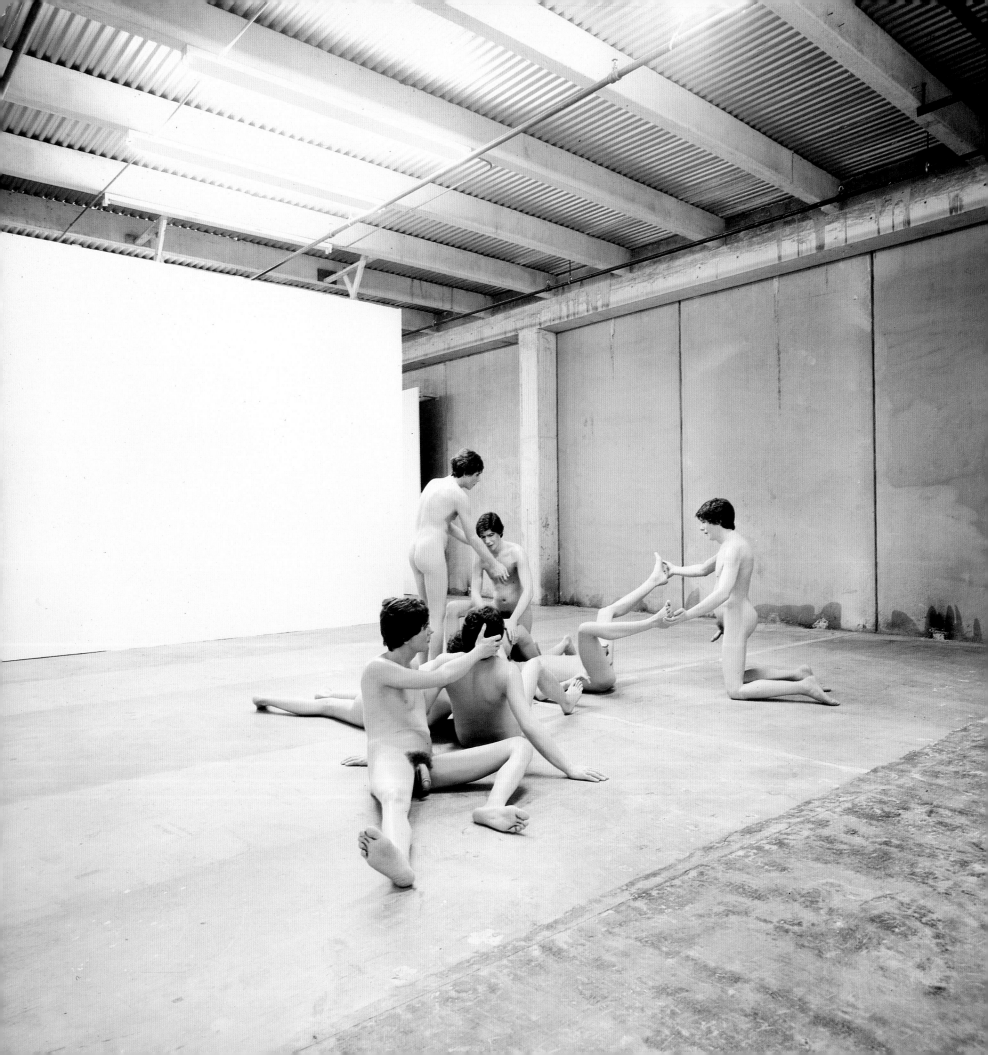

LEFT: A work by Charles Ray.
RIGHT: Christian Boltanski piece.

LINKS: Eine Arbeit von Charles Ray.
RECHTS: Ein Objekt von Christian Boltanski.

A GAUCHE: Une œuvre de Charles Ray.
A DROITE: Une pièce de Christian Boltanski.

DELANO HOTEL RENOVATIONS

Philippe Starck, 1995; original architect, B. Robert Swartburg, 1937

An Art Deco Hotel that had lost its pizzazz was given new life – and an entirely new look – in the whimsical hands of the French designer Philippe Starck. The hotel, along with several others in a district near Miami Beach's convention center, was exempted from the umbrella protection of the city's historic preservation laws, and was thus able to be adapted rather than renovated.

In the hotel's public areas, walls and floors are wood, but virtually everything else is white; sections of the lobby are divided by gigantic floating gauze curtains. In the dining room, the walls and virtually everything else – tables, plates, napkins – are white, except the dark wooden legs of the chairs.

Visual puns abound. Furniture is cozy and overstuffed and even oversized. A double chaise, basically a bed, is plunked in the check-in area. Outside, in the poll area, there are oversized upholstered lounge chairs where more rugged outdoor furniture would be the norm. There's even furniture partly submerged in the pool.

The pool itself is designed to look as if it is skimming the surface of the earth. It is long and shallow, less a pool for swimming than a place to see and be seen. Indeed, if there is an essence to the Delano, it is the atmosphere around the pool.

Starck spent only a small amount of time in Miami before he created his ode to the city, and indeed, the Delano is not so much about any particular historic or physical aspect of the places as it is about the sybaritic lifestyle that the tropics offer. In fact, the Delano could be in the south of France or on some sunwashed island in the Adriatic, not on bustling, grimy Collins Avenue.

Durch die verspielten und witzigen Ideen des französischen Designers Philippe Starck erhielt ein Hotel, das seinen Charme verloren hatte, neuen Schwung – und ein völlig neues Erscheinungsbild.

Die öffentlichen Räume sowie alle Wände und Böden des Hotels bestehen aus Holz, aber nahezu alles Übrige ist in Weiß gehalten: So wurden z.B. Teile der Empfangshalle durch riesige, hauchdünne weiße Draperien abgeteilt. Und auch im Speisesaal herrscht die Farbe Weiß vor.

Im ganzen Hotel entdeckt man überall optische Spielereien. Die Einrichtung und Möblierung ist behaglich, mit vielen Polstern, und wirkt fast schon überdimensioniert. Im Rezeptionsbereich wurde ein großes Liegesofa (im Grunde ein Bett) aufgestellt, und um den Swimmingpool gruppieren sich große Polstersessel statt der üblichen robusten Gartenmöbel. Ein Teil des Mobiliars reicht sogar bis in den Pool hinein.

Der Swimmingpool selbst erweckt den Eindruck, als würde er auf der Erdoberfläche treiben. Es handelt sich um ein langes, flaches Becken, das weniger zum Schwimmen als zum Sehen und Gesehenwerden geeignet scheint. Und tatsächlich ist es die Atmosphäre am Pool, die dem Delano Hotel seine besondere Ausstrahlung verleiht.

Starck verbrachte nur kurze Zeit in Miami, bevor er seine Ode an diese Stadt entwarf. Dementsprechend ging es ihm beim Umbau des Delano weniger um einen bestimmten historischen oder baulichen Aspekt des Geländes, sondern eher um den sinnenfrohen Lebensstil der Tropen.

Un hôtel Art Déco qui avait perdu son charme vient de renaître grâce aux idées du designer français Philippe Starck. L'hôtel, ainsi que plusieurs autres du quartier proche du centre de congrès de Miami Beach, échappait à la règlementation de protection de l'architecture historique de la ville, et a donc pu être rénové, plutôt que simplement restauré.

Dans les espaces de réception, les murs et les sols sont recouverts de bois, mais pratiquement tout le reste est blanc. Le hall d'entrée est divisé par d'immenses rideaux de gaze flottants. Dans la salle à manger, tout est pratiquement blanc à l'exception du bois sombre des sièges.

Les trouvailles visuelles abondent. Le mobilier est confortable, très rembourré, souvent surdimensionné. Une double chaise-longue s'étale dans la zone de réception. Dehors, près de la piscine, sont disposées d'énormes chaises-longues rembourrées, alors qu'on s'attendrait à des sièges plus robustes. Certains éléments de mobilier sont même immergés dans la piscine.

La piscine est conçue de manière à donner l'impression qu'elle flotte à la surface du sol. Longue et creuse, il s'agit moins d'une piscine pour nager que d'un endroit où voir et être vu. En fait l'atmosphère autour de cette piscine est l'essence même du nouveau Delano.

Starck n'a pas passé beaucoup de temps à Miami avant de concevoir cette ode à la ville et, en fait, le Delano parle moins des aspects physiques ou historiques du lieu que du style de vie des Tropiques. Il pourrait tout aussi bien se trouver dans le sud de la France ou sur quelque île ensoleillée de l'Adriatique ou des Caraïbes.

RIGHT: View of the Delano from its pool.
OVERLEAF: The front lobby and registration desk.

RECHTS: Ansicht des Delano, vom Swimmingpool aus.
FOLGENDE DOPPELSEITE: Eingangshalle und Rezeption.

A DROITE: Vue du Delano, prise de la piscine.
DOUBLE PAGE SUIVANTE: Le hall principal et le comptoir de la réception.

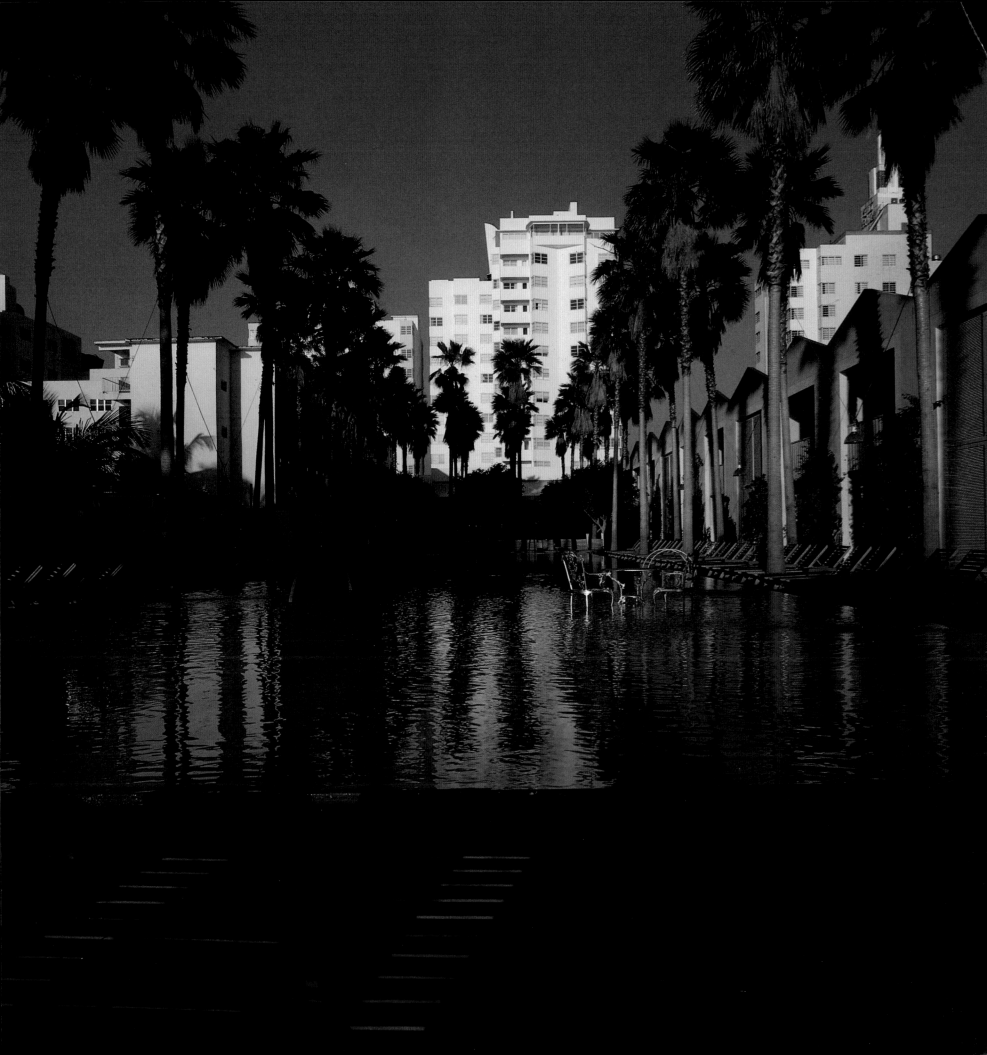

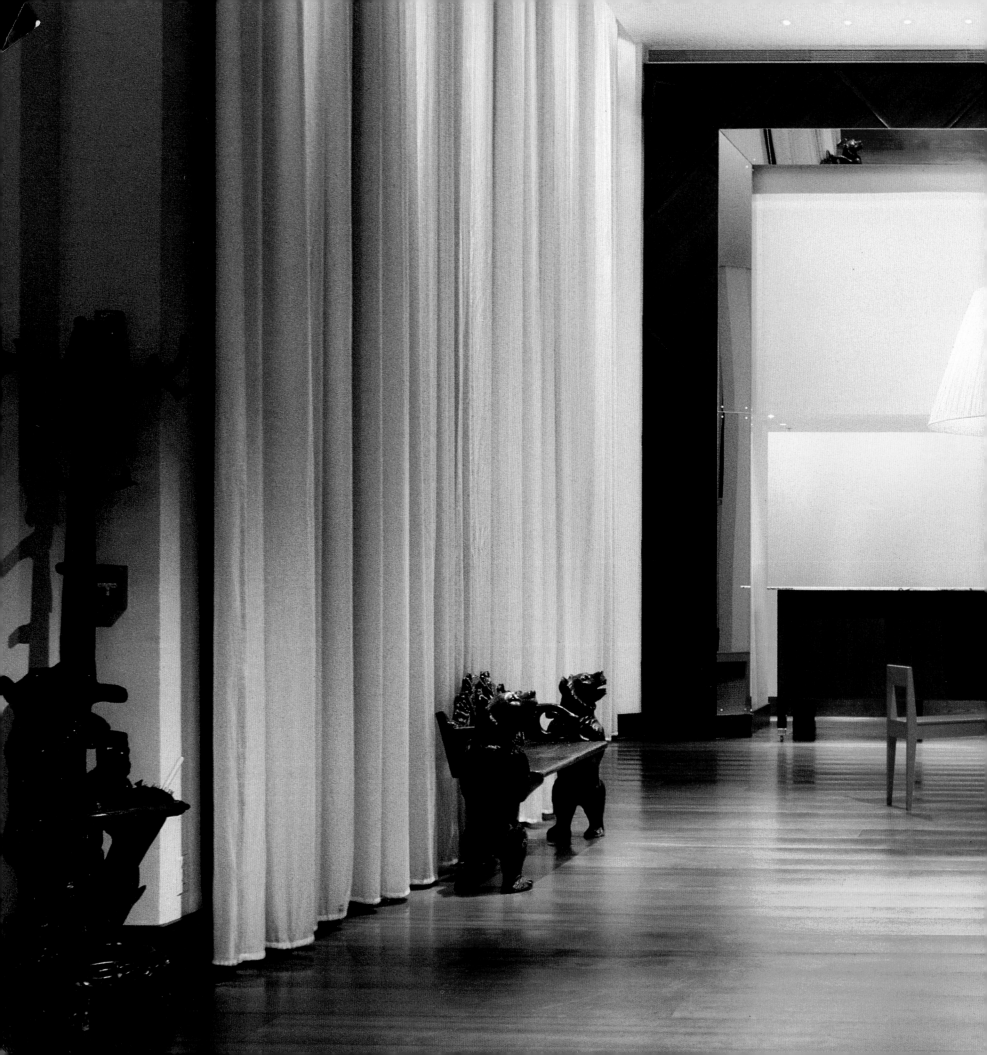

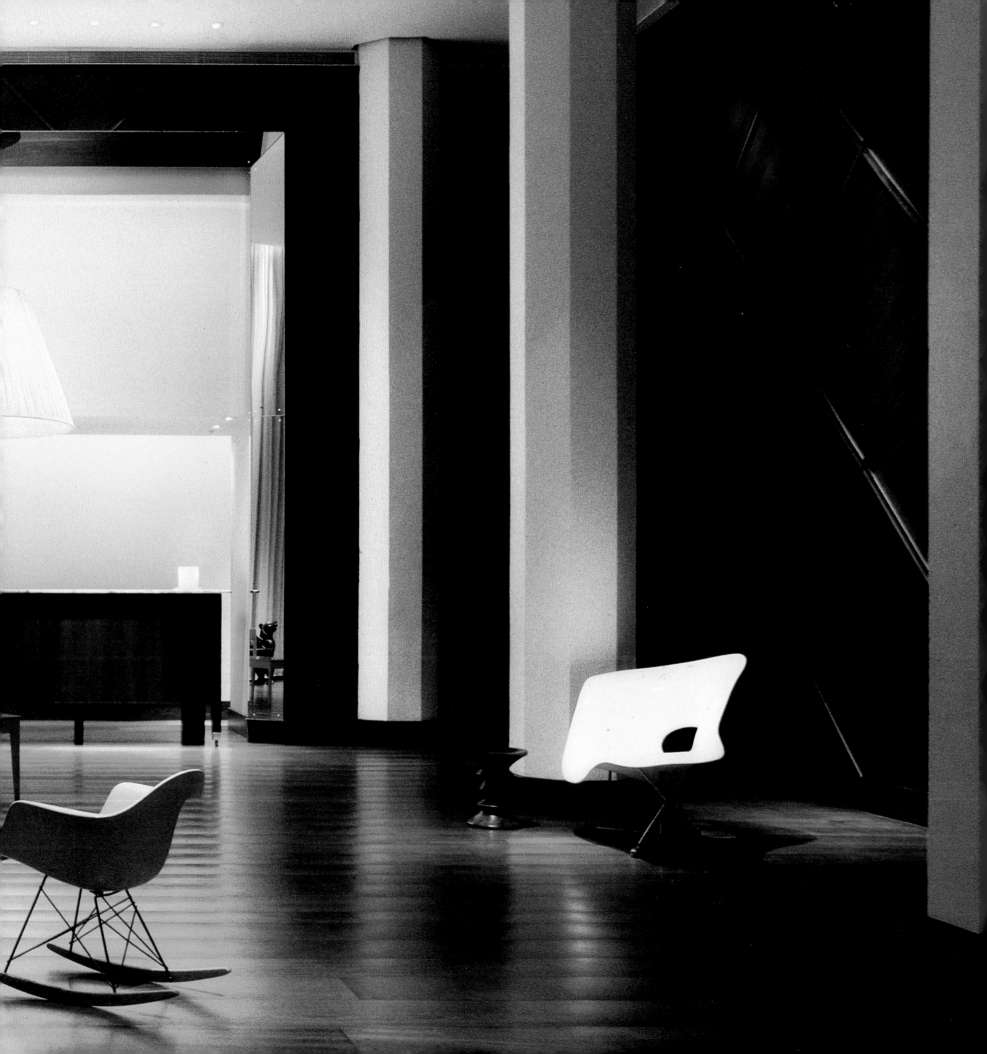

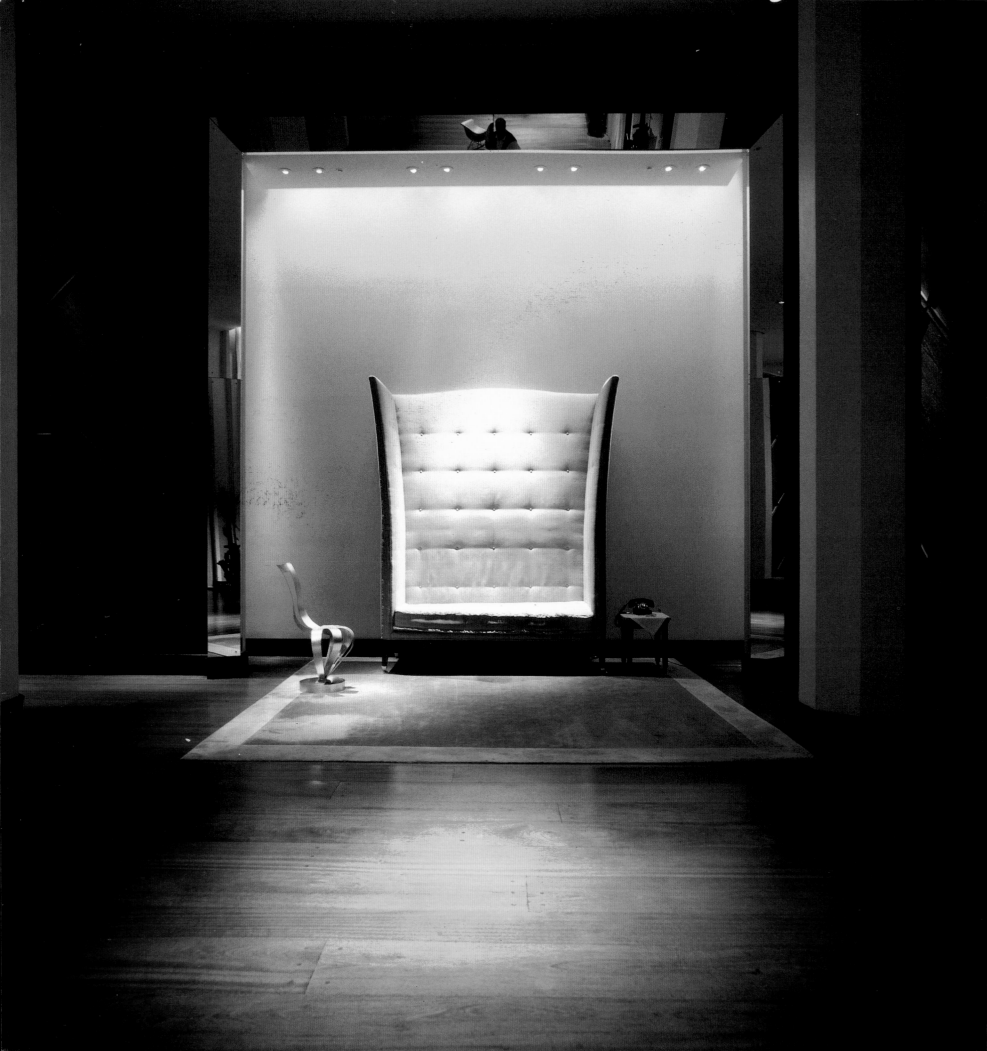

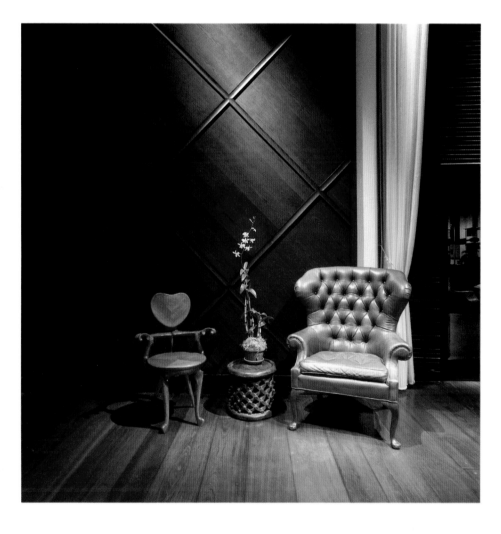

LEFT AND ABOVE: To furnish the public spaces, Starck arranged unusual furniture as if it were in a living room.

LINKS UND OBEN: Für die Ausstattung der öffentlichen Räume stellte Starck ungewöhnliche Möbel zu einer Art Wohnzimmer zusammen.

A GAUCHE ET CI-DESSUS: Pour les espaces de réception, Starck a choisi divers meubles de salon inhabituels.

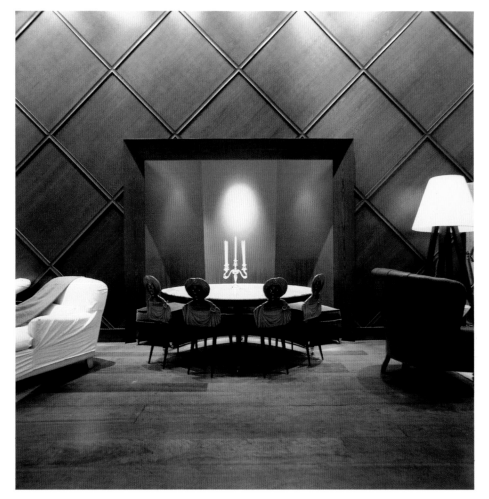

ABOVE AND RIGHT: The Delano's public spaces offer many places to sit in a combination of old and new furnishings.
FIRST OVERLEAF: A David Barton gym occupies the Delano's basement.
SECOND OVERLEAF: A paneled lobby wall is illuminated by dozens of small sconces.
THIRD OVERLEAF: Enormous drapes divide the cavernous lobby.

OBEN UND RECHTS: Die öffentlichen Räume des Delano bieten Sitzgelegenheiten unterschiedlicher Provenienz.
FOLGENDE DOPPELSEITE: Das Tiefgeschoß des Delano beherbergt ein von David Barton entworfenes Fitneßzentrum.
DARAUFFOLGENDE DOPPELSEITE: Eine holzgetäfelte Wand in der Eingangshalle wird von vielen Lämpchen illuminiert.
DRITTE DOPPELSEITE: Riesige Draperien unterteilen die höhlenartige Eingangsshalle.

CI-DESSUS ET A DROITE: Les espaces de réception du Delano offrent de nombreux endroits où s'assoir et combinent meubles nouveaux et anciens.
PREMIERE DOUBLE PAGE SUIVANTE: Un gymnase de David Barton occupe le sous-sol de l'hôtel.
SECONDE DOUBLE PAGE SUIVANTE: Le mur lambrissé de la réception est illuminé par des dizaines de petites ampoules.
TROISIEME DOUBLE PAGE SUIVANTE: De vastes draperies divisent le hall aux allures de caverne.

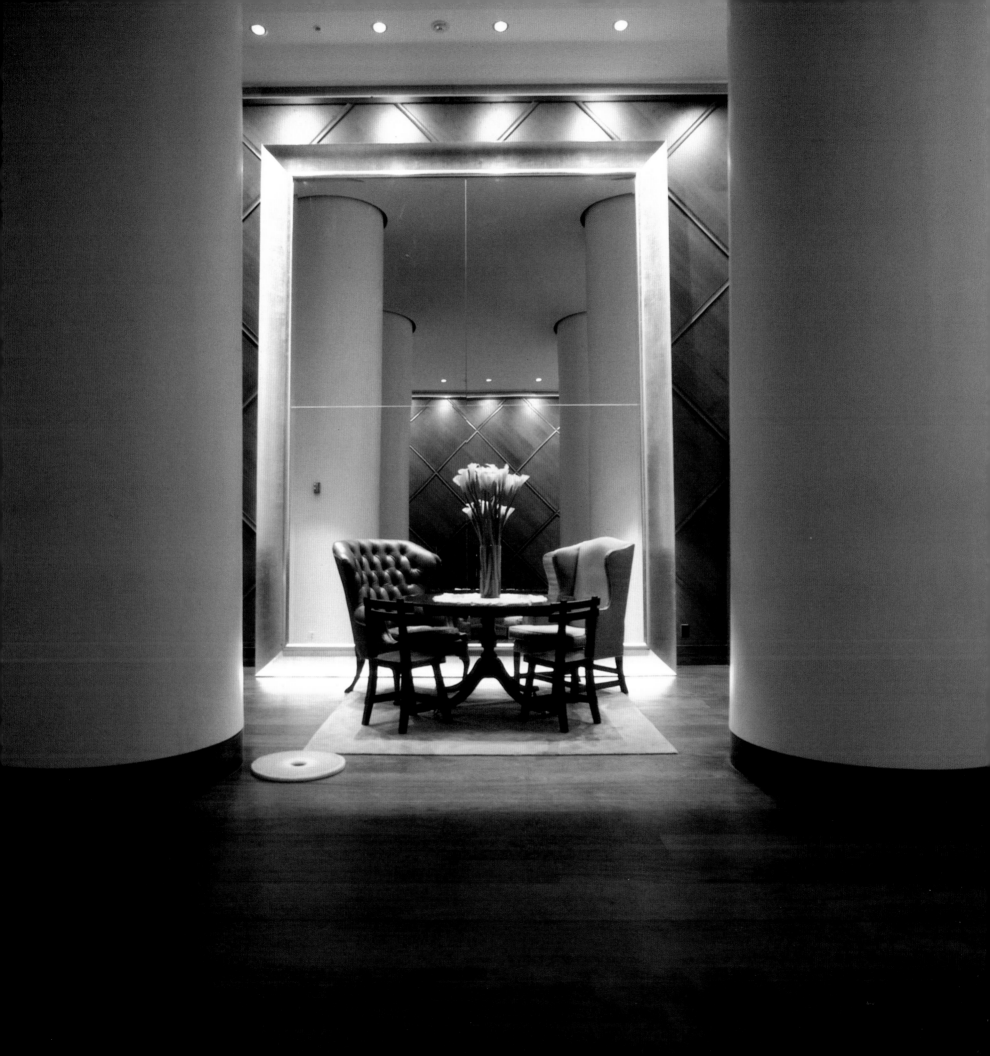

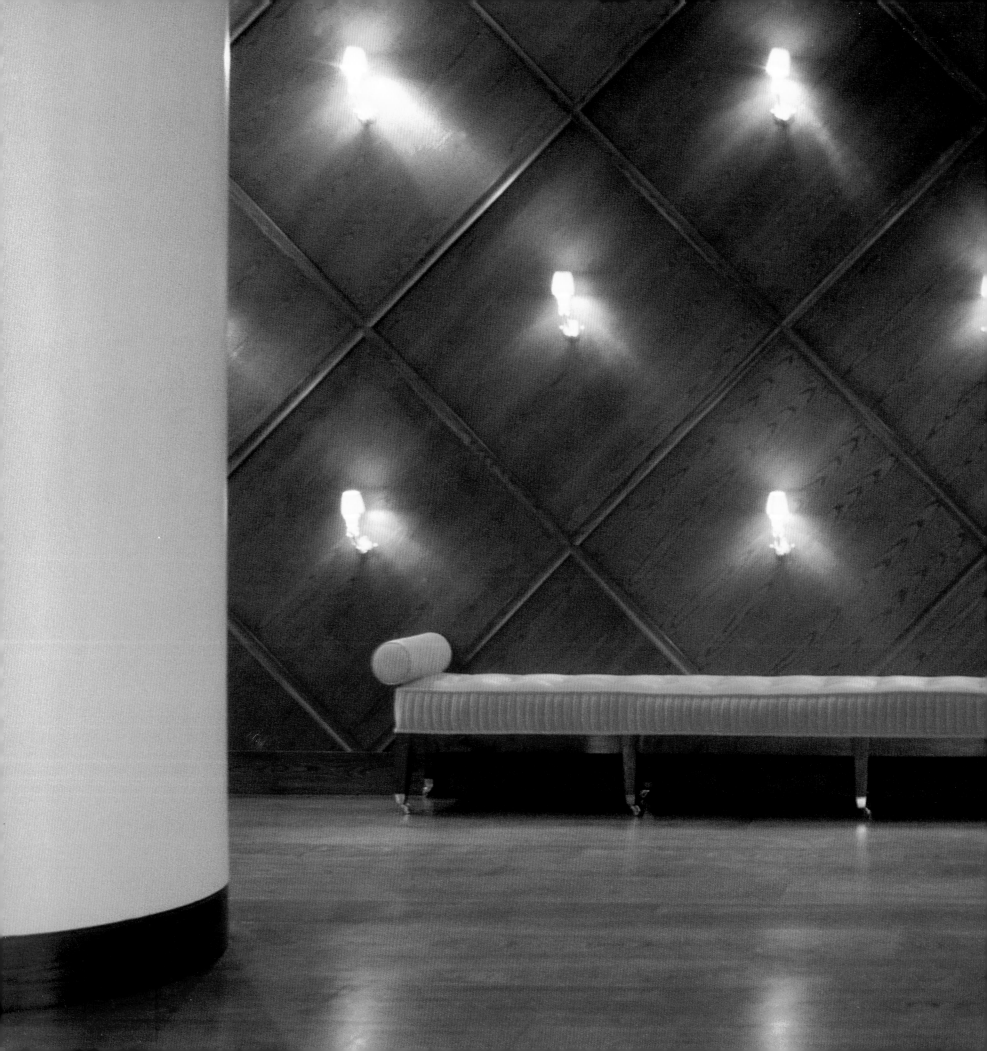

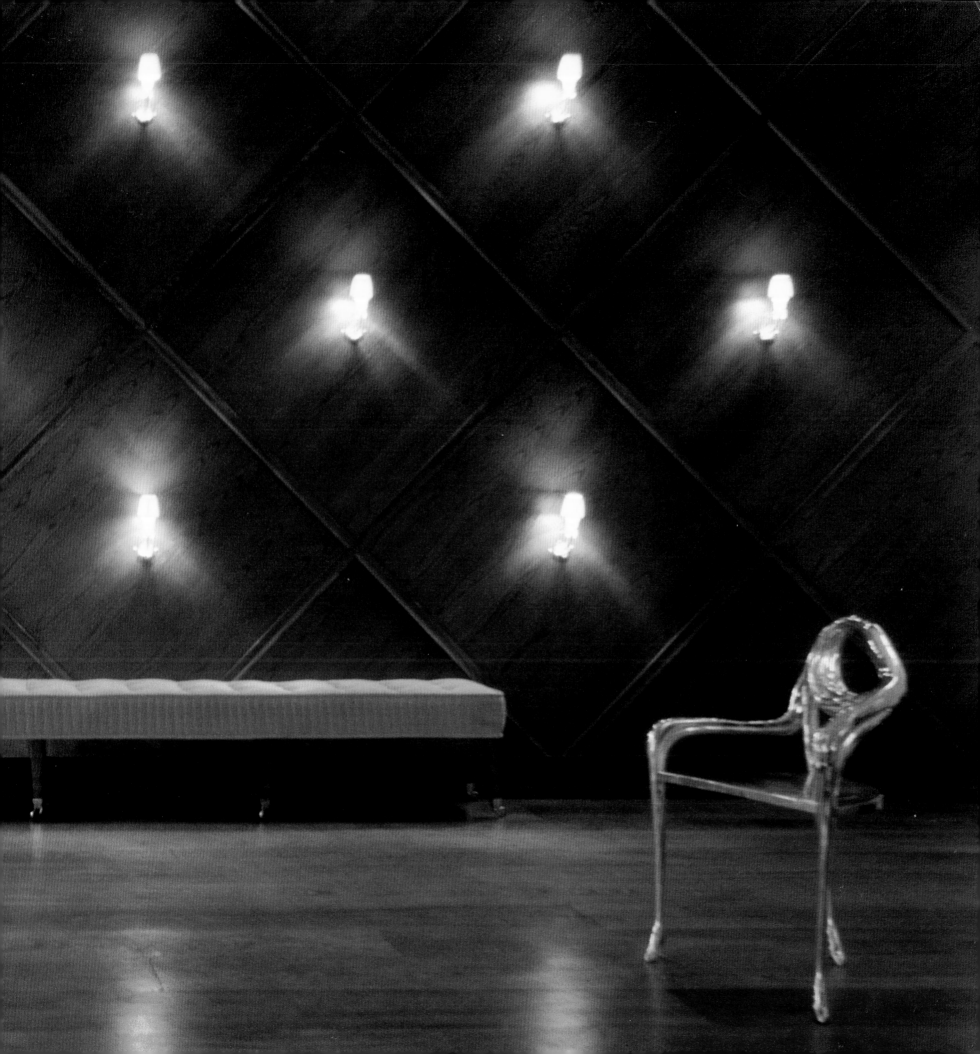

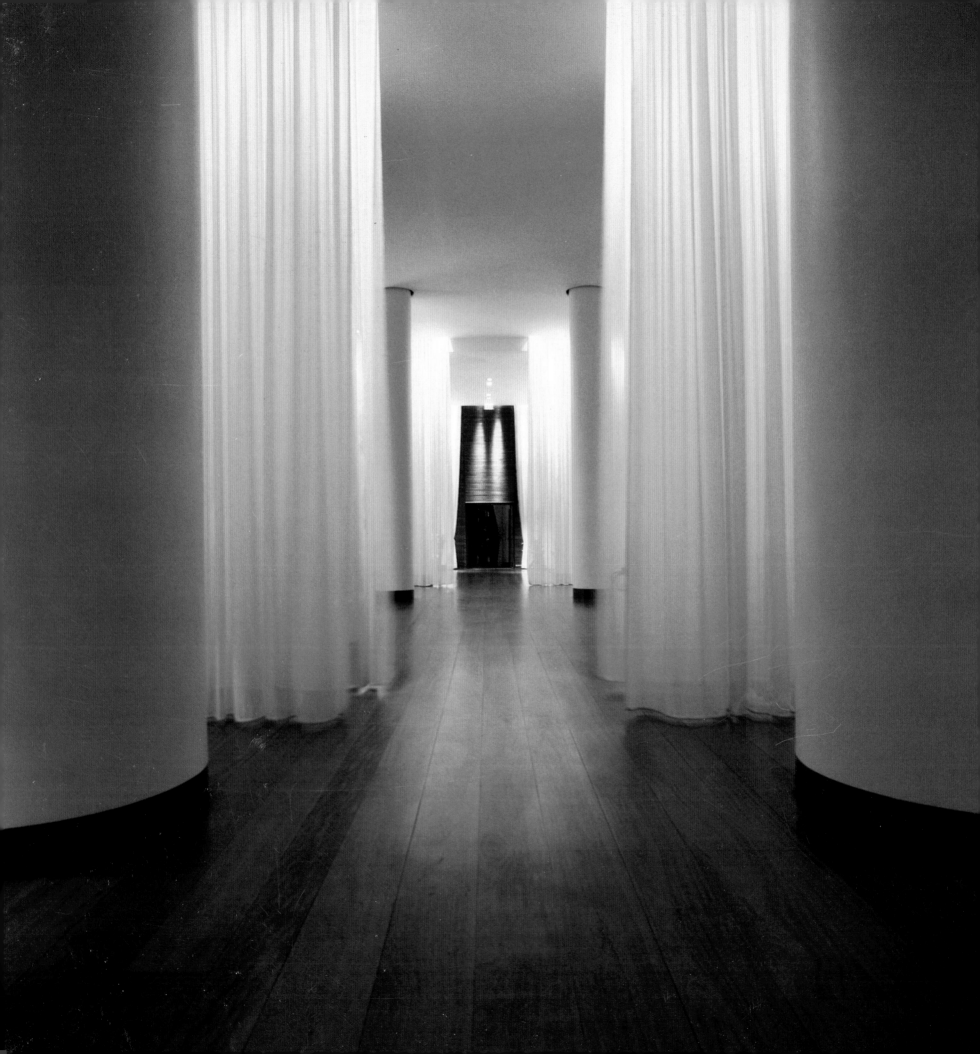